Not Here, Not Now, Not That!

Protest over Art and Culture in America

STEVEN J. TEPPER

The University of Chicago Press
Chicago and London

Steven J. Tepper is assistant professor of sociology and associate director of the Curb Center for Art, Enterprise, and Public Policy at Vanderbilt University. He is a contributing author and coeditor of *Engaging Art: The Next Great Transformation of America's Cultural Life.*

The University of Chicago Press, Chicago 60637
The University of Chicago Press, Ltd., London
© 2011 by The University of Chicago
All rights reserved. Published 2011.
Printed in the United States of America

20 19 18 17 16 15 14 13 12 11 1 2 3 4 5

ISBN-13: 978-0-226-79286-6 (cloth)
ISBN-10: 0-226-79286-2 (cloth)
ISBN-13: 978-0-226-79287-3 (paper)
ISBN-10: 0-226-79287-0 (paper)

Library of Congress Cataloging-in-Publication Data
Tepper, Steven J.
 Not here, not now, not that!: protest over art and culture in America /
Steven J. Tepper.
 p. cm.
 Includes bibliographical references and index.
 ISBN-13: 978-0-226-79286-6 (cloth: alk. paper)
 ISBN-10: 0-226-79286-2 (cloth: alk. paper)
 ISBN-13: 978-0-226-79287-3 (pbk.: alk. paper)
 ISBN-10: 0-226-79287-0 (pbk.: alk. paper) 1. Arts—United States—Citizen participation. 2. Arts—Political aspects—United States. 3. Culture conflict—United States. 4. Homosexuality and the arts—United States. 5. Arts and religion—United States. 6. Protest movements—United States. I. Title.
 NX230.T46 2011
 306.4'70973—dc22 2010037424

This book is dedicated to the amazing Dana Mossman Tepper

Not Here, Not Now, Not That!

CONTENTS

List of Figures / ix
List of Tables / xi
Acknowledgments / xiii

INTRODUCTION / The Social Nature of Offense and
Public Protest over Art and Culture / 1

ONE / A Bird's-Eye View of Cultural Conflict in America / 25

TWO / Social Change and Cultural Conflict: Uncertainty,
Control, and Symbolic Politics / 61

THREE / Some Like It Hot: Why Some Cities Are
More Contentious than Others / 85

FOUR / Fast Times in Atlanta: Change, Identity, and Protest / 105

FIVE / From Words to Action: The Political and
Institutional Context for Protest / 121

INTRODUCTION TO CHAPTERS SIX, SEVEN, AND EIGHT /
Profiles of Contention / 147

SIX / Cities of Cultural Regulation: Cincinnati, Dayton,
Kansas City, and Oklahoma City / 153

SEVEN / Cities of Contention: Dallas, Fort Worth,
Charlotte, and Denver / 171

EIGHT / Cities of Recognition: San Francisco, Albuquerque,
San Jose, and Cleveland / 189

NINE / On Air, Our Air: Fighting for Decency on the Airwaves / 217

CONCLUSION / Art and Cultural Expression in America: Symbols of
Community, Sources of Conflict, and Sites of Democracy / 247

EPILOGUE / Reflections on Cultural Policy, Democracy, and Protest / 265

Methodological Appendix / 287
Notes / 327
Works Cited / 335
Index / 351

FIGURES

1.1 How many different articles were written about the controversy? / 48

1.2 How many different groups participated in the controversy? / 49

5.1 Comparing number of protest events by levels of unconventional political culture / 133

5.2 Comparing number of protest events by levels of traditional index / 134

5.3 Comparing number of racial/ethnic conflicts in the 1970s and 1980s with the number of arts conflicts in the 1990s / 135

5.4 Comparing number of protest events for cities with and without a gay rights ordinance / 136

5.5 Comparing number of protest events by level of voter turnout / 139

5.6 Comparing number of protest events by levels of conservative index in cities / 143

TABLES

1.1 Ranking of cities by total number of conflict events, 1995–98 / 38

1.2 Types of challenges / 39

1.3 Primary grievances expressed by protesters / 42

1.4 Was the protest based in conservative or liberal concerns? / 43

1.5 Who participated in the protest against the artwork? / 44

1.6 Nature of protest activity / 45

1.7 Protest outcomes / 47

1.8 Intensity of protest / 49

1.9 Religious and national dimensions of conflict / 51

1.10 Comparing characteristics of protest along two dimensions: National/local and religious/nonreligious / 52

1.11 Comparing protest outcomes for conflicts with and without the involvement of elected officials / 54

2.1 Saguaro Survey: Comparing the percentage of respondents who would ban disagreeable books / 74

2.2 DDB Survey: Comparing the percentage of respondents who think the government should do more to control what is on TV / 78

2.3 General Social Survey: Comparing the percentage of respondents who would be in favor of banning a pro-gay book from the library / 81

3.1 Ranking of cities by total number of conflict events, 1995–98 / 97

3.2 Ranking of cities by predicted number of conflict events, controlling for population size (log), 1995–98 / 98

3.3 Top fifteen fastest-growing cities (in terms of foreign-born residents) compared with the bottom fifteen cities, 1995–98 / 99

3.4 Differences in predicted number of protest events for cities at bottom 10th percentile and cities at top 90th percentile / 102

3.5 Differences in predicted number of *conservative-based* protest events for cities at bottom 10th percentile and cities at top 90th percentile / 104

5.1 Forms of collective action / 128

5.2 How is grievance to an official or administrator handled? / 130

6.1 Comparing cities of cultural regulation (CCR), cities of contention (CC), cities of recognition (CR) / 155

9.1 Complaint letters and e-mails filed with the FCC / 220

A.1 Predicting whether or not a conflict event is likely to be a wildfire based on types of participants, grievances, and discourse: Binary logistic regression / 303

A.2 Predicting support for restricting unpopular library book: Binary logistic model / 306

A.3 Predicting support for increased government control of TV: Binary logistic regression / 309

A.4 Predicting support for removing pro-gay library book: Binary logistic regression / 312

A.5 Descriptive statistics for variables in chapter 3 / 316

A.6 Predicting total conflicts: Poisson model for table 3.4 / 317

A.7 Predicting conservative-based conflicts: Poisson model for table 3.5 / 318

A.8 Factor analysis for magazine subscriptions by city: Rotated component matrix / 320

A.9 Protest regressed on political culture variables: Poisson regression / 323

ACKNOWLEDGMENTS

This book would not have been possible without the support and encouragement of Paul DiMaggio. My interest in cultural conflict grew alongside Paul's interest in this area and I benefited immensely from his early work on arts protests in the Philadelphia area. Paul's advice and input were invaluable, and I continue to be inspired by his energy and creativity.

Not Here, Not Now, Not That! traveled many unexpected pathways and arrived at new insights thanks to the generosity of those who provided access to their data or who encouraged me to look to new sources: thanks to Terry Clark, who introduced me to the DDB Life Style Survey; to Robert Putnam and his colleagues for their excellent work on the Social Capital and Community Benchmark Survey; to Gary Jensen, who told me about the American Bureau of Circulation magazine subscription data; to Jonathan Levy at the Federal Communication Commission, who helped secure data on complaint letters from every zip code in America; to Susan Olzak, who provided me with her data of city-based ethnic protests; and to Gavin McKiernan at the Parents Television Council, who encouraged his local chapters to participate in focus groups.

At Princeton, Stan Katz provided me with a supportive environment in which to work and explore new ideas. The policy perspectives in the book were sharpened by the six years I spent working alongside Stan at the Woodrow Wilson School. At Princeton I also received great support from Paul Starr, Bob Wuthnow, and Brian Steensland; Kieran Healy, Eszter Hargittai, and Julian Dierkes challenged me to think critically and deeply about my subject.

As the book took shape at Vanderbilt, many colleagues inspired me to stretch my insights and thinking. Dan Cornfield helped me connect the work to larger themes of democracy and public life. Richard Pitt was a great

sounding board when I felt most uncertain about the book's fate and direction. Jenn Lena, Richard Lloyd, Terry McDonnell, and the entire Culture and Creativity Workshop at Vanderbilt provided invaluable feedback and comments. Elizabeth Long Lingo read several drafts and helped me frame the conclusion of the book. Katherine Everhart edited an early draft of the book, and Connie Sinclair provided me with much-needed organizational support in finishing the manuscript and throughout the editing phase.

I shared many meals at the Indian buffet with my colleague Bill Ivey, debating and interrogating the book's themes. As the former chairman of the National Endowment for the Arts and twice chairman of the National Academy of Recording Arts and Sciences (the Grammy Awards), Bill is no stranger to cultural conflict and provided many critical insights along the way. Moreover, there is no one with whom I would rather ponder and debate a new idea or puzzle. Bill has a tremendous mind, much of it lurking in the shadows of this book. Bill also brought me to Vanderbilt and gave me the space and time I needed to complete the manuscript.

Heather Talley deserves much of the credit for chapter 9, which is based on her brilliantly conducted focus groups and interviews with activists from the Parents Television Council across the United States. Heather is a first-rate scholar and I was fortunate that she was able to dedicate the summer of 2008 to this work.

I had many research assistants over the last decade, and they all deserve recognition for their hard work and contributions: Katy Siquig, Brent Levy, Adam Sedgewick, Jessie Washington, Taryn Kudler, Fatin Abbas, Alexandra Filinda, Susan Lutz, Stefan Cap, Zach Augustine, Benjamin Popper, Aliza Sir, and Simon Hirsch.

The work was funded in part by grants from the Henry Luce Foundation, the Andrew Mellon Foundation, the Pew Charitable Trusts, and the John D. Rockefeller Foundation. I am also grateful to Alberta Arthurs, formerly at the Rockefeller Foundation, who encouraged me to read Albert Hirschman's book *Exit, Voice, and Loyalty*, which heavily influenced my thinking about the democratic consequences of protest over art and media.

I could not have written the book without the graciousness of the Touve family and their little yellow garage apartment. What a marvelous space to spend my sabbatical year writing.

Tom Smith and Rob Harris listened to many early morning rants about the book on our daily runs through Nashville. Tom in particular kept me motivated by asking me each morning for two consecutive years: "Is the book finished?"

Finally, to my family—a clan of brilliant and curious people who not only provided emotional support throughout the process but also asked amazing questions that helped me better articulate and clarify the emerging story. Thank you Dana, Sally, Sam, David, Sondra, Ted, Steve, Gene, Stu, Mark, Nancy, Guy, and Sidney.

And special thanks to Douglas Mitchell at the University of Chicago Press. I treasure our correspondence. Each letter from Doug contained a morsel of epistolary brilliance—a delicious turn of phrase or clever insight that happily reminded me that we should always have fun with language and ideas.

The Social Nature of Offense
and Public Protest over Art and Culture

In spring 2006 a Vanderbilt University fraternity hosted a themed party, "Pimps and Hos." Women were encouraged to attend dressed like prostitutes, and male students were told to come decked out in gold chains, felted gangster hats, sunglasses, and wide-lapel velvet suits. Posters advertising the party were tacked up on and off campus, even on trees and telephone poles near my home. The event *offended* me. For one thing, I didn't like having to explain to my seven-year-old daughter the meaning of "ho," nor did I think much of the overtly sexual posters that hyped the party. I was also offended by what I considered the demeaning, misogynistic, and probably racist character of the event. I was upset that many of my own students uncritically embraced the theme, attended the party, and never seemed to realize that it endorsed a culture that was antithetical to the university's core principals. In fact, when I expressed my views, several women in my class politely told me to "lighten up."

Think about the last time you were offended. Some readers may have to dig deep to come up with an incident. Others might feel routinely surrounded by offensive material, perhaps *Sex and the City* on television, the Dixie Chicks on the radio, Victoria's Secret displays at the mall, billboards featuring emaciated models in Ralph Lauren underwear, or books about sex on the shelves of the public library. When it comes to taking offense, we all seem to have different threshold levels or tipping points.

This fact was driven home in a graduate school seminar at Harvard years ago. We were discussing a chapter by political philosopher Joel Feinberg called "A Rise on the Bus" (1985). Feinberg presents a series of thirty-one possible scenarios. You are riding a bus and can't get off. Passengers get on, sit near you, and start acting out in ways that might be upsetting, beginning

with the banal, such as singing off-key, belching, or scratching on a metallic surface, and escalating to the more shocking, such as farting, copulating in the adjacent seat, or even eating feces out of a bag. The tipping point at which an action was *so* offensive as to be prohibited was different for every student. In fact, one—a marine fresh from six months at sea—claimed that *none* of the actions would bother him; he'd seen it all! Most students in the seminar had different tipping points at which they felt that the activity was so offensive it should not be allowed.

Offense is clearly personal and idiosyncratic; but offense can also be the shared property of a community. After all, the U.S. Supreme Court has defined obscenity as an act of expression that merits government regulation because it is considered patently *offensive* based on "community standards." Whether or not such standards can, in practice, be ascertained is an open question. Nonetheless, our legal system tells us that the "community"— rather than just individuals—represents the appropriate level of analysis at which to determine levels of offensiveness. Steven Dubin, who has written about arts conflicts in the 1980s, has described this as the "social construction of acceptability," the notion that "offense" is a property of social life and collective definitions—not just individual tastes and preferences (1992). This communal, social aspect to offense emerges clearly when there is *public* conflict over words and images.

Throughout America personal offense spills out into the public square when citizens object to some form of expression—books, songs, sculpture, holiday displays, and flags. This book explores the social nature of offense and the conditions that give rise to public controversies over cultural expression. What is it about where we live, how we relate to our neighbors, our collective hopes and fears, and our local politics that combine to foment disagreement and protest over art? By examining hundreds of disputes in dozens of U.S. cities, I argue that cultural conflict has a distinctive local profile. Cities exhibit different profiles of contention based, in part, on the demographic, institutional, and political makeup of the city. Fights over art and culture are not just the result of clashing personalities or contending values; they also represent the democratic outcome of citizens negotiating the consequences of social change within their communities.

In Boston, festival organizers canceled a play—*Shakespeare's Dogs*—by a local theater group because it featured people, dressed as dogs, pretending to urinate on trees. In Oklahoma City, citizens demanded the resignation of a city librarian for knowingly making available the Academy Award–winning film *The Tin Drum*, which features a scene of a nine-year-old boy having sex with a teenage girl. In Kansas City, students organized a petition

to stop what they considered to be sexually provocative dance moves and practice outfits worn by girls on the school's drill team. In Tampa, school board officials banned the government report by Kenneth Starr, U.S. special prosecutor, that described the details of President Clinton's sexual relations with a White House intern. In Miami, several hundred Haitians gathered in front of city hall to protest the Hollywood film *How Stella Got Her Groove Back* because a scene in the film associates them with the AIDS virus. In Denver, a Christian group demanded that gargoyles be removed from a public library because the winged creatures were satanic and evil. In Salt Lake City, a Jewish family sued the school district because their tenth-grade daughter was forced to sing "The Lord Bless You and Keep You" in a Christmas choir concert.

While many of these incidents seem to reflect individual judgments about taste and propriety, I will argue that they are fundamentally social in nature. Claims against cultural expression are social because grievances arise out of particular social contexts; get articulated through conversation with others; mobilized by organizations or groups; reported on by the press; and defended, attacked, amplified, or deflected by fellow citizens.

My premise is straightforward. I believe controversies over art and expression are symptomatic of deeper community struggles. Artworks often serve as lightning rods, bringing forward and giving voice to underlying tension caused by social change. When communities experience an influx of new populations, new institutions, new types of families, new patterns of leisure, and new technologies, community members fight over symbols such as art and culture as a way to assert themselves. When everything feels "up for grabs," people grab on to symbols as a way to make sense of change and affirm their identity and place in the world. A protest against a Halloween party at a local bookstore in Denver may, on the surface, reflect concerns about paganism and blasphemy. But it most likely also expresses deeper anxieties about whether Denver is becoming more or less Christian; whether traditionalists in the community feel like they are losing ground to newcomers who hold different beliefs.

Speaking out or joining in a protest over art is determined, in part, by the prevailing political, institutional, and public opinion climate. You are more likely to make a public claim against an artwork if you feel there is sufficient support for your opinion among your neighbors, colleagues, and public officials. And the political culture of a community—the nature of civic activism, the history of protest, and the style of politics—helps determine the intensity and frequency of conflict. In some communities protest activity is routine; in others it is rare.

So while every conflict is unique and every offense is rooted in personal reactions, the public expression of grievances against art and culture, in the aggregate, reflects patterns influenced by social change, political culture, and the institutional makeup of a community. These patterns are what I refer to as the *structure* of cultural conflict.

Theories of Conflict

This book is about public disagreements over music, parades, visual art, books, and other forms of expressive life. These cultural objects function as powerful symbols—images, words, and sounds—evoking approbation, bewilderment, indifference, or antagonism. I am interested in the latter, and more specifically the conditions that give rise to overt antagonism over cultural expression. But why should we care about conflict over art and culture? And more specifically, why should sociologists care? What do these conflicts tell us about social life?

Theories of conflict have provided social scientists with a rich set of intellectual tools to explain a vast array of social arrangements, processes, and outcomes. "Conflict" is as central to sociology as "survival" is to evolutionary biology. Understanding conflict—its forms, incidences, and consequences—is critical for studying disruptive events like war, rebellion, strife, and civil unrest. Conflict, or competition between groups, also explains the creation and maintenance of stable institutions and routine aspects of social life (political parties, laws and regulations, schools and cultural institutions). Social groups may create these institutions to advance collective aims; but more often than not, they create them as a way to pursue their own interests—power, wealth, status—at the expense of competing groups, whether the competition comes from another economic class or a different ethnic or racial group.

Historically, sociologists, influenced by Karl Marx, have been most interested in conflict and competition over economic resources—such as wages and capital. These conflicts might take the shape of rebellions, strikes, and riots, or they might appear as social movements that attempt to influence government through a variety of political tactics and repertoires. Ultimately, understanding the dynamics of social conflict reveals a great deal about the potential for equity and economic justice.

Sociologists have paid increasing attention to symbolic and moral conflicts that are not overtly related to economic struggles but rather revolve around differences in values and lifestyles, such as conflicts over clothing (for example, sumptuary laws), campaigns against vice, temperance cru-

sades, abortion, and disputes over art and entertainment. Sociologist Lewis Coser recognized early on that symbolic and economic conflicts are cut from the same cloth; both, in his words, are "struggles over values or claims to status, power, and scarce resources, in which the aims of the conflicting groups are not only to gain the desired values, but also to neutralize, injure, or eliminate rivals" (in Oberschall 1978, 291). Like fights over land and jobs, symbolic conflicts over such things as clothing, music, food and drink, books, and visual art have significant repercussions for power and social inequality. Nicola Beisel (1997), for example, writes that moral politics, especially campaigns to protect children from obscenity and other harmful culture, constitute "real politics" (202). They are "real politics" because, as in the case of anti-vice campaigns in the nineteenth and twentieth centuries, they represent an attempt by upper classes to designate "good" and "bad" culture, thereby providing a road map for class reproduction. Children who consume "good" culture, socialize with other children who consume this culture, and avoid the "harmful" culture of immigrants and those in the lower classes will be assured of finding appropriate mates, good jobs, and a secure place in the upper echelons.

Cultural conflict surfaces such questions as: Will drunkenness or temperance prevail as a dominant value? Abstinence or promiscuity? Respect for parents and teachers or rebellion and disrespect? Fidelity or divorce? Patriarchy or women's liberation? Religious or secular values? Traditional family structure or tolerance for gay and lesbian lifestyles? Citizens compete with one another in an effort to define and control the symbols and cultural expression that communicate the values of their community. They compete over whose message is seen and heard in the press, whose books are available in schools and libraries, whose monuments are in the public park, whose flag flies over the county courthouse, and whose language appears on traffic signs. Securing scarce symbolic resources brings many advantages to the winners, such as prestige and status. If temperance emerges as a cherished value in a community, then those who are temperate will be more highly regarded than those who are not. And as Joseph Gusfield (1963) shows, this was precisely the strategy used by middle-class reformers in the nineteenth century to distinguish themselves from the behavior and lifestyle of newly arrived Catholic immigrants. Similarly, if opponents of pornography successfully portray allegedly obscene materials as pernicious, then those who consume and sell such material become pariahs in a community, while those who fight against obscenity become heroes and honored citizens (Zurcher and Kirkpatrick 1976). Status and prestige convert into social inclusion and exclusion, acceptance and rejection—a fact

that most of us have known, even if not acknowledged, since grade school. And there is incontrovertible evidence that such social "sorting"—abetted by cultural cues—is critical for social mobility and economic advantage.

So we should care about cultural conflict because it is pervasive and shapes social life. As James Davison Hunter writes, "Culture, by its very constitution in social life, is contested. As always, the stakes are not, at least first, material but rather symbolic: the power of culture to name things, to define reality, to create and shape worlds of meaning" (Hunter and Wolfe 2006, 33). Winning the battle over symbols can earn for its victors both social prestige and economic advantage.

Culture Wars

Another reason for studying cultural conflict is that clashes over values and symbols, according to some, are becoming more prominent and more strident. James Davison Hunter (1991) is one of the first academic scholars to bring sustained attention to contemporary cultural conflict. According to Hunter we are witnessing the rise of a "culture war"—a momentous struggle between orthodox and progressive forces to define the meaning of America. He writes, "In a society as pluralistic as ours, the tendencies toward cultural conflict are inevitably intensified as the diversity of actors and institutions in competition has increased" (33). In these accounts cultural conflict includes "hot-button" issues like abortion, prayer in schools, gay marriage, English only, and government funding of the arts. While scholars disagree as to whether most Americans are truly split over fundamental values and beliefs, it is generally accepted that cultural and moral disputes have come to dominate public discourse. Since the early 1990s the rhetoric of a "culture war" has been the subject of numerous academic articles and books, and it has become accepted wisdom among pundits and journalists that Americans are divided over values. In fact, following the 2000 presidential election in the United States, the media was quick to point out that the election hinged on the "value chasm separating the blue states from the red ones" (Fiorina 2004, 3).

Fights over art and cultural expression, the subject of this book, have been commandeered by the culture warriors and are increasingly attracting national headlines. Organizations like the Family Research Council, the American Family Association, and the Christian Coalition have protested allegedly blasphemous and obscene content in publicly funded art, media, and commercial entertainment in order to mobilize constituents, raise money, and influence elections. These groups assert that America is in the

midst of a serious moral decline and have targeted artists, entertainment executives, journalists, librarians, and institutions like the National Endowment for the Arts (NEA) as both cause and symptom of this decline. Former senator and presidential candidate Bob Dole entered the fray in 1995 when he scolded the entertainment industry for promoting sex and violence, proclaiming that "a line has been crossed—not just of taste, but of human dignity and decency" (Hendricks 1995, 1). In 1997 the Southern Baptist Convention launched a nationwide boycott of the Walt Disney Company, attacking the animated film *Pocahontas* for promoting paganism, the film *The Lion King* for containing obscene subliminal messages, and the ABC television network comedy *Ellen* for undermining family values. And in addition to traditional conservative voices, such critics as Tipper Gore and former Democratic Party activist Dolores Tucker have attacked gangsta rap and punk music for promoting antisocial behavior, violence, racism, and sexism.

On the left, civil libertarians, arts advocates, and scholars have responded by labeling critics as philistines and arguing that the First Amendment is being threatened as never before. Groups such as the People for the American Way (PFAW) and the American Library Association regularly publish reports calling attention to the "alarming" and growing number of attacks on artistic and intellectual freedom. The 1995 PFAW report "Artistic Freedom under Attack" claims that "after years of attacks from religious and political extremists, Americans' sensitivity to freedom of expression seems to have been numbed" (People for the American Way and Artsave 1995, 11). The report concludes that the "explosion of censorship and other challenges to artistic expression shows no signs of abating . . . rather, the *culture wars* will only continue to heat up" (21).

Not only have journalists and social activist organizations linked arts conflicts with the larger culture wars, but scholars have also made the connection. Hunter discusses conflicts over two widely publicized art cases in the late 1980s—Andres Serrano's photograph titled "Piss Christ" and a show of homoerotic images by Robert Mapplethorpe—as part of the culture wars. He also discusses fights over films (*The Last Temptation of Christ*), music (2 Live Crew), and television (*Saturday Night Live*). Elaine Sharp (1999) begins her book about morality politics with the controversy that erupted over the exhibition *Sensation* at the Brooklyn Museum. And both James Nolan (1996) and Rhys Williams (1997), who edited books on the culture wars, begin their introductions with examples of arts conflicts. In short, social scientists have begun to recognize that any study of social conflict at the dawn of the twenty-first century, especially conflict involving culture and morality, must take fights over art and cultural expression seriously.

Explaining Conflicts over Art and Culture

Explanations of conflict over art and culture fall roughly into the following categories: (1) offensive art offends, (2) fights over art reflect deep moral disagreements and value clashes, (3) art is simply a hot-button issue strategically deployed by enterprising politicians and moral reformers, and (4) artistic conflict is the product of anxiety and unease caused by social change.

Purveyors of the "offensive art offends" explanation often blame the cultural establishment—from the avant-garde to Hollywood—for producing images that challenge middle-class values. For example, in *Arresting Images*, Steven Dubin (1992) claims that controversies over cultural expression depend, in part, on the extent to which a work challenges established norms (see also Bolton 1992; Carver 1994; Steiner 1995). In the spirit of Mary Douglas's (1966) ideas of purity and danger, others contend that when art mixes categories that are normally distinct (religion and sex, children and nudity, politics and race), it is more likely to provoke the ire of censors (Carmilly-Weinberger 1986; Dubin 1992; Heins 1993). And notions of contemporary art and the avant-garde often place the artist in contraposition to the preferences of the average citizen; artists in the twentieth century have looked for ever-new ways to overturn conventions and shock their audiences with innovative work (Adler 1975; Crane 1987). As Daniel Bell writes, "The legacy of modernism is that of the free, creative spirit at war with bourgeois society" (1996, 40).

Following this line of reasoning, we should not be surprised by the controversy engendered by a female artist who pours chocolate over her naked body onstage while carrying on a discussion about human excrement, or the self-portrait of a photographer with a bullwhip inserted in his anus. Unfortunately, explanations of conflict that focus on the unnerving content and style of modern and postmodern art tend to be tautological, concluding that "provocative art leads to provocation." This formulation is neither interesting nor theoretically useful. Moreover, such a theory cannot account for the fact that many seemingly benign artistic projects still raise unexpected controversy (Tepper 2000; Senie 1998). As Harriet Senie (1998) notes, "Time and time again, well-meaning individuals involved with a public art commission are shocked that their carefully considered projects are so glaringly misunderstood by a hostile audience" (237). Thus while intentionally "provocative" cultural expression certainly increases the likelihood of conflict, it is neither a sufficient nor necessary feature of controversy.

Furthermore, focusing on controversial artwork cannot explain why the *same* art event that causes uproar in one community is often met with

indifference or rousing acceptance in another. For example, the infamous Robert Mapplethorpe retrospective, *The Perfect Moment*, was exhibited in Philadelphia, Chicago, and Hartford without any controversy. When the exhibit arrived in Cincinnati, a storm of outrage descended on the Cincinnati Contemporary Arts Center, leading to the indictment of the center's director on charges of obscenity.

The epic play *Angels in America*, by Tony Kushner, which deals with homosexual themes and contains frontal nudity, traveled to dozens of cities and communities between 1995 and 1999 but only generated conflict in a handful of places. In Charlotte, North Carolina, the controversy began with a threat from the district attorney's office that the play would likely bring indecent exposure charges against the Charlotte Repertory Theatre. With a court injunction protecting the theater, the play was eventually performed in the midst of demonstrations and protests in the street, both for and against the show. A year later, at a city council meeting attended by seven hundred people, officials voted to cut all funding to the Arts and Science Council, which had supported the *Angels* presentation. The controversy consumed the city's attention for more than two years, leading to over 150 newspaper articles and opinion letters in the *Charlotte Observer*. In Austin, Albuquerque, Baton Rouge, Memphis, and dozens of other cities, the same show was celebrated as one of the season's most important works. A columnist for the *Commercial Appeal* contrasted the different public reactions to the play in both Charlotte and Memphis when he wrote, "It still fascinates me that Memphis—which has its share of ardent churchgoers—has not protested local funding of the same play causing an uproar in Jesse Helms country" (Smith 1997).

It appears, then, that unless the conditions for controversy are ripe, even the most rabble-rousing artist will sometimes fail to ignite a conflict. Perhaps the best example is artist Jim Richardson's attempt to draw attention to the issue of the flag-burning amendment in 1989. Starting with one small charred American flag, Richardson escalated his protest by burning more and bigger flags and then by contacting veterans associations, newspapers, the U.S. Attorney's office, and the ACLU. But to Richardson's dismay, after six weeks of flag burning, nobody seemed to care (Meyer 1989, 1). In contrast, an exhibit in Phoenix, Arizona, that focused on the iconography of the U.S. flag in American art and included a presentation of the flag on the museum floor was greeted with hostility, protest, vandalism, and threats from the city council, along with private patrons, to withdraw funds from the sponsoring museum (Van Der Werf 1996). Given this variation from one city to another in the public response to virtually identical cultural

presentations, it is reasonable to conclude that the inflammatory content of an artwork is not the singular cause of conflict.

The second line of argument claims that fights over art reflect deep and fundamental value clashes. Here again I evoke Hunter and his argument about the struggle between progressive and orthodox views. He claims that progressives view art as a celebration of individuality, a medium to challenge prevailing norms, and a symbol of unfettered expression. They see opponents of art as "know-nothing," bigoted, intolerant censors. On the other side, conservatives and traditionalists accuse progressives, entertainment executives, and avant-garde artists of nihilism, a disregard for "community standards," hostility toward the sublime and the beautiful, excessive decadence, and the degradation of public decency. While such rhetoric certainly surfaces in high-profile debates over art, like other culture war issues, there is ample evidence that the vast majority of Americans share a common, positive attitude about the arts—they think the arts are important, they want more arts in the schools, and they think the government should continue to fund the arts. Moreover, there is evidence that the vast majority of conservatives and liberals, while not sitting together in the same living room, are in fact watching the same television shows. Audiences in conservative areas of the country are no less likely to watch violent and sexually explicit shows than audiences in more progressive markets (Carter 2004; Rich 2004). So it is unlikely that arts conflicts are rooted in broad-based disagreement over the purpose and value of art in society.

Yet another common explanation is that enterprising politicians, religious leaders, and moral reformers use arts conflicts as a way to attract media attention, raise money, and mobilize voters. Controversial art has proven to be an issue around which groups like the American Family Association, the Christian Coalition, and numerous televangelists could rally the troops and enlist new supporters. Art has become a steroid used by the Christian right to build its organizational muscle. As reported in the *U.S. News and World Report*, "These groups lost their anger and energy during the Reagan era and need new causes to raise money and membership" (Roberts and Friedman 1990). And learning from the successes of these groups, mainstream politicians—from former senators Jesse Helms and Bob Dole to former New York mayor Rudolph Giuliani—have lashed out against obscenity, blasphemy, and violence in art and media. As E. J. Dionne Jr. wrote for the *Washington Post*, "The current drives against obscenity are simply successful ventures at political entrepreneurship promoted by a few conservative leaders worried as much about polls and election returns as smut" (1990). Larry Rothfield, editor of a collection of essays about

the controversial *Sensation* exhibition at the Brooklyn Museum, argues that ultimately arts conflicts can be explained by political interests—in this case, a museum that used controversy to boost attendance, a mayor who used it to secure support from his base, and free expression advocates who used it to draw attention to their cause (2001).

Paul DiMaggio and colleagues studied arts conflicts in Philadelphia between 1965 and 2001 and found strong evidence that cultural conflict is connected to election cycles, with politicians using art and culture to appeal to voters and mobilize constituents. They write: "We hypothesize that the rhythm of local elections induces city officials to play cultural politics—which often focuses appeals on particular constituencies—during the run-up to local elections" (1999, 43). While some politicians and moral entrepreneurs clearly use arts conflicts to stoke passions and influence supporters, these actors are only involved in a relatively small proportion of all conflicts, especially local conflicts. A comprehensive study of attempts to censor cultural expression in the 1980s found that the vast majority of protests did not originate with politicians, moral reform organizations, or even church leaders and ministers (Harer and Harris 1994). Of the 2,818 complaints identified by John Harer and Steven Harris, 611 came from individual parents, 224 from citizens, 149 from local organizations, and 103 from students. Government officials were the source of 103 complaints. So the actions of enterprising political leaders do not account for most conflicts. Furthermore, even when such political activity is relevant, scholars still must examine where it occurs and where it doesn't—why was the mayor of Raleigh, North Carolina, in the news over and over again for attacking art and culture in the 1990s, while not a single politician joined in a protest in Seattle during the same time period?

Scholars argue that current battles over art and culture are not simply political diversions, but rather reflect underlying tensions in a community. In the foreword to *The Cultural Battlefield*, Jill Bond writes that cultural battles "are becoming proxies for political differences and social conflicts that should be discussed openly" (in Peter and Crosier 1995, 3). And Dubin contends that arts conflicts are likely to occur in communities that are fractured, polarized, and suffering low collective morale (1992). Similarly, the 1994 volume of *Artistic Freedom under Attack* confidently asserts that as America becomes more diverse, the "resulting tensions lead to the removal or alteration of artistic works" (People for the American Way and Artsave 1994, 11).

In *Spirit Poles and Flying Pigs*, Erika Doss (1995) explores conflict over a public art sculpture dubbed the *Spirit Poles* erected in Concord, California,

in 1989. Citizens, politicians, and a local fundamentalist preacher protested the artwork, featuring ninety-one aluminum poles with pointed tips, an abstract statement about modern technology, because the sculpture didn't fit the town's "sleepy suburban" image. The backlash stemmed from a growing concern that recent urbanization placed the interests of outsiders above those of locals in the community. Doss also recounts an incident in 1989 when the Japanese American community in Little Tokyo, Los Angeles, erupted over a proposed mural by Barbara Krueger that featured the words from the Pledge of Allegiance. The community felt that the mural evoked memories of American acts of cultural repression in World War II internment camps. Doss links the conflict to underlying tensions in the community. She argues that changing economic conditions—for example, the rise of Japanese investment in South Los Angeles—along with growing racial strife created the conditions that led to the mural controversy (Doss 1995).

And using historical accounts of anti-vice crusades in the late nineteenth century in the United States, Nicola Beisel (1990) finds that attempts to censor or suppress art and cultural expression found greater support in New York and Boston than in Philadelphia. She explains the difference by showing that elites in the first two cities were facing a greater threat, both politically and socially, from arriving immigrant communities than elites in Philadelphia. Beisel is interested in what makes moral claims—such as protests against art—potent. She concludes that changes in gender roles and the social meaning of sexuality combined with concerns about rising rates of immigration led to anxiety for middle-class and upper-class parents who were concerned about the future prospects for their children.

These last three examples suggest a rather broad and far-reaching theory of cultural conflict—urbanization, immigration, and changing economic and social conditions lead to disputes over art and cultural expression. Such claims, like those that link conflict to ethnic tensions or religious cleavages, cry out for the type of comparative research that has been the staple of macro-level theory building in the social sciences since Émile Durkheim's analysis of suicide in the nineteenth century (Durkheim 1951). How could Durkheim test his proposition that a country's suicide rate can be explained by the degree of social integration of its citizens without comparing dozens of countries and looking for broader patterns? Nor could we imagine a convincing theory explaining the prevalence of political upheaval without Charles Tilly's pathbreaking comparative work looking at revolutions and protest activity in Europe both across time and across countries (Tilly 1978, 1986, 1995). Research on art and cultural conflict has reached the stage of theory building and testing that requires scholars to assemble the necessary

evidence to evaluate claims about the relationship between such conflict and social conditions. This study aims to do just that: assemble and analyze evidence about hundreds of conflict events in dozens of American cities during the 1990s. Like Durkheim's study of suicide, such evidence can help us examine whether the causes of cultural conflict are linked to underlying social conditions rather than merely the result of the individual actions of artists, religious leaders, and politicians.

The Structure of Cultural Conflict

When I refer to "underlying social conditions," I am suggesting that cultural conflict has a structure to it—incidences of protest over art and culture are strongly correlated with distinguishing sets of community characteristics. This notion of structure has its roots in the Chicago School research tradition, especially the work of criminologists who argued that economic conditions, social diversity, and residential mobility led to different crime rates across communities and cities. Adding to demographic and economic factors, James Coleman's seminal work on community conflict identified additional structural variables such as the number, density, and types of community organizations and the local levels of activism and civic engagement. These structural elements have been linked with a wide range of conflict events—from Ku Klux Klan membership (McVeigh 1999), to lynching (Olzak 1990), urban riots (DiPasquale and Glaeser 1998), and strikes (Olzak 1989).

Like these earlier studies of racial and economic conflict, my approach in this book is also structural. By marshaling a significant amount of data, I demonstrate that social change, in conjunction with specific community characteristics, can predict levels and intensity of arts conflicts. I go beyond case studies in order to examine 805 cases of conflict across seventy-one cities in the 1990s. Like Elaine Sharp's recent work on morality politics (2005b), my work will show that arts conflicts exhibit patterns of variation across cities that, as Sharp writes, either "challenge or support existing social and political theories about cultural conflict" (7).

My approach also brings a much-needed local emphasis to the study of cultural conflict. Most of the writing and discussion about art and cultural conflict has focused on the most visible and strident battles at the national level (the *Sensation* exhibit, Mapplethorpe's photographs, Annie Sprinkle's performance art, Janet Jackson's exposed breast during the 2004 Super Bowl telecast). For obvious reasons, the media has focused disproportionately on these high drama spectacles. But scholarly articles and books have also

arrived at their conclusions—whether it is the notion of a culture war, political mobilization, or the consequences of social change—by examining these well-publicized cases (Dubin 1992; Halle 2001; Hunter 1991; Nolan 1996; Pally 1994; Peter and Crosier 1995; Steiner 1995). However, it remains unclear whether these well-known battles are related to deeper tensions and concerns among the larger American public or whether they simply reflect political posturing and issue entrepreneurship among the nation's elite.

Much needed progress can be made in understanding cultural conflict by getting beyond the big stories and the national debates. When we scratch below the surface, we find ample evidence that conflicts are percolating daily in cities and communities across America. Harer and Harris (1994) report that there were close to two thousand attempts to censor books, magazines, films, plays, and music in American communities during the 1980s. Judith Dobrzynski reported in the *New York Times* that brushfires over the arts were spreading across the country to towns and cities, which have become "the new battlegrounds" for cultural conflict (1997). If this is indeed correct, then we must begin to ask questions about the nature of these conflicts. Who initiates conflict at the local level? What is the nature of the grievances against cultural works? What is the role of religious and national actors? How are controversies resolved? Do authentic local conflicts—those dealing exclusively with local art and local actors—differ from conflicts involving national actors and organizations? And what explains why some communities are more contentious than others when it comes to fighting over art and culture? While scholars have provided colorful and insightful case studies of local conflicts (Dubin 1992; Halle 2001), it is the assembly and systematic comparison of these local protests that distinguishes this study and makes it an important contribution to a broader, sociologically informed and rigorously tested theory of cultural conflict.

Clarifying the Approach

In this book social change is presented as the main, but not only, "protagonist" in the story of protest over art and culture. But social change is a slippery concept and has come to mean many different things in sociological analysis. Broad, incremental, and epochal changes such as urbanization, modernization, the rise of bureaucracy, industrialization, and globalization certainly have implications for arts protests. We could, for example, ask how protest over art and culture differs between urban and less urban societies, how capitalism has influenced protest over art and media, how protest differs between premodern and modern societies, and whether the forces of

globalization and postmodernity have fundamentally altered how citizens engage cultural difference and disagreement. This book takes a different approach. I am less interested in how protest over art fits into large macro-theories of change than in the *proximate causes* of protest. In particular, what forms of social change lead individuals and groups to get involved in public disputes over art and media? In answering this question I focus almost exclusively on change at the community or city level. What is the relationship between protest over art and culture and real and perceived changes in the types of people, institutions, lifestyles, norms, and values that comprise a community? My theory of social change follows in the tradition of Joseph Gusfield, who believed that symbolic protest emerges from social threat and group competition. Essentially, according to Gusfield, when established high-status groups (political, economic, and social elites) feel threatened by incoming groups (for example, immigrants), they will attack the "lifestyle" of these emerging groups as a way to reestablish their own social and moral virtue.

Like Gusfield, I conceptualize social change as *perceived threats* to lifestyle and values. But rather than focus directly on a zero-sum game of status competition between groups and individuals (that is, the degradation of one group's lifestyle serves to elevate the lifestyle and status of another group), I see protest emerging from differing understandings of community life. The opening of a Walmart on Main Street may challenge citizens to reassess a particular vision of their community. Increasing numbers of teen mothers or the presence of adult bookstores may be perceived as threats to certain family values or notions of a morally decent city. The unfamiliar sound of foreign languages spoken at the bus stop, in the grocery store, or at a public park might make some residents feel uncomfortable interacting with and around strangers and raise difficult questions about what binds their community together. Witnessing a parade that celebrates different lifestyles or cultural traditions may raise questions about which community traditions and values are worth celebrating. In short, social change is characterized as local-level disruptions that call into question established notions of community life. Such disruptions precipitate symbolic politics—in particular, protest over art and media.

In most of the book, I measure social change as the rate of immigration (percentage change in the percentage of foreign-born residents in a city). I recognize that this is a relatively blunt instrument for measuring all of the factors that bear down upon how citizens conceive of threats to community life. For some, the underlying social strain or threat has to do with changes in local schools; for others, concerns are rooted in changes in the look and

feel of downtown; still others will focus on teen pregnancy, youth crime, or the increased visibility of alternative lifestyles. What is important about immigration as a source of disruption is that it is highly visible. Other city-level changes—education levels, occupational shifts, physical alterations, family structure—are incremental and hard to detect in the short term. Changes in immigration, in contrast, even when relatively small, are tractable and noticeable on a day-to-day basis. First-generation, foreign-born residents, especially those who immigrated during the 1980s and 1990s, not only look and sound different from native-born citizens, but they also dress differently, drive different types of cars, and embrace cultural traditions and lifestyles that are unfamiliar. Of all the measurable sources of social change at the city level, rates of immigration capture best the most visible "threat" to community life and community identity in the last two decades of the twentieth century. Furthermore, in focus-group conversations with activists across the country (see chapter 9), immigration was raised time and again by parents as the source of disconcerting community change and as an important context for wanting greater restrictions on media content.

Not all protests can be linked to a "fear" of social change at the local level. Some protests emerge in places where there is very little local disruption and change. But places experiencing more change and disruption have a higher frequency of protest over art, and their disagreements over culture are strongly linked to competing notions of community life. Moreover, disruptions to stable conceptions of community life can lead not only to attempts to defend the "old ways" but also to efforts to establish new discourses and new ideals. Thus, previously disadvantaged groups might protest art and culture to assert their own notions of community—and their place within it—during times of social change and disruption.

In sum, for the purposes of this book, I am only interested in local social change—in particular, changes that disrupt people's conception of community life and challenge their own role and relevance in the social life of their city. I am not interested in *explaining* social change. Rather, I see social change as an independent predictor or condition that influences how often people fight over art and culture as well as the nature and dynamics of these disputes. I focus on rates of immigration as the manifestation of the types of local changes that challenge conceptions of community life and make a city or community ripe for protest. Because social change is theorized as a disruption to people's perception of community life, *and* because I see arts protests as reactions to the fear, discomfort, and opportunity caused by such disruptions, these protests are fundamentally struggles to define, defend, and shape community life.

It is important to clarify what this book is not. First and foremost, this is not a book about censorship. There have been many good books and scholarly articles dealing with the legal rights of artists, the evolving legal framework of censorship, and philosophical and political theories of free expression and democracy. While philosophers and legal scholars might consider many of the cases in my study *censorship*, I will refrain from passing judgment about whether an offending art object should or should not have been restricted, banned, or removed. The book is not intended to advance the case of advocates on the right and left of the free expression debate. Rather, it is intended to shed light on community dynamics that give rise to the impulse to censor, whether or not that impulse is morally justifiable or legally defensible.

Debates over censorship often center on whether an offending object is truly "art." Again, I will sidestep these debates in this book. I will not defend the artistic purpose or merit of a piece of art—whether it is the music played by an ice-cream truck, a clown show on cable access television, or a play by a well-known New York playwright. In fact, I am equally interested in conflicts over "cultural expression" with little artistic intent—the costume of a school mascot, the cover of a city phone book, a photograph in the newspaper. While discourse and debate around these offending objects often centers on whether or not it is "art" or "literature," again the conditions that give rise to such conflicts, I believe, are not primarily about clashes over aesthetics.

Related to this point, most previous scholarship on arts conflicts focuses heavily on discourse. Scholars are particularly interested in how debates get framed and articulated by critics and defenders of artworks. Such debates are thought to reveal the "cultural frames" used by citizens and moral entrepreneurs to understand the meaning of a cultural object or event: Is this art or is it obscenity and pornography? Is it an expression of community or something foreign and unfamiliar? Is it harmful to children or just fun and games? These rhetorical labels help connect potentially offending objects with deeper social concerns, thereby mobilizing and crystallizing sentiment in support of a course of action—acceptance, protest, violence. So discourse is extremely important in the study of cultural conflict. In this book I will occasionally discuss differences in how communities talk about offending objects, and I will draw on quotes, both from newspaper accounts and focus groups, about the purpose of protest and the relationship between an arts conflict and ideas about community life. But analyzing discourse is of secondary importance to me. I am less interested in how discourse or rhetoric provokes, sustains, and mobilizes citizens over the course of a conflict and

more interested in what explains why citizens and local leaders initiate conflict in the first place.

As already mentioned, a great deal of the book relies on statistical evidence. I argue that protest events that may seem idiosyncratic—such as a fight over a school mascot or as obvious as public outcry over nudity on television—can be explained, in their most simple formulation, by numbers; albeit numbers that represent profound social patterns. This approach might make the reader nervous. It certainly worries the author a great deal. It is natural to question whether broad, community-level indicators—like demographic change, voter turnout rates, numbers of Evangelical churches in a city—could possibly predict what appears to be irregular outbursts of conflict over art and cultural expression. My response is that this study and the theories that motivate it do not claim to be able to predict any single case of conflict; rather, community-level variables can predict overall patterns—for example, whether one community is more or less contentious than another when you examine multiple conflicts over several years.

By way of example, Nashville, Tennessee, my current hometown, shows up in my data as a relatively contentious city. Between 1995 and 1998 the city witnessed eighteen conflicts over art and culture—well over the national average of eleven. So in 2003, when a private donor, with approval of the mayor and the arts council, installed in a prominent city location a forty-foot sculpture featuring nine enormous naked men and women dancing together in a circle, we might have predicted a fiery episode of protest and recrimination. But as it turns out the sculpture, titled *Musica* (because it sits at the entrance to music row, Nashville's famous block of recording studios and record labels), generated only a few letters to the editor and no official protest activity. The specifics of the case are relevant. The sculptor hired a public relations firm to help educate the community before the piece was installed; the mayor, who approved the project, was extremely popular at the time, later becoming governor of Tennessee; and the artist, who was personable, engaged the community and worked with the arts council to change parts of the design before installation. So when I look closely at the case, I begin to doubt whether my "model" of conflict can really tell me anything. Nashville is a contentious city, but *Musica* was not a contentious piece of art—in spite of its in-your-face nudity.

Let me try to make sense of this puzzle by way of analogy. Imagine a person who has an autoimmune deficiency. Such a person, when the disease is active, is highly likely to catch a common cold. A particular cold might be traced to some specific circumstance—being in the room with someone who was sick, for instance. Now consider another person *without* an autoim-

mune disorder. Faced with the same circumstance (for example, exposure to germs), this person might also come down with a common cold. Thus the cold itself is not an indication of the underlying autoimmune disease. We could look at both people—sniffling and coughing—and have no evidence as to who was seriously sick and who simply had a cold. In fact, the person with the autoimmune disease might have caught the cold even when the disease was in remission. But if we were to look at a chart that tracked the number of colds that each of the two people caught over four or five years, we would certainly see a big discrepancy between the two, and we might be clued into the fact that one of our patients likely has an underlying condition. So I am interested in overall patterns, not particular events.

Overview

In the story that follows, I meticulously record and analyze cases of cultural conflict in seventy-one cities. Some of these cities, like Springfield, Illinois, had as few as one conflict over the four years under investigation; others, like Atlanta, Georgia, had, on average, close to one conflict every six weeks, or thirty-seven conflicts from 1995 to 1998. I have selected this time frame in large part because discussion of arts conflicts and the culture wars more generally reached its peak in the mid-1990s. Close to a dozen books were published on the "culture wars," the National Endowment for the Arts continued to be assailed by conservative politicians and moral reformers, and organizations on the left began to publish and keep closer track of censorship attempts in American communities. Furthermore, the population growth of 32.7 million people in the 1990s was the largest numerical increase of any decade in U.S. history, much of it accounted by foreign-born citizens and their children. Thus this time period seemed particularly well suited to test existing theories about the relationship between social change and cultural conflict. Finally, the 1990s, according to Todd Gitlin, witnessed the emergence of what he calls "identity obsessions," the increasing tendency for individuals to cling to a "perspective"—the Jewish perspective, the Latino perspective, the Christian perspective—and then engage in symbolic battles to legitimate their beliefs at the expense of others.[1]

Collecting and analyzing conflict events across seventy-one cities was no small task.[2] Nor was the collection of demographic and political data across these sites, information that will help us determine the social preconditions of conflict. More than eight hundred cases of conflict were identified by scanning the headlines and text of close to one hundred thousand newspaper stories. The research team read more than five thousand articles and

completed a detailed survey including seventy-three questions about each case of conflict (for example, Who was involved? What was the grievance? What was the nature of the presentation?).

It is worth clarifying what we mean by a conflict over artistic and cultural expression. While a more detailed definition can be found in the methodological appendix, for my purposes a conflict over art and culture involves an action or grievance against an artistic presentation (murals, plays, books, sculptures, fine arts exhibitions, television programs, movies, popular music, poetry) or an educational or interpretative exhibition, such as a historical exhibit at a school or public library or a documentary film. Conflicts can be directed at commercial, nonprofit, or government-funded presentations. Actors against a cultural work may include individual citizens, nonprofit groups, or elected officials. All conflicts involve an initiating action against a cultural presentation (public demonstration, petition, banning, letter-writing campaign); but not all conflicts will have defenders of the work in question. In order for a conflict to be considered in our analysis, it must be reported in the local press. This definition is, in large measure, derived from DiMaggio and colleagues' (1999) study of Philadelphia-based conflicts.

Chapter 1 takes a bird's-eye view of patterns of cultural conflict across the nation. Drawing on the 805 cases of conflict in our database, as well as data collected from other national inventories of conflict events, we will ask a number of questions, including: What types of cultural presentations were challenged most often and what was the balance between high and popular culture? What constituted the major source of objection, and who is considered placed at risk by these presentations? Where did challenges originate? Who were the individuals or groups most often associated with a challenge? How often did national actors get involved in local protests? What remedies did people seek for dealing with an offending cultural work? What percentage of conflicts could be considered low, medium, and high intensity (spark, brushfire, and battle)? What determined the likelihood that an action against a cultural work would ignite into a more protracted battle? And how did conflicts, on average, get resolved? This chapter compares the cumulative picture that emerges from the data with the high-profile cases of conflict typically reported by the national media; it asks: To what extent do these local conflicts resemble and support the thesis that America is in the midst of a culture war, with the arts serving as a key theater of engagement?

In chapter 2 I argue that underlying social change and competition— real and imagined—between social groups create conditions that are ripe for protest over art and culture. The chapter reviews relevant social theory,

discussing notions of status and lifestyle politics, value clashes, ritual and boundary maintenance, and identity politics. I then examine historical evidence linking crusades against art and entertainment with broad-based fears about immigrants, changing values, and a loss of community. The chapter concludes with original analysis from three national surveys that demonstrates that individuals who express concerns about immigration or the rate of social change are much more likely to favor restricting unpopular books and televisions shows.

In chapter 3 I turn to the anatomy of conflict at the local level. I review the "decline of community" thesis and discuss how social change is particularly salient in the context of real demographic and economic shifts at the level of communities. I argue that we must bring "community back in" to the study of cultural conflict, critically extending and deepening existing work that focuses more on broad-based social change and efforts by national elites and social movement organizations to restrict art and culture. This chapter explains why some cities were more contentious than others between 1995 and 1998. The chapter confirms that social change is a strong predictor of conflict—with those cities experiencing an influx of new immigrants being more likely to fight over art and culture than cities with more stable populations.

Chapter 4 offers a case study to further illuminate the theories and empirical findings of chapters 2 and 3. Atlanta was the fastest-growing city in America throughout much of the 1980s and 1990s. It also experienced the greatest number of protests over art and culture: thirty-seven protest events between 1995 and 1998. This chapter describes the range of cultural presentations—from books in the library to public monuments and festivals—that Atlantans fought over in an attempt to clarify the identity of the city in the midst of explosive growth and change. This change coincided with the 1996 Olympic Games, hosted by Atlanta. This international spotlight provided additional impetus for citizens to fight over both the history and future of the city.

In chapter 5 I examine the political and institutional context for local protests over art and culture. First I argue that the "repertoires of contention" (Tilly 2006) deployed in arts conflicts resemble the strategies used in other types of social movements and contentious politics. Comparing cities side by side, I find that places with more politically engaged citizens (high rates of voter turnout), and those characterized by an "unconventional" political culture are more likely to fight over art. I also find that a city's history of protest is related to current levels of contention. And the public opinion climate of a city influences both the amount and type of conflict. As

expected, cities that have a large base of conservative and religious citizens are more likely to experience protests against artworks deemed blasphemous, obscene, or harmful to children. This chapter demonstrates that arts conflicts—like other forms of protest—are deeply embedded in democratic processes and institutions.

Chapters 6, 7, and 8 explore the profile of three distinctive types of cities—cities of cultural regulation, cities of contention, and cities of recognition. In cities defined by cultural regulation (Dayton, Ohio; Cincinnati, Ohio; Kansas City, Missouri-Kansas; and Oklahoma City, Oklahoma), conservative-based causes (blasphemy, obscenity, violence) dominate the agenda. These protests are less the result of population changes than of residents from fairly homogenous communities striking out against anything that violates community norms. In such cities cultural conflict is more routine and less strident. Often offending works are simply removed or restricted in the absence of sustained public protest. Conflict in these communities is fairly contained, routine, and quickly resolved.

Contentious cities (Denver, Colorado; Charlotte, North Carolina; Dallas, Texas; Fort Worth, Texas) have the highest levels of conflict, with complaints evenly distributed between conservative and liberal causes (supporting ethnic and religious minorities, women, and gays and lesbians). In these cities, both liberal and conservative grievances seem to find a foothold and work side by side to generate above-average levels of conflict over art and culture. These conflicts might be considered flares of competition.

Chapter 8 examines cities characterized by "identity politics" (San Francisco, California; Albuquerque, New Mexico; San Jose, California, and Cleveland, Ohio). These cities are highly diverse and typically have a disproportionate number of liberal-based conflicts. The profile here is one in which identity politics lies at the root of many disputes as marginalized members of a community demand that public symbols—including art and culture—depict them in ways that affirm their value and role in the community.

The first eight chapters examine the relationship among social change, political culture, and protest over art. These chapters rely on evidence from national surveys, events reported in the press, and analysis of city-level characteristics—demographic change and political culture. Chapter 9 explores conflict and protest from the perspectives of activists themselves. Through focus groups with local chapters of the Parents Television Council, I will describe the concerns and hopes of parents who feel compelled to speak out about the state of today's broadcast media and to "bear witness" against

what is perceived to be a national culture that is increasingly out of touch with local norms and values. How do citizens make sense of "local protest" as a response to the influence of huge media conglomerates? How do they define success? Why is it important to them to take a public stand on these issues? And how do they relate trends in the national media with events and conditions in their local community?

The concluding chapter examines the link between cultural conflict, social change, and democracy. In reflecting on the expressive dimensions of arts protests, I suggest that protests are driven in part by strong emotions of shame and discomfort. This chapter also examines the rise of "noisy culture"—the exponential growth in the amount of widely available art and entertainment. More diverse people are producing a greater variety of culture for what seems like ever-expanding audiences to read, hear, see, and experience. In such a world there is something to offend everyone most of the time. Conflict seems unavoidable. This chapter argues that the combination of noisy culture and the expected increase in rates of social and demographic change will create conditions ripe for cultural conflict and protest in future years. But protests over books in the library, films in the local cinema, and sculpture in the town hall are legitimate ways for citizens to express discontent and to voice concern about the changes they see around them. Conflicts over art and symbolic expression might appear to be driven by activists on the extremes, but, as I argue in the conclusion, these events are really moments where citizens productively bear witness to disruptive social change. Cultural conflict represents the choice of citizens to express dissatisfaction rather than to remain disgruntled and silent—to choose, in the words of Albert Hirschman—"voice" rather than "exit" (1970).

In the epilogue I offer reflections on how the book's arguments and analysis bridge to the world of cultural policy. I discuss the existing twentieth-century model for dealing with arts conflicts and suggest that Americans need a new twenty-first-century approach—especially in light of changing demographics, new and emerging forms of culture and media, and growing strains on community life. I conclude with suggested principals and practices of engagement designed to help guarantee that the voices of concerned citizens are taken seriously and that arts conflicts contribute to substantive democracy.

As I argue in this book, we must look beyond individual citizens and beyond individual artworks in order to understand the social conditions that produce conflict. What conditions help turn offense into action, dissatisfaction into public voice, private grievance into bearing witness publicly? It is

sometimes about the particular piece of art; it is sometimes about particularly loud and vociferous critics. But, I contend, there is a deeper social pattern that appears even after we iron out the particular personalities, politics, and impolitic art. There is, in short, a topography of conflict—a discernable frequency, intensity, and scope of conflict that characterizes cities and that can be seen from a bird's-eye view—high up and well beyond the glare and heat of the fire.

A Bird's-Eye View of
Cultural Conflict in America

A Cautionary Tale

In 1925, when reporters descended on the small town of Dayton, Tennessee, to cover the infamous Scopes trial, they arrived with a set of assumptions about the ideological divide separating small-town southern life from the more liberal, progressive, secular, and cosmopolitan America residing in its bigger cities in the north. The trial, the jurors, the speeches, the testimony, and the town itself became national news with journalists portraying the conflict as a clash between fundamentalism, bigotry, and religion, on the one hand, and free speech, enlightenment, and science, on the other. The protagonists in the story were well-known figures—the flamboyant prosecutor, William Jennings Bryan; the most famous lawyer of the time, Clarence Darrow; and the acerbic and controversial journalist H. L. Mencken. The trial of John Scopes, accused of breaking state law by teaching evolution, was caught in the eddies of larger, national debates and ideological currents. Yet the reality of life in Dayton—the character of religious faith and fundamentalism, the extent of disagreement among neighbors, local reaction and sentiment toward the defendant—differed considerably from the hyperbolic coverage in the national press. Dayton residents were concerned about local control over school curricula and were worried about proselytizing "unproven" scientific ideas in the schools. Most were not stridently anti-evolution, nor did they see the trial as principally about free expression, the insertion of religion into the schools, or other "hot-button" national issues (Olasky 1986).

The Scopes trial is a cautionary tale for understanding the nature of cultural conflict in contemporary America. It reminds us of the importance of stepping outside of national discourse and taking the character of local conflict seriously. Today's accounts of conflict—whether over National Endowment for the Arts (NEA) funding or Hollywood films—are reported by the

national press using familiar narratives about competing worldviews not unlike the stories told about the trial in 1925. Even local conflicts—once they get entwined in national debates and become fodder for national actors—lose their distinctiveness and come to represent yet another theater of engagement for the larger culture wars. However, if we hope to understand what is at stake for citizens and communities when they disagree over art, we must look more broadly and examine the full range of stories, the nature of grievances, the variety of actors, and the ways in which conflicts are instigated and resolved. In this chapter I move beyond today's Scopes trials in order to take account of both small and large conflicts occurring daily in cities across the country. This chapter focuses on one overarching question: Do *typical* conflicts over art and entertainment in America resemble visible national conflicts? In the process I explore the role of religion and politics and highlight differences between small and large conflicts and between local conflicts and those that involve national actors.

First Impressions

In 1989, having graduated from the University of North Carolina at Chapel Hill, I began working for my alma mater in the office of public affairs and development. Among my first duties was to work with graduates from the senior class of 1987 on their class gift—a commissioned sculpture that was to be installed on campus in front of the main library. The sculptor, Julia Balk, produced a set of bronze figures intended to represent the diversity of student life. My office reviewed several preliminary sketches, made suggestions to the artist, and eagerly awaited the delivery of the final piece. When it arrived the construction crew had barely finished laying the bricks around the base of the sculpture when controversy erupted. To our surprise the sculpture was greeted with hostility and outrage from many students, especially African American students. Titled *The Student Body*, the sculpture originally featured seven bronze figures, including two African American students, one twirling a basketball on his finger and the other balancing books on her head like a basket of fruit; a white couple walking arm in arm; and a young man reading a book while his girlfriend rests her head on his shoulder. In retrospect the offense seems obvious. The sculpture reinforced blatant gender and racial stereotypes, but the artist offered a reasonable defense—the basketball player was meant as a tribute to the school's most famous alumnus, Michael Jordan; the balanced books were intended to suggest the challenges today's students face as they balance the demands of school, athletics, volunteering, and work; the couple walking arm in arm were read-

ing and learning together, even though the position of the figures suggested a studious male student and a wistful and dreamy female companion.

The controversy lasted more than two months and eventually led to the relocation of the artwork to a less visible spot on campus. Every day dozens of students crowded around the sculpture—shouting, chanting, debating, and even vandalizing the piece (taking a hacksaw to the finger of the basketball player and removing the ball). At that time Chapel Hill was not otherwise a seedbed of activism. In fact, this was the first sustained protest I had witnessed since arriving on campus six years earlier. Why did this particular artwork raise such ire? There were other potentially racist symbols that had long been part of the campus topography, like a nearby one-hundred-year-old statue of a confederate soldier—Silent Sam. Sam stood tall with musket at his side without incident. So why this artwork—*The Student Body*—at this time?

Not yet trained in sociology, the episode, nonetheless, invoked embryonic sociological instincts. I concluded that the controversy was not simply the result of an insensitive New York artist who misread the culture of a large southern university, failing to see how her work might offend minorities and women. Nor was it the result of some political group on campus opportunistically seeking publicity and support for their cause. Instead the conflict seemed to grow naturally out of existing racial tensions on campus. Prior to the sculpture controversy the campus had been embroiled in a debate over whether it should build a freestanding black cultural center, the choice of black students, or a multicultural center, which was favored by white administrators, many of whom were civil rights liberals who believed strongly in integration and rejected policies that promoted racial exclusivity. The controversy over the sculpture was a lightning rod for these deeper struggles over race relations and notions of equality.

High-Profile Cases

I began to notice other controversies over art and culture that were gaining prominence in the press, such as the attacks on the National Endowment for the Arts. The endowment was under fire for supporting several exhibitions that included works that many found offensive. One included the infamous photo by artist Andres Serrano, "Piss Christ," featuring a crucifix submerged in urine; the other was an exhibit of Robert Mapplethorpe's photographs, including such homoerotic images as a man urinating in another man's mouth and a self-portrait of the artist with a bullwhip inserted in his anus. Politicians and national religious leaders were at the forefront

of these attacks. Pat Robertson repeatedly admonished the NEA on his Christian Broadcasting Network; Rev. Donald Wildmon of the American Family Association began a highly visible letter-writing campaign; U.S. senators Jesse Helms and Alphonse D'Amato gave rhetorically charged speeches and pushed for the elimination of the endowment. Conservative groups like the Eagle Forum announced their opposition to the reauthorization of the NEA. Arts leaders, including the director of the Cincinnati Contemporary Arts Center, who was indicted on obscenity charges for displaying the Mapplethorpe exhibit, reacted by claiming the right to free expression, promoting the benefit of "art for art's sake," and pointing out the humiliation America would suffer internationally if it allowed religion to run roughshod over great art (Bolton 1992).

Years after the NEA controversies there was a national uproar over an exhibition of contemporary art at the Brooklyn Museum. On September 17, 1999, staff at the museum were busy preparing for the public opening of *Sensation*—an exhibition of paintings and sculptures by young British artists that featured, among other works, mutilated animals suspended in formaldehyde, a bust of a man made from his own frozen blood, and a portrait of the Virgin Mary decorated with clumps of elephant dung. That afternoon the director of the museum received a phone call from New York's cultural affairs commissioner saying that if the show was not stopped, Mayor Rudolph Giuliani planned to cut city funding to the museum. At a press conference the following day, the mayor reaffirmed his opposition, saying that he was offended by the art and that the museum had no "right to government subsidy for desecrating somebody else's religion" (Barry and Vogel 1999, A5). In addition to withdrawing funding, the mayor threatened to seize control of the museum and terminate its lease, which was held by the city. When the museum refused to cancel the show, the mayor immediately cut off funding and began eviction proceedings. The cultural community, somewhat belatedly, rallied behind the museum. The director of the Metropolitan Museum of Art wrote an opinion editorial in the *New York Times*, and leaders of twenty-two major cultural institutions in New York signed a letter stating their opposition to the mayor's actions (Stewart 1999, 3).

With the help of prominent free expression lawyers and civil liberties groups, the museum sued the city for violating its First Amendment rights. Meanwhile, with the court case pending, some religious leaders went on the offensive, attacking the museum for denigrating the Christian faith, referring in particular to the painting by Chris Ofili of the Virgin Mary with elephant dung. Cardinal John O'Connor denounced the painting and said he was "saddened by what appears to be an attack not only on our Blessed

Mother" but also on "religion itself and on the Catholic Church" (Niebuhr 1999, A38). William Donohue, president of the Catholic League for Religious and Civil Rights, also publicly denounced the exhibition and organized his members to carry picket signs and hand out "vomit bags" outside the museum (Hu 1999, B5). Finally, in a move to rally his political troops, presidential candidate Pat Buchanan visited the show and issued a public statement saying it was "dispirited, degrading, disgusting, sacrilegious, and blasphemous" (Roane 1999, B5). Ultimately, after more than one hundred articles in the *New York Times* and hundreds of pages of legal briefs, the mayor and the city lost the court challenge and public funds were restored to the museum six months after the controversy erupted.

In another highly visible national case, Tony Kushner's Pulitzer Prize–winning play *Angels in America* arrived in Clearwater, Florida, at Ruth Eckerd Hall in the wake of heated debate. The play chronicles the breakup of a heterosexual couple and a gay male couple. When reading through a brochure describing the coming performance, city commissioner Bill Justice learned that the show contained nudity, profanity, and sexual situations. Justice compared the play, which he had not seen, to entertainment available at local strip clubs and called upon the city to uphold family values. He declared, "My feeling is that you can tell a good story with your clothes on. If we say that we have family values, we should not be showing things that you can't take your family to" (Waldrip 1995a, A1). Having failed to get the city attorney to stop the show on the grounds that it violated a local anti-nudity ordinance, Justice demanded that the city withdraw its $400,000 subsidy to the presenting hall. Preachers, residents, and activist groups, such as Citizens Opposing Pornography and the local branch of the Christian Coalition, showed up at a city commission meeting to speak out against the play, calling it "filth" and "anti-family." The director of Eckerd Hall defended the play, saying that it was an important artistic work that dealt with a wide range of issues such as AIDS, religion, politics, and sexuality. Ultimately, the commission did not cut funding, although it did pass a sternly worded resolution warning that future subsidy would depend on whether or not the performance hall was "sensitive to and aware of community standards" (Waldrip 1995b, A1). In spite of this initial outcry, the show was performed without further incident.

During the 1990s, contemporary fine art and avant-garde theater were not the only targets of opposition and outcry. Rev. Wildmon, who had vociferously attacked the National Endowment for the Arts for funding Mapplethorpe and Serrano, turned his guns on the national media, including network television and Hollywood. In 1995 Wildmon's American Family

Association (AFA), a religious right organization based in Tupelo, Mississippi, launched a national campaign against the NC-17-rated film *Showgirls*. The film chronicles the story of an ambitious young woman who dances her way from sleazy nightclubs to an elite Las Vegas hotel. Wildmon, president of AFA, urged members of his organization across the United States to boycott the film, which he claimed was pornographic. He proclaimed, "Widespread distribution of a film like *Showgirls* is going to change all of society" (People for the American Way and Artsave 1996). Local activists took up the cause in dozens of American cities. In Topeka, Kansas, the manager of a Christian radio station threatened to announce on air the name and home address of the local theater manager and encouraged listeners to write and call until the film was canceled. After a demonstration, protest, and hundreds of local calls, the theater company pulled the film from both its cinemas in Topeka and other theaters throughout Kansas. Christian activists also picketed the film in Riverside, California; Phoenix, Arizona; Salt Lake City, Utah; and Allentown, Pennsylvania. Overall the protest over *Showgirls* was highly successful, leading dozens of theaters throughout the country either to refuse to show the film or to cancel it in the face of local protest.

Soon after, Christian groups took aim against the Walt Disney Company. Concern first arose less from the content of Disney programming and more over the policies of Disney. The South Florida chapter of the American Family Association announced a boycott of Disney products in response to what they called Disney's anti-family culture, including the hosting of Gay and Lesbian Day at the theme park in Orlando and Disney's decision to extend health benefits to the partners of gay employees. Yet even beloved animated family films came under fire for alleged anti-family messages. The Virginia-based American Life League mailed almost one million postcards to supporters urging a boycott because of subliminal messages found in *Aladdin*. The league claimed that just before the princess is whisked away on the flying carpet, the hero murmurs, "Good teenagers, take off your clothes." Disney claims the barely audible passage is actually, "Scat, good tiger, take off and go." The league also pointed to other subliminal messages—the word *sex* written in a dust cloud in *The Lion King*, and an erection that protrudes from the gown of a minister during a wedding ceremony in *The Little Mermaid*. The last is described in a lawsuit against Disney filed by an Arkansas woman in the Washington County Circuit Court. The suit claimed that "during a scene in the movie [*The Little Mermaid*] where two of the characters are to be married by a clergyman dressed as a priest, the movement of the priest's garments in the area of his crotch suggests that the priest is getting an erection as the bride and groom approach the alter

[*sic*]. The depiction of this event is visible at regular speed on the home video, but is even more noticeable when viewed in slow motion or frame-by-frame." The lawsuit was eventually dropped[1] (Bannon 1995, A1; Svetkey 1995, 42).

The anti-Disney ferment came to a head in June 1997, when 12,000 delegates to the Southern Baptist Convention adopted a resolution and boycott accusing the entertainment giant of "promoting immoral ideologies, such as homosexuality, infidelity and adultery" (Jones 1997). The proverbial last straw for the Baptists was the announcement that Ellen DeGeneres, who played the lead character on Disney-ABC's network program *Ellen*, was gay, both in real life *and* on her television show. Subsequently, Ellen's character "came out" via a groundbreaking lesbian kiss in primetime.

These high-profile cases, both local and national, represent what many would consider *typical* arts controversy in America. Each was well covered by both the national and local press. The *Sensation* exhibit was even the topic of discussion at several academic conferences about cultural conflict and artistic freedom.[2] Discussions about these high-profile cases rely on the following four generalizations: First, conflicts over the arts and culture often involve religious activists, typically from the Christian right, who challenge cultural expression on the grounds that it is undermining traditional values. Second, conflicts involve national actors, like the American Family Association, the Christian Coalition, and the American Civil Liberties Union, who either encourage local protests through national campaigns or enter as actors once a local conflict has arisen. Third, when linked to public subsidy or publicly supported institutions, conflicts often involve elected officials. Finally, conflicts are rooted in competing ideologies, are difficult to resolve, and often require intervention by the courts.[3] My early impressions of the character of these national conflicts resembled the accounts offered by scholars who were publishing books on cultural conflict in the 1990s. In *Culture Wars*, James Davison Hunter (1991) offers a comprehensive theory for the often-fractious debates that erupted regularly in the 1980s and 1990s over schools, family, art, and education. Hunter contends that disputes over abortion, gay rights, multiculturalism, flag burning, modern art, sex education, and violent television are rooted in two opposing impulses—one toward orthodoxy and the other toward progressivism. Orthodoxy is rooted in religious faith and involves deference to a transcendent authority, biblical literalism, and a commitment to traditional family values. Progressivism is rooted in a worldview based on individual experience and the principles of tolerance, diversity, and enlightened rational discourse. Religion lies at the heart of Hunter's analysis and on the fault line of these two opposing

impulses. Even more importantly, Hunter documents the way in which elite actors—national organizations, religious leaders, and politicians—come to dominate public discourse by offering citizens polarizing and ideologically charged rhetoric. Such rhetoric is amplified by the media, which is drawn to sensationalized and titillating stories, as well as by new technologies like direct mail (and now e-mail and the Internet) that allow each side in the dispute to customize its message in a way that demonizes their opponents, plays on hyperbole, and stirs the emotions and passions of readers and potential recruits. For Hunter, the culture wars tap into deep-seated divisions in the moral outlook of Americans, but the protests themselves—the style of contention, the claims, and the acrimony—are symptoms of the growing power of national social movement organizations, many led by visible religious leaders. These "fields of conflict," as Hunter describes them, are dominated by national actors, religious leaders, strong moral claims, and a sense of intractable disagreement—they are, in essence, fights to the finish.

Hunter's explanations fit easily with popular accounts of arts controversies. Nonetheless, for me, there remained a gap between the makeup of these highly visible conflicts and the partly formed sociological theory that I arrived at inductively when first confronted with the Chapel Hill controversy. My early supposition was that conflicts over art reflect something distinctive about the tensions, anxieties, and character of specific communities—whether a university community, a neighborhood, or a city. I was convinced that the most interesting dynamics of cultural conflict went beyond the political posturing, issue entrepreneurship, and crafty strategies of national crusaders (whether on the left or right). What might I find if I scratched below the surface? Would religion continue to dominate at the local level? Would politicians and elected officials be important antagonists? Would disputes be ideologically charged? Would conflicts be strident and polarizing? Do less visible, locally oriented conflicts resemble the culture war disputes taking place on the national stage? In this chapter I explore these questions with data from 805 conflict events across seventy-one American cities.

The Role of Religion

Many of the conflicts described above were initiated or inflamed by religious actors. For example, Donald Wildmon represents the antipathy between religion and art in America. His crusade began when he sat down to watch television with his family one December night in 1976 and was unable to find a single television program that didn't feature sex, violence, or profan-

ity (Mendenhall 2002, 102). Over the next three decades, Wildmon built the American Family Association, and with support from local chapters across the United States he relentlessly targeted nationally produced films, television shows, music, and fine art exhibitions that offended his Christian values. While Wildmon's campaign has been joined at times by other Christian activists and politicians—Jerry Falwell of the Moral Majority, Phyllis Schlafly of the Eagle Forum, Charles Keating Jr. of Citizens for Decent Literature—most observers of the recent culture wars would credit Wildmon with the most sustained effort to pressure television and movie executives, corporations, elected officials, and others to clean up the airwaves, theaters, museums, and other spaces of public culture. Wildmon takes his place in a long line of religious crusaders—from Pope Gregory I to Girolamo Savonarola to Anthony Comstock—who have found the content of art and the vision of artists objectionable, demeaning, seditious, or otherwise threatening to the social and moral fabric of the times. These conflicts and tensions between art and religion are perhaps to be expected given that the two spheres of life operate under very different underlying principles. A San Francisco rabbi describes the tension this way: "The ethos of the art world is that you're supposed to be getting outside of boundaries all the time and the ethos of the religion world is that you're supposed to be making boundaries all the time" (Wuthnow 2001, 39). In many instances, screenwriters, playwrights, choreographers, novelists, photographers, painters, and musicians are looking to transgress boundaries, while religious leaders are seeking ways to set limits and rein them in. Conflict is inevitable.

Beyond the metaphysical clash between art and religion, especially in the contemporary era (art has not always been associated with transgression), there are more immediate political and practical reasons why religious leaders have been at the forefront of battles over contemporary art and entertainment. Many scholars have studied the rise of the religious right over the last three decades (Wuthnow and Liebman 1983; Lienesch 1993) and its alliance with conservative causes and with the Republican Party. The religious right—comprised mainly of evangelical and fundamentalist Christians—made its first political advances in the late 1970s with a few local victories around gay rights and school curriculum. Televangelist Jerry Falwell drew upon these early victories, as well as his television ministry (comprised of three hundred stations reaching millions of viewers across the nation) to recruit local pastors and evangelicals to his newly formed organization—the Moral Majority. Falwell and the Moral Majority actively campaigned for Ronald Reagan in 1980, and Reagan's victory established the Christian right as a significant voting bloc in the Republican Party. The political agenda of

the religious right has included such diverse issues as taxes, prayer in school, affirmative action, abortion, welfare reform, and opposition to gay rights. Many commentators, along with activist themselves, acknowledge that the movement is motivated by a desire to reassert Christian values in the wake of a perceived ascendancy of liberal and secular beliefs, from gay rights to feminism, to the permissiveness and sexual openness espoused by the counterculture. In the 1970s and 1980s, conservative citizens felt embattled, marginalized, and increasingly exiled from mainstream culture. Art and entertainment become primary sites of political engagement for religious leaders trying to reinsert their values into the mainstream. As communications scholar Quentin Schultze argues, American Christians who feel "vulnerable and beleaguered" will "argue for a place in the broader culture and try to find a way out of their exile through activism directed at the reclamation of American life" (Schultze 2003, 34). Protests over art and culture are part of this reclamation.

The Role of Formal Politics

At the federal level, the arts have long been a punching bag for politicians. By tracing government hearings and reports around comic books, films, violent television, and music, Bill Ivey shows how elected officials have time and again browbeaten the purveyors of art and entertainment into self-ratings and self-censorship in the name of protecting children from sex and violence. In *Arts Inc.: How Greed and Neglect Have Destroyed Our Cultural Rights*, Ivey (2008) writes, "The political appeal of hearings on the content of culture is undeniable—an opportunity to posture on issues that push the buttons of our body politic even as the Constitution prevents legislators from actually *doing* much of anything about them" (226).

The buttons that seem most attractive to politicians are those polished to a high shine by the rhetoric of religious leaders. As religious actors, especially those representing evangelical and fundamentalist Christians, have become important and influential political actors in the last three decades, they have soldered together moral and social issues with traditional political issues like taxes, military spending, welfare, and education. Republican candidates, especially during primary campaigns, often use hot button cultural issues to mobilize their base and gain the nomination, while using more conciliatory and less strident rhetoric during general elections (when they need to win independent voters and less conservative members of their party). This is the explanation provided by many political pundits and scholars for New York Mayor Giuliani's attack on the *Sensation* exhibit. Giuliani's

attacks were intended to shore up voters' support on the conservative right as he moved into what was predicted to be a hotly contested Senate race against Hillary Clinton. By mobilizing the religious right, Giuliani was hoping to short-circuit an otherwise lengthy and costly primary process, quickly secure the Republican nomination, and focus his resources and energy on battling the presumptive Democratic nominee, Hillary Clinton. This same pattern plays out in other cities as well.

Erika Doss (1995) provides evidence that city council candidates, involved in a very tight election in Concord, Massachusetts, attacked the city's public art program in order to rally support for their candidacy. Similarly, Steven Dubin (1992), in his book *Arresting Images*, gives politicians a prominent role as initiators or agitators of arts conflicts. In one case a Chicago alderman demanded the removal of a painting hanging in the Institute for Contemporary Art of the late Chicago mayor Harold Washington depicted in women's underwear. Dubin credited the overzealous reaction to changes in politics, with the balance of power between the new and old guard in Chicago politics very much in play. The conflict over the painting provided the opportunity to "flex political muscle, consolidate local alliances and generate political capital" (Dubin 1992, 37). Elaine Sharp (1999) also finds that in a competitive environment, politicians often act as entrepreneurs, jumping into controversies when they recognize the potential for "political credit and career building that can accrue to those who take a visible stance on the right side of a morality issue" (228). James Davison Hunter (1991) also acknowledges that candidates often use cultural conflicts to gain constituencies and to discredit their opponents.

It is easy to single out cases of overzealous politicians, but is there any evidence that politicians consistently use arts controversies to win elections? In a study of arts conflicts in the city of Philadelphia between 1965 and 1997, DiMaggio and colleagues (1999) conclude that cultural conflicts—especially those originating from conservative-based grievances—are shaped by the "seasonal influence of political weather, by which we refer to incentives and opportunities created by the federal and local election cycles for office-holders, office-seekers, and their allies to place cultural issues on the public agenda" (39). Holding other factors constant, DiMaggio and his colleagues find that local public officials initiate disproportionately more controversies during mayoral election cycles than in the political off-season.

Many see the growing political importance of morally charged issues as part of a larger shift in politics away from typical class-based concerns focused on such issues as wages, health care, housing, trade, and economic development and toward issues represented by identity-based and lifestyle

concerns, such as the environment, minority rights, abortion, religion, and culture. In today's "new political culture" (Clark and Hoffmann-Martinot 1998), elections are often won based on single issues that mobilize and play upon people's emotions, passions, and identity. Art has proven to be a single issue capable of rousing deep feeling. Art, as well as entertainment, often mixes sacred and profane images; it is highly visual and dramatic; it is pervasive and hard to avoid; it pushes boundaries and conventions; and it is often available via sources—radio, television, movie theaters, libraries, and schools—that are easily accessible to children. Not surprisingly then, art and culture are politically salient objects. As Bill Ivey (2008) quotes one U.S. congressman, known to take public positions against the NEA, "It is just too good an issue for us" (223). In other words, controversial art can be the perfect political punching bag deployed to mobilize an electorate.

A Descriptive Overview of Cultural Conflict

This chapter explores cultural conflict by examining the role of religion, the influence of political actors, the consequence and significance of national organizations, and the differences between high- and low-intensity disputes. First, however, I highlight the basic contours of conflict in American cities. What are people fighting about? What types of claims are being made? And what are the outcomes of protest? Perhaps most importantly, though, I consider the relationship between conflict and place. As noted in the introduction, *New York Times* columnist Judith Dobrzynski wrote in 1997 that towns and cities had become important new arenas for cultural conflict as brushfires over the arts ignited and diffused throughout the country. But are the battles over art as local as Dobrzynski suggests? If so, how many of the arts conflicts that erupted at the local level were initiated by individuals or groups at the city level or involved local action including protest, demonstration, petition, and formal complaint? Given that I am interested in conflict not as a macro-level social phenomenon but as a practice exercised by citizens throughout the United States, my definition of protest, while allowing for events that include national actors, requires some local component to be included in the research (see the methodological appendix for more detail). If a U.S. senator objects to a violent television show, this is not counted unless citizens, elected leaders, or community activists in a specific city follow up the senator's objections with additional protest or public complaint. This book takes up 805 cases of conflict across 71 cities between 1995 and 1998: 259 events in 1995; 204 in 1996; 206 in 1997; and

136 in 1998. But how should we gauge whether these numbers are a lot or a little? Does this amount represent a *new* battlefield? Without the benefit of the Farmer's Almanac to tell us what to expect year to year or how the climate of today's conflict compares with storms raging thirty years ago, it is hard to read whether the last few years of the 1990s were a particularly hot time for local conflict over art and culture. There is some evidence that the numbers of events in this sample are similar to or even a bit lower than similar national inventories in the 1970s and 1980s. Historian L. B. Woods (1979) attempted to document "censorship attempts" across America in the 1970s and found an average yearly total of 316 events between 1970 and 1975. Harer and Harris (1994) replicated Wood's methodology by examining the publications and reports of national censorship and civil liberties organizations and found approximately 217 yearly cases between 1980 and 1990. While my methods and sample frame are different (for example, I only examine 71 cities, while they include any case of conflict in any U.S. city or community), there are not dramatic differences across the three decades with conflict events averaging somewhere between two hundred and three hundred events a year. DiMaggio and colleagues' (1999) research, which uses a similar methodology as the one used in this book and examines change over time (from 1965 to 1997), provides evidence of the "new battleground" thesis. They found that Philadelphia experienced twenty-seven conflicts between 1965 and 1975; twenty-six between 1975 and 1985; and forty-two between 1985 and 1997. They write, "The upward trend does indicate that Philadelphians fought more often about literature, music, the media and the arts in recent years than they had previously. This pattern is therefore consistent with the culture-wars account" (30). Interestingly, I find a fairly steep decline in 1998 compared to the three previous years, perhaps suggesting that the passions that inflamed the early 1990s— fights over NEA funding, crusades against rap and punk rock music, and early efforts by Rev. Wildmon to target television and film—were beginning to wane. All of these comparisons and findings are tentative and speculative. In the end it is clear that protest events over art and culture seem to be a fairly routine part of American life. This book takes up a robust number of cases in order to determine what citizens fight over, where conflict occurs, and why people clash over words and images that, in principal, "can never hurt you."

A major premise of this book is that words and symbols seem to hurt more in some places than others, or at least they provoke people to take action in some places more than others. Later, in chapters 3 through 8, I

Table 1.1 Ranking of cities by total number of conflict events, 1995–98
The fifteen cities with the most events and the fifteen cities with the fewest events

Metropolitan Area	Total # of Events	Metropolitan Area	Total # of Events
Atlanta, GA	37	Albuquerque, NM	9
Hartford, CT	29	Louisville, KY	7
Cleveland, OH	21	Charleston, SC	6
Portland, OR	20	Baton Rouge, LA	5
Pittsburgh, PA	19	Knoxville, TN	5
Raleigh, NC	18	Buffalo, NY	5
Fort Worth, TX	18	Tacoma, WA	5
San Jose, CA	18	West Palm Beach, FL	5
Denver, CO	18	Roanoke, VA	4
Dallas, TX	18	Des Moines, IA	3
St. Louis, MO	17	Norfolk, VA	3
Milwaukee, WI	17	Bangor, ME	1
Baltimore, MD	17	Grand Forks, ND	1
Phoenix, AZ	16	Springfield, IL	1
Seattle, WA	15	Evansville, IN	1

Note: N = 805

consider how the profile of conflict changes from place to place. For now it is worth noting that while, on average, cities experienced 11.34 conflicts over four years, some cities experienced as many as thirty-seven conflicts (Atlanta, Georgia), while others experienced as few as one (Evansville, Indiana; Springfield, Illinois; Grand Forks, North Dakota; and Bangor, Maine). Population size is an important factor in generating instances of conflict, but even cities with similar size populations experience very different rates of conflict. For example, Norfolk, Virginia, and Raleigh, North Carolina, had populations of about one million in 2000 but very different rates of conflict. Table 1.1 contains the top- and bottom-ranked cities in terms of protest activity. Interestingly, more than half of the top cities—Atlanta, Raleigh, Fort Worth, San Jose, Denver, and Dallas—are located in the Sun Belt. The Sun Belt describes the region of the country that stretches approximately from Virginia south to Florida and west to California, and it has been defined by economic growth and high rates of immigration. Why cities in this part of the country displaying these types of social change experience high numbers of conflict is taken up in chapter 3. I now consider what types of culture elicit local conflicts, what grievances motivate community debate, which actors engage in local struggles, which strategies they employ, what outcomes emerge, and the roles of national and religious organizations in debates across towns and cities in the United States.

The Objects of Conflict

While news accounts would lead one to believe that the images of fine art painters and photographers are the most controversial, what does our data reveal? Which kinds of objects and types of presentation were challenged most often? Based on our 805 cases of conflict, books of fiction were the most popular target of controversy—the source of conflict in 120 cases, or 14.8 percent of the time (see table 1.2). Paintings and graphic artwork, including murals, were responsible for 11.8 percent of all challenges, and an equal number of protests occurred over movies. Popular music concerts were the target of attacks in 9.8 percent of the cases, and sculpture accounted for 8.4 percent. Perhaps the only surprising finding here is that there were very few cases involving television, radio, or recorded music. National political

Table 1.2 Types of challenges

Medium of Cultural Work	Frequency	Percent
Fiction book	120	14.8
Painting/graphic artwork	95	11.8
Fictional film	95	11.8
Pop music concert	79	9.8
Sculpture	68	8.4
Nonfiction book	43	5.3
Art photography	40	5.0
Other	39	4.8
Statue/memorial	32	4.0
Educational multimedia exhibit	27	3.2
Theater	19	2.4
Nonfiction Film	20	2.4
Multiple types	19	2.4
Television: drama/sitcom	15	1.9
Dance	14	1.7
Other live music	12	1.5
Magazine	11	1.4
Radio music	11	1.4
Television: historical/documentary	9	1.1
Fine arts concert	6	0.7
Performance art	5	0.6
Television music	5	0.6
Opera/musicals	4	0.5
Other non-music performance	4	0.5
Recorded music	4	0.5
Pageant	3	0.4
Combination film/book/magazine	4	0.4
Comedy	2	0.2
Total	805	100

leaders and religious activists—from Bob Dole to Rev. Donald Wildmon and Delores Tucker—have frequently targeted the entertainment industry for promoting sex, violence, and profanity through movies, television, and recorded music. As Ivey and others such as Judith Levine note, there have been congressional hearings, national summits, national task forces, and a fleet of study commissions focusing on media violence and the sexual content of today's entertainment (Levine 2000). While movies garnered their fair share of criticism in this study, television was the target in only twenty-nine conflict events, radio in eleven events, and recorded music in only four events. While occasionally citizens picket a record store for carrying "gangsta rap" or an administrator might ban songs with obscene lyrics from a campus radio station, it appears that debates over broadcast culture occur mostly at the national level, with politicians and activists targeting the entertainment industry more generally rather than local officials or citizens taking action against area businesses or television and radio stations. The findings also suggest that when it comes to radio and television, people were more likely to attack the source of the cultural work—the creators and producers in Los Angeles and New York—rather than the distributors and presenters in local communities. With the rise of the Parents Television Council and its local affiliates (see chapter 9), the number of local protests over television and radio may increase.

Interestingly, books are the most popular targets of protest. When cases over fiction and nonfiction are combined, conflict over books comprised 163 cases. This would not surprise anyone who keeps up with the American Library Association's Office of Intellectual Freedom, which reports on censorship in its monthly newsletter. (The association also sponsors a well-publicized "banned books" week every year.) Books in schools and public libraries represent an interesting contrast to films, television shows, art exhibits, sculpture, and theater. First, protests over books are typically focused on material that is not new but rather that has been on the shelves for some amount of time before protest arises—either for decades like Mark Twain's *Huckleberry Finn* or J. D. Salinger's *Catcher in the Rye* or for shorter periods of time like Judy Blume's young adult fiction or reference books like *The Joy of Sex*. The important point is that these offending objects are not typically thrust in people's faces. Rather, someone—a group or an individual—either stumbles across an offensive passage or otherwise targets a book as a way to gain new or revive attention to a cause. Similarly, in most cases the books are not "public" in the sense of requiring an audience or occurring in a public or open space, but they are public in a different sense. Books are made available through public institutions like schools and libraries,

institutions that supposedly represent the values of the communities they serve. Schools and libraries impart our collective understandings to children about what it means to be an American or to be a member of a community (Hunter 1991). Even though most parents have the ability to restrict their children's access to certain books (for example, through placing limits on their children's library cards or by having their child read an alternative book for a school assignment), publicly challenging a book is a way of making a claim to neighbors and fellow residents that one set of community values still retains dominance. For example, when a gay rights group donated several dozen gay-themed books to a local Kansas City school library, numerous parents pressured school officials to remove the books. One parent remarked, "We, the parents and patrons, are in charge and we will take care of our children. . . . We cannot sit back quietly and let this issue slide by" (Saylor and Scott 1993, C1). For some letting an issue "slide by"—especially one that involves a local community institution—is tantamount to condoning, or worse, promoting, the very values that they find most offensive. This theme is explored further in chapter 9.

The Grievances

Understanding *what* types of cultural objects motivate conflict is not synonymous with knowing *why* these objects raise concern. Thus I ask: What constitutes the major source of objection, or what is the primary grievance against offending cultural works?[4] Who is considered at risk by these presentations? Throughout history—from the Pope's insistence in 1558 that fig leaves be painted on the nudes in Michelangelo's *The Last Judgment* to more recent attacks of the film *Schindler's List*—obscenity, pornography, and indecency have been staple sources of complaint against cultural works. In addition to indecency, perhaps the second most important claim (at least since the middle of the nineteenth century) has been that certain cultural works threaten the innocence and the health of children (Beisel 1997; Binder 1993; Heins 1993; Pally 1994). Not surprisingly, the two are often linked; people complain about indecent materials because they believe these are harmful to children. These trends appear in the cases contained in this sample as well. In 164, or 20.4 percent, of cases, the *primary grievance* against a cultural work was that it was indecent or pornographic (table 1.3). If you combine complaints of indecency with those involving homosexual content, then the percentage of events represented by indecency complaints is approximately one in four, or 25 percent. This represents the most of any category. In 15.5 percent of cases, the primary grievance was that a work

was perceived, above all else, to be harmful to children.[5] As expected, of the 202 indecency complaints (combining heterosexual and homosexual content), the majority (57 percent) concerned the health and well-being of children.[6]

Interestingly, in ninety-three protest events (11.6 percent of cases) opponents claimed that a cultural presentation was harmful or offensive to ethnic minorities. These conflicts ranged from complaints about the word "nigger" in *Huckleberry Finn* to protests by anti-defamation groups over the depiction of Muslims in the movie *The Siege.* In Albuquerque, New Mexico, several protest events involved conflicts between Native Americans and Hispanics. One particularly contentious event involved a commissioned sculpture honoring the Spanish explorer Don Juan de Oñate as part of the city's celebration of the 400th anniversary of the colonizing by Spain of the territory that is now the state of New Mexico. The Native American community was outraged by the proposed sculpture that they felt honored a man who had massacred hundreds of Acoma Indians, but advocates of the sculpture defended their right to celebrate the Hispanic legacy in New Mexico. A representative of the anti-Hispanic defamation league retorted, "Frankly, the Acoma Indians have no place in the memorial. After 400 years, the Spanish people should be able to stand up and say: 'It's our anniversary. We have made it'" (Reed 1998b, A1). In another case in Albuquerque, New Mexico, the mayor objected to a mural at the public library that he said contained an image that looked like a Spaniard stabbing a Mayan Indian. As discussed

Table 1.3 **Primary grievances expressed by protesters**

Primary Grievance	Frequency	Percent
Indecent or pornographic-heterosexual content	164	20.4
Harmful or offensive to children or youth	125	15.5
Harmful or offensive to racial/ethnic group	93	11.6
Blasphemous or offensive to religion	76	9.4
Other	64	8.0
Aesthetically offensive (ugly)	45	5.6
Profanity or foul language	43	5.3
Indecent or pornographic-homosexual content	38	4.7
Politically offensive or harmful	28	3.5
Offensive to dissenting religious groups	24	3.0
Graphic violence	20	2.5
Promotes deviant behavior	20	2.5
Harmful or offensive to women	19	2.4
In poor taste	18	2.2
Historically inaccurate/biased	16	1.9
Anti-family	12	1.5
Total	805	100.0

Table 1.4 Was the protest based in conservative or liberal concerns?

Political Valence	Frequency	Percent
Conservative valence	428	53.1
Liberal valence	217	27.0
Neither conservative nor liberal	160	19.9
Total	805	100.0

in the introduction, these conflicts represent a form of identity politics in which diverse cultural groups promote or attack visible symbols in a community—such as artworks and monuments—in an effort to gain recognition or increase the status of their group. While scholars have recognized the role that identity politics can play in conflicts over art (Doss 1995; Dubin 1994; Rodriguez 1999), these types of conflicts have received far less attention in the media and fall outside of the familiar culture war narrative, which focuses on conflicting values rather than group identity.

In contextualizing what constitutes a grievance, I ask what proportion of cases has a conservative political valence and what percentage has a liberal political valence? Here "conservative" refers to complaints that come from people to the right of the political spectrum and are against content perceived to be anti-Christian, inappropriately sexual or obscene, homosexual in nature, or excessively profane or violent. "Liberal" refers to actions against content perceived to be racist, sexist, anti-gay, misogynistic, or in violation of the separation of church and state. As the evidence presented suggests, cultural conflicts are dominated by the right with 428 cases, or 53.1 percent, originating in conservative causes (see table 1.4). In 27 percent of the cases, people or organizations registered a grievance rooted in liberal concerns, and 19.9 percent of the grievances were neither liberal nor conservative but rather "aesthetically offensive," "historically inaccurate," "lacking educational value," or "in poor taste." While the majority of grievances echo the concerns of today's social conservatives, the picture of cultural conflict is more complicated than some anti-censorship groups seem to believe. One in four attempts to regulate, restrict, or bear witness against a cultural presentation involved groups typically associated with liberal causes.

The Actors

Many political commentators have concluded that protests over art and culture serve to advance the interests of politicians and religious activists. My findings paint a very different portrait (see table 1.5). Religious actors were

Table 1.5 Who participated in the protest against the artwork?[a]

	All participants against the artwork[b]		Initiating actor against the artwork	
	Frequency	Percent	Frequency	Percent
Parent or citizen	499	62.0	349	43.4
Elected government official	303	37.6	95	11.8
Local/neighborhood association	178	22.1	61	7.6
Presenters or curators of the work (self-censorship)	245	30.4	74	9.2
School administration or teachers	110	13.7	30	3.7
Newspaper editorial board	57	7.1	10	1.2
Racial/ethnic/women's organization	127	15.8	29	3.6
Religious individual or organization	177	22.0	115	14.3
Other	42	5.2	42	5.2
Total	1,738	NA	805	100

[a]Every case has both initiating and subsequent actors. An initiating actor is the person or group who first brought forward a grievance against the artwork.
[b]This column includes all who participated in the action, allowing for each case to fall into multiple categories and thus producing a percentage higher than 100%.

present (either initiating conflict or joining later in a protest) in 177 cases (22 percent). Government officials and politicians were present in 303 cases (38 percent). In 50 cases, government, political, *and* religious actors were present. By contrast, individual parents or citizens—that is, people with grievances who were not associated with organized groups—were present in 499 episodes of conflict, or 62 percent of cases. Interestingly, 49 percent of all cases did not involve any form of collective or organized action. Almost half of the cases emerged in response to individual action, typically initiated by parents, politicians, curators, librarians, or administrators in presenting organizations. These episodes were not the result of a campaign, crusade, social movement, or organized protest. There was offense and protest but very little conflict. While religious actors and political actors were involved in 60 percent of all conflicts, they were much more likely to enter a conflict after it had already begun then to *initiate* protest in the first place. In fact political/government officials *initiated* action in only 11.8 percent of the cases, and religious actors initiated conflict in only 14.3 percent of cases (see table 1.5). In contrast, parents and citizens acting alone and not affiliated with a group started protest in 43.4 percent of cases (more than three times as much as political or government officials or religious organizations and leaders).

Certainly some individuals acting alone or independently were motivated to make a claim against an artwork in part because of their involvement in an organization. Perhaps their local minister spoke out against a

film or book in a Sunday sermon, or they learned about an exhibit from a fellow Rotarian or from someone at a neighborhood association meeting. Many people who protest a book or film or painting are motivated by religious beliefs and values, even if they are not officially identified by the press as representing a church or religious group. So I have likely underestimated the extent to which conflicts are rooted in organized or collective action as well as the degree to which events involve religious concerns. Nonetheless, the evidence clearly shows that it is parents and citizens who are driving these protests at the local level, not religious and political leaders. If anything, political and government officials are much more likely to get involved only after a conflict has already surfaced—either operating like birds of prey, looking to pounce on unsuspecting arts conflicts in order to score political points, or simply in their official capacity, for example, as a school board member who must take a position when an issue comes before them as a matter of procedure.

The Nature of Conflict

When individuals and groups have grievances, how do they express their concerns? What is the nature of the actions that they take against cultural works they find offensive or inappropriate? In the majority of cases (56.6 percent) citizens or parents make a phone call, write a letter, or visit with a local official or someone in charge of the offending object in order to make their grievance known (see table 1.6). In such cases they may contact a member of the school board, the mayor, or a city councilman to complain.

Table 1.6 Nature of protest activity

Nature of actions against artwork	Frequency	Percent
Complaint from a citizen or parent	455	56.5
Restriction of artwork by administrator or manager	303	37.6
Demonstrations, boycott, petition, or march	193	24.0
Complaint from a public official	149	18.5
New policy/law proposed or passed	122	15.2
Public awareness campaign	118	14.7
Issue raised at public meeting	103	12.8
Complaint from an organization	103	12.8
Legal action	52	6.5
Newspaper editorial	50	6.2
Vandalism/defacement	38	4.7
Police action	29	3.6
Total	1,715	NA

Note: Most cases involve more than one type of activity, resulting in percentages higher than 100%.

They may also contact someone directly at the presenting organization it-self—a gallery or theater director, library administrator, or the proprietor of a retail outlet. General complaints—via letters, phone calls, or meet-ings—were also made by elected or appointed government officials (in 18.5 percent of cases) as well as by individuals representing a constituency or organization. So the president of the local chapter of the American Family Association might get involved in a protest, as might a minister on behalf of his parish (such organizationally based complaints arose in 12.8 percent of cases). Twenty-four percent of cases involve some form of public display or protest—petition, demonstration, boycott, or march; 15 percent involved a newly proposed policy or bill, for example, a new school policy regarding the showing of R-rated films, a new regulation banning nudity onstage, or a local noise ordinance. The most contentious forms of protest—vandalism and defacement, lawsuits, and police action—were rare, accounting for only 4.7 percent, 6.5 percent, and 3.6 percent, respectively.

The above statistics represent all protest activity against an artwork—whether the activity was the initial action against the work or whether it occurred subsequently during the case. For example, an initial action might involve writing a letter to the mayor; a subsequent action might involve marching in front of the courthouse. When we turn to the nature of the *first* or *initial* actions against an offending artwork, we find an even greater emphasis on the role of individual citizens and parents. Fairly routine forms of complaint are pervasive. Almost 60 percent of the cases began with a simple complaint—a citizen, official, or organizational representative writes a letter, makes a phone call, or plans a visit—to someone in charge and asks that person to fix the problem by moving or restricting a work of art or book, for example. Most initiating actions did not begin with public protests, speeches, press releases, petitions, boycotts, or other highly visible events. Instead, controversies appear to begin as mere sparks of discontent. Later in this chapter I consider how such sparks ignite into larger and more intense disputes.

The Outcomes

How often was a cultural work terminated or restricted in some way? How often were lawsuits resolved in favor of opponents, and how often were such suits decided in favor of the artwork or the institution responsible for presenting the work? In 303, or 37.6 percent, of cases, actions taken against an artwork included some form of restriction by an administrator or manager of a cultural institution—terminating the work, setting an age

Table 1.7 Protest outcomes

Protest outcomes	Frequency	Percent
Work presented and remained in place	339	42.1
Access to work is restricted	163	20.3
Work suspended	134	16.7
Legislation of policy that is neutral	88	10.9
Work prevented from occurring	67	8.3
Legislation or policy opposing work	63	7.8
Responsible parties fired or resigned or presenting organization closes or is shut down	29	3.6
Lawsuit resolved in favor of supporters of work	29	3.6
Lawsuit resolved in favor of opponents of work	16	2.0
Legislation or policy supporting work	13	1.6
Total	941	NA

Note: Percentages do not add to 100 because some events had multiple outcomes.

requirement, moving the work, or otherwise preventing full access (see table 1.6). In 9.2 percent of the cases, such restriction took place unilaterally as the first action against an artwork—even in the absence of a formal or public complaint (see table 1.5). In other words, someone in charge (a librarian, curator, gallery owner, or proprietor) simply removed, terminated, canceled, or otherwise chose to restrict an existing or planned performance, exhibition, presentation, or book. It is debatable whether 9.2 percent is a high or low number. Nonetheless it seems fair to argue that in a small, but perhaps important, minority of cases communities seem to be engaged in preemptive self-regulation.

When we look at the final outcome of a controversy, the trend is clear—in many cases access to work is suspended, restricted, or prevented from occurring in the first place. One of these three responses occurs in close to 45 percent of the cases (see table 1.7, sum of rows 2, 3, and 5). This may give pause to civil libertarians and free expression advocates. While slightly more lawsuits are resolved in favor of the artwork than are resolved in favor of the opponents of the artwork, far more policies, bills, and ordinances are passed that make it more difficult for similar works to be presented in the future (for example, a ban on R-rated films in a school) than are passed to protect future attacks or attempts to censor.

Culture wars are conceptualized as "fights to the finish." Opponents are motivated by deeply held moral concerns and opposing worldviews. This makes compromise difficult. With so many protest events ending in restriction, it is tempting to conclude that opponents were unwavering in their demands to have objects or presentations removed or canceled. Yet there is

contradictory evidence suggesting protest is more routine, less strident, and less contentious. Most protests did not involve highly visible moral crusades, nor did they involve extreme politics—such as vandalism or lawsuits or police action. Many involved unilateral acts to restrict artworks even before public conflict arose, and a large number were entirely one-sided with no visible defense. In the majority of cases where a grievance was made to a public official or a responsible administrator, the complaint was handled in a democratic fashion—discussed at a public hearing, referred to a standing committee, discussed at a regularly scheduled council or board meeting, or raised before a special ad hoc review committee.

How intense were the conflicts in terms of tactics, traction, and scope? How many different types of actors or groups (parents, religious groups, elected officials, administrators, local organizations, local chapters of national organizations, the media, and such) participated in the conflict, and how much coverage did the protest receive in the news media? Both the number of different actors and the number of articles covering the protest follow a classic right tail distribution. The majority of conflicts had relatively few participating actors and did not attract a great deal of newspaper coverage, with some notable exceptions that mobilized large numbers of participants and received significant press attention (see figures 1.1 and 1.2).

In deference to the fire-related rhetoric that typically surrounds descriptions of cultural conflict events—"heated debate," "inflamed passions," "smoldering fears," "hot buttons"—I have chosen to classify my events into four categories representing different levels of intensity—embers, sparks, brushfires, and wildfires. Embers include one or two different actors and one

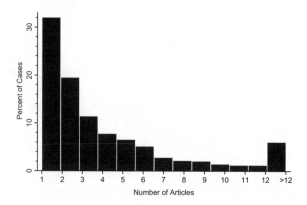

1.1 How many different articles were written about the controversy?
Note: N = 805

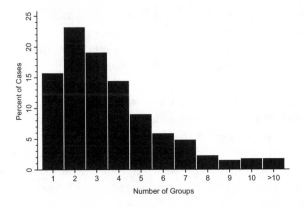

1.2 How many different groups participated in the controversy?
Note: N = 805

Table 1.8 **Intensity of protest**

Intensity of Protest	Frequency	Percent
Ember[a]	180	22.4
Spark[b]	318	39.5
Brushfire[c]	160	19.9
Wildfire[d]	147	18.3
Total	805	100

[a]Ember = 1 or 2 actors and/or 1 article
[b]Spark = 3–4 actors and/or 2–4 articles
[c]Brushfire = 5–6 actors and/or 5–8 articles
[d]Wildfire = 7 or more actors and/or 9 or more articles

article. These cases typically involve a complaint from an individual with no follow-up, little response from officials or administrators, and very little attention in the media. These embers simply don't catch fire or even create much of a noticeable flash. Sparks are more visible, appearing two to four times in local newspapers and/or engaging three to four actors. Brushfires catch fire but are reasonably contained. They involve five to six actors and/ or five to eight articles. These events have risen to the level of public drama, but they are not as intense as wildfires. The most intense conflicts burn. They get significant coverage in the press in at least nine articles but in some cases in well over one hundred articles, and wildfires involve seven or more different actors. The distribution of embers, sparks, brushfires, and wildfires reveals that well over half of protest events would be considered embers or sparks—61.9 percent (table 1.8). Wildfires, which, at least in intensity,

seem closer to what we might expect from a culture war dispute, represent 18 percent of all protest events.

It is not my intention to validate or disconfirm the culture war thesis. Instead I hope to provide an empirical snapshot of the types of conflicts that occur in cities across America. My findings do, however, provide an interesting contrast to the way culture war disputes are often discussed and reported on in the press. Compared to the high-visibility events, the protest events in my sample are less well organized, typically initiated by parents and citizens rather than by political and religious actors, and they involve less strident and publicly visible tactics. In addition, the majority of protests seem to attract limited press attention and involve a limited number of different actors. Many never get beyond an ember or spark, nor do they involve any organized or collective effort. People are offended, they express their concerns to those they perceive as being in charge, and then complaints are handled in a fairly democratic fashion, sometimes resulting in restriction or termination and in some cases an endorsement or ruling in favor of the challenged artwork. By downplaying the culture war explanation, I am not suggesting that cultural conflict is not important for communities. Instead, as I argue in the remainder of the book, the collection of protest in a city—both small and large disputes—reveals a lot about how communities negotiate and affirm identity in the face of change.

Examining Religious and National Dimensions of Local Conflicts

As discussed in the introduction, cultural conflict is often connected to religious actors as well as to national actors—like conservative Christian groups, civil liberties organizations, and national politicians. If we divide our 805 cases into four categories along these two dimensions of interest we get the following: 503 cases were strictly local and involved no religious actors of any kind (*local*); 82 cases were local *and* involved local religious actors (*local-R*); 95 cases involved national organizations or leaders who represented religious groups or causes (*national-R*); and 125 cases involved national actors with no religious connection (*national*). Table 1.9 provides a more complete depiction of these variables. Some of the cases with national actors involve local actors but not vice versa; and some of the cases that involve religious actors also involve nonreligious actors but not vice versa. In essence, religious and national actors trump nonreligious and local actors for the purposes of fitting cases into one of the four categories. How do these four categories differ from one another? Are local conflicts

Table 1.9 Religious and national dimensions of conflict

Dimension of conflict	Frequency	Percent
Local, no religious actors (*local*)	503	62.5
Local and religious actors (*local-R*)	82	10.2
National and religious actors (*national-R*)	95	11.8
National, no religious actors (*national*)	125	15.5
Total	805	100

different from national conflicts in important ways? Are conflicts involving religious actors different from those without religious actors?

Table 1.10 reports the results from a multivariate General Linear Model (GLM). In this model, I examine the differences in the adjusted means for a range of variables of interest. I compare the four categories across a variety of different aspects, including the intensity of protests, the likelihood of involvement of elected officials, and the probability of termination or restriction of the cultural work.[7] The most dramatic finding is that across multiple dimensions, protest events involving national-religious actors (*national-R*) are significantly different from all of the other three categories. In particular, such conflicts (*national-R*) are less likely to involve elected officials. Seventeen percent involve elected officials versus 35 percent for *local*, 30 percent for *local-R*, and 38 percent for *national*. *National-R* events are also less likely to involve *both* opponents and defenders of an artwork. In other words, they are more likely to be one-sided and less likely to be intensely covered by media or engaged by different actors. Moreover, *national-R* conflicts are less likely to result in the restriction, termination, or alteration of an artwork or presentation. Twenty percent are restricted compared to 44 percent for *local*, 37 percent for *local-R*, and 41 percent for *national*. Finally, *national-R* conflicts are much more likely to involve popular culture, primarily films and concerts. Sixty-three percent of *national-R* conflicts are over pop culture, compared to 20 percent for *local*, 24 percent for *local-R*, and 26 percent for *national*.

Contrary to what we would expect, the actors we have come to associate with the culture wars—the American Family Association, the Christian Coalition, Focus on the Family, the Catholic League—are not whipping up fury and fire in local communities. Instead they are actively launching small offensives on a number of fronts—protesting Marilyn Manson concerts, the films *Showgirls* and *The Priest*, Jock Sturges's books of photography, Disney programs—but not effectively turning these skirmishes into conflicts that gain any traction at the local level. When the smoke clears, all we are left with is traces of smoke. Typically the national organizations will put

Table 1.10 Comparing characteristics of protest along two dimensions: National/local and religious/nonreligious

Dependent variable	Local	Local-R	National-R	National
Cultural work is restricted, terminated, or altered	0.44	0.37	0.20	0.41
Elected officials participated in conflict	0.35	0.30	0.17	0.38
Conflicts are two-sided[a]	0.62	0.54	0.38	0.60
Uncivil discourse ("name-calling")	0.14	0.17	0.24	0.17
Targeting popular culture	0.20	0.26	0.63	0.24
Conflicts involve court system and lawsuits	0.10	0.09	0.10	0.19
Number of actors	3.56	4.43	3.14	3.99
Number of articles	4.68	7.29	3.47	5.60

Note: N = 805. Data are in the form of percentages based on adjusted mean scores with the exception of variables that measure for intensity levels, such as number of actors and articles. Analysis controls for whether the protest involved collective action (e.g., if an organization became involved or multiple individuals coordinated their actions).
[a]Conflicts are two-sided when there are people or groups who came out publicly both for and against an artwork.

out a mail alert or draw attention to an offensive movie or book during a weekly radio broadcast. Such alerts might call for a boycott, demonstration, prayer vigil, book burning, or protest and include detailed suggestions for organizing a local event. Individual members, local chapters, or independent churches will often carry out the suggested activity, sometimes without ever mentioning to the press their connection to the national organization. A few dozen people might show up to hand out Bibles in front of a Marilyn Manson concert or to hold picket signs in front of theaters that are showing *Showgirls*, but it seems that these nationally coordinated or instigated protests do not mobilize much local action. Defenders of the challenged films or concerts do not rush to the streets to hold counterdemonstrations; public officials rarely introduce new laws or policies to support the claims of these national organizations and their activists; and private owners of movie theaters, bookstores, and concert venues rarely cancel, restrict, or otherwise change their plans to exhibit or carry a particular film or book. These events might help the national organizations recruit members, raise money, and garner publicity, but they do not seem to matter much for local communities, at least in terms of stoking local culture wars.

Interestingly, even though the involvement of *national-religious* actors does not intensify a controversy, there is some evidence that *national-religious* actors are associated with protests in which contending parties try to discredit one another through unflattering labels and uncivil rhetoric (for example, using labels like "bigot," "ignorant," "unpatriotic," "pornographer," "racist," and such). In 24 percent of the cases involving *national-*

religious actors, "uncivil words" were exchanged between opposing sides, compared to just 14 percent for *local* conflicts and 17 percent for either *local-R* or *national* conflicts. Unlike *national-religious* actors, when *local-religious* actors get involved, conflicts tend to be more, not less, intense. They attract more local press coverage (7.3 articles compared to 4.7 articles), and they involve a greater number of different actors (4.4 compared to 3.6, though this difference is not statistically significant). Table 1.10 reveals that while the involvement of *national* actors does not necessarily increase the level of intensity, it does increase the likelihood that conflicts will involve the court system. In 19 percent of the cases involving *national* actors, protest ended up in the courts, twice as often as any other category. In many cases the American Civil Liberties Union took up a cause in defense of free expression, civil liberties, or the separation of church and state. One such case involved a lawsuit against the Oklahoma City district attorney's office for raiding private homes and video stores and confiscating copies of the Academy Award–winning foreign film the *Tin Drum*, which the city claimed was legally obscene because it contained a simulated sex scene between two teenagers during World War II.

Conflicts involving national (but not religious) actors are not significantly different from those with local actors. They are not more intense or more visible, more likely to involve elected officials, or more likely to end in termination or restriction of an artwork. Ultimately, conflicts involving *national-religious* actors are outliers in that they involve fewer participants, garner less newspaper coverage, and generally do not motivate potential defenders of artworks to take up arms in the battle. In other words, they gain less traction locally than either events that only involve *local* actors or events that involve *national* actors who are not affiliated with a religious group. Interestingly, as noted above, while conflicts involving *national-religious* actors fail to generate a great deal of local mobilization, they do provoke more strident or uncivil language. In other words, they resemble the culture wars more in sound than fury.

In addition to emphasizing the role of religious and national actors in protests, commentary about cultural conflict often focuses on politicians and elected officials. What is the difference between protest events that involve elected officials and those that do not? Table 1.11 compares adjusted means across a range of variables for events with and without elected officials. While elected officials initiate conflict in a small percentage of cases, when they get involved—whether initially or subsequently—protest events are much more likely to involve multiple actors (5.2 actors versus 2.9 actors), attract more media coverage (8.1 newspaper stories versus 3.4 stories),

Table 1.11 Comparing protest outcomes for conflicts with and without the involvement of elected officials

Protest Outcomes	No elected official (adjusted mean)	Elected official involved (adjusted mean)
Cultural work is restricted, terminated, altered	0.38	0.44
Cultural work is censored	0.46*	0.58*
Conflicts are two-sided[a]	0.49*	0.76*
Uncivil discourse ("name-calling")	0.14*	0.21*
Targeting popular culture	0.27	0.25
Conflicts involve court system and lawsuits	0.09*	0.15*
Number of actors	2.91*	5.22*
Number of articles	3.4*	8.14*

Note: N = 805. Data are in the form of percentages based on adjusted mean scores with the exception of variables that measure for intensity levels, such as number of actors and articles. Analysis controls for whether the protest involved collective action (e.g., if an organization became involved or multiple individuals coordinated their actions).
[a]Conflicts are two-sided when there are people or groups who came out publicly both for and against an artwork.
*Differences in means for these items are significant at the 0.05 level or higher.

involve two sides (76 percent of cases versus 49 percent), and involve harsh and critical rhetoric (21 percent of cases versus 14 percent). The participation of elected officials is also correlated with the chance that a protest event will make its way to court and, importantly, with the likelihood that challenged artworks will be restricted (44 percent of cases compared to 38 percent).

Wildfires

Unlike religious actors, when elected officials get involved, protest events do seem to take on the character of a culture war—or at least appear more intense—both in the number of participants and in the language used by contending factions. But what actually predicts whether or not a protest is likely to become a wildfire? Using a technique known as logistic analysis, I examine the likelihood that certain characteristics of a protest event will be associated with wildfires. The bulleted list below illustrates that the involvement of elected officials greatly increases the likelihood that a protest event will become a wildfire. In fact, when elected officials are involved, the chances are 7.4 times greater than if elected officials are not involved. Comparing local, national, and religious actors, the results suggest that there is no difference between events that involve only local actors and those that

involve national leaders or organizations, or events that involve religious actors and those that do not. In contrast, events that involve public schools and libraries are more likely to lead to more intense conflicts. In fact, school and library conflicts are 2.3 times more likely to become wildfires. The intensity and visibility of conflict are primarily attributable to the fact that the protest involves important public institutions (Hunter 1991).

What factors increase the likelihood that a conflict will become a wildfire*?

· The odds of becoming a wildfire are 7.4 times greater for conflicts involving elected officials (compared to those that do not involve elected officials).

· The odds of becoming a wildfire are 2.3 times greater for conflicts involving schools and libraries (as compared to those that do not involve schools and libraries).

· The odds of becoming a wildfire are 4.2 times greater for conflicts where the court system becomes involved (as compared to those that do not involve the courts).

· The odds of becoming a wildfire are 2.9 times greater for conflicts where opposing sides try to discredit each other with the use of derogatory or dismissive labels.

· The odds of becoming a wildfire are 4.9 times more likely for conflicts that involve collective action or groups of organized protesters (as compared to those that involve only uncoordinated individuals).

· The odds of becoming a wildfire are 2.2 times more likely for those local conflicts that involve local religious actors as compared to those local conflicts that do not involve local religious actors. National conflicts and national conflicts with religious actors are no more likely to become wildfires than nonreligious local conflicts.

In addition, when conflicts involve harsher rhetoric—where opposing sides try to discredit each other through the use of derogatory or dismissive labels—the chances of the conflict intensifying increase by 2.9 times. Conservative-based grievances are no more likely to be wildfires than liberal-based grievances. Court battles are also more likely to be wildfires (4.2 times) than cases that do not involve legal disputes—a unsurprising finding given that court cases often last months or years. And conflicts that involve collective action (groups of organized protesters) as opposed to those that involve only individual citizens and parents acting on their own are much more likely to be wildfires.[8]

*Wildfire = seven or more different types of actors and/or nine or more articles.

Finally, is there any affinity between religious and political actors? Do politicians enter conflicts to appease, support, or gain religious constituents? Do elected officials form alliances with religious leaders as part of moral crusades against art? In several of the cases described at the beginning of this chapter, religious and political leaders seem to be working side by side, flying toward the same flame of contention. The Catholic League condemned the Brooklyn Museum and organized a public rally only after Giuliani had already called public attention to what he considered to be blasphemous and anti-Catholic art in the *Sensation* exhibit. In Clearwater, Florida, the local chapter of the Christian Coalition joined the protest, exerting pressure on the city council to cut funding, only after the issue was already well seeded and fertilized by a grandstanding city council member. Yet these cases might be outliers. Statistically there is no correlation between elected officials and religious actors. In essence, there is no evidence that elected officials and religious leaders in America are teamed up to attack art and culture at the local level.

Conclusion

In 1996 an alarming declaration was made in *Artistic Freedom under Attack,* a report published by the People for the American Way, a national organization founded by Norman Lear that focuses on civil liberties, free expression, religious freedom, and other liberal causes: "In 1995, the Culture War exploded in America. After several years of rear-guard actions, launched in large measure by religious political extremist organizations, like the American Family Association, the Christian Action Network and others, this past year saw otherwise mainstream politicians working to exploit culture war issues for political gain. . . . The arts funding battle at the national level is being duplicated at the local level" (People for the American Way 1996, 4). The notion that protest over art and entertainment emerges in response to the activities of religious and political "extremists" and national actors not only appeared in PFAW statements but also gradually entered mainstream discourse and scholarship. Yet the local dimensions of culture struggles remain largely overlooked. In contrast to the monolithic model of nationally driven culture wars, Hunter acknowledges that "the culture war does not manifest itself at all times in all places in the same way. It is episodic and, very often, local in its expression. . . . Yet because what is under dispute and what is at stake is culture at its deepest level, carried by organizations relating to larger movements, these local, often disparate conflicts are played out

repeatedly in predictable ways. . . . Local and national elites are in virtually every instance of cultural conflict" (1991, 30).

Ultimately, the question is to what extent do local cases of conflict over art and culture resemble the national high-profile cases that are most typically reported in the national news and analyzed and discussed by scholars and policy makers? The findings in this chapter paint a somewhat complicated picture. The issues that seem to motivate national culture war politics are the same ones at the heart of many locally initiated conflicts—concerns about obscenity and sexual content along with fears about the consequence of art and media on children and young people. Like national protests, local conflicts are in large measure rooted in "family values," with protesters defending traditional and orthodox beliefs against an overly permissive and secular national culture. To the extent that protests represent "irreconcilable moral differences," it is not surprising that most opponents seek the removal or termination of an offending presentation, and, to the alarm of civil libertarians, such critics often succeed in their efforts. Forty-five percent of all contested artworks are removed, terminated, or never presented in the first place.

Finally, there is some evidence that *national-religious* actors were busy stirring up trouble in local communities. One hundred and twenty-five cases were initiated with an alert, radio program, or information campaign launched by such groups as the American Family Association, Moral Majority, or the Christian Coalition. When local citizens demonstrate in front of a movie theater presenting the film *The Priest*, activists join a boycott over Disney, or parents hold a prayer vigil at a local Marilyn Manson concert, the thumbprint of national-religious leaders is all over the crime scene. Moreover, 37.6 percent of events involved elected officials. More importantly, when politicians became involved in a protest, the conflict inevitably became more protracted and more intense. As in the case of national events, elected officials tend to politicize issues, drawing in more contending parties and leading to more intense flare-ups in local communities.

In spite of these findings, there are many features of local conflicts that seem to diverge from the culture war narrative. For one, even though religious and political leaders participated in local conflicts, few were actually responsible for initiating protests in the first place. In fact, the majority of conflict events were initiated by parents or citizens who, acting independently, lodged a complaint or grievance with someone in charge of the offending presentation. Elected officials were often drawn into a controversy as secondary actors—typically in response to a complaint directed at an

institution that fell under their jurisdiction—as school board members, city councilmen, or library board directors. In the absence of national religious actors, local religious actors only account for 10 percent of the cases. While religious values might motivate parents and citizens to protest books, movies, theater, and music, the vast majority of conflicts do not draw in religious leaders or organizations. In fact there is a decidedly unorganized dimension to many of these conflicts. Forty-three percent of conflicts are initiated by parents or citizens acting alone. Unlike the national profile of arts conflicts—drawn together by the warp and woof of national institutions that stand ready to mobilize constituents, send out press releases, and otherwise launch attacks from one issue to the next—there seems to be far less institutionalized activity at the local level. In a few cases local organizations or chapters are active across multiple cases in the same city. But in general few local organizations are formed with the explicit goal of protesting art and culture, and few existing local organizations consistently engage in repeated attacks. Contrary to expectations probably less than 20 percent of the local protests resemble true culture war politics—sustained, organized, and coordinated attacks from both the left and right that embroil communities in strident, polarizing, and fractious debate.

In fact, opposing sides resorted to uncivil and deprecating language in only 16 percent of the cases. When claims were made to officials or administrators—librarians, arts councils, principals, school boards—they were typically handled in a democratic manner at regularly scheduled board meetings, at public hearings, or by special committees set up to adjudicate citizen complaints. In regards to the intensity of conflicts, more than half of all conflicts could be considered embers or sparks. They generated very little publicity and tended to involve only a select few participants. Even though many conflicts ended in restriction or termination, this outcome was not arrived at after long, protracted fights. In 9.2 percent of the cases, officials or administrators restricted or terminated a presentation without any prior public controversy, engaging in preemptive strikes. While such actions might reflect the influence of conservative ideology, these responses were not the result of highly visible campaigns launched by well-organized groups on the far right and left.

There are two obvious questions I need to address to put these findings in context. First, to what extent am I comparing apples and oranges? Perhaps local conflicts have a distinctly different profile of contention because my sample of events is biased. In particular, many of the 805 protest events in my sample include school and library conflicts—which are fundamentally different from the type of culture war issues that involve government

funding over art or that engage the trespasses of Hollywood. Some might argue that controversies over school and library material are part and parcel to routine debates over the shape and content of public education. As such, they are handled as part of formal decision-making processes—there are standing committees that review books and films, routines for filing complaints, and processes for adjudication and appeals. School conflicts have become highly institutionalized, leaving less room for the more extreme tactics of culture warriors.

I offer two lines of defense. In the first place, a large number of cases involving schools and libraries did, indeed, involve social movement actors, religious organizations, politicians, and others who were bent on pushing "hot buttons," mobilizing constituents, and generally escalating conflict. Ultimately, schools are not immune to culture warriors—an observation that aligns with Hunter's description of schools as primary theaters of engagement. Second, comparing school and library conflicts with those that did not involve schools and libraries reveals that while there are notable differences, school conflicts are associated with more, not less, intense conflicts. They are more likely to be initiated by parents or citizens acting alone and slightly less likely to involve collective action, but they are *more* likely to be brushfires or wildfires, *more* likely to involve elected officials, and are slightly *more* likely to lead to termination or restriction. Most of our findings in this chapter hold true, even if we were to exclude school and library conflicts from our sample.

Why should we care whether or not local conflicts over art and culture resemble the more visible national battles? Hunter argues that fights over art and culture, as well as the other "fields of conflicts"—family, education, law—primarily involve efforts to define and shape "public culture" or more precisely the symbols that define our national life and purpose. In this regard, as long as national leaders are shaping public discourse over gay marriage, arts funding, abortion, and flag burning, then the culture wars will have an impact on how regular citizens, no matter where they live, relate to the body politic. These national fights both influence "private culture"—the norms that influence individual behavior and determine everyday life—and shape public policy—the laws and regulations that politicians put in place and citizens abide by.

I argue that the fact that local conflicts diverge from the public disputes that define and influence our national political life matters for three reasons. First, protests over art and culture are fundamentally about "public culture" as Hunter suggests, but public culture is as much about local stories, local meaning, and local symbols as it is about national stories, national identity,

and the myth and meaning of America. As I demonstrate later in this book, people protest art and culture in large part to respond to local changes that threaten their sense of community and shared values. While national actors and national debates might influence how people perceive social change and how they think about family, education, the media, and schools, ultimately their willingness to speak out, join a local demonstration, sign a petition, or contact a public official rests on local conditions, not just on larger changes or trends in the national climate.

Second, while some protests resemble McConflicts, with supersize rhetoric shipped to all parts of the country from the same big potato farm in Tupelo, Mississippi, these are not the protest events that I find most interesting or revealing. Rather, I am compelled by, and this book is premised on, how different the profile of contention is from city to city. Perhaps the most interesting descriptive finding is that the conflicts initiated by national-religious actors—the McConflicts—seemed to have the least amount of local traction. These protests are certainly an important part of the picture and in some cases result in intense and engaged local protest. Yet most of these conflicts were sparks or embers rather than brushfires or wildfires. Moreover, such nationally initiated conflicts did not provoke strong reactions from opposing sides, lead to protracted court cases, fuel ongoing local activism, or result in particularly strident strategies of protest. For the local citizens involved, these nationally visible protests resemble a type of expressive politics that afforded citizens an opportunity to "take a stand" without having to stand to the bitter end. In contrast to the McConflicts taken up by culture war scholars, local conflicts reflect the effort of citizens to shape cultural life in their communities.

Finally, national morality politics, including fights over art and culture, are often depicted as a type of "extreme" politics driven by ideological passions on the far left and right. I show that these conflicts are not on the fringes of our political culture but rather rational, democratic responses to social and cultural change. As our communities and cities wrestle with new demographics, new economies, and shifting cultural norms, the words and images of artists, novelists, dancers, composers, and filmmakers become critical arenas for finding voice and facing change. In this era of globalization we are often incited to "Think Globally. Act Locally." Battles over art and culture exemplify this approach and reveal how we construct communities in this sociohistorical moment.

Social Change and Cultural Conflict: Uncertainty, Control, and Symbolic Politics

Control is one of the most important motivators of human behavior and has been a central tenet of both psychological and sociological theory. Our daily routines, our relationships, and our beliefs are often organized in ways that provide us with a sense of control over our lives and protect us from vagaries imposed by others and by the natural world. Everyone has felt the loss of control that accompanies unexpected or persistent change—the loss of a job, a move, a pressing deadline, health problems, the birth of a child. Any of these events, both small and large, can throw a person into a tailspin—raising questions about what to do next, how to act, with whom to confide, and what to believe. Like many, I respond to change by purging, pruning, and sorting. I reorder my office, organize the basement, rearrange books, throw away papers, create new piles, discard my kids' old toys, and weed the garden. Purging, pruning, and sorting are strategies for "taking control." But these are largely symbolic acts; that is, they *represent* the idea of order and control more than the reality. After all, stacking and sorting does not create an orderly life. My new pile of papers is not very different from my old one, just arranged more neatly and reordered a bit so that seemingly urgent tasks are positioned near the top. This rearranging doesn't lead to any real change in my situation; it doesn't increase my productivity or give me more collegial work colleagues, less demanding students, or fewer ear infections for my children. Nonetheless, these small rituals give me some sense of efficacy and control in the face of daunting challenges and disruptions.

Others choose more extreme measures to gain control. In a National Public Radio (NPR) program focusing on body piercing and tattoos, a reporter interviewed high school girls who had rings and barbells protruding through every conceivable body part or had used their bodies to display

epic, Michelangelo-like tattoos. Each girl expressed a similar reason for sub-
jecting their bodies to various forms of mutilation—they wanted to take
control of their lives. The body, like the clutter on my desk, served as a
symbolic arena in which to exert influence and power. Many interviewees
spoke of feelings of insecurity and identity confusion, noting that their lives
were defined by an array of contradictory messages coming from the out-
side—media, parents, classmates, and teachers—and by unexpected changes
taking place inside their bodies. In contrast, the ability and privilege of add-
ing a distinguishing tattoo, scar, or piercing was wholly their own doing,
an act of autonomy and control. As I remember, one girl remarked, "Every
time I look in the mirror and see my piercing, I think to myself . . . this is my
body, I did that to myself."

Teenage girls are particularly susceptible to feelings of anxiety and loss
of control. And psychologists have linked such conditions as bulimia and
anorexia (as well as piercing and burning) to a type of ritualistic purging and
ordering that helps these girls resolve the contradictions that result from their
often rocky transition into adulthood (Schouten 1991). But it is important
to remember that the strategies of these teenage girls are representative of
a larger social phenomenon—people confront change by engaging in sym-
bolic rituals that generate a sense of control and efficacy.

Like individuals, communities are besieged by disorder and change.
Folklorists and sociologists argue that traditional societies often emphasize
sacred objects and perform ceremonial rituals as a way to resist moderniza-
tion and change. Community psychologists discuss the "collective trauma"
and "social anxiety" that result from both sudden and gradual change,
whether natural disasters, economic development, the arrival of new im-
migrants, demographic shifts, or tourism. Many of these changes are ac-
companied by new voices, faces, and values. To seize control, communities,
like individuals, resort to symbolic action—attacking, promoting, or re-
ordering their symbolic environment in order to reassure themselves of some
sense of normalcy. Strategies might entail collective rituals like parades or
public commemorations that are intended to celebrate or affirm a sense of
solidarity and shared experience. Tactics may also involve protest, including
conflicts and controversies over art and culture. The removal or restriction
of offensive material (books, films, songs) is analogous to ritualistic purging
exercises, a communal version of my own obsessive cleaning, or a young
women's desire to decorate her body as a symbolic gesture of self-control
and order. Drawing on a rich tradition of sociological theory, I argue in
this chapter that arts conflicts are rooted in structural transformation. Using
data from three national surveys, I demonstrate an empirical link between

a citizen's fear of social change and his or her desire for greater restrictions on art, culture, and entertainment. As we will see, when people worry about "things changing too fast," including the arrival of new immigrants, they want to control and restrict the cultural expression of others.

The Sociological Perspective

If social life can be characterized as an elaborate board game—with written rules, diverse game pieces, implicit strategies for winning, and norms governing how to interact with opponents—then social change is the re-arrangement of the pieces, the players, the rules, the tacit understandings, and even the definitions of winning and losing. Sometimes social change can be dramatic, as when chess pieces are scattered by the inadvertent swipe of a dog's tail. But most of the time change is incremental, as players enter and leave the game, as new rules are added or as existing rules are modified, and as the game board gets redesigned. Sociologists have been particularly interested in the causes and consequences of social change, paying close attention to transformations in how people relate to one another, how they organize their economic and political institutions, the social roles they occupy, the groups they identify with, and the values and norms that govern their behavior.

Some sociologists study the dramatic social changes that accompany war, famine, natural disasters, or other external shocks, but most have studied longer-term change brought about by industrialization, modernization, urbanization, and globalization. All of these drivers of social change have pushed in the same direction—with local, parochial, community-oriented, homogenous, traditional, and religious practices reshaped by national or global, cosmopolitan, diverse, multicultural, mass, professional, urban, and secular forces. There have been many protagonists along the way—national and international corporations, new immigrants, mass media, new social movements, technology—and these protagonists have accentuated the underlying tensions between stability and change. As Robert Merton has written, "In times of great social change, differences in the values, commitments, and intellectual orientations of conflicting groups become deepened into basic cleavages. As the society becomes polarized, so do contending claims to truth" (1972, 9).

Such tensions generate various forms of social conflict. Historically, sociologists and political scientists have focused on the political and economic conflicts that arise from social change, studying revolutions, civil unrest, strikes, and riots. In these accounts, groups and individuals are motivated

by perceived political and economic interests—control over resources and access to power.

Yet another important, though less developed, area of sociology focuses on conflicts over symbols. Writing about social life and moral order, Robert Wuthnow describes the importance of ritual for defining boundaries and dramatizing the moral obligations and behaviors of individuals in a community. Rather than fulfilling a purely practical or instrumental function, rituals are symbolic acts that stand for something else; in so doing, they communicate meanings and reinforce moral commitments (Wuthnow 1987). Rituals dramatize the prevailing sense of right and wrong, especially during times of uncertainty when new groups have entered the social mix. For example, witch hunts in colonial America were rituals—or public acts—intended to communicate about norms and values. Wuthnow writes, "Heretics and witches become figures symbolizing the boundaries; that is, they represent ways of violating or transgressing shared values. Witch trials dramatize the nature of collective loyalties and define precisely the range of acceptable and unacceptable activity" (115).

Joseph Gusfield (1963) provides a slightly different view of symbolic conflict in his work on the American temperance movement. Gusfield's main goal in his study was to show that groups in society not only compete with one another over economic and political clout but also over prestige and status. People are motivated to achieve "respectability"—the social approval of neighbors, colleagues, or fellow citizens. Such social approval might lead to direct economic or political gain—influencing one's ability to win elected office, for example, or to be selected for a job. But as Gusfield argues, gaining social prestige can be an end in itself and is a rational goal toward which individuals naturally aspire. He demonstrates how the prestige of traditional middle-class, Protestant, small-town values has been threatened at various times in American history by new immigrants, urban elites, and a growing mass society. As a response the old middle class (abstainers) attempted to censor the lifestyle and values of the new middle class (drinkers), thereby raising their status at the expense of the prestige and status of new, competing groups. By controlling the meaning and interpretation of certain symbols (such as alcohol)—imbuing them with positive or negative connotations—groups can effectively raise or lower their own status as well as that of competing groups. And social change provides the impetus and motivation for groups to jockey for position on the status hierarchy.

But moral crusades and protests over culture are not always about prestige and status. Citizens might attempt to ban or restrict art because it deeply offends their values or challenges their way of life (Wood and Hughes 1984;

Page and Clelland 1978). For example, parents might want the *Book of Gay Sex* removed from the library because it offends their sensibilities and sense of propriety, not because they feel like they are competing for status with other groups. In fact, Gusfield acknowledges this general point, noting that the link between culture, lifestyle, and formal status groups had become tenuous by the end of the twentieth century. He suggests that recent symbolic politics might be less about the competition among identifiable social groups over status and more about opposing value systems. Even within the same group, say middle-class suburban residents, conflicts can emerge over differing orientations toward tradition and modernity. White middle-class residents in Phoenix were split down the middle as to whether the local art museum should display an exhibit of the work of the artist Dread Scott that featured a toilet wrapped in an American flag.

Social Change and Protest over Culture

While diverging from Gusfield's particular brand of status politics, recent accounts of protests over books, films, fine art, music, and other forms of cultural expression draw heavily on his ideas. Nicola Beisel (1997) argues that late nineteenth-century anti-vice campaigns in American cities, especially those launched by the infamous crusader Anthony Comstock, were connected to middle- and upper-class anxieties resulting from social change. Comstock generated support for efforts to ban gambling, pornography, obscene literature, and photographic reproductions of nude paintings by linking such cultural expression with the tastes and lifestyles of immigrants. In particular, he claimed that young people were vulnerable to the moral trespasses of new immigrant groups—Italians, Polish, Irish, and others. Upper- and middle-class parents feared that exposure to the habits and interests of immigrants would undermine their own shared culture. If their children chose the wrong kind of culture and lifestyles—from art to gambling—they would be rendered unfit for sought-after jobs and social positions, excluded from social clubs, less attractive to desirable and prospective spouses, and unable to secure good jobs. For Beisel, attempts to restrict art and culture are motivated by a desire to reproduce class privilege in the face of social change.

Contemporary anti-vice campaigns are also linked to symbolic politics and the distribution of prestige and status in society. Anti-pornography campaigns in the 1970s replaced the temperance movements of earlier times. Drinking is no longer an "alternative" lifestyle, but rather represents the culture and social habits of mainstream Americans. In its place, sexuality

and permissiveness have become the new "intemperance"—symbolizing a breakdown in family values, a loss of discipline, secularism, and depravity. Anti-porn crusaders in the 1970s and '80s felt that their status and lifestyle had been undermined (Zurcher and Kirkpatrick 1976). But unlike temperance crusaders, who saw threats arising from particular classes or groups of people (immigrants, urban dwellers, and such), anti-porn crusaders responded more to the general ascendancy of alternative and nontraditional lifestyles. Activists not only perceived a shift in values and attitudes, but they also felt their own influence over their children to be threatened by the rising power of the courts, the educational establishment, and the media. This loss of control was often expressed as a frustration that *outsiders* were determining the type of culture available in their communities. As one anti-porn protester commented, "Do you know that this week there is only one picture in town that has a G-rating? That means there's only one picture in town that a family could go to see together—out of all the theaters we got!" (Zurcher and Kirkpatrick 1976, 68). Protesters felt exposed to the advertisements they received in the mail, the unsavory programs on television, and the types of films in their local cinema. They were worried that changes in the fabric of American society were threatening *their* way of life. One protester summarized his concerns, "Change is raging out of control and something ought to be done about it!" (85). Again cultural conflict is related to social change, status anxiety, and efforts to regulate the moral and cultural fabric of communities.

Protests over books in schools and libraries, which represent many conflict events in my study, have also been linked to a fear of change. The most vivid example, occurring two decades before my study, is the case of the textbook controversy that erupted in Kanawha County, West Virginia, in the 1970s. The county, which includes dozens of small communities along with the state capital of Charleston, had, at the time, a single school board that governed the entire county. The controversy began with the protest of one board member over the content of 325 language arts textbooks (English, composition, journalism, speech). Objections centered on the supposed "moral relativism" of the books, which protesters felt undermined decency, respect for authority, religion, and patriotism. The protests involved thousands of citizens, beginning with petitions and contentious school board meetings, and escalating into a boycott of the entire school system by thousands of families, vandalism of schools, bombings, and shootings. While the intensity of this particular conflict is unmatched by any of the more recent conflicts documented in my study, its origins and motivations are rooted in the types of social changes discussed above and throughout this

book. Ann Page and Donald Clelland (1978), who wrote about the event, contend that protesters were worried that a "way of life" was under attack by the encroaching values and beliefs of a new professional class. The rural values of Kanawha, rooted in the traditional lifestyle of mining communities, were bumping up against the growing urbanity of Charleston and the emergence of new professionals in the schools, county and city government, and local business. The editor of the *Charleston Daily Mail* wrote that the controversy reflected "a vague sense that everything was coming apart at the seams" (Crawford 1974 [2010], 3). Like the case of anti-vice campaigns in the nineteenth century, the parents in Kanawha County felt they were losing their children to the influence of educators who held views that were not reflective of their own values, customs, and beliefs. Such fears, bubbling under the surface in many American communities, found particularly violent expression in Kanawha in the 1970s amid increasingly visible economic, demographic, and cultural change.

More recently, Steven Dubin (1992) documents dozens of arts controversies in the 1980s—ranging from nationally visible protests over Robert Mapplethorpe's homoerotic photographs, Andres Serrano's urine-soaked crucifix, and Dread Scott's American flag installation to more local controversies over sculpture, fine art exhibitions, advertisements, plays, and films. While much of Dubin's work focuses on the "contextual maze" surrounding each incident—or the combustible array of personalities, artworks, and community dynamics—he forcefully argues that social change is a critical factor predicting *where* conflict erupts. He writes of the events of the 1980s: "Paintings, photographs, performances, movies, school curricula and campus speech all became battle sites in the oscillation between resistance and accommodation to social change" (296). In a nod to Gusfield, Dubin compares contemporary arts conflicts to temperance campaigns and argues that status competition is at play and that protests emerge from the strongly held conviction that certain groups may be gaining a more advantageous social position than others. And he identifies with arguments about the politics of "lifestyle concern" when he concedes that people protest art that challenges "established notions of what the social world should look like and that threatens people's vested interests in the status quo" (25). Finally, Dubin evokes the spirit of Wuthnow and Émile Durkheim when he argues that arts conflicts are part of a search for collective identity and describes them as a "sifting and cleansing procedure." Dubin's book is, in many respects, a precursor to my own study. He develops grounded theory from detailed and descriptive analysis of specific, but not randomly chosen, protest events. Part of my goal in this book is to test Dubin's arguments, as well as those

of Gusfield, Zurcher, Beisel, and others, by looking systematically at what predicts levels of conflict across different social contexts. At the heart of the analysis is the recognition that social change is a precursor to conflict above and beyond more proximate causes like individual personalities, circumstances, and the content and context of an artistic presentation.

Dubin also documents many cases of conflict that represent the flip side of the social change coin. Social change not only leads established groups to search for ways to affirm traditional patterns of life and behavior; it can also provide the impetus for new groups to make claims for recognition and broader public respect. According to Merton (1972), social change is often funneled through movements or rituals that largely involve public affirmation of the status and collective identity of emerging groups. As cities become larger and more diverse, minority groups are more likely to achieve a critical mass that facilitates the formation of unique subcultures (Button, Rienzo, and Wald 1997). As they grow in proportion to the rest of the population, such groups feel they have the legitimacy and political efficacy to challenge the status quo culture. Again to quote Merton, "When a once largely powerless collectivity acquires a socially validated sense of growing power, its members experience an intensified need for self-affirmation" (1972, 11). Such affirmation can be achieved through rituals, such as symbolic fights over art and culture, that legitimate and honor the status and identity of these new and growing groups.

This self-affirmation through cultural expression and protest has been referred to as identity politics. The 1980s and 1990s witnessed a rise in identity politics leading to disputes over curriculum, monuments, exhibits, films, television, and music that demean women and ethnic and religious minorities. Todd Gitlin (1995) has argued that identity politics had become so prevalent that the obsession by groups "to demand the right to be different" and to protect and purify their identities has dismantled a formerly cohesive progressive agenda (144).

As noted in chapter 1, more than 25 percent of all conflicts in my study originated with claims made by minority groups, with many resembling classic identity politics contests. In dozens of cities across America, Haitians protested the movie *Stella Got Her Groove Back* because of a remark in the film linking Haitians to the AIDS virus. Their efforts led to a public apology from Universal, the film's distributor, who agreed to remove the offending lines from the video version of the film. This was seen by the Haitian community as a victory for respect and recognition. In Las Vegas a women's group protested a statue in front of a casino that featured skimpily clad women bent over to reveal their bottoms. In San Jose, California, a group

representing a growing population of Mexican Americans staged a protest against a town parade celebrating Spanish settlers in the region. These types of conflicts can be linked, like those instigated in the name of tradition, to social change. In particular, as African Americans, Hispanics, immigrants, gays and lesbians, and women emerge from the shadows of political and social life, they challenge cultural works in an effort to either obliterate residual symbols of racism or sexism or to simply make their voices heard and gain broader recognition.

In the end sociologists are not entirely in agreement over the nature of cultural or symbolic conflict. As we have seen, citizens may fight over culture in order to elevate or protect their status and prestige by publicly condemning or condoning those actions (drinking, selling pornography, getting an abortion, teaching a book that contains sex or violence) that *symbolize* the alternative lifestyle of competing groups (anti-authoritarianism, intemperance, permissiveness, sexual liberation). In my study protests over gay-themed art (books in the library, plays, films, and exhibits) could be viewed as a form of status politics, with efforts by traditional groups to combat the growing visibility of the gay movement in the United States. When county commissioners defund the arts because public money was used to support a gay-themed play (as occurred in Charlotte, North Carolina, in 1996), or if a gay-themed book is removed from a public library, activists will have scored a symbolic victory by enlisting government to publicly affirm the status of one group (traditional families) over another (gays and lesbians).

Cultural conflict can also be a component of class conflict. Rather than a clash over "status," cultural disputes serve to reproduce social class. Fights over school curriculum, library books, and the availability of "indecent" art are attempts by upper- and middle-class parents to control the values and lifestyle choices imparted to their children through schools, libraries, and other public institutions. These parents often equate indecent, immoral, and permissive culture with immigrants and working-class youth.

But notions of status and class may be too narrow for understanding cultural conflict. Individuals may not necessarily feel that their place in the status hierarchy is either rising or falling; rather, they may simply feel that their lifestyle and beliefs are under assault. Some have called this the "politics of lifestyle concern," viewing conflict as the result of broad value cleavages between fundamentalists and traditionalists versus modernists and cosmopolitans. For Gusfield, the cultural fundamentalist is "attuned to the traditional patterns as they are transmitted within family, neighborhood, and local organizations"; whereas the cultural modernist "looks outward, to the media of mass communications, the national organizations, the

colleges and universities, and the influences which originate outside the local community" (1963, 140). David Riesman (2001) calls this a character-ological struggle between inner-directed traditionalists and the "smooth city types" (34).

When conflict arises out of a clash of worldviews, protesters are likely to target general moral and cultural decline and to evoke notions of community. For example, the protests documented in this book raise such questions as: "Whose community is this? Do I still belong? Are my values still relevant? Am I an insider or an outsider?" They also raise questions about control—control over the character of one's local community in the face of national and international forces, control over one's children in the face of mass media and professional communities of experts (teachers, psychologists, librarians), and control over local space. Purging one's community of certain symbols helps to establish the boundaries of permissible expression, pushing back against a general sense that morals have become too loose, culture too coarse, and communities too secular. When citizens claim to be "speaking for the larger community," or when they note that they "can not sit quietly while standards of decency are eroded," they are suggesting that their values are representative if not of a majority of citizens, then at least of a sizable minority. And when these values are legitimated by the actions of government or local institutions (by removing a book, instituting a new school policy banning R-rated films, covering over a nude painting), then protesters can be said to "win prestige" and respectability, not unlike the victory of temperance crusaders with the passage of the Eighteenth Amendment (Gusfield 1963).

Some sociologists see cultural conflict as a mechanism for social change rather than a reaction to it. In particular, they see protest over art and culture as an important part of identity politics—efforts by emerging social groups to amplify their voice in the public square. When the parents of a black student demand that *Huckleberry Finn* be removed from the library because of its frequent use of the word "nigger," they engage in such protest activity because they feel supported to do so by the growing presence of nonwhite citizens in their community and because their increasing public role demands that they are seen on "their own terms." It is they who get to decide—not professional educators, artists, the media, or nineteenth-century American authors—on the words and images that communicate their identity and culture.

Most of the time it is difficult to sort out which of the above theories explain a particular dispute or protest. Without interviewing participants, public statements alone cannot tell us whether protesters are motivated by

a desire to defend their status from a deeply held belief, from a desire to socialize their children to join the ranks of the respectable middle class, or as a way to ritualistically purge offending objects in order to maintain and reinforce existing normative boundaries. And even if I could interview all the participants, it would still be difficult to distinguish among status concerns, lifestyle concerns, and broader value commitments, because all three are interrelated in complex ways. Certainly values and ideological commitments help determine someone's perceived status in their community. And lifestyle cannot be divorced from status or values. Our choice of what to wear, how to talk, who to socialize with, and how to raise our children are informed by the values we grew up with as well as by the respect we hope others will pay us today.

But even if our study cannot, at the current level of analysis, distinguish among the different variations of symbolic politics, we can test the more fundamental thesis that symbolic politics (of all types) are more likely to occur in the presence of rapid social change. When communities experience such change, the playing field, to return to the earlier metaphor of social life, is rearranged, and existing rules, players, and strategies become uncertain. And as mentioned earlier, when everything is up for grabs, people grab on to symbols—celebrating some and denigrating others—in order to try to reassert some control over their environment. Protests over art and culture are not unlike my own efforts to rearrange piles and tidy up my house in the midst of change and uncertainty. If citizens can control the types of books available in libraries and schools, films available in local cinemas, songs on the radio, and exhibits in local museums and galleries—in short, the expressive life of their community—they can publicly affirm the way things *ought* to be.

Evidence for the Social Change Perspective

This book shares many of the perspectives discussed above. What is different is that I am marshaling significant amounts of data to test these propositions. Gusfield's work is based on a historical, comparative method. He shows how certain groups of people, and certain arguments, resonated at various times in history and how the strength of the temperance movement was related to the pace of immigration. He does not attempt to quantify this relationship to see if, indeed, changing levels of immigration across time predict levels of conflict. Likewise, Beisel's (1997) work on anti-vice campaigns largely relies on the public discourse and rhetoric of crusaders and activists in order to demonstrate her thesis that the reproduction of

social class was threatened by new immigrant groups. She tests her thesis by examining three cases—New York, Boston, and Philadelphia. Immigrants in New York and Boston were more visible and more politically powerful than they were in Philadelphia, which accounts for the success of anti-vice crusaders in these cities and the lack of success in Philadelphia. While her argument is carefully rendered with ample historical material, a sample of three is hardly enough to demonstrate her point empirically. And other accounts of protest are largely based on case studies and careful description of the actors, the grievances, and the outcomes of disputes. These studies should not be faulted for their choice of method, which is appropriate for analyzing discourse, understanding how arguments get framed, and examining how social movements develop. Their collective work demonstrates the symbolic dimensions of cultural conflict and provides the backdrop for my analysis. I first test whether individuals who feel anxious about social change are more likely to favor restrictions on art and culture. I then examine whether social change predicts protests over art and cultural expression in American cities during the 1990s. I will provide a much-needed bird's-eye view to accompany and possibly refine the rich historical and ethnographic work that has preceded me.

Individual-Level Predictors of a "Censorious Disposition"

The main thrust of my empirical argument rests on community-level analysis; in particular, I ask why some communities are more contentious than others when it comes to fighting over art and culture. This question will be addressed in subsequent chapters. Of course communities are composed of individuals. And while I want to avoid the ecological fallacy of assuming that a community comprised of a disproportionate number of censoriously inclined individuals is necessarily going to witness more protest, I do want to demonstrate, at the individual level, that social change, and more precisely fear or concern about social change, is strongly related to an individual's desire to restrict art and cultural expression. There are several national surveys that ask questions about civil liberties and about a respondent's concern over art, culture, and entertainment. These questions have been largely ignored by other scholars. The few studies that attempt to explain the disposition of citizens to restrict art have focused primarily on measuring either ideology or values, on the one hand, or the demographic profile of respondents, on the other. They ask such questions as: Are people with traditional, religious, or conservative values more likely to want to ban books? Do city dwellers show more tolerance for alternative lifestyles than

rural or suburban residents? Do education and occupation predict tolerance for diverse points of view? Do they predict support for anti-pornography positions (Wood and Hughes 1984)? But to date none of these studies have examined whether "perceptions of social change" are related to the disposition to restrict art and culture. Below I provide evidence from three different national surveys that conclusively demonstrates this thesis.

Social Capital and Community Benchmark Survey

Beginning in 1995, Harvard professor Robert Putnam began an ambitious initiative called the Saguaro Seminar, aimed at bringing researchers and students together to study the nature of social capital and civic engagement in America. Between July 2000 and November 2000, the seminar sponsored a survey of close to 30,000 Americans, including a national sample of 3,000 individuals and community samples totaling 26,200 additional respondents. The survey has been used to study the strength of connections among Americans as well as social and political engagement, religious participation, tolerance for diversity, trust in neighbors and leaders, and patterns of entertainment and leisure. Fortunately for our purposes here, the survey contains an underexamined question relevant to cultural conflict. It asks respondents to indicate whether they agree or disagree with the following question: "A book that most people disapprove of should be kept out of my local public library." This question is directly relevant to our study as protests over books—whether in libraries or classrooms—were by far the most prevalent.

On the Saguaro Survey, 76.7 percent of respondents *strongly or somewhat disagree* that an unpopular book should be kept out of the library, while 23.3 percent *strongly or somewhat agree*, an amount that, depending on how you look at it, could give solace to or elicit concern from advocates for civil liberties and free expression.[1] But what predicts which position a respondent will take on this issue? And more specifically, how do answers to this question vary based on a person's perception of social change? As indicated, immigration is a significant source of conflict and anxiety, especially in the last two decades of explosive growth in the number of foreign-born residents in the United States. The Saguaro Survey taps into this anxiety and concern with a question that asks respondents to agree or disagree with the following statement: "Immigrants are getting too demanding in their push for equal rights." Thirty-five percent of respondents agreed with this statement (strongly or somewhat) and 65 percent disagreed (strongly or somewhat). This question is a good proxy for concerns about the pace of

Table 2.1 Saguaro Survey: Comparing the percentage of respondents who would ban disagreeable books

Survey question	% who would ban disagreeable books	Number of respondents in each category
Immigrants are getting too demanding		
Yes	0.37	17,177
No	0.15	9,143
Ideology		
Very conservative	0.42	3,134
Very liberal	0.15	2,290
Social trust		
Trusting	0.19	13,894
Not trusting	0.28	11,822
Sense of community		
City provides sense of community	0.25	10,759
City does not provide community	0.14	2,572
Importance of religion		
Very important	0.27	21,807
Not very important	0.10	5,659
Length of residency		
Resident: 1–5 years	0.21	7,216
Resident: 20 or more years	0.26	7,257
Education		
H.S. or less	0.37	8,943
Some college	0.21	8,895
College degree	0.13	9,413

Source: Social Capital and Community Benchmark Survey, Saguaro Seminar.

social change. In general, people who think immigrants are getting too demanding are likely anxious about the changing social composition of their communities and the cultural differences accentuated by new foreign-born residents. As it turns out those who agree with this statement are much more likely to indicate a willingness to ban an unpopular book from the library—37 percent compared to 15 percent for those who are not concerned about immigrants (see table 2.1).

An influx of new immigrants leads to a general breakdown in shared assumptions, as people no longer trust that new neighbors and citizens share their values. In such circumstances, attacks on offending art and culture can help clarify the moral order. This lack of trust can be measured with the Saguaro Survey by examining the question: "Generally speaking, would you say that most people can be trusted or that you can't be too careful in dealing with people?" As expected, lower levels of trust are correlated to concerns about immigration and also linked to an increased likelihood of banning unpopular books. In fact, trust and fear work together, when both are present (for example, people are concerned about immigrants *and* gen-

erally untrusting), then preference for banning books is even higher (almost 40 percent compared to 23.3 percent for the general population).

To the extent that arts conflicts represent symbolic rituals meant to affirm community values and solidarity, we would expect those residents who feel a high degree of community identity to be the most inclined to favor protecting their community from potentially threatening culture. The Saguaro Survey asks, "Does living in your city give you a sense of community?" As expected, people who have a strong sense of community are more likely to be in favor of banning unpopular books (25 percent) compared to those who have a weak attachment (14 percent).

In addition to concerns about social change, ideological commitments and values can influence whether people want to restrict art and culture. I noted earlier that one prominent feature of cultural conflict is the tension between traditionalism and modernism. And in general we would expect people who hold conservative values and who are very religious to be more likely to want to restrict unpopular books. And as table 2.1 shows, 27 percent of religiously oriented people are willing to restrict or ban unpopular books compared to just 10 percent of those respondents for whom religion was not an important part of their lives. Similarly, 42 percent of those who say they have a very conservative outlook on social and political issues favor restricting library books, compared to 15 percent of those who report having a liberal outlook. Lastly, both in historical studies of anti-obscenity campaigns and moral crusades as well as in my own analyses, concern for the welfare of children drives many protests (Beisel 1997; Heins 2001; Binder 1993). We would therefore expect that people who have children at home are going to be more inclined to favor restricting potentially offensive artwork. While not reported in the tables, the data confirm a strong positive relationship between the number of children in the home and a willingness to ban unpopular books.

The skeptical reader will point out that many of the above dispositions (concern about immigrants, social trust, conservativeness, importance of religion, and sense of community) are interrelated. Therefore it is hard to tell whether concern about immigrants (our proxy for anxiety related to social change) is independently predicting the propensity to ban books, or whether it is just an artifact of a general conservative and traditional ideology. Or perhaps education levels explain everything. Knowing whether a person has attended or graduated from college may be the strongest predictor of a willingness to restrict culture, confirming earlier studies that find that educated people are generally more welcoming of diversity. It turns out, however, that when I control for all these possible factors at the same

time (through a statistical technique known as logistic regression), the hypothesis about social change is confirmed (see the methodological appendix for more details on the statistical models used for this analysis). Concern about immigrants is one of the strongest *independent* predictors of a willingness to ban unpopular books. The bulleted list below indicates that people who are concerned about immigrants demanding too many rights are 2.3 times more likely to ban books than those who are not concerned about immigrants. A forty-four-year-old, conservatively leaning, religiously oriented college-educated man, who is worried about immigrants, describes his city as providing a sense of community, and who generally mistrusts other people, has a 56 percent chance of saying that he would ban an unpopular library book. A man with the exact same characteristics, but who does *not* worry about the rising presence of immigrants, has only a 36 percent chance. And when we compare "concern about immigrants" with other variables, our analysis shows that the former is very stable and produces the greatest "fit," which means that this is the single most important variable for helping to explain why some people would ban an unpopular book from the library, while others would not (see the methodological appendix for details on goodness of fit test).

Saguaro Survey: Examining the odds of agreeing that unpopular books should be banned from the library*

· People who are concerned about immigrants demanding too many rights have 2.3 times the odds of banning an unpopular book than those who are not concerned about immigrants.
· People who are very conservative have 4 times the odds of banning an unpopular book than those who are very liberal.
· People who are generally distrusting of others have 1.22 times the odds of banning an unpopular book than those who are trusting.
· People who feel a sense of community in their city have 1.4 times the odds of banning an unpopular book than those with a weak sense of community.
· People for whom religion is important to them have 2.5 times the odds of banning an unpopular books than those for whom religion is not very important.

*The relationships were derived from a logistic regression model. All relationships were significant at the 0.001 level. Other control variables not presented or discussed include income, age, length of residency in city, ethnicity, children in the home, and gender. The full model is available in the methodological appendix. Data source: *Social Capital and Community Benchmark Survey.*

· People who never attended college have 2.4 times the odds of banning an unpopular book than those who have a college degree.

DDB Needham Life Style Survey

Another useful source for examining the link between social change and the disposition to restrict or control art and culture is the DDB Needham Life Style Survey, owned and administered by the advertising and marketing firm DDB Needham Worldwide, Inc. Begun in 1975 and repeated every few years, this survey provides rich information about social, economic, political, and personal issues, from political and religious beliefs to financial worries, leisure activities, social values, and condom usage. With an annual sample of 3,500 to 4,000, data are available through 1999, providing more than 87,000 respondents over the last three decades. Like the Social Capital and Community Benchmark Survey, this survey contains a question that taps into fears of social change as well as a question that tracks people's disposition to restrict art and culture. The survey asks respondents to agree or disagree with the statement, "Everything is changing too fast these days"—a good measure, it seems to me, of the general anxiety surrounding social change. A related question in the survey asks respondents to agree or disagree with the statement, "I often wish for the good old days." Again, I take the answer to this question to be a reasonably good indicator of people's general unease. While it is quite possible for someone to wish for the good old days and still be comfortable with contemporary social change, I suspect that such yearning is related to concerns about present-day values and lifestyles.

The survey also asks whether people agree or disagree with the statement that "the government should do more to control what is on television." Across the entire sample, 35 percent agree with this statement. And when we examine those people who say things are changing too fast and who long for the good old days, we find an even higher percentage in favor of more government control—42 percent and 40 percent, respectively (see table 2.2). Those who do *not* agree with these statements are much *less* likely to favor government control—23 and 26 percent, respectively. Again, fear of social change is a leading suspect in explaining a person's desire to control and restrict television programming. And like before, social change does not act alone but is accompanied by the ideological and religious commitments of respondents. A far greater percentage of religiously oriented people, as well as those who believe abortion should be illegal, say that government should take greater control over what is on television.

Table 2.2 DDB Survey: Comparing the percentage of respondents who think the government should do more to control what is on TV

Survey question	% who want more control over TV	Number of respondents in each category
Everything is changing too fast these days		
Yes	0.42	48,926
No	0.23	28,491
Abortion should be legal		
Yes	0.29	29,647
No	0.43	35,974
Children at home		
Yes	0.33	36,429
No	0.38	32,270
Social trust (most people are honest)		
Yes	0.34	50,422
No	0.36	26,793
Religion is an important part of my life		
Yes	0.40	46,126
No	0.25	19,802
I often wish for the good old days		
Yes	0.40	31,319
No	0.26	28,305
Education		
H.S. or less	0.41	35,537
Some college	0.32	20,548
College degree	0.27	18,104

Source: DDB Survey.

These patterns hold up even when I examine all of these items side by side and look at whether "concerns about social change" and religious and political values and beliefs independently influence a person's position on this issue. Statistical analysis (see the methodological appendix) reveals that people who feel "everything is changing too fast" are 1.8 times more likely than those who do not feel this way to favor more government control over television, after taking into account a host of other possible factors (education, income, children in the home, gender) (see the bulleted list below). Another way to think about this is to consider a forty-four-year-old religiously oriented, college-educated man, with an average income, who believes abortion should be illegal, who generally mistrusts other people, who has children in the home, who wishes for the good old days and feels that "everything is changing too fast." A person with such characteristics has a 52 percent chance of agreeing with the statement that government should exercise more control over television. A man with the exact same characteristics who *does not* feel that everything is changing too fast—that is, he is not overly concerned with social change—has a 30 percent chance of

agreeing. And, as with the previous analysis that focused on "concern about immigrants," I find that concern about social change ("everything is changing too fast") is the single most important variable for helping to explain why some people are in favor of more government control over television content while others are opposed.

DDB Survey: Examining the odds of agreeing with the statement: "The government should do more to control the content of television." Comparing subgroups*

- People who believe that "everything is changing too fast these days" have 1.8 times the odds of favoring greater government control over television than those who disagree with this statement.
- People who believe abortion should be illegal have 1.6 times the odds of favoring greater government control over television than those who believe abortion should be legal.
- People who agree with the statement "I often wish for the good old days" have 1.5 times the odds of favoring TV restrictions than those who disagree.
- People for whom religion is important to them have 1.5 times the odds of favoring TV restrictions than those for whom religion is not important.
- People who disagree that most people are "honest" have 1.2 times the odds of favoring TV restrictions than those who agree with this statement (high social trust).
- People who never attended college have 1.2 times the odds of favoring TV restrictions than college graduates.

General Social Survey

Finally, one of the largest social science projects in the United States, the General Social Survey (GSS), funded by the National Science Foundation, provides still further evidence of the social change thesis. The General Social Survey gathers data on contemporary American society, examining attitudes toward government and the media, drinking behavior, crime and punishment, race relations, quality of life, membership in voluntary associations, and a host of other social attitudes and beliefs. The survey data are collected roughly every two years using a probability sample of approximately

*The relationships were derived from a logistic regression model. All relationships were significant at the 0.001 level. Other control variables not presented or discussed include age, ethnicity, and gender. The full model is available in the methodological appendix. Data source: *DDB Survey*.

1,500 individuals with a core group of questions asked each time and a set of rotating questions that are called "topical modules." One such topical module in 1993 included a set of questions about immigration, including a question identical to the one asked in the Saguaro survey: "Do you agree or disagree with the statement that immigrants are getting too demanding in their push for equal rights." Again I consider answers to this question to be a proxy for concern about "social change." Two other questions in the 1993 module are relevant: the first asks, "Do you think the number of immigrants from foreign countries who are permitted to come to the United States to live should be increased a lot, increased a little, left the same as it is now, decreased a little, or decreased a lot?" The second question asks whether respondents think that "more immigrants coming to this country" will "make it harder to keep the country united." These questions obviously tap into people's tolerance or intolerance for foreign-born residents. But they do more that that. Each question focuses on perceptions or reactions to changing conditions—should immigration be increased or decreased, will more immigration make it harder to keep the country united, are immigrants getting too demanding (now, as compared to in the past).

In addition to perceptions about immigration, the survey asks a set of questions about civil liberties, including the extent to which respondents would prohibit unpopular speakers, unpopular books, and unpopular teachers. Most relevant to our study is the following question: "Consider a man who admits to being a homosexual. If some people in your community suggested that a book he wrote in favor of homosexuality should be taken out of your public library, would you favor removing this book, or not?" The GSS question is not only theoretically interesting, but it is directly germane to my seventy-one-city study. Of the 805 protest events recorded in my study, the greatest single number of conflicts was over books (149 events), and of those, 13.4 percent, or 23, were over books that promoted homosexual content. Attempts to ban books that touch on issues of homosexuality—*Heather Has Two Mommies, Daddy's Roommate, Annie on My Mind, New Joy of Gay Sex, I Know Why the Caged Bird Sings, Untouchable,* and *Run Shelley Run*—occurred in Louisville, Austin, Kansas City, Charlotte, Harrisburg, and many other cities. In an ironic twist, one citizen in Charlotte, North Carolina, complained to the board of county commissioners about *The Faber Book of Gay Short Fiction,* demanding that it be removed from the library. His protest took the form of reading passages from the book at a commissioner's meeting, which was broadcast on public television. The man returned to a subsequent meeting to read more passages. The commissioners decided the passages were not obscene (under state law), but

because children could be in the television audience, they decided to ban the public broadcast of the meeting rather than remove the book from the library. Citizens can read the book, but they cannot watch public debate about the book.

Returning to the General Social Survey, the evidence is consistent with hypotheses about social change. Table 2.3 shows that people who "feel immigrants are getting too pushy," who agree that we should "let fewer immigrants into the country," and who think *more* immigrants will make it harder to "unite the country" are all much more likely to favor banning pro-gay books than those who disagree with these sentiments. Similar to the findings from the other two surveys discussed above, religious and political beliefs also divide Americans on the issue of restricting gay-themed books— 43 percent of those who think abortion should be illegal would ban a gay-themed book compared to only 20 percent of those who believe abortion should be legal; 41 percent of conservatives favor restriction compared to

Table 2.3 General Social Survey: Comparing the percentage of respondents who would be in favor of banning a pro-gay book from the library

Survey question	% in favor of banning pro-gay books	Number of respondents in each category
Immigrants are getting too demanding		
Yes	0.36	528
No	0.19	378
We should let fewer immigrants into the country		
Yes	0.31	999
No	0.24	749
More immigrants will make it harder to unite the country		
Yes	0.33	1,146
No	0.18	599
Abortion should be legal		
Yes	0.20	1,063
No	0.43	14,284
Religious belief		
Fundamentalist	0.49	9,195
Liberal	0.23	7,232
Political ideology		
Liberal	0.23	3,223
Conservative	0.41	3,892
Education		
H.S. or less	0.47	16,436
Some college	0.25	6,838
College degree	0.15	6,287

Source: General Social Survey.

23 percent of liberals; and religious fundamentalists are the most likely to restrict, at 49 percent, compared to religious liberals at 23 percent. More sophisticated analysis (reported in the bulleted list below and described in the methodological appendix) confirms these findings—people who feel that immigrants are making it harder to unite the country are 1.96 times more likely to ban pro-gay books than those who are not concerned about immigrants. The only difference between the GSS findings and the findings from the other two surveys is that ideological and religious beliefs seem to play an even stronger role than fear of change—possibly because specifically drawing attention to "homosexual" books in the wording of the question touches on a "hot button" that makes religion and political ideology more salient.

GSS Survey: Examining the odds of agreeing that a pro-gay book should be removed from the public library. Comparing subgroups*

- People who are concerned about immigrants demanding too many rights have 1.6 times the odds of agreeing that a pro-gay book should be banned from the library compared to those who are not concerned about immigrants.
- People who believe we should decrease the number of immigrants that we let into America have 1.4 times the odds of being in favor of removing a pro-gay book than those who are in favor of current or increased immigration.
- People who think that letting more immigrants into the United States will threaten our national unity have 2.0 times the odds of favoring the removal of a pro-gay book than those who do not hold this position.
- People who believe abortion should be illegal have 2.2 times the odds of favoring the removal of a pro-gay book than those who believe abortion should be legal.
- People who are conservative have 1.8 times the odds of being in favor of removing a pro-gay book than those who are liberal.
- People who describe their religious views as "fundamentalist" have 1.8 times the odds of being in favor of removing a pro-gay book than "religious liberals."
- People from the South have 1.4 times the odds of being in favor of removing a pro-gay book than non-southerners.

*The relationships were derived from a logistic regression model. All relationships were significant at the 0.001 level. Other control variables not presented or discussed include age, ethnicity, and gender. The full model is available in the methodological appendix. Data source: *General Social Survey.*

· People who never attended college have 2.5 times the odds of being in favor of removing a pro-gay book than college grads.

In summary, new evidence provided in this chapter suggests that the link between cultural conflict and social change, long acknowledged by sociologists, can, in fact, be verified at the level of individual beliefs and perceptions. People who perceive that "everything is changing too fast" as well as those who are concerned about the increasing presence of immigrants are unquestionably more likely to favor more control and greater restrictions on potentially offending cultural expression in books and on television. This is true across three different surveys that ask related but different questions. And concern about social change is not a minor factor in explaining differences between the censorious and the permissive; in two of the three surveys, it turns out to be the most important factor of all the potential suspects, including traditional beliefs, religiosity, sense of community, feelings of trust toward fellow citizens, and the standard demographic variables like income, education, size of city of residency, gender, race, age, and whether or not respondents had children under the age of eighteen. When "homosexuality" was explicitly mentioned in the General Social Survey question, ideology (political and religious) becomes the most important factor, although social change continued to play a significant role. Interestingly, concerns about immigration are related to a willingness to restrict potentially offensive culture even when that culture is unrelated to the specific lifestyle of immigrants.[2] There is no direct link, for instance, between gay books and immigrant lifestyles. Nonetheless, immigration, for some, threatens the broader consensus over values, translating into a *disposition* to purge and purify and, potentially, to actual attempts to remove or ban books, films, music, and other forms of cultural expression. The next chapter will look more closely at incidents of protest across seventy-one cities and will test the thesis that those cities undergoing rapid social change will experience the greatest number of protest events.

Some Like It Hot: Why Some Cities Are More Contentious than Others

Chapter 2 discussed the relationship between social change and cultural conflict and demonstrated that the inclination to restrict art and culture was strongly related to a person's unease about shifting demographics, including the arrival of new immigrants, as well as a general fear about the pace of change. Evidence presented was strong and conclusive, an empirical validation of a familiar concept in sociology and psychology: individuals seek to control their environment, especially their symbolic environment, when threatened by unfamiliar values, lifestyles, and forms of expression. This disposition to restrict art and culture (measured in the previous chapter through answers to survey questions) is not the same thing as actual protest or action on the ground.

Offense does not always lead to *action*. As a Jew I was offended by the way Jews were portrayed in Mel Gibson's 2004 film *The Passion of the Christ*. But I did not march with a protest sign in front of my local theater's box office, I did not call the theater owner to demand the movie be taken off the screen, I did not write my congressman, and I did not circulate a petition. I simply expressed my private concern to friends and family. At the time I was living in Princeton, New Jersey, a diverse and tolerant city that boasts a large Jewish community. Had I lived in a southern town that was less diverse, or had I felt more like an embattled minority, concerned that the film might trigger latent anti-Semitism, I might well have been inclined to give public voice to my offense. In other words, offense is magnified, diminished, or refracted through the lens of community. In fact, cultural conflict is as much a property of communities as it is of individuals. This wider view requires us to shift focus away from individual responses to survey questions toward an examination of the structural characteristics that explain, when it comes

to fights over art and culture, why some cities are more contentious than others.

In this chapter I suggest that social change is linked both theoretically and empirically with notions of community identity. It is not just a general sense of uncertainty and unease that causes people to protest art and culture, but rather a more specific fear about unmanageable change in the immediate environment. This local dimension is overlooked by historical and contemporary studies of cultural conflict that treat social change in broad, sweeping terms. We must investigate the impact that local changes—in particular, demographic changes—exert on incidents of cultural conflict within communities. People respond to "clear and present danger" within their communities, not to some abstract notion of change. This assertion is supported by existing theories of social change and community as well as by new evidence presented here that links demographic change with higher levels of protest across seventy-one U.S. cities.

Social Change and Community

Social change has preoccupied sociologists from the very beginning of the discipline. Ferdinand Tönnies, Émile Durkheim, Max Weber, Charles Cooley, Georg Simmel, Louis Wirth, Robert Park, and many of the other founding fathers of sociology were engaged with the question of how society remains integrated in the face of the disintegrating and alienating forces of industrialization, urbanism, modernism, the collapse of time and space through transportation and new technologies, and the rise of large, faceless bureaucracies. One of the main organizing ideas for sociology has been the "decline of community," with scholars and social critics concerned about the seemingly inevitable loss of small-scale, face-to-face communities defined by social solidarity, intimate social relations, and shared norms and values. Sociologists have been challenged to describe the forms of social organization that are replacing traditional communities. Whether described as *Gemeinschaft* (Tönnies 1957), organic solidarity (Durkheim 1947), urbanism (Simmel 1971), or associative relations (Weber 1946), theorists have argued that solidarity is maintained, even in the absence of community, through interdependence. As social life becomes more complex, each citizen assumes narrower economic and political roles. People are trained for particular jobs that require specialized skills sets; they are increasingly dependent on professionals and experts for news and information, to run their governments and charities, and to entertain them. In the modern world,

solidarity—or in lay language, the ability to get along—is generated out of necessity; in order to meet our own needs and the needs of our families, we must accept our integration into a larger, complex whole. Tönnies describes this transition as the movement from community (*Gemeinschaft*) to society (*Gesellschaft*), involving a complete reorganization of the structures of social and economic life. Alongside this structural transformation have been changes in culture. In particular, as the grip of community loosens, new values emerge—individualism, secularism, cosmopolitanism, rationality. Individuals become less reliant on and influenced by religion and the values of rural and small-town America—Puritanism, deference to authority, temperance, and faith.

Cultural conflict figures prominently in this narrative of social change. The transition from intimate community to faceless society is not without tensions. Traditional members of a community often strike out against new beliefs and styles of life that threaten a sense of solidarity. Puritans in colonial America pursued and punished witches as a response to new immigrants (Quakers) and new values (anti-establishment sentiment) (Erikson 1966). More recently the Kanawha textbook controversy in West Virginia, discussed in chapter 2, resulted from this tension between modernization and tradition, as parents and citizens sought to defend their "way of life" against the influences of new families, new businesses, professional educators, and an apparent rise of secularism.

The "decline of community" thesis lurks in the background of most sociological investigations of cultural conflict. Scholars recognize that a clash of values or lifestyle concerns play a role in most protests as traditional community values bump up against modernism, secularism, cosmopolitanism, urbanism, and, increasingly, globalism.

An early example of this tension is the conflict over clothing styles in the eighteenth and nineteenth centuries, as reformers promoted sumptuary laws to cope with disorienting changes in gender and class relations in growing urban centers. As Alan Hunt (1996) argues in *Governance of the Consuming Passions*, concerns about who could wear gold or silver buttons, fur hats, or crimson scarves emerged at "the boundaries of modernity." Similarly, control and regulation of sex and sexual images has been linked to broad-based social changes. Carroll Smith-Rosenberg (1978) argues that the campaign against teenage masturbation in Jacksonian America was a response to "the gradual erosion of the traditional agricultural family, the adoption of new social and economic values, and the development of institutional differentiation" (217). These early purity campaigns are precursors

of the 150-year debate between traditionalism and modernism; community and urbanity; family and personal freedom. The crusade against masturbation encapsulated the notion that "the old ways were pure, the new ways corrupt. The young man loose from his family [and community] became the loose young man" (220). A half-century later, young women were the target of moral reform in response to fears about urbanization and social change. Social critics at the time attacked the growing popularity of novels. Young women who read novels alone and in private were thought to be susceptible to impure thoughts evoked by titillating stories (Flint 1995). In the presence of changing family norms and the allure of the "sinful" city, nineteenth-century novels provoked fear and moral condemnation.

And as discussed in chapter 2, Joseph Gusfield's work on the American temperance movement treats conflict as the product of the transition from rural, small-town America to an urban context dominated by national institutions and concerns. He notes, "As America became more urban, more secular, and more Catholic . . . populist elements in the Temperance movement intensified" (1963, 7). The "rear guard," represented by the old middle class (rural, small-town, religious, communal, family-oriented, and temperate), tried to control the leisure habits of a new, city-dwelling middle class. Most recently, James Davison Hunter (1991) has resuscitated yet another variation of the traditional versus modern strain that has animated sociology for more than a hundred years. Hunter sees an increasing split between traditional and orthodox values—values that have their roots in the old, rural middle class—and more secular, liberal, and progressive values that are based in a cosmopolitan and urban worldview. He links this growing divide in part to an expansion of religious pluralism in the twentieth century as well as to splits within existing denominations (Protestants, Catholics, and Jews). Confronted by the social dilemmas posed by a "loss of community"—early twentieth-century labor struggles, rising crime, public health problems, and rapid immigration—progressives within each faith promoted a public agenda characterized by the values of humanism, universalism, and liberalism. Again the "old guard" reacted with a flurry of conservative theological writing and edicts as well as with new national organizations that were prepared to contest "public culture" that threatened their orthodox beliefs.

Finally, social change is the backdrop to cultural conflict in Thomas Birch's introduction to *The Cultural Battlefield* (Peter and Crosier 1995), a book about controversies over art in the United States in the 1980s and 1990s. He notes that we should not be surprised when art today stirs debate and arouses conflict given the *changes* in American society, which he says

are "lurking in our collective subconscious": women entering the workforce, African Americans entering the ranks of the middle class in great numbers, homosexuals becoming more visible, and the arrival of new immigrants. He writes, "Much of this makes many people uncomfortable as they see their familiar world changing . . . and art touches those raw nerves of discomfort" (17). In all of these accounts, large-scale social change produces and reproduces the age-old tensions that arise when supposedly tight-knit communities experience growth, geographic mobility, and the increasing presence of national (and international) institutions.

Bringing Community Back into the Study of Cultural Conflict

Most of these analyses, while rooted in historical notions of social change and *community*, focus mostly on the actions and reactions of national elites. This is an entirely appropriate level of analysis for studying the rhetoric of social movement actors and moral crusaders and for understanding strategies of protest and mobilization, which are often lodged within national organizations. But to the extent that social change is important, these authors do not adequately situate conflict within communities themselves. Social change, like immigration, industrialization, and urbanization, might be broad based and sweeping, but the consequences of such change and the way in which it is understood by citizens is refracted through the lens of community. Hunter (1991) acknowledges this when he notes that citizens become involved in conflicts in part because of their concern for the character of life in their community (54). But he goes on to say that "ultimately, particular [local] attachments tend to be subsumed by or encompassed by the interests of national life" (54). Disputes over "public culture," for Hunter, are very much about conflicts over symbols of national identity and can be linked not only to broad social change but also to cultural shifts dating as far back as the eighteenth-century Enlightenment. Hunter and others move fluidly between specific protest events, often involving local actors, and broad, sweeping arguments about the nature of social and cultural change in society. These analyses implicitly support the idea that a zeitgeist of change—monumental shifts in religion, ideology, culture, and social relations—inevitably leads to protests and power struggles. But exactly why these broad-based struggles and changes get translated into local action—or why national movements take hold in some places and during certain times but not others—remains underanalyzed.

To borrow and modify a phrase from Theda Skocpol (1985), we need to bring "community back in" to the analysis of cultural conflict. We need to

consider how community context serves as a critical backdrop for the dance among social change, tradition, and protest over art. It is very difficult to demonstrate a causal link between large-scale social change at the national level and the incidence of cultural conflict. To do so would require identifying discrete patterns of change that could be isolated and measured across time and then compared with some constant measure of protest activity. But America has not experienced episodes of social change, fluctuating between certainty and uncertainty, troubled and untroubled, or stability and instability. Rather, from the beginning of the Republic, citizens have been engaged in a ceaseless struggle to resist and accommodate social change. Beginning with industrialization, notions of community and solidarity have been threatened by new technology, geographic mobility, changing occupational structures, new forms of communication, new patterns of consumption and leisure, new immigrants, new social movements, and war. We would be hard-pressed to find a single era in which social change was not grinding away at existing patterns of life and when national actors were not actively protesting one form of culture or another—from witchcraft to masturbation, novels, comic books, music, drinking, television, fashion, or video games. The real question, it seems to me, is that given this constant din of social change, anxiety, and activism, why do specific episodes of protest erupt in some places and at some times and not others? What are the factors that crystallize this sentiment, link it to community concerns, and give it public voice?

This is precisely the question posed by Michael Young (2006) in his work on moral reform movements in nineteenth-century America. He emphasizes the "local" dimension of cultural conflict and writes, "Broad social change cannot explain the precise timing of the uneven geographic wave of social movements that broke out across the country in the 1830s. At best this demographic upheaval provided widespread but diffuse restlessness that could be channeled" (42). Ultimately, antislavery and temperance movements took root locally in churches, auxiliary reform organizations, and benevolent societies. Young's main goal is to explain a particular form of local protest—confessional politics and "bearing witness against sin." My goal in this chapter is less descriptive and more explanatory—how does varying degrees of social change influence levels of protest across American communities?

One reason to bring "community back in" is methodological—variations in cultural conflict across communities offer a compelling strategy for identifying more precisely the link between social change and conflict. My

methodological approach follows in the tradition of James Coleman, who argued in 1957 that some communities are "ripe for conflict" (17) and that preexisting community characteristics (such as social change) can either exaggerate of moderate levels of protest. He suggests scholars must examine multiple communities side by side in order to isolate these "preconditions" of conflict.

This study is not the first to take up Coleman's challenge. Scholars have examined a variety of conflict events across multiple cities, linking protest activity to community characteristics like demographic change, economic conditions, and organizational and institutional variation. These scholars have found that social change is connected to racial and ethnic conflict, including lynching, labor unrest, and the burning of black churches (McVeigh 1999; Olzak 1989, 1990; Olzak, Shanahan, and McEneaney 1996; Soule and Van Dyke 1999). Others have traced demographic and political change to conflicts over sex-related programs in public schools and gay rights (Button, Rienzo, and Wald 1997; Hess and Leal 1999). This book represents the first effort to apply the method of comparing cities side by side to the study of conflict over art and culture.

Going beyond methodological imperatives, another reason to bring "community back in" is because theories of social change, identity, and cultural conflict are most relevant in the context of specific communities. Coleman's theory of community conflict was based on the premise that mass migration "may deposit whole new groups of people into an existing community . . . the newcomers differ in their styles of life; they may have different religions, different cultural backgrounds, different occupations . . . that become the potential basis of conflicting responses" to issues involving schools, taxes, churches, and other local institutions (1957, 7). Thus heterogeneous values *within the context of specific communities* create conditions for protest.

And theories of "lifestyle politics" or "status politics," described in chapter 2, suggest that protest is motivated by community dynamics. When people fight over status and reputation, as Gusfield argues, they are typically seeking recognition from people locally and they are comparing themselves with neighbors, co-workers, people who attend the same church, send their kids to the same school, and with community leaders or activists they see in the newspapers or television. Social change at the national level might elevate anxiety and concern, but this concern is amplified when it is reflected locally and it is acted upon when citizens feel some sense of "clear and present danger"—for example, their values and lifestyle are perceived to be

under assault by newcomers and by changes experienced or perceived daily, not by some abstract notion of change occurring somewhere "out there." When a local resident stood up at a town hall meeting in the village of Carpentersville, Illinois, to advocate for an English-only ordinance, she was not reacting to some general fear of immigration but rather to the reality of how immigration had shaped her day-to-day life. She appealed to council members and fellow residents: "What is tearing my community apart, and I have lived here for over twenty-four years, is the fact that there are so many different languages. . . . I cannot interact with my neighbors any more. . . . It used to be all white. . . . I had playgroups. . . . I had coffee . . . but now they are all Mexicans" (Carpentersville 2007).

When we confront something unfamiliar or offensive, it forces us to consider whether the offending object truly belongs—not in some metaphysical and abstract way but in the specific and concrete sense of belonging in "this community" (Cohen 1985). The answer to this question—"Does it belong?"—has consequences for our own sense of whether *we*, in fact, belong. We can adapt an old expression to emphasize the point: we look at an offending object, event, or form of expression and declare, "This town is not big enough for the two of us." If the object, say a book in the library, remains uncontested, then we are forced to ask the second question, "Do I belong in a community that values making *this* type of book available"—say, *The Joy of Gay Sex*, a controversial book in several communities in my study. In my earlier example of *The Passion of the Christ*, I did not feel compelled to challenge the first proposition—Does the movie belong?—in part because I had no doubts about the second proposition—I belong. I had a good sense of the dominant values in the Princeton community and did not feel threatened by the presence of a potentially anti-Semitic film.

As the beginning of this chapter demonstrated, long-standing clashes between conservative, traditional, small-town, Protestant values and more urban, cosmopolitan, and secular values originate with the "decline of community." As communities lose their distinctive identity, as intimate relations are replaced by impersonal relations, and as mass culture envelops America, citizens reconstruct community through symbols—either propping up symbols that celebrate solidarity or purging and protesting those symbols and lifestyles that threaten old notions of community. Again, notions of community lie at the heart of most attempts to understand disputes over values in America.

I contend, therefore, that social change at the level of one's community can be the trigger for turning private offense into public action. In the

context of social change, citizens ask themselves: Is this a community that respects modesty and sexual prudence, or is it one that encourages permissiveness? Is it a community that believes in tradition and religion or is it one that promotes self-indulgence and secularism? Is it a community that believes children should be obedient or one that tolerates rebellion and self-expression? Is it a community that celebrates its past or one that looks only to the future? When community members witness, firsthand, the influx of new residents and new ideas (unfamiliar people working at the grocery store, new faces featured on the local news, people with different lifestyles staging parades and festivals in local parks, new types of families showing up at PTA meetings), offending cultural expression becomes more salient and, for many, less easily tolerated. Citizens must clarify the "moral order," in Robert Wuthnow's terms, in order to reaffirm that they indeed "belong" to this community, that there is an alignment of personal and public values.

Finally, we need to bring the community back in because the vast majority of conflicts over art and culture are played out mostly in cities and communities across America, outside the glow of the big national media stories. John Harer and Steven Harris (1994) report that there were more than two thousand attempts to censor books, magazines, films, plays, and music in American communities during the 1980s. As I noted previously, Judith Dobrzynski reported in the *New York Times* that cities, towns, and communities were "the new battlegrounds" for brushfires over the arts at the end of the twentieth century (1997). And in my own study, the vast majority of the 805 cases of conflict were not only initiated locally but also remained local, without evidence of interference from organizations, political leaders, or moral crusaders at the national level. National actors or organizations got involved in only one-quarter of the cases.

What Is a "Community"?

For the purposes of this study, the community is defined as a city, or more precisely as a metropolitan statistical area (MSA), which includes an urban core and surrounding small cities, suburbs, and towns. An MSA typically is comprised of several contiguous counties. By no means is the metropolitan area the only appropriate level of analysis for a study of arts conflicts. One could compare levels of conflict across states, regions, central cities, neighborhoods, or school districts. In fact, some might argue that the MSA is too large and amorphous to capture adequately the types of community

dynamics and social relations that lead to conflict. It is certainly not the type of community that is typically represented by scholars like Durkheim, Tönnies, and others who discuss social integration, conflict, and community.

Nonetheless, the metropolitan area is a compelling site for studying cultural conflict. There is a distinction between close, intimate, face-to-face communities and "commonwealths" (Bender 1978). The latter are based upon shared public ideals rather than affection and acquaintance. In this regard, cities are more like commonwealths than traditional communities in that they embody and enact specific public policies that reflect notions of shared public ideals—for example, the right level of investments in schools, the need for public parks, and the desire for a publicly supported professional sports arena. In addition to specific policies, cities also embody a set of symbols that represent shared ideals and values. Cities can represent the *idea* of community, even if they lack the intimacy and solidarity of traditional communities. In other words, cities are imagined communities (Anderson 1991)—bundles of institutions, news stories, narratives, public spaces, architectural icons, and events (like parades and festivals). As such the idea of the "city" calls forth emotional responses from its residents, who each have their own perceptual map of its physical, social, and cultural landmarks, boundaries, and contours. This public representation of the city—filtered through individual experience and interpretation—becomes a benchmark against which we measure ourselves. We ask, "Is this my kind of city?" Or, "Is it a good fit for a person like me?"

I have lived in Nashville, Tennessee, for four years as of this writing. When I travel, people ask me, "How do you like Nashville?" They don't ask, "How do you like living in Tennessee?" or "How do you like living in Hillsboro Village [my neighborhood]?" or, Acklen Avenue [my street]? In response I don't say, "Gee, Nashville is so big, I can't really say." Instead I refer to various characteristics that are salient for me: Nashville is great for families; it has a great music scene; it has terrific public spaces, friendly people, great local colleges, a growing economy, and a diverse mix of residents. For *me*, Nashville has a particular character—it is a community made up of values, norms, institutions, spaces, and events. For other residents, Nashville may be comprised of a different constellation of symbols, and I am perfectly happy if others appreciate Nashville for different reasons. However, when my version of Nashville is threatened by someone else's version; that is, when our "imagined communities" cannot peacefully coexist, then conflict is likely. People protest art and culture in part because their image of "their city" is under threat—often due to social change. Dominant institutions in a community—its museums, libraries, schools, and radio and

television stations—are not neutral players in this battle over the imagined community. When these institutions accept or reject a book, painting, film, or television show, they are endorsing one version of community standards over another, sending a signal to residents that their lifestyle is either more or less aligned with the rest of the community.

The metropolitan area comprises organizational ties and memberships. People's memberships in clubs, churches, civic associations, and political organizations often cut across neighborhood boundaries and extend throughout a metropolitan area. Moreover, citizens are likely to work with colleagues who live within their MSA but outside of their neighborhood or town, or attend sporting events, shop, or ride the bus alongside fellow metropolitan residents (Fischer 1976). Residents of a metropolitan area also get their local news from the same sources—one or two daily newspapers and local network television news. In other words, an MSA represents a media market. It also represents an art market. People typically travel across neighborhoods and town boundaries when participating in art and cultural events. It is not uncommon to drive across town to see a movie or theater production or art exhibit. If a Catholic citizen is offended by the movie *Priest*, she is probably equally likely to object to a screening of the film whether it is presented at a theater that is five blocks or five miles from her house. In sum, the metropolitan area is a reasonable way to demarcate a fairly well-integrated social unit where citizens share overlapping organizational memberships and are joined together in the same media, entertainment, and labor market. For all of these reasons, the city represents a logical site for investigating community change, identity, and cultural conflict.

Comparing Cities

Like the proverbial "moth to the flame," some cities gravitate to the heat of public arts controversies. In this section I test the theory that social change explains different levels of contentiousness. As discussed in chapter 1, I examine protests over art and culture identified through newspaper searches in seventy-one U.S. cities between 1995 and 1998. The methodology used to identify and select cases is explained in greater detail in the appendix. But to summarize our main criteria, a conflict consists of a reported protest over the content of a cultural presentation—including books (nonfiction and fiction), films, songs, concerts, sculpture, statues, murals, exhibits, theater, poetry, and dance. The cultural presentation can take place in commercial or noncommercial venues; it can be funded privately or publicly; it can be temporary or permanent. The protest must be local, that is, the initiating

action (boycott, demonstration, public meeting) must take place within the metropolitan area or by an elected official or group that specifically represents constituents from a particular city area.

There were approximately 805 events across my seventy-one cities that fit the above definition. On average, cities experienced eleven events over four years, or two to three conflict events per year. But few cities were average. In fact, there is great variation across the cities. If we look at raw numbers of events (see table 3.1), Atlanta leads with thirty-seven protests over the four-year period. Bangor, Maine; Springfield, Illinois; Grand Rapids, North Dakota; and Evansville, Indiana, bring up the rear with only one conflict each during this same time period. The cities with the fewest conflicts are also among the smallest cities in my sample. Clearly size matters—the larger the city, the more opportunity there is for conflict—more art, more people, more organizations, and more reporters. But size does not explain everything. Some large cities rank in the lower quartile in terms of number of protests—like San Francisco, Houston, Las Vegas, and New Orleans. In table 3.2, I re-rank the cities after having removed the "effect" of population size. Here I look at what is called "residuals"—this is the number of conflict events that are "left over" after accounting for the effects of population size (see the methodological appendix for more details). The residuals can be negative or positive. Negative means that a city has far fewer events than would have been predicted given its size. A positive number means that a city has far more events than would have been predicted given its size. So Atlanta has a 19.96—which means it has roughly twenty more events than would have been predicted given its size alone. Norfolk, Virginia, has a residual of –9.83, or roughly ten fewer events than would have been predicted given its size. Norfolk had three protest events (see table 3.2) when we would have predicted, knowing only its size, that it would have had thirteen.

There are many other ways to rank and reorganize our cities—we can look at types of grievances, who gets involved, the duration or intensity of the conflict, how it gets resolved, and the types of tactics deployed by protesters. Chapters 6, 7, and 8 will take a much more nuanced view of conflict in an attempt to classify, sort, and describe different profiles of protest. For now I treat all conflict events the same—a protest over a book in the library that involves a few parents is treated the same as a long, protracted lawsuit involving national social movement actors that takes years to resolve.[1]

What explains the difference between Atlanta and Springfield, Illinois? Is social change, as predicted, related to the number of conflict events in a city? As it turns out, like the findings from chapter 2, social change is one of

Table 3.1 Ranking of cities by total number of conflict events, 1995–98

Rank	Metropolitan area	Total # of events	Events per capita (*1 million)	Rank	Metropolitan area	Total # of events	Events per capita (*1 million)
1	Atlanta, GA	37	12.50	38	Columbia, SC	10	22.06
2	Hartford, CT	29	25.05	39	Fresno, CA	10	13.23
3	Cleveland, OH	21	9.54	40	Richmond, VA	10	11.55
4	Portland, OR	20	13.20	41	Sacramento, CA	10	7.46
5	Pittsburgh, PA	19	7.93	42	Austin, TX	9	10.64
6	Raleigh, NC	18	21.04	43	Providence, RI	9	7.93
7	Forth Worth, TX	18	13.23	44	Newark, NJ	9	3.94
8	San Jose, CA	18	12.02	45	Harrisburg, PA	9	15.31
9	Denver, CO	18	11.09	46	Omaha, NE	9	14.07
10	Dallas, TX	18	6.73	47	Oklahoma City, OK	9	9.39
11	St. Louis, MO	17	6.82				
12	Milwaukee, WI	17	11.87	48	New Orleans, LA	9	7.00
13	Baltimore, MD	17	7.14				
14	Detroit, MI	17	3.98	49	San Francisco, CA	9	5.61
15	Phoenix, AZ	16	7.15				
16	Minneapolis, MN	15	5.91	50	Houston, TX	9	2.71
				51	Albuquerque, NM	9	15.28
17	Seattle, WA	15	7.38				
18	Wichita, KS	14	28.85	52	Las Vegas, NV	8	9.38
19	San Diego, CA	14	5.60	53	Akron, OH	8	12.17
20	Riverside, CA	14	5.41	54	Tulsa, OK	8	11.28
21	Kansas City, MO/KS	14	8.84	55	Albany, NY	7	8.13
				56	Louisville, KY	7	7.38
22	Philadelphia, PA	13	2.64	57	Tallahassee, FL	7	29.97
				58	Charleston, SC	6	11.84
23	Anchorage, AK	13	57.44	59	Baton Rouge, LA	5	9.46
24	Nashville, TN	13	13.2				
25	Salt Lake City, UT	13	12.12	60	Knoxville, TN	5	8.53
				61	Buffalo, NY	5	4.20
26	Cincinnati, OH	13	8.52	62	West Palm Beach, FL	5	5.79
27	Chicago, IL	13	1.75				
28	Greensboro, NC	13	12.38	63	Tacoma, WA	5	8.53
				64	Roanoke, VA	4	17.82
29	Charlotte, NC	13	11.19	65	Des Moines, IA	3	7.63
30	Tampa, FL	13	6.29				
31	Memphis, TN	12	11.91	66	Norfolk, VA	3	2.08
32	Columbus, OH	12	8.92	67	Lexington, KY	2	4.93
33	Syracuse, NY	12	16.17	68	Grand Forks, ND	1	9.69
34	Boston, MA	12	3.72				
35	Santa Rosa, CA	11	28.33	69	Springfield, IL	1	5.28
36	Dayton, OH	11	11.56	70	Evansville, IN	1	3.58
37	Allentown, PA	11	18.48	71	Bangor, ME	1	10.91

Table 3.2 Ranking of cities by predicted number of conflict events, controlling for population size (log), 1995–98

Rank	Metropolitan area	Residuals	Rank	Metropolitan area	Residuals
1	Atlanta, GA	19.96	37	Austin, TX	−0.44
2	Hartford, CT	16.15	38	Roanoke, VA	−0.51
3	Anchorage, AK	8.45	39	Columbus, OH	−0.52
4	Portland, OR	7.95	40	Richmond, VA	−0.55
5	Raleigh, NC	7.50	41	Providence, RI	−0.76
6	Cleveland, OH	6.28	42	San Diego, CA	−1.29
7	Wichita, KS	6.04	43	Riverside, CA	−1.45
8	Forth Worth, TX	5.43	44	Tulsa, OK	−1.67
9	San Jose, CA	5.00	45	Oklahoma City, OK	−2.01
10	St. Louis, MO	4.72	46	Charleston, SC	−2.16
11	Denver, CO	4.64	47	Akron, OH	−2.33
12	Milwaukee, WI	4.20	48	Tampa, FL	−2.44
13	Santa Rosa, CA	4.03	49	Las Vegas, NV	−2.48
14	Pittsburgh, PA	2.90	50	Sacramento, CA	−2.50
15	Dallas, TX	2.40	51	Springfield, IL	−2.76
16	Columbia, SC	2.34	52	Albuquerque, NM	−2.82
17	Tallahassee, FL	2.32	53	Newark, NJ	−3.10
18	Syracuse, NY	2.14	54	New Orleans, LA	−3.31
19	Baltimore, MD	1.92	55	Baton Rouge, LA	−3.34
20	Nashville, TN	1.87	56	Albany, NY	−3.53
21	Salt Lake City, UT	1.49	57	Detroit, MI	−3.68
22	Allentown, PA	1.13	58	Knoxville, TN	−3.80
23	Memphis, TN	0.77	59	Louisville, KY	−3.96
24	Kansas City, MO/KS	0.69	60	Des Moines, IA	−4.01
25	Seattle, WA	0.63	61	San Francisco, CA	−4.31
26	Greensboro, NC	0.59	62	Philadelphia, PA	−4.32
27	Bangor, ME	0.49	63	Evansville, IN	−4.49
28	Phoenix, AZ	0.20	64	Boston, MA	−4.43
29	Harrisburg, PA	0.18	65	Tacoma, WA	−4.81
30	Charlotte, NC	0.13	66	Lexington, KY	−6.16
31	Fresno, CA	0.06	67	West Palm Beach, FL	−6.54
32	Dayton, OH	0.02	68	Buffalo, NY	−6.97
33	Grand Forks, ND	−0.04	69	Chicago, IL	−7.14
34	Cincinnati, OH	−0.08	70	Houston, TX	−7.56
35	Omaha, NE	−0.20	71	Norfolk, VA	−9.83
36	Minneapolis, MN	−0.36			

the most important predictors of protest events. Social change can be measured in many different ways—total growth in population, changes in the education levels of residents, changes in home-ownership, changes in family type, changes in ethnicity, changes in occupations, and changes in immigration rates. Given previous research and theory (Beisel 1997; Gusfield 1962; Coleman 1957; Olzak 1990), and given our findings from chapter 2, we would expect immigration rates to be the most powerful agents of social

change. Rates of immigration accelerated beginning in the 1980s after having remained relatively low, by historical standards, through the decades following World War II. And many of these new foreign-born residents are nonwhite and bring with them unfamiliar languages, customs, and cultural styles (clothing, music, food). If we look at cities that experienced rapid changes in the percent of foreign-born residents in the preceding decade (1980), we see greater numbers of protest events. Table 3.3 shows the top fifteen and bottom fifteen cities in terms of the rate at which they experienced an influx of new immigrants.[2] The average number of protest events in the top group of fifteen fast-changing cities is 14.9; the average number of protest events for the bottom fifteen is 10.1. At first glance there appears to be strong evidence to support our thesis; demographic changes, in particular the rate of growth of foreign-born residents, are associated with greater frequency of protest over art and culture. The influx of new immigrants is not associated with more protests over immigrant art but rather with a wide range of presentations, most of which have nothing to do with immigrants—violent lyrics on the radio, sexually explicit books, anti-religious music concerts, and R-rated films in schools. To be clear, I am arguing that the rate of immigration is a measure of underlying social unease. Immigration

Table 3.3 Top fifteen fastest-growing cities (in terms of foreign-born residents) compared with the bottom fifteen cities, 1995–98

Rank	Metropolitan area	% change in % foreign born	Total # of protest events	Rank	Metropolitan area	% change in % foreign born	Total # of protest events
1	Dallas, TX	0.961	18	57	Allentown, PA	−0.057	11
2	Atlanta, GA	0.856	37	58	Evansville, IN	−0.09	1
3	Forth Worth, TX	0.827	18	59	Milwaukee, WI	−0.098	17
4	San Jose, CA	0.708	18	60	Charleston, SC	−0.102	6
5	Houston, TX	0.695	9	61	St. Louis, MO	−0.103	17
6	Raleigh, NC	0.68	18	62	Albany, NY	−0.114	7
7	Fresno, CA	0.661	10	63	Omaha, NE	−0.141	9
8	Riverside, CA	0.608	14	64	Detroit, MI	−0.147	17
9	Austin, TX	0.603	9	65	Akron, OH	−0.15	8
10	Roanoke, VA	0.476	4	66	Syracuse, NY	−0.162	12
11	Greensboro, NC	0.377	13	67	Cleveland, OH	−0.201	21
12	Charlotte, NC	0.361	13	68	Buffalo, NY	−0.213	5
13	San Diego, CA	0.357	14	69	Springfield, IL	−0.247	1
14	Nashville, TN	0.339	13	70	Pittsburgh, PA	−0.262	19
15	Phoenix, AZ	0.336	16	71	Grand Forks, ND	−0.269	1
Average # of protest events			14.93	Average # of protest events			10.13

rates are highly correlated with other forms of social change (population growth more generally, changes in occupations, changes in residential patterns). New foreign-born residents also provide, perhaps, the most visible, noticeable, and immediate confirmation that our communities are changing. We might think of immigration as the "canary in the mine"—a strong symbol to residents that existing norms, lifestyles, and social relations are in flux.

But the correlations noted above may be explained by other factors. For instance, cities with higher rates of immigration also have lower rates of college graduates; and as we know from chapter 2, lower education levels are related to more intolerance and a greater willingness to restrict a range of potentially offensive expression. Rates of immigration are higher in the Sunbelt cities, and it might be that regional differences in values, rather than population changes, explain levels of protest. Or perhaps cities with many new foreign-born residents might also be places where there are more children, both because of the higher birth rates of new immigrants and because cities with growing economies might attract young workers (with children) as well as new immigrants. Many protests occur over material made available to children; so places with more children (and more immigrants) should be logical sites for conflict. Finally, immigrants tend to move into larger cities, and, as we noted above, larger cities have more protest events. In order to isolate the effects of immigration from all of these other possible explanations, we need to use more sophisticated statistical techniques. Using a type of multivariable analysis (Poisson regression models—see appendix for details and results), I examine the influence of a range of possible factors on levels of protest across the seventy-one cities.

In addition to demographic change, what other specific factors might explain protest levels?[3] First, as noted above, we need to take into account the size of the city's population in 1990. Second, based upon previous studies and our own results from chapter 2, we must examine the independent influence of education, with the expectation that greater numbers of college graduates in a city will be associated with higher levels of tolerance and permissiveness—leading to fewer public protests over art. Third, it is important to get some sense of the general level of diversity in a city. The more ethnically diverse a city is to begin with, the less likely people will be offended by potentially challenging forms of expression. Diverse communities, having already experienced growing pains, are perhaps less likely to engage in high levels of cultural conflict. For these communities, like San Francisco, Austin, Houston, San Jose, and Chicago, the "genie" of social change has long been

out of the bottle and therefore poses less of a threat to identity and community. I account for diversity by measuring the percentage of nonwhite Hispanics in the population in 1990.

As in the previous chapter, I examine whether the presence of "conservative" values leads to more or less protest. The majority of the 805 protest events were lodged by citizens and groups whose grievances were fueled by traditional, religious, and orthodox worldviews. Claims that artworks, books, films, or music are obscene, blasphemous, violent, dangerous to children, or otherwise degrading of community values fall in line with the "decline of community thesis" and the tension between old, small-town Protestant values and those of an urban, cosmopolitan, and secular belief system. To the extent that conflicts are lodged by a "rear guard" aiming to protect and promote traditional values, we would expect levels of conflict to be higher in the South (where such values are more prevalent) as well as in cities with a disproportionate number of conservative and fundamentalist churches. Recall that in chapter 2 respondents who lived in the South, as well as those who self-identified as conservative, were more than twice as likely to favor restricting unpopular books. And since many of the protest events in our sample concern books, films, and media in schools and libraries, and since "harm to children" is a frequent justification for protest (both in this study as well as historically), we would expect more conflicts to arise in those cities with a greater number of children, measured by the percentage of families with children in the home (Beisel 1997; Binder 1993; Heins 2001).

As argued in this chapter, protest over art and culture is tied to a sense of community and to residents' fears that certain types of expression challenge community identity and solidarity. This finding was borne out in chapter 2, where I demonstrated that respondents who reported having a strong sense of community were 1.4 times more likely to think a disagreeable book should be banned from the library compared with those without a strong sense of community. Also, longtime residents of a community were more likely to favor restriction than more recent dwellers. In the current analysis, I examine whether cities with a greater percentage of residents who have lived in the same city for the past five years—a proxy for sense of community—are more likely to fight over art and culture.

Table 3.4 once again provides strong support for the social change thesis. I report on the expected number of protest events for a typical city whose average level of immigration (percent change in percent foreign-born citizens) falls at the bottom 10th percentile; I compare this to the expected number

Table 3.4 Differences in predicted number of protest events for cities at bottom 10th percentile and cities at top 90th percentile across multiple dimensions and demographics

	10th percentile: # of protest events	90th percentile: # of protest events	Significance level
% change in % foreign born (1980–90)	7.54	13.56	***
City size (logged)	6.34	12.97	***
% college graduates (1990)	9.42	9.49	
% Hispanic (1990)	10.32	7.55	**
South	11.49 (no)	9.45 (yes)	*
# of conservative churches (logged)	9.83	9.12	
Gay rights ordinance	6.75 (no)	9.45 (yes)	***
% homes with children under 18	9.00	9.91	

Dependent variable = *Total number of conflicts (no embers)*
*** = significant at the 0.01 level
** = significant at the 0.05 level
* = significant at the 0.1 level

of protest events for a typical city that falls at the top 90th percentile. I then do the same thing for the other variables mentioned above and presented in table 3.4.[4]

Based on our model, a typical city[5] at the 10th percentile in terms of changes in immigration (percent change in percent foreign born) would experience 7.5 conflict events over four years; the same city (equal on every other dimension) at the 90th percentile in terms of immigration would experience 13.6 conflict events, almost twice as many. Of all city characteristics, other than sheer population size, changes in foreign-born residents exert the greatest influence on predicting protest events over art and culture. Another important characteristic is the percentage of Hispanics in a city. As expected, more diverse cities have fewer conflicts, suggesting there is some threshold level beyond which social change is no longer perceived as a "clear and present" danger. Cities that are already quite ethnically diverse, such as Chicago, are less likely to fight over art and culture than more homogenous cities, all other things equal. Surprisingly, southern cities, when all else is held constant, are actually less, not more, likely to experience protests, and there is no evidence that the number of evangelical and fundamentalist churches in a city is associated with more conflict events. Thus the presence of conservative values—at least at the city level—does not translate into more conflicts.

The influence of conservative values might be diminished as the result of lumping all conflict events together—events that reflect conservative values, those that reflect liberal values or ethnic concerns, and those that are neutral.

In theory, conservative values should only predict conservative protests, not all protests. It is also possible that cities in predominantly conservative parts of the country are more likely to self-censor or regulate cultural fare that is potentially offensive before it becomes a point of contention.[6] It also turns out that education levels are not important, nor is the percentage of families with children in the home. And sense of community (measured by the percentage of people who were living in the same city as they lived in five years earlier) does not influence levels of protest (even though it did modestly predict, in chapter 2, the disposition to censor books). It may be that length or residency in a city is a bad indicator of "sense of community." Or, more specifically, five years of residence (the length of time documented by the Census Bureau) is not long enough to create a "sense of community."

Based on data provided by Button, Rienzo, and Wald (1997), I was able to identify whether or not a city had ever passed a gay rights ordinance, which range from legal protections for gays and lesbians to more symbolic ordinances that affirm the dignity, respect, and equality of all residents regardless of sexual preference. I include this variable in my analysis to see whether the visible presence of gays in a community (measured by the existence of the ordinance) would provoke the "rear guard" to protest art and culture as a way to clarify moral boundaries and affirm traditional family values and lifestyles. Table 3.4 shows a strong relationship between the presence of a gay rights ordinance and protest levels: 6.75 predicted protests for cities without an ordinance compared to 9.45 for those with an ordinance.

As mentioned above, the analysis presented in table 3.4 treats all conflict events alike—those with a conservative valence as well as those with a liberal or neutral valence. To the extent that existing theories are based on the "decline of community" thesis and the notion that conservative impulses are triggered by rapid social change, we would expect many of the characteristics above (population change, sense of community, presence of children, conservative values, and so forth) to be more important when we only look at conservative-based protest events. In table 3.5 I redo the analysis to look only at conservative-based events. I find that change in immigration (foreign-born residents) now becomes the single most important factor (more important than the size of the city) (results not reported here, but available in the methodological appendix). Also, the dampening effect of ethnic diversity, which leads to lower levels of protest in the full model, becomes much more important—cities with high percentages of Latino residents are much less likely to fight over art and culture that offends conservative sensibilities. Surprisingly, values—measured by churches and whether or not a city is located in the South—remain unimportant in predicting

Table 3.5 Differences in predicted number of *conservative-based* protest events for cities at bottom 10th percentile and cities at top 90th percentile across multiple dimensions and demographics

	10th percentile: # of protest events	90th percentile: # of protest events	Significance level
% change in % foreign born (1980–90)	4.47	8.73	***
City size (logged)	3.93	7.86	**
% college graduates (1990)	5.99	5.51	
% Hispanic (1990)	6.59	4.15	***
South	6.80 (no)	5.78 (yes)	
# of conservative churches (logged)	6.52	5.18	
Gay rights ordinance	4.39 (no)	5.78 (yes)	**
% homes with children under 18	5.01	6.65	**

Dependent variable = *Total number of conservative-based conflicts (no embers)*
*** = significant at the 0.01 level
** = significant at the 0.05 level
* = significant at the 0.1 level

levels of conservative protest.[7] The percentage of homes with children is now strongly related to higher levels of protest (5.01 protests in a typical city with a low percentage of families with children compared to 6.65 protests in a city with a high percentage). This confirms that conflicts involving obscenity, violence, and indecency are often tied to concerns about their potential harm to children.

The data presented above provide the strongest test to date of the thesis that social change is related to conflict over art and culture. Importantly, I have demonstrated this by examining social change at the community level. It is at this level where the effects of social change should be felt most dramatically and where citizens struggle to align perceptions of their city with their own identity and core values. These identity struggles are played out through symbolic conflict, such as protest over art and culture. Whether or not residents in contentious cities like it "hot," as the title of the chapter suggests, is beside the point. When they get handed the "hot potato" of social change, they don't sit quietly. It is not the heat of conflict they seek, but rather the heat of change they react to with protest and recrimination. The next chapter examines firsthand the dynamics of conflict in one particular city, Atlanta, Georgia, where levels of social change and cultural conflict were particularly elevated during the 1990s. "Hotlanta," the city's affable nickname, contains more than an element of marketing and self-promotion, it also reflects the pitch and intensity of its struggle over art and culture.

Fast Times in Atlanta:
Change, Identity, and Protest

At the beginning of the twenty-first century, Atlanta had many claims to fame. It boasted the busiest airport in the world (with more than 85.9 million people passing through each year). It ranked third among U.S. cities as home to Fortune 500 companies. Four of the nation's ten fastest-growing counties were within commuting range of Atlanta's central city, with average commute times leading the nation. The city also boasted the largest 10K running race in the world, the first ballet company in the United States and the world's largest suburban office park. Atlanta is also one of the most progressive southern cities in the nation. It was headquarters for the momentous civil rights movement of the 1960s; it was the first southern city to elect a black mayor; it is home to the greatest number of historically black colleges and universities; and it has been called the "mecca of the black middle class," with African Americans relocating to Atlanta and its suburbs in large numbers throughout the 1980s and 1990s. The above facts (with the exception of the average commute time) are happily trotted out by the Atlanta Chamber of Commerce and the Convention and Visitor Bureau in press releases, on Web sites, and in promotional material. They are facts that won the 1996 Centennial Olympic Games for the city, as boosters marketed Atlanta as cosmopolitan, forward looking, economically driven, culturally rich, and historically grounded.

But the chamber's Web site doesn't point out the fact that when it comes to protest over art and culture, Atlanta is one of the most contentious cities in the nation. We've seen that Atlanta experienced thirty-seven conflicts over art, books, entertainment, and other forms of cultural expression between 1995 and 1998, more than three times the average number of conflict events for the seventy-one cities in my sample. While levels of protest in Atlanta are exceptional, the causes of such protest are not. For as we have seen, social

change in its many guises is one of the strongest correlates of the propensity of individual citizens to want more restrictions on books and television as well as the likelihood that protest will actually erupt in cities. In Atlanta, rapid change led residents and city leaders to ask a central question: "What is the character and identity of this city at the turn of the century?" Acts of protest were attempts to answer part of the question by clarifying the moral order, forcing the community to draw lines around permissible expression. In responding to change, Atlanta can be likened to an adolescent teen, manipulating symbols and appearances in an effort to control and shape her identity and character in the midst of disorienting transitions.

A City in a Hurry

Atlanta's history and identity are bound up with its image as a city of the new South, defined by economic opportunity and expansion. In 1925 the city launched an advertising campaign called "Forward Atlanta," designed to showcase the community as a hub of industry and commerce. Over the next century, political and business elites formed one of the most integrated and dominant pro-growth coalitions in the United States, promoting business and development through tax schemes, housing, transportation policy, and lifestyle amenities like sports and culture. This commitment to growth was reiterated in the 1960s with a new informal slogan, "Atlanta: A City Too Busy to Hate," and again in its 2005 tag line, "Everyday Is an Opening Day." R. W. Apple (2000), in an article in the *New York Times*, described Atlanta as "venerable and impatient," "a city in constant evolution." But growth is not simply a successful brand strategy; it is also the reality of life in the Atlanta metropolitan region over the past few decades.

Population Changes

In the 1990s Atlanta experienced unprecedented population changes; and the city is often referred to as the "poster child" for growth and sprawl. An average of 69,100 people moved into the metropolitan region each year, adding a total of 475,600 people between 1990 and 1997. Atlanta added more people in the 1990s than any other U.S. city (Bullard, Johnson, and Torres 2000, 8). During this time, it earned the nickname "Hotlanta," in part because of a housing boom that made Atlanta the nation's leader in residential construction during the period (Bullard, Johnson, and Torres 2000, 106). New construction mostly happened in the suburbs—expanding Atlanta's footprint from five to twenty-eight counties since 1960 (Sjoquist

2000, 237). Much of this explosive growth has come from residents moving in from other cities and abroad.

Art Hansen (2005) argues that international immigration during the 1990s transformed the state of Georgia, particularly the Atlanta area. By 2000, one-tenth of metro residents, or 420,000 people, were foreign born, the majority having immigrated to the United States during the 1990s. Nearly one in seven spoke another language at home (Hansen 2005, 90). And while figures are not exact, it is estimated that the number of undocumented immigrants rose from 34,000 in the early 1990s to more than 228,000 by the end of the decade (101). While Hispanics represent the most populous immigrant group, Atlanta has also experienced a significant influx of immigrants from India, China, and Vietnam as well as refugees from Bosnia, Somalia, and Ethiopia. These population changes have produced their most visible impact on public schools. Hispanic student enrollment in metro Atlanta more than doubled from 11,668 to 24,550 over five years in the 1990s. And the number of schools that were at least 90 percent white declined by 23 percent (Stafford 1999).

To return to the metaphor of the adolescent, Atlanta in the 1990s was like that eighth-grade friend that went away for summer camp and returned tall and lanky, arms too long for his sleeves, pants revealing too much sock, acne creeping along the brow, and voice cracking with every tug of modest enthusiasm. In a sense Atlanta's optimism caught up with and overwhelmed the city during 1990s as change, sprawl, development, and the inflow of new residents from other countries reshaped the city.

And of course Atlanta's bones—its infrastructure of transportation, industry, and schools—have stretched to accommodate this ever-expanding flesh of new residents. Much of the growth has occurred in Atlanta's surrounding suburbs of Fulton, Cobb, and Gwinnett counties. And the Olympics in 1996 brought a period of heavy investment in infrastructure, with capital improvements and other government expenditures estimated at more than $1 billion (Keating 2001, 148). New investment helped to build more than five thousand new apartments to house athletes and international visitors (Bullard, Johnson, and Torres 2000, 121); it also supported the expansion of MARTA (the rapid transit system) and construction of the Olympic Stadium and the Centennial Olympic Park. As public transportation expanded, many suburbanites grew anxious that their "quality of life" was being compromised by people who looked different from themselves and who now had access to work and live in the suburbs. Other structural changes included gentrification and redevelopment in the center city. Both before and after the Olympics, new businesses were moving into Atlanta at

record rates, with over 1,500 corporations locating in the Atlanta region between 1983 and 1992—362 of them described by the chamber as "international." *Fortune* magazine characterized Atlanta as a place that "supplants provincialism with savoir-faire to attract global companies" (Duffy 1995, 37).

A final area of change in the 1990s was the institutionalization and growing visibility of the gay rights movement. Atlanta was one of the first southern cities to adopt pro-gay policies, passing an antidiscrimination amendment to the city's charter in 1986. A destination city for gay professionals, the presence, visibility, and political influence of gays reached its apogee in the 1990s. By the mid-1990s the number of gay and lesbian groups in Atlanta reached its highest level (dropping slightly by 2000), with 124 organizations. Organizations founded in the 1990s included local chapters of highly visible national gay rights groups, such as the Gay and Lesbian Alliance Against Defamation (GLAAD), the Lambda Legal Defense and Education Fund, and Queer Nation (Fleishmann and Hardman 2004).

Gays and lesbians also became significant voting blocs in the 1990s, clustering in highly visible and concentrated gay neighborhoods. By the mid-1990s the gay community was clearly on the agenda of politicians and candidates, sponsoring several political forums and eventually electing the first openly gay city council member in 1997. Their growing clout and influence resulted in a highly successful protest in 1994, prior to the Olympic Games. In reaction to an anti-gay resolution adopted by Cobb County commissioners, the gay community succeeded in getting the Olympic Committee to move several events previously scheduled for Cobb County to other locations. In short, not only did Atlanta experience significant demographic shifts in the 1990s, it also experienced highly visible changes in culture, with new lifestyles emerging from the margins. Gay and lesbians became more visible, institutionalized, and politically powerful.

The Atlanta Paradox

Atlanta's identity as the "vibrant, business-minded capital of the New South" is not without contradictions and tensions (Apple 2000, E37). As David Sjoquist (2000) notes in *The Atlanta Paradox*, "Atlanta offers a sharply contrasting mosaic: the poverty of its public housing projects versus the sprawling riches of its suburbs; the mansions in Buckhead versus the weathered wooden row houses in Cabbagetown; the glistening office towers and glitzy shopping in Midtown and Lenox Square versus the abandoned stores on the Southside" (1). Atlanta's contradictions extend to race relations, combining a history of accommodation and political and social mobility for blacks

with patterns of long-standing racial segregation in housing and significant inequality with regard to jobs and education. In 1990 the poverty rate of blacks in the city was 35 percent, an increase from 29 percent in 1970. While jobs and new residents flooded the metro region, black workers, especially in the core city, have seen rising disparities. In the wake of Atlanta's rising tide lies a city that is still struggling with racism and poverty.

And while Atlanta's Chamber of Commerce celebrates its international and cosmopolitan identity, its citizens are more conflicted by the changes. In a survey of racial attitudes and perceptions in Atlanta, scholars found that a large percentage of Atlantans—regardless of race, gender, education, income, or political ideology—believed that their lives would be worse off if immigration continued at the present rate (Sjoquist 2000, 82). Moreover, compared to other cities its size, Atlanta maintains a very traditional and conservative profile. In terms of public opinion, residents in Atlanta tend to lean to the right compared to the rest of the nation. For example, data from the General Social Survey reveal that 75 percent of Atlantans think that homosexuality is always wrong as compared to 69 percent of citizens in similarly sized cities across the United States.[1] In terms of religion, Atlanta boasted 130 Christian organizations compared to an average of 54 for other similarly sized cities; 2,228 churches compared to a national average of 1,378; among the Atlanta churches were 1,034 conservative/evangelical churches, compared to a national average of 492.[2]

In many ways Atlanta faces the type of "crisis of values" that Wayne Baker (2005) says has become a preoccupation for many Americans. Baker argues that over time most countries see a shift in their values along two dimensions as citizens become more economically self-sufficient and GDP rises. Citizens become both *less* traditional and *more* self-expressive (this is a variation of the "decline of community" thesis discussed in chapter 3). European countries rate extremely high on these dimensions, with traditional values being supplanted by modern and cosmopolitan outlooks accompanied by the values of self-realization and self-expression. However, America has been on a different trajectory, according to Baker. Data from the World Values Survey reveal that Americans have maintained their traditional values in the face of economic growth and change. In fact, we have combined our traditional values (family, religion, community, patriotism) with a rising emphasis on personal expression. This unlikely combination, Baker argues, creates cognitive dissonance as citizens grapple with opposing value orientations—traditionalism versus expressive individualism. Dissonance—a sense that something is not quite right in the world—shows up in opinion surveys as a general pessimism about the moral condition of America, with

a high percentage of respondents agreeing with the sentiment that America is experiencing a serious moral decline, or a "crisis in values." Atlanta faces its own unique brand of "cognitive dissonance." On the one hand, it celebrates a growing international reputation; on the other, many of its citizens worry about immigrants taking their jobs and influencing politics. Atlanta is desperately trying to look ahead and forget the scars that mark its racial past, while citizens are continually reminded of rising inequality and persistent racial segregation. In response to the city's new slogan, "Every day is opening day," one citizen, contributing to a popular Web blog, suggested an alternative: "Subtly segregated for your convenience" (Metblog 2005). And while Atlanta celebrates its savoir-faire and cosmopolitanism, at the same time it holds on to its conservative values, with the church maintaining its presence in the social and cultural life of the city.

Cultural Conflict

Atlanta's growing pains—its contradictions and tensions—produced conditions ripe for cultural conflict. In the 1990s, Atlantans protested library books and schoolbooks more than any other type of art and culture. The most visible and most protracted conflict occurred in Gwinnett County, one of Atlanta's wealthiest and fastest-growing counties. In 1994, several Gwinnett County library patrons complained that *What Is a Girl? What Is a Boy?*—a sexual education book for children—should not be freely available in the children's section of the library. These patrons felt that illustrated frontal nudity as well as passages such as "Every boy has a penis and testicles" and "Every girl has a vulva and vagina" were inappropriate for children and should require parental consent. One parent noted that if "I was embarrassed by the nude woman in the back of the book . . . surely I wouldn't want my children to see that" (Williams 1994). A newly appointed member of the library board joined the protest and teamed up with a local organization, Parents Involved for a Better Community, to demand that the offensive book be restricted.

A local chapter of Citizens for Family Friendly Libraries (CFFL) formed in 1996 to exert added pressure on the library. In the same year the group's founder was appointed to the library board, where she succeeded in getting a parental advisory committee established as well as placing books that predominately feature sexual acts on a restricted shelf behind the reference desk. In 1997 the parents' library committee, with pressure from CFFL, voted to remove from the library the book *Women on Top*, which features descriptions of women's sexual fantasies. The conflict raged into 1998 when

the library board voted to submit *Basketball Diaries,* an account of a teenage heroin addict, to the county solicitor to determine if it was "harmful to minors" based on existing Georgia state law. The book was not found to be harmful and was retained in the library's collection.

The rhetoric surrounding the Gwinnett library controversy often posed insiders against outsiders, reinforcing the notion that conflict involves clarifying community boundaries and identity. Many of those who criticized the books felt that the local library should be accountable to community standards and not to the policies and choices of the American Library Association and other national library professionals. In several of the letters to the editor appearing in the *Atlanta Journal and Constitution,* citizens prefaced their comments by noting that they were "longtime" residents of the county or that they represented the values of most people in the community, positioning themselves against "outsiders" such as newly arrived residents, or national groups like the American Civil Liberties Union or the American Library Association. One resident attacked the National Coalition Against Censorship (a group that was quoted in the newspaper supporting the library's position), saying, "This national organization should stay out of our community and let Gwinnett citizens and the local library decide what is decent for our county" (Cosby 1997). Most critics positioned themselves as concerned parents who wanted more control over the materials available to their children in the library. On the other side, library professionals and others in the community responded by saying that a few parents should not be able to decide what the rest of the community can read.

The Gwinnett County library controversy, along with the other thirteen protest events over books in libraries and schools in Atlanta in the late 1990s, raised issues of localism, community values, and control. Protesters did not focus explicitly on religious ideology; nor was their cause directly related to political campaigns or larger social movements—affirming the conclusions reached in chapter 1. Instead, protest events reflected local concern about "community standards." Parents and citizens repeatedly demanded the right to "protect" their children from books that might be harmful or offensive. But beyond the protection of their own children, they often made explicit mention of upholding the values of their community. These books, and the teachers and professionals that promote and defend them, were accused, time and again, of being insensitive to the needs of the community. And while the protest activity was not directly or explicitly linked to concerns about social change, it is worth asking why these protests became so strident and so visible in the 1990s.

While I do not have details on protest activity earlier then 1994, most of the challenged books had been on the library shelves or a part of the school curriculum for many years before they raised the ire of parents and critics. I contend that they became sources of conflict in the 1990s just when residents of Gwinnett County and other metro counties were struggling with the consequences of dramatic social and demographic change. Expressing outrage at "indecent" material in the library; asking officials to sequester some books from others; demanding that books be labeled, banned, or removed; seeking the dismissal of teachers, librarians, and board members who condoned or defended certain types of books: all of these actions are attempts to exert control—symbolic control—over one's community. Again and again, citizens linked their grievances and protest to some notion of community identity and standards. And in most cases simply protecting one's own child (through parental notification or special library cards) was not enough. It was important to publicly bear witness against offending objects and to "take a stand." One critic wrote to the newspaper, "We must take a stand. We have a concern for our fellow man and we cannot dismiss this as a nonissue. We cannot be counted with the uninvolved" (Graves 1997). Similarly, a women wrote that "people have a right to say what they want in this country—we are citizens, too, and I am tired of being told that I don't speak for anyone—I speak for me—and if you do not like it, that's tough. I won't be silenced" (Cox 1997). Still another parent wrote that the protest has succeeded because "people are thinking about it and aware that other people are concerned and that such words [books] are not OK with every single parent" (Stepp 1997). And more directly related to concerns about social change, one man wrote, "There's more afoot than this library book. I submit that radical thinkers are trying to take over this county and we have to be on guard to prevent this from happening" (Loupe 1995).

In Atlanta citizens and activists protested books in the library and schools in order to "have a say" and to make their voice heard. For them "silence" and "noninvolvement" were not options. Regardless of the outcome of conflict, it seems clear that parents and critics were seeking some public affirmation that their values still mattered in world of "radical thinkers."

For the World to See: The 1996 Olympics and Struggles over Identity

I argue in this chapter and throughout the book that social change provides the backdrop against which protests over art and culture emerge. Atlanta certainly experienced its share of change, more than any other city in the

nation during the 1990s. Added to this, Atlanta emerged in the national and international spotlight as the result of hosting the 1996 Olympic Games. The games proved to be a "focusing event," forcing Atlanta to publicly wrestle with its changing identity. Focusing events are highly visible episodes, either positive or negative, that redefine a policy agenda, mobilize or expand social movements, or otherwise call attention to latent problems or opportunities that demand attention. In the preglow of the Olympic torch, Atlanta's history and tradition were bumping up against its image as a progressive, world-class city. As one *Atlanta Journal and Constitution* writer noted, "The darkest parts of the South's past have provoked a debate among metro Atlanta officials as they face the Olympic spotlight this summer" (Sabulis 1996).

One of the most symbolic and visible events of the Olympics was the opening torch relay that began in Los Angeles and proceeded across the country, ending in the Olympic Stadium in Atlanta. The *Washington Post* reported that the Atlanta Committee for the Olympic Games (ACOG) contacted the city of Los Angeles and requested that two nude statues in the Los Angeles Coliseum be covered up because they may offend viewers of the relay. While the ACOG denied the report, the notion that Atlantans would be offended by nude statues made national headlines and provoked local reactions, hinting at the larger identity struggle facing Atlanta. One reader wrote to the paper, "I guess the rest of the world was right: We are nothing more than a bunch of Bible-thumping, redneck trailer trash, dressed up in silk suits" (L. Brown 1996).

The Olympic Games changed the opportunity structure for potential protesters. As discussed by social movement scholars, the opportunity structure characterizes the receptiveness of stakeholders—elected officials, the media, citizens, community leaders—to claims made by activists and reformers. The Olympics provided a stage for various groups to advance their agenda, including the gay community, which saw the games as a chance to promote their cause and defend their lifestyle against recent attacks from conservative leaders in one of Atlanta's largest counties. In 1993 Cobb County commissioners passed an anti-gay resolution in reaction to a recent law passed by metro Atlanta that recognized domestic partners. The resolution condemned the "gay lifestyle as incompatible with the community's standards." Commissioner Gordon Wysong introduced the resolution and criticized domestic partner ordinances as undermining sodomy laws; he attacked the governor's proposal for hosting the Gay Games in Atlanta, which he said would "threaten the health, safety and welfare of the community." He added, "It's mind boggling to imagine what activities constitute 'gay

games'" (Vejnoska 1993). Finally, he argued that the gay movement across the nation was really an attempt to legalize pedophilia. His remarks played into broad-based fears about AIDS and homosexuality, emphasizing homosexuality's illegality, health risks to society, and danger to children and the community. Wysong and the resolution made national headlines, which once again forced the greater Atlanta community to come to terms with its "true self."

The headlines attracted the attention of Greg Louganis, an openly gay Olympic swimmer. He demanded that U.S. Olympic officials withdraw the 1996 Olympic volleyball competition from Cobb County, where it was scheduled to take place, because of the anti-gay resolution. Local gay rights activists followed Louganis's lead and vigorously took to the streets, staging protest rallies and marches. The Olympics provided the opportunity to push back against the Cobb County policy, but the occasion also *demanded* that the gay community take a stand and be heard. As one member of the Lesbian Avengers, a local gay rights group, said during a protest along Atlanta's well-known Peachtree Street, "I want the Olympics out of Cobb because, nationwide, people think that Atlanta is anti-gay. They think we're all in the closet, and that's not true" (Morris and Puckett 1994). The Cobb County resolution demanded a response from the gay community, and the glare of the Olympic Games provided an additional opportunity for gays to get noticed and to set the record straight.

The Cobb County anti-gay ordinance and the response of the gay community are important to our study of arts conflict for two reasons. First, the events were highly contentious and focused on a clash of values and lifestyle concerns. The "gay issue" in Atlanta, highlighted by these events, is an important backdrop to the multiple complaints and protests that erupted in Atlanta several years later. For conservative members of the community, the controversy was stark evidence of the social changes in their midst—the growing visibility, clout, and voice of a segment of the community that represented the antithesis of their particular brand of "community values." In Joseph Gusfield's terms, these members were engaged in defending their "status." For gays and lesbians, the ordinance represented the distance not yet traveled—the continued prejudice and intolerance of many in Atlanta, especially those living in the suburbs. For the gay community, the Cobb resolution was a stark reminder that social change, while moving in the right direction, was still limping along.

Second, the anti-gay ordinance also led directly to a highly visible and emotionally charged conflict over arts funding in Cobb County. The origi-

nal anti-gay ordinance pledged "not to fund those activities which seek to contravene . . . existing community standards." Two weeks later the commissioners used this language as a reason to eliminate funding of arts organizations that they felt promoted the "gay agenda," which Commissioner Wysong said was creeping into the affluent, politically conservative Atlanta suburb. Of particular concern to the commissioners was a recently staged Terrence McNally play about AIDS at the local Theatre in the Square called *Lips Together, Teeth Apart*. Fearing a First Amendment legal battle, commissioners decided not to single out the presenting theater for punishment. Instead they defunded all of the arts in Cobb County, rescinding the $110,000 annual budget that was allocated across several arts organizations. At the meeting where the commissioners voted to defund the arts, more than two hundred community members showed up, including a strong presence by the gay community. Again the identity of the community was at stake. Wysong was quoted in the paper as saying, "People will see us as a county which has and maintains standards of conduct and values, and we're not embarrassed by them." On the other side, one resident who attended the council meeting declared that if the arts were eliminated, the public would "think we're a bunch of hicks with no culture, a bunch of uneducated rednecks" (Watson 1993). The perception of outsiders was critically important to both sides. As noted earlier, symbolic fights, likes those over art and culture, are often about a community's image of itself, which for many residents gets filtered through the impressions that outsiders have of them. And the anti-gay resolution and the subsequent fight over arts funding in Cobb County suggest that protest over art and culture can serve to push back against social change—as in the case of Wysong and his constituents—and to pull change along with greater urgency—as in the case of the gay community in Atlanta.

Atlanta's most difficult struggles over identity are less about fig leafs and nudity, or traditionalism versus gay rights, and more about whether and how to recognize its "old South" past while trying to showcase itself as a modern, international city. Bill Howard, the vice president for tourism at the Atlanta Convention and Visitors Bureau, noted the challenge presented by the Olympics: "We have to balance the two stories, between historians who want to remember the past and what I call the Vision Group, which is forward-thinking and prefers to de-emphasize the past" (Sabulis 1996). Andrew Young, former mayor of Atlanta and a member of the Olympic Organizing Committee, while recognizing the importance of history clearly supported the "vision group" camp when he declared, "The thing we are

celebrating in these Olympics is the triumph over all of this. . . . I want people to like what they *see* . . . a community where everybody in the world has learned to get along" (Sabulis 1996).

Even before the games, the city and the state were already struggling with their image, conflicted over the symbols reflected in the Georgia state flag. At the time the flag displayed the stars and bars of the Confederacy, which has long been considered an offensive reminder of the South's racist past. And while supporters of the flag argued that the Confederate symbols (stars and bars) were a part of the historical legacy of the state, the stars and bars were actually added to the state flag in 1956, following the *Brown v. Board of Education* ruling (1954) that outlawed segregated schools. The addition of the Confederate design was clearly a symbolic act meant to reaffirm prevailing racist attitudes at the time. While debate over the flag surfaced throughout the 1980s and 1990s, it was particularly intense in the years leading up to the Olympics, as many Atlantans, as well as the governor, argued that the 1956 flag would project the wrong image to the world. Only hours before the ceremonial lighting of the Olympic torch, civil rights leader Rev. Hosea L. Williams and fifty protesters gathered in front of the Georgia State Capitol for their own ceremonial torching of the Georgia state flag (Alexander and Dratch 1993). Like the protests over Cobb County's anti-gay ordinance, opponents of the state flag saw their "opportunity structure" expand with the increased attention brought to Atlanta because of the Olympic Games and the public wrangling over the city's international image. Although the flag was not changed in time for the Olympic Games, it was redesigned in 2001 and then again in 2004, with the Confederate icon reduced and eventually removed altogether.

As the Olympics drew near, more controversy erupted over Atlanta's past, including how to commemorate one of Atlanta's most famous personalities, Margaret Mitchell. Mitchell was the author of *Gone with the Wind* and creator of such iconographic fictional characters as Scarlett O'Hara, Rhett Butler, and the controversial Prissy, the stereotyped black slave famous for the line, "We's got ter have a doctah. . . . Ah doan know nothin' 'bout bring'n babies." In preparation for the Olympic Games, the German automaker Daimler-Benz gave $5 million to restore the original apartment house where Mitchell lived and wrote her world-famous novel. But many accused Mitchell of being a racist, and there was considerable debate about whether the house should be showcased during the games. Unlike the typical protest over art and culture, the disagreement over the Mitchell house turned violent when arsonists torched the house twice prior to the Olym-

pics, effectively stopping the restoration before the all-important summer of 1996. Eventually the house was restored and dedicated in 1997.

The Mitchell house controversy was representative of several conflicts over how to celebrate Atlanta's legacy and heritage. Officials in the town of Roswell, at the request of the Olympic Committee, deleted the word *antebellum* from their annual summer festival, and they canceled plans to have a Civil War reenactment. The chairman of Roswell's Historic Preservation Commission sanitized the grounds of a city-owned mansion—the centerpiece of the festival—by pulling markers that showed where slave quarters once stood. An administrator for the grounds noted, "We'll just put them right back out after the Olympics are over" (Sabulis 1996). The director of the festival acknowledged that the changes were made so that the festival could put its best foot forward: "We want to put on a festival for the world to see. We're not trying to include anything that would be offensive to anybody" (Campos 1995). And neighboring Fulton County canceled their plans to host a booth at the Roswell Festival because they wanted to disassociate the county with the "old South" image and the Civil War that served to brand the festival. One of the Fulton County commissioners told the paper that she was not "interested in using tax dollars for any type of Confederate display during the Olympics. It involves a certain kind of ideology that doesn't represent the entire county" (Campos 1995).

The Atlanta History Center, which had held Civil War reenactments for the previous nine years, also canceled its plans. The leader of a local battalion known for staging Civil War battles at the center told newspaper reporters that his battalion had been turned away from just about every possible venue in Atlanta (Sabulis 1996). In a related incident, Atlanta's Stone Mountain Park, a heritage site that showcases the history of the Confederacy, decided to omit the story of the park's most notorious twentieth-century tenant, the Ku Klux Klan, from its new museum, which opened in time for the Olympics. The Klan held meetings, rallies, and burned crosses on park property well into the 1980s. Park officials wanted to avoid negative aspects of its history, but some black officials, like U.S. Representative John Lewis from Atlanta, disagreed with the decision. Quoted in the *Atlanta Journal and Constitution*, he said, "The Klan at Stone Mountain . . . that should be told. Yes, we're ashamed, but it was part of our past. . . . We must show the history of struggle" (Sabulis 1996).

But the "vision group," those leaders and residents who wanted the world to see the "forward-looking" Atlanta during the Olympic Games, preferred to downplay the struggles. The Corporation for Olympic Development

in Atlanta decided to scrap plans for a sculpture to commemorate Mary Combs, Atlanta's first black property owner who sold her land to buy her husband's freedom from slavery. The sculpture was to be placed in a largely affluent area of central Atlanta near Woodruff Park. Titled *Memory House*, the sculpture was intended by the artist to look like a shotgun house, resembling homes found in poor neighborhoods across the South. Black leaders in the community, including the Atlanta chapter of the Coalition of 100 Black Women, strongly supported the sculpture. But critics claimed it was inappropriate because it showcased an era of poverty at a location that has become synonymous with the city's growing wealth. As one black leader remarked in the paper, "The story of a free black women who bought land in that area to buy her husband out of slavery is just too much for people to swallow" (Harris 1996). The irony of trying to "forget" the story of Memory House was lost on those intent to showcase Atlanta's glossy image, airbrushed of the ugly aspects of its past.

Sociologists and cultural historians have written extensively about the politics of memory and commemoration—whether studying attempts to preserve historic sites in Germany after World War II or fights over the legacy of George Washington or Thomas Jefferson in the United States. It is common for groups to orchestrate their own interpretation of history (or to edit unfavorable interpretations from the public record) in order to advance their values, cause, or identity. Sociologists describe this as the "social construction" of history (Zolberg 1998). Whether or not Thomas Jefferson fathered children with one of his slaves may seem like gossip, only relevant to history buffs, descendants of Jefferson, or those titillated by scandal. But Jefferson is an American icon. We understand ourselves through telling his story—seeing him as a father of freedom and liberty, gentleman farmer and intellectual, and statesmen. Projecting Jefferson in a different light—as a racist, slave owner, and misogynist, for example—forces us to think critically about our past and about our heroes. It opens up the possibility for new narratives to emerge; stories that might validate the lives of those Americans often forgotten by history. Given the symbolic role of history and commemoration—its affirming or denying certain group identities at the benefit or expense of others—it is not surprising that Atlantans were divided over how to celebrate their past. But I want to argue that the conflicts described above are not just about the politics of memory. They are also about the politics of change and identity. Symbols of the past—attempts to interpret or reinterpret history—are particularly salient during times of rapid change. As citizens struggled to visualize Atlanta's future—to understand what kind of city it was becoming—they placed even greater emphasis on the social

construction of its past. And the interpretation of Atlanta's past—or even what parts of its past were open for interpretation—was the source of ongoing conflict in the 1990s. As former Fulton County commission chairman Michael Lomas remarked in the *Atlanta Journal and Constitution*, "This city hasn't figured out how, at highly visible moments, to talk about its past. Talking about the past winds up being embarrassing, awkward, and it winds up being edited away" (Sabulis 1996).

Like no other city, Atlanta was the exemplar of social change in the 1990s: its residents, its schools, its politics, and its physical appearance were being transformed daily. Atlanta was also the poster child for protest over art and culture during this period, witnessing more conflicts than any other city in my sample. Some of these events, like the battle over library books in Gwinnett County, lasted for years, were well organized, drew the attention of local and national politicians, and invoked deeply antagonistic values. They looked very much like typical "culture war" battles. Others were the result of disgruntled parents who felt the schools and libraries were "out of touch" with community values. Three themes appeared repeatedly across the different cases. First, many of the disagreements centered on how Atlanta wanted to represent itself to the world during the Olympic Games and how outsiders would view the city. Residents were anxious about their national image—whether people would see them as upholding progressive or conservative values, as rednecks or urbanites, as world class or parochial. Second, counterbalancing anxieties about its national image, residents and community leaders were even more suspicious of whether the values of "outsiders"—sexual permissiveness, vulgarity, or homosexuality—were creeping into their community. In this respect, in keeping with the theories discussed earlier, many arguments were framed around the notion of local standards and community values. Third, citizens spoke often of the need to be heard—to have their say, to take a stand, and to ensure that other Atlantans were aware that "not everyone" agreed with the status quo, whether the status quo was represented by the availability of certain books in schools and libraries or the "glossy" image of Atlanta that civic boosters were promoting during the Olympics.

In the case of Atlanta, social change was unambiguously related to protest over art and culture. And as predicted by theories of community change and identity, Atlantans fought over the boundaries of permissible expression in an attempt to clarify whose values and whose lifestyles are celebrated and whose are censored. Social theorists have argued that cultural conflict is a handmaiden of social change, and in the last two chapters I have provided evidence for this across multiple levels of analysis.

Individuals who are concerned about social change report a greater willingness to restrict books and television programs. Cities that are experiencing rapid change have a higher incidence of protest events targeting art and culture. The specific cases documented in Atlanta at the end of the 1990s portray a city and its residents struggling to make sense of social change, relying on symbolic protests—whether over books, commemorative events, or monuments—as a way to challenge or articulate the "real" Atlanta at the turn of the century. We live in cities comprised of symbols. These symbols help us construct "imagined communities" inscribed with those characteristics—objects, places, lifestyles—that complement our own sense of identity. That identity is challenged when new people, new institutions, and new patterns of work and life begin to transform our cities. We respond by defending or attacking the symbols that we find most challenging to our existing beliefs and practices. Oftentimes these symbols are expressed in art and culture—books, television shows, memorials, exhibits, parades, performances. But cultural conflict is not explained only by a clash of values in the midst of social change. Conflict is also about politics, public opinion, and the culture of protest in a city. Protest activity is linked to citizen engagement and political culture. If social change is the engine of cultural conflict, chapter 5 emphasizes the political tracks along which protest activity is driven.

From Words to Action: The Political and Institutional Context for Protest

In the preceding chapters I argued that cultural conflict is an outgrowth of social change and demonstrated that cities experiencing rapid population change are more likely to experience higher than average numbers of arts conflicts. This chapter continues to investigate the structure underlying cultural conflict. In particular, how is the political culture of a city related to levels of conflict? I examine several measures of political culture, including a city's demographic and workforce composition, its levels of political engagement, its history of protest, and its public opinion climate. The chapter demonstrates that protest over art is similar to other forms of political action; it arises from similar contexts, shares similar dynamics, and is equally important for democratic life.

Scholars have long debated whether protest activity is inside or outside the political mainstream and whether it is rational and strategic or emotional and ad hoc. Charles Tilly (1978, 1986, 1995), who has empirically examined contentious politics and political claim-making historically, finds that protest is an important tool in what he considers to be an ever-expanding repertoire of contention. Most scholars of political life share Tilly's conclusion that protest is a legitimate mode of collective action. But do such conclusions about protest, in general, apply specifically to protests over art and culture? Are protests over books, paintings, sculpture, television, and film anything more than knee-jerk reactions to offense and insult, and if so, do reactions constitute a form of democratic engagement?

Critic John Ruskin once described modern art as a bucket of paint flung in the face of its audience, and artists of all genres seem to have a knack for proverbially throwing paint and pushing "hot buttons" (Carver 1994). I do not dispute the fact that arts conflicts trigger hot buttons, nor do I downplay

the role of values, emotions, and offense. Rather, I acknowledge that most people are offended, often viscerally, by something most of the time. But importantly for my purposes, not every offense finds its way into the public square. Instead protest is much more likely when the political culture is conducive.

There is a discernible structure to conflicts over art. They do not erupt spontaneously and unpredictably. Protest over art is part and parcel to democratic life and a routine way in which citizens make their voices heard. These are political acts, rational and deliberate, and they are the product of an engaged citizenry who cares about the quality of life in their communities. This chapter proceeds by first linking arts conflicts with other forms of contestation—from social movements to contentious politics. Then I examine whether arts protests, based on my cases, are handled democratically and within the bounds of normal political discourse and disagreement.

I point out five patterns concerning the relationship between political culture and the emergence and development of conflicts over art and culture. First, I demonstrate that an "unconventional political culture"—characterized by nontraditional families, highly educated knowledge workers, a high percentage of working women, and lower-than-average church attendance—is only weakly related to arts protests. Instead it appears that cities with more traditional "lifestyles" (rather than an unconventional culture) are more likely to engage in conflict over art and media. Second, I argue that cities with engaged and active citizens are also likely to have more protests. In contrast, when people are disengaged or disinterested in the life of their community, they are unlikely to exert the effort—and risk the social consequences—of raising a ruckus. It is easier to exit, in the words of Albert Hirschman (1970), than to take the risk of making one's voice heard. Third, I suggest that citizens are attuned to the protest culture of their communities. They are informed by prior collective action events, against which they judge the appropriateness of current protest. In cities with a long history of protest, residents are aware of and accept protest as a legitimate means of political action. In other communities, protest is frowned upon or quietly discouraged, and there is a politics of politeness, a respect for authority, and a willingness to accept the status quo. Finally, citizens and officials are aware of the public opinion climate and are more likely to take a public stand against an artwork in places where the climate is sympathetic to their complaint. There are more conservative-based protests (related to obscenity, pornography, homosexuality, violence, and blasphemy) in cities with a conservative climate of opinion, and the opposite is true for liberal-based

protests (related to issues of concern to ethnic minorities, women, and sexual and religious minorities).

Dispatches from the Arts Front

Most people can recite the popular nursery rhyme: "Sticks and stones may break your bones, but words will never hurt you." Yet people get hurt by words over and over again, in different contexts, across different demographic groups, different historical moments, and different communities. Social scientists who believe that all human action is rational and calculated are puzzled by arts protests. What rational explanation could account for the time, cost, and social risk involved in protesting a book, film, or song? Such cultural objects have no *obvious* impact on our material existence—how much money we make, our political rights, the safety of our neighborhood, the fairness and equity of our wages, or the accessibility of affordable housing, good schools, or health care.[1] At the same time, cultural sociologists recognize the power and importance of public symbols and words, which, as discussed in chapters 2 and 3, can influence community identity, promote or denigrate the status of individuals, help establish boundaries between groups, and shape political allegiances. It turns out that words do, indeed, matter. Therefore, any observer sensitive to the importance of culture (above and beyond strategic action in the service of material interests) will not be surprised to find that people routinely fight over words. Nonetheless, many (especially faculty colleagues) are surprised when I share dispatches from the front: examples of protest that show up in news accounts every day. There is the story of the owner of a local bookstore in Dayton who, for more than a year, launched an anonymous campaign to vandalize books in local libraries that dealt with the topic of homosexuality. Referred to as the "unipooper" by the local police, his protest typically involved defecating on the offensive reading material and leaving a note behind that said he was the guardian of decency in the community. Another group of Dayton residents protested an exhibition in a local government building that included one painting that featured the yin-yang symbol, representing the unity of opposites in Chinese philosophy, and another painting that featured the skull of a cow with horns. Both paintings were deemed "satanic" by the protesters. Veterans in Phoenix stormed an exhibition featuring the work of artist Dread Scott, including the installation titled *The Proper Way to Display the U.S. Flag*, physically removing an American flag from the museum floor and struggling with museum guards. In Charlotte,

North Carolina, county commissioners, supported by local church groups and activist organizations, eliminated all county funds for the arts because a city-supported theater presented the Tony Award–winning play *Angels in America*. *Angels* includes a few seconds of fleeting frontal nudity as well as themes about AIDS and the gay community. In Raleigh, North Carolina, the school district's assistant superintendent, having received a complaint from a parent, banned the popular dance "The Macarena" because it is supposedly too suggestive—the dance ends with a hip thrust to the lyrics "Ehhh! Macarena!" Or consider the frequent complaints over Mark Twain's classic novel *Huckleberry Finn* for its use of the word "nigger." This book has been in schools and libraries for close to one hundred years, universally accepted as one of the great American novels, and praised for its sensitive account of race; still, some parents demand that it be taken off the shelves or removed from a reading list. Others show up outside concert venues with candles to protest Marilyn Manson and other shock rockers and to pray for the teenagers who willingly go inside to enjoy music. Parents and religious groups throughout the country participate in boycotts of, and in one case sued, the Disney Company, in part because animated films are thought to contain subliminal messages promoting drug use and teenage sex.

In recounting this abridged list of cases in my study, it is easy to see how people might form the opinion that these cases reveal unchecked emotional and rash reactions to relatively harmless cultural expression. Many complaints and protests seem "over the top" and outside the political mainstream. Frequently, defenders of an artwork label opponents "ignorant," "backward," "zealots," and "out of touch."

This tendency to discredit or marginalize protest over art is commonplace among many intellectuals, journalists, and free expression advocates. In the People for the American Way's (PFAW) multivolume series *Artistic Freedom under Attack* (1993, 1994, 1995, 1996), conflicts over art are described as expressions of "intolerance" often coming from the "far right," "rear guards," and "political and religious extremists." Protests are described as "distorted attacks" that "reflect the widespread sense of frustration and even rage that now permeates American culture" (1995, 9). In the introduction to volume four, the chair of PFAW, Carole Shields, describes protest as arising from a "small but determined lot" in contrast to the "thousands of Americans" who are willing to stand up for freedom of expression (1996, 10).

Further marginalizing their political role, the efforts of arts protesters are often depicted as flashes of irrational behavior. John Harer and Steven Harris (1994) write that "the pressure for censorship on a personal level is too often driven by the emotional moment" (xiv). Librarian David

Berninghausen (1975), in defending intellectual freedom, describes attempts to restrict books as "flights from reason." Thomas Birch, a Washington lobbyist, refers to arts conflicts as the "raw nerve" of politics (1995, 17). Elaine Sharp characterizes "morality politics"—including fights over art and culture—as a type of "extraordinary politics" because of the passion, stridency, and intensity that people bring with them to the fight (1999, 4). Many scholars think about culture war disputes as "fights to the finish," imbued with moral passion that makes compromise difficult. Yet democracy requires its citizens to compromise, or at the very least to recognize that opposing sides have a right to make claims. In this respect, arts protests, along with other culture war disputes, seem inherently undemocratic and linked to intolerance and incivility. Overall, these accounts place cultural conflict at the margins rather than the center of democratic life.

This view of protest over art as a type of "extreme" politics—defined by passion, spontaneity, irrational behavior, and fanaticism—has its roots in early scholarly writing about collective protest in the 1950s. Then, many sociologists and political scientists—concerned with populist movements in Europe—saw collective protest as dysfunctional, irrational, and inherently undesirable and described those who joined as disconnected from intermediate associations that would link them with more productive and less disruptive social pursuits (Kornhauser 1959; Meyer 2004). The assumption was that social movements and protests represented alternatives to, rather than expressions of, politics. Studies of farmworker protests, labor unrest, riots, nativist movements, and other forms of "disruptive politics" treated protest as arising from a combination of feelings of strain (when groups in society confront severe obstacles to social, economic, and political mobility) and the effects of mass society (the powerlessness and alienation that accompany the rise of modern corporations, mass media, and large-scale bureaucracies). In short, non-routine collective protests were signs that democracy—personified by political parties, elections, the courts, and legitimate and responsive bureaucracy—was breaking down.

Today social scientists generally disavow the notion that protest is the result of irrational actors on the margins of society (Rule 1988; Schwartz 1976; McAdam 1982). Instead, protests are seen as part of social movements that rely on a high degree of organization, goal-oriented strategic action, and access to political and economic elites. Protest participants are viewed as strategic actors who are embedded in dense social networks (McVeigh 1995). Social movement scholars acknowledge that protest may involve non-routine and disruptive tactics like demonstrations, but these tactics are seen as "resources" to get attention or shape a policy agenda.

Protests often arise from within existing organizations, involve leaders with previous political experience, and draw upon tactics that have worked in the past (McCammon et al. 2008).

Not only are social movements and protest politics rational and strategic, but also the people who join such efforts tend to be engaged and politically active. As Rory McVeigh and Christian Smith (1999) note: "Our results show that protest participants are similar in many respects to those who participate actively in institutionalized politics. In particular, we find that people who are involved in other forms of organized activity are also considerably more likely to be involved in institutionalized politics and the politics of protest" (697). John Green and his colleagues find that people who protest are more likely to be volunteers, go to church regularly, and participate in community organizations (Green et al. 1996).

Scholars see protest over everything from the environment to animal rights, abortion, and the arts as integral to a new form of lifestyle politics. In postindustrial societies, conventional politics that involve political parties, elections, labor unions, the courts, and government agencies are increasingly giving way to "expressive politics" (Clark and Hoffmann-Martinot 1998). Rather than organizing around economic interests, people are engaged in new forms of protest that serve to affirm their identities, assert their values, and express their voice. This new political culture emphasizes identity and lifestyle. In short, "the personal is political." From this perspective, arts conflicts are "real politics" in the context of today's shifting political landscape (Sharp 2005a, 2005b).

Are arts protests really similar to other forms of protest and collective action? Do we really think taking swipes at statues, complaining about classic novels like *Huckleberry Finn*, burning books in front of Barnes and Nobles, and holding prayer vigils in front of a Marilyn Manson concert are examples of politics as usual—routine, rational, predictable? Do protests over art constitute a sort of social movement, as emerging scholarship suggests? Are these efforts geared toward institutional change? Do they engage or flow through conventional political channels? Are they legitimate, healthy, democratic, and civil? Do arts protests have a discernable set of processes or mechanisms? Are they rooted in organizations and politically oriented groups? Is cultural conflict typical of the "lifestyle politics" that define the new political culture? Do these efforts constitute collective "protest," or are they just routine complaints, randomly occurring offenses, or irrational outbursts?

Like other forms of protest, cultural conflict is complex and multifaceted. Nonetheless, there are some consistent elements. As I have defined it, a

conflict requires a public action that challenges some form of expression deemed inappropriate or offensive. Typically, the public action is directed toward a person or institution of authority—someone who has decision-making power over what forms of expression are presented publicly. Ultimately, arts conflicts involve public claims-making, challenges to existing power structures (institutions and gatekeepers who decide the content of our cultural life), and frequently collective action. Importantly, they draw from the same "repertoires of contention" that can be found in other social and political movements. Jeff Larson and Sarah Soule (2003) outline seventeen different forms or "repertoires" of collective action. Table 5.1 provides a list of each form of collective action in column A; examples of an arts conflict that utilized that form of protest are provided in column B.

While *forms* of protest like those listed in table 5.1 are only one way to characterize political action (we could also focus on goals, strategies of mobilization, characteristics of participants, nature of claims, or targets of protest), it is clear that arts protesters draw from the same repertoire as activists involved in fights over housing, roads, taxes, schools, public services, civil rights, and military conflicts. Arts protests might not exactly embody Charles Tilly and Sidney Tarrow's (2006) notion of contentious politics, nor might these conflicts strictly constitute a social movement, but they are not a breed apart either. Arts protesters are familiar with and draw upon a wide range of tactics to make claims and influence the type of art and entertainment available in their communities. While not the task of this book, it would be useful and important to look more carefully at how arts conflicts connect with other forms of protest and social movement activity. In what ways are they similar or different? Are arts conflicts more expressive (aimed at voicing discontent) than instrumental (aimed at policy changes)? Are they more or less easily resolved compared to other community-based protest? Are national actors more or less likely to become involved? Are participants different—in terms of demographic characteristics—than participants involved in other types of collective action? In short, how does the *structure* of arts protest compare to the structure of other kinds of political action?

Even in the absence of studying and comparing the inner workings of arts conflicts, it is possible to see how the types of structures and contexts that predict other forms of protest do or do not predict arts protests. In particular, are politically and civically engaged communities more likely to protest art and culture? If the political culture and context of a community does not consistently predict arts conflicts, then perhaps such episodes are nothing more than neighborly disputes (no different from a complaint about a fence built over a neighbor's property line), disputes that might be

Table 5.1 Forms of collective action

Form of collective action	Example from sample of arts conflicts between 1995 and 1998
1. Rally/Demonstration	A local chapter of the Gay and Lesbian Alliance Against Defamation (GLAAD) demonstrates in front of a Portland movie theater that is showing *Braveheart*. One speaker was quoted in the press as saying, "The message of this film is that gay men are idiot effeminates and when they're really annoying, it's OK to get rid of them."
2. March (moving from one location to another)	No example
3. Vigil (candlelight vigil, prayer, silent witness)	In Greensboro, North Carolina, nearly 80 people held a prayer vigil outside the arena in which shock rock group Marilyn Manson was scheduled to perform.
4. Picket (holding signs and placards and walking around in a circle)	On August 25, 1997, an ad hoc citizens group with 250 members picketed outside two Wichita bookstores to protest Jock Sturges's book of photography—which includes pictures of nude children and teenagers.
5. Civil disobedience (crossing barricades, sit-ins, tying up phone lines, and some forms of violence)	Two Christian songs were banned from the repertoire of a public school choir in Salt Lake City because of a restraining order filed by a Jewish student. Christian students disrupted the school's graduation ceremony, seizing the microphone, and encouraging the audience to sing one of the banned songs.
6. Ceremony (celebrate or protest anniversaries or other commemorative dates)	African Americans protested a ceremony organized by the Sons of Confederate Veterans to rededicate a 50-year-old Confederate monument outside Howard County Circuit Courthouse in Ellicott City, Maryland. African Americans argued that the ceremony was an endorsement of the Confederate cause, and therefore the ceremony should not have been allowed because the monument was a tribute to the cause of slavery.
7. Dramaturgical demonstration (concerts, theatrical presentation, dance)	An organization known as Performers and Artists for Nuclear Disarmament (PAND) staged a "guerilla theater" performance in Akron, Ohio, to protest the local symphony's decision to play a tribute concert in recognition of the city's support of a nuclear-powered submarine.
8. Motorcade	No example
9. Information distribution (petitions, lobbying, letter writing)	In Bangor, Maine, residents organized a letter-writing campaign to several stores that sell punk music and punk music paraphernalia, arguing that such material promotes Satanism, death, vampires, and erotica. In Milwaukee, Wisconsin, a petition bearing 285 signatures was presented to library officials requesting a ban on the circulation and purchase of R-rated videos
10. Symbolic display (cross burning, signs, graffiti)	At a community rally against violence, crime, and drugs in Philadelphia, youths donated gangsta rap tapes to be burned en masse during the rally.

Table 5.1 (*continued*)

Form of collective action	Example from sample of arts conflicts between 1995 and 1998
11. Attack by instigators (physical attack or verbal threats instigated by a group)	In mid-April 1995, about 20 people, including members of the Morris County Right to Life, protested outside a theater in Chatham because they objected to the portrayal of Catholic clergy in *Priest*. A few days later the theater in Chatham as well as one in Union received bomb threats. The owner of the two theaters decided to stop showing the film due to the protests and threats.
12. Riot, melee, mob violence	No example
13. Strike/slow-down/sick-in	In Dallas, Texas, Vietnamese immigrants and veteran organizations protested an exhibit of contemporary Vietnamese art at a local art center. The protesters organized demonstrations and a two-day hunger strike. In Salt Lake City, Utah, teachers threaten a "sick-in"— staying home sick—to protest parents' efforts to ban Isabel Allende's famous novel *The House of the Spirits* from an advanced English class.
14. Boycott	A Tulsa-area Baptist church joined the national Southern Baptists in boycotting the Walt Disney Company because of the company's "significant departure from Disney's family values image."
15. Press conference	Prior to a school board meeting in Pittsburgh, the ACLU and local parents hold a press conference to voice their opposition to a proposal to pull two books *Bridge to Terabithia* and *Julie of the Wolves* from the fifth- and sixth-grade curriculum on the grounds of profanity and religious denigration.
16. Public announcement of new organization	No example
17. Lawsuit	A lawyer in Houston filed a suit against Harris Country Judge John Devine because of religious decor in the judge's courtroom, including artwork depicting the tablets of the Ten Commandments and other religious scenes.

Source: Forms of collective action derived from Jeff Larson and Sarah Soule, "Organizational Resources and Repertoires of Collective Action." Paper presented at the annual meeting of the American Sociological Association, Atlanta, GA, August 16, 2003.

more visible and incite more passion, but, in the end, no more meaningful to democratic life and political engagement.

Before I examine the political context for the emergence and development of arts conflicts, I want to consider the responsiveness of officials to claims made against artworks. Specifically, I ask whether these claims are

Table 5.2 How is grievance to an official or administrator handled?

Response to grievance	Frequency	Percent
Undemocratic response		
Ignored the complaint	32	6.0
Made an executive/unilateral decision	<u>166</u>	<u>30.0</u>
Subtotal	198	36.0
Democratic response		
Discussed at regularly scheduled meetings of board/ council	115	21.0
Called a special meeting of regularly constituted group	29	5.0
Called a special meeting of ad hoc group	24	4.0
Called a special open meeting or public hearing	19	3.0
Deferred the decision to standing committee	<u>126</u>	<u>23.0</u>
Subtotal	353	56.0
Other		7.0
Total responses	551	100
No request made to an official or administrator	254	
Total	805	

responded to democratically through processes of deliberation, debate, and review by elected officials and responsible administrators. Table 5.2 reveals that 56 percent of all claims that were made to an elected official or responsible administrator (public librarian, school board member, school principal, radio station owner, or museum director) were handled in one of five ways. Complaints were: (1) discussed at a regularly scheduled meeting of a board or council; (2) discussed at a special, ad hoc meeting of a regularly constituted group (for example, the school board comes together at a special meeting to discuss a contested policy); (3) discussed at a meeting of an ad hoc group (for example, the mayor asks a task force to review policies for exhibiting art on city property); (4) discussed at an open meeting or public hearing; (5) handed off to a standing committee to review. In contrast, 36 percent of all claims were either ignored or handled by executive fiat. That is, a unilateral decision was made with no public debate or discussion. In 254 cases there was no formal complaint to an administrator or official. For example, a group might hold a rally or prayer vigil to "bear witness" to some offending artwork or presentation without actually asking anyone to do something about it. Significantly though, in the 551 cases where a specific request was made, most were handled through some democratic process. Again, this provides additional circumstantial evidence that arts conflicts share more in common with "routine" politics than with "extreme" politics.

Not only are the majority of arts conflicts resolved through democratic deliberation, but also there is evidence that many of the opponents and defenders of an artwork recognize the legitimacy of the process and accept the final outcome, whether or not their claim is successful. For example, in Minneapolis protesters regrouped after a failed attempt to get city officials to ban a Marilyn Manson concert and held a peaceful demonstration outside the stadium, noting that if they couldn't stop the concert, they could at least "bring God's attention to the area" (Nightshade 2007, A24). In Knoxville, the general manager of a community television station acknowledged that the city had a right to regulate an adult show after multiple complaints, public hearings, and city commission meetings. He noted, "If the city council chooses to set community standards for public access cable . . . then Community Television will enforce those rules" (Balloch 1998, A3). In Las Vegas, after the school board decided to ban a school trip to a museum to see an exhibit about AIDS, the museum's public affairs coordinator commended the board for "listening to the concerns of the community" and "trying to make the best judgment" (Patton 1996, B1). In case after case of arts protest, participants acknowledged and accepted the decisions of administrators and officials when those decisions involved bureaucratic review, deliberation, and what appeared to be a fair and open process.

The Effect of Unconventional Political Culture versus Traditional Culture on Arts Conflict

Since the 1960s, the most popular way to think about local political culture was through the lens of Daniel Elazar's (1966) typology of political subcultures—individualistic, moralistic, and traditionalistic. Individualistic culture is based in a deep belief in the market and in the power of individuals to negotiate and bargain for private gain. A moralistic culture is characterized by the belief in collective enterprise and the role of citizens working together for the common good. In a traditionalistic culture, politics are viewed as an arena in which citizens defer to the judgments of elites and most people favor the preservation of the status quo. There have been many revisions to Elazar's scheme in the last several decades. Each new refinement focuses on how cities differ in fundamental ways in terms of how citizens think about the role of government and the nature of citizenship. Today, issues of ethnic, linguistic, sexual, and religious identity are at the forefront of politics, as are issues related to the environment, animal rights, and globalization (Clark and Inglehart 1998; Sharp 2005a). At the metropolitan level, Sharp characterizes this "new political culture" as an "unconventional political

culture." Using census-level data and aggregate data on religious partici-
pation, Sharp's index of unconventional culture incorporates five factors:
(1) high levels of education, (2) high levels of technical and creative work-
ers (the creative class), (3) high levels of single-parent or nontraditional
families, (4) high levels of women in the workplace, and (5) and low levels
of church or religious adherence.[2] While "lifestyle politics" often revolve
around what some might consider liberal-based grievances (ethnic identity,
women's issues, or the environment), Sharp and others acknowledge that
politics based on religious values also fit within this new political culture. As
argued in chapter 2, arts conflicts are very much about "lifestyle" as opposed
to issues related to material well-being like employment and housing. Like
other lifestyle issues, people fight over art because such battles connect to
their personal identities, their sense of right and wrong, and their desire to
express and validate their beliefs and values. Therefore, we would expect
that cities with a more unconventional political culture would fight more
over art and culture.

Following Sharp, I employ an index to capture unconventional political
culture that includes numbers of college graduates, nontraditional families
(unmarried families and single-parent families), workers in creative occu-
pations, employment levels for working-age women, and levels of church
attendance. Not surprisingly, unconventional political culture and protests
over art are positively correlated. Using a statistical technique known as
General Linear Modeling (see the methodological appendix), I find that
average-sized cities ranked in the top third in terms of unconventional cul-
tures (cities such as Seattle, Raleigh, Nashville, Austin, and Albuquerque)
experienced approximately ten protest events in the late 1990s compared to
only eight events for averaged-sized cities ranked in the bottom third of the
unconventional culture index (cities such as Knoxville, Greensboro, Pitts-
burgh, Louisville, Allentown) (see figure 5.1).[3] The same pattern holds when
comparing the number of protests that originate in conservative grievances
(for example, homosexuality, indecency, or blasphemy) or those that origi-
nate in liberal grievances (for example, offense to ethnic minorities, women,
and religious minorities). However, using more sophisticated multiple
regression techniques and additional control variables (see models in meth-
odological appendix), I find that the relationship between unconventional
culture and protest over art appears to disappear.

In many ways our measure of unconventional culture emphasizes an
underlying cosmopolitanism—highly educated citizens working in creative
occupations who are less bound to traditional structures of community and
family. While such markers of cosmopolitanism may be linked to a certain

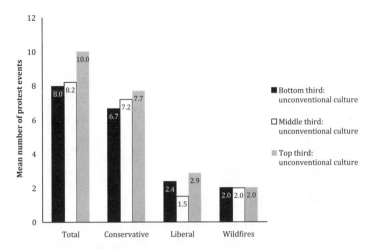

5.1 Comparing number of protest events by levels of unconventional political culture[a]
Note: Mean number of protest events controls for both population size and changes in the foreign-born population, which are two of the strongest predictors of arts conflict when included in a multiple regression model. Additionally, the city of Hartford was removed from the analysis because it is an outlier in terms of protest events, as it was more than three standard deviations from the mean.
[a]Unconventional Political Culture Index is derived from Sharp (2002) and includes the following variables: college graduates, nontraditional families (unmarried families and single-parent families), workers in creative occupations, employment levels for working-age women, and levels of church attendance.

type of lifestyle politics—feminism, environmentalism, animal rights, quality of life issues, and such—they may *not* be linked to the lifestyle politics surrounding most arts protests, which often focus on concerns about community identity, traditional values, and family life. If this is true, then perhaps a more "traditional" culture, rather than an "unconventional culture" will have a stronger relationship to arts conflicts. One way to measure traditional culture is to examine the reading interests of community members. It turns out that some cities have much higher subscription rates to magazines that focus on community and family life (for example, *Family Circle*, *Ladies' Home Journal*, *Reader's Digest*), while others have higher subscription rates to more cosmopolitan magazines (for example, *Food and Wine*, the *New Yorker*, *Vanity Fair*). Comparing such differences, I believe, is a reasonable way to differentiate cities as having either a cosmopolitan or traditional political culture. And it turns out that those cities with a higher Traditional Index score (based on magazine subscriptions) have much higher rates of arts protests—5.1 versus 8.4 (see figure 5.2). And unlike our measure of unconventional culture, traditional culture turns out to be one of the strongest

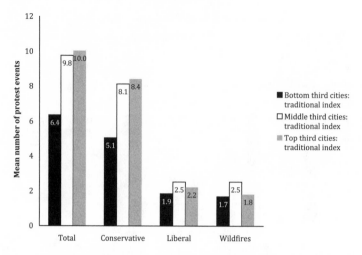

5.2 Comparing number of protest events by levels of traditional index[a]
Note: Mean number of protest events controls for both population size and changes in the foreign-born population, which are two of the strongest predictors of arts conflict when included in a multiple regression model. Additionally, the city of Hartford was removed from the analysis because it is an outlier in terms of protest events, as it was more than three standard deviations from the mean.
[a]Traditional Lifestyle Index is a scale based on subscriptions to a set of magazines that represent a traditional home and family orientation, including *Better Homes and Gardens, Country Living, Family Circle, Ladies' Home Journal,* and *Reader's Digest.* The Index is divided into three categories for purposes of comparison—bottom third of the index, middle third, and the top third of the index.

predictors of arts conflicts even when analyzed using more sophisticated statistical techniques (see the methodological appendix).

The Effect of History of Protest

Political culture describes the values and political orientation of a community's citizens and also describes and characterizes the *way* a community engages in politics. Are opposing sides confrontational or conciliatory? Do ordinary folks get involved, or does political work get done primarily by elites? Many factors influence a city's style of politics, but one important factor, often overlooked by scholars, is a city's history of protest and activism. Some cities are more contentious than others, whether fighting over art, civil rights, or land use. Using data from Robert Putnam's study of civic engagement (see chapter 2), there is evidence that people protest at different rates across different cities. For example, in Philadelphia 12 percent of respondents say they participated in a protest or demonstration; in Dayton 23

percent and in Santa Rosa 26 percent of residents participated in protests. In Hartford only 18 percent of citizens have signed a petition, whereas 54 percent have done so in San Diego. Of course, individual participation is only one measure of protest culture. For example, Chicago and Philadelphia do not appear to be high protest cities when examining reported citizen engagement, yet each of these cities has a history of visible protest. In fact, data collected by Susan Olzak on the number of ethnically related protests and demonstrations in American cities between 1954 and 1992 reveal that Chicago and Philadelphia are among the most contentious, with eighty-seven and thirty protests, respectively, compared to three cases in Denver, seven in Dallas, and eight in Buffalo. Clearly, a history of contentious politics where citizens routinely make claims in the public square informs current levels of protest. Not only do activists learn from past episodes and adjust their

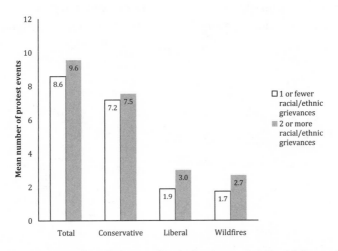

5.3 Comparing number of racial/ethnic conflicts in the 1970s and 1980s with the number of arts conflicts in the 1990s[a]

Note: Mean number of protest events controls for both population size and changes in the foreign-born population, which are two of the strongest predictors of arts conflict when included in a multiple regression model. Additionally, the city of Hartford was removed from the analysis because it is an outlier in terms of protest events, as it was more than three standard deviations from the mean.

[a]Number of racial/ethnic conflicts is derived from data collected by Susan Olzak. Olzak's data on ethnic protest includes demonstrations, marches, sit-ins, and other disruptive tactics aimed at addressing civil rights, schools, housing, and other issues related to the concerns of ethnic minorities. The data, which covers events that took place in the 1970s and 1980s, is divided into two categories for the purposes of comparison: those cities with two more racial/ethnic conflicts during this period; and those cities with one or fewer recorded ethnic conflicts.

strategies accordingly, but citizens also figure out the norms of their community, such as what are appropriate and inappropriate ways to make claims and express discontent (McCammon et al. 2008; Tilly 2006). In some places, protest is de rigueur; in others, it is unfashionable.

While protest culture is difficult to measure, Olzak's data offer a reasonable proxy and is used to gauge the culture of the cities in this sample. Figure 5.3 shows that once we account for the size of a city and immigration rates, we see that cities with one or fewer racial conflicts from 1954 to 1992 had an estimated 8.6 total conflicts over art, while cities with two or more racial protests experienced an estimated 9.6 protests, a 12 percent difference. In addition, the presence of earlier ethnic protests consistently predicts the number of wildfires[4]—the most intense cultural conflicts—and the number of conflicts based in liberal concerns.

Another indication of the protest culture of a city is the extent to which gay rights advocates have successfully made claims on city government; that is, whether or not a city has passed a gay rights ordinance that provides for domestic partnership benefits or contains antidiscrimination clauses. In some cases, ordinances were passed after visible and contentious pro-

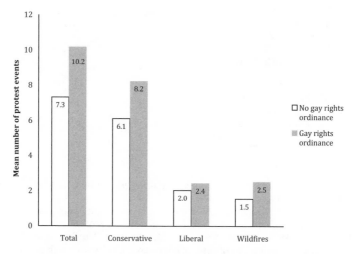

5.4 Comparing number of protest events for cities with and without a gay rights ordinance
Note: Mean number of protest events controls for both population size and changes in the foreign-born population, which are two of the strongest predictors of arts conflict.
Additionally, the city of Hartford was removed from the analysis because it is an outlier in terms of protest events, as it was more than three standard deviations from the mean.
Source: Data collected on gay rights ordinances was provided by Richard Button at Florida State University.

test and demonstrations. In other instances, ordinances were passed more quietly (Button, Rienzo, and Wald 1997). In either case, the presence of an ordinance might be a sign of an activist political subculture, an example of the new political culture discussed above, or a sign that city officials are open to the claims of activists (for example, the political opportunities are favorable for protesters). Not surprisingly, cities with gay rights ordinances (most of which were passed in the 1980s) were more likely to fight over art and culture in the 1990s. Figure 5.4 shows that cities with a gay rights ordinance on the books had an estimated 2.9 more conflicts than those with no ordinance (10.2 and 7.3, respectively) and one additional wildfire (2.5 and 1.5, respectively). If racial protests and the passage of gay rights ordinances capture, to some extent, "protest culture," then the findings above provide additional evidence that arts conflicts are deeply connected to the ongoing political dynamics and culture of a city.

The Effect of Civic Engagement on the Levels and Intensity of Conflict

In *Democracy in America*, nineteenth-century social theorist Alexis de Tocqueville offered many prescient insights into the unique workings of American democracy (Tocqueville 1994 [1835]). In particular, he praised America's rich associational life (the abundance of clubs, churches, mutual societies, and voluntary associations), which he felt had a defining influence on the propensity for Americans to leave their individual shells and join in the affairs of their community. Tocqueville argued that voluntarism, voting, and associationalism created "habits of the heart"—norms that promote public spiritedness and reciprocity (287). In recent years scholars have revisited the themes in *Democracy in America* in an effort to understand today's political culture and the factors that lead to an active and engaged citizenry (Bellah et al. 1985; Newton 1997; Putnam 2000; Putnam, Leonardi, and Nanetti 1993; Schudson 1996). Like Tocqueville, these scholars tend to focus on the collective and consensual democratic outcomes that result from high levels of civic engagement. A vibrant civic life has been linked to economic productivity, government efficacy, an increase in community service (Putnam, Leonardi, and Nanetti 1993; Putnam 1995), investment in education (Goldin and Katz, 1999), and general levels of civility and tolerance (Almond and Verba, 1965; Newton 1997). Yet these scholars have largely ignored the role of civic engagement in fostering conflict, cleavages, and disagreement.[5] Perhaps a robust civic culture not only strengthens the common enterprise but also plays a role in fostering opposing enterprises.[6]

As noted in the introduction, James Coleman (1957) identifies community attachment and social integration as important elements in determining the level and intensity of conflict in a community. In his opinion, citizens who are more attached to and integrated into their communities tend to feel more strongly about its shape and future and thus are more likely to involve themselves in local affairs. As Coleman writes, "With strong attachment, people are greatly concerned with what is happening to their community and will fight more quickly to see it go the way they want it to. . . . In effect, communities whose members are highly involved will have more controversies, and feeling will be more intense about the issues" (4). According to this argument, an active and engaged citizenry will lead to political participation of all kinds. Sometimes the focus of this participation will be on public goods or collective benefits. At other times it might be linked to community conflict, including conflict over art and cultural expression.

It is worth noting, however, that some scholars, like those who see protest as irrational and outside the political mainstream, have argued the exact opposite. For these scholars, conflict over moral and cultural issues results from political and social alienation rather than attachment and engagement. For example, many critics of mass culture have linked the rise of conservative or extreme political movements, participation in riots, and other nondemocratic forms of participation with the disintegration of social ties and the breakdown of community life in modern society (Arendt 1958; Gusfield 1962; Mannheim and Shils 1940; Ransford 1968; Selznick 1951). They argue that individuals who feel estranged from the daily political and social life of their communities are more likely to join political movements that are anti-democratic in nature. Similarly, Erika Doss (1995, 135) argues that conflicts over art are, in many respects, the results of a disengaged and disenfranchised citizenry. She writes, "Angered by perceptions of powerlessness and manipulation, growing numbers of Americans have targeted public art to question their role in the relevance and direction of civic life" (14). While Doss considers public involvement in arts controversies to be an important avenue of democratic participation (in contrast to the types of extremism cited above), her premise leads to the same conclusion about the relationship between engagement and cultural conflict—the lack of social ties and political participation, rather than their presence, leads to more conflict. The question remains, does an active and engaged citizenry and a vibrant civic culture, or its opposite, lead to more conflict?

How can we measure the extent to which a city has a thriving civic culture—high levels of participation, broad social integration, and widespread

interest in community life? One measure of community engagement, at least political engagement, is level of voter turnout in a city or metropolitan statistical area (MSA). In discussing a conflict over fluoridation of water supplies, Coleman (1957) cites voting statistics as a measure of the extent to which citizens are apathetic or disengaged from community affairs. Others have used voting statistics as a proxy for political engagement (Campbell et al. 1967; Kaufman 1999; Lazarsfeld, Berelson, and Gaudet 1968; Putnam 1995).

Voting is, of course, only one form of political participation. Citizens might also participate by donating money or time to a political cause, by contacting an elected official, by working on a campaign, or by simply talking about political affairs with neighbors and friends. Although voting is not the most active form of participation, it is arguably the foundation upon which many other forms of participation rest. As Raymond Wolfinger and Steven Rosenstone (1980) argue, "Elections are at the core of the American political system . . . and for most Americans, voting is the only form

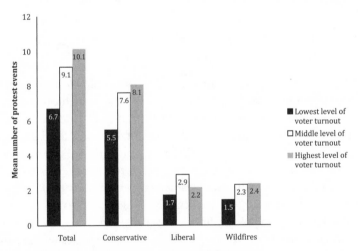

5.5 Comparing number of protest events by level of voter turnout[a]
Note: Mean number of protest events controls for both population size and changes in the foreign-born population, which are two of the strongest predictors of arts conflict. Additionally, the city of Hartford was removed from the analysis because it is an outlier in terms of protest events, as it was more than three standard deviations from the mean.
[a]Lowest level of voter turnout represents cities ranked in bottom one-third in terms of voter turnout for the 1992 presidential election. Middle level of voter turnout represents cities ranking in middle one-third in terms of voter turnout. Highest level of voter turnout represents cities ranking in top one-third in terms of voter turnout.

of political participation" (1). In short, communities where people do not vote will probably not excel in other forms of political participation either. Thus I use measures of "voter turnout" in the 1992 presidential election to gauge the extent to which citizens are engaged in and aware of the affairs of their community. The U.S. presidential election, rather than local races (for example, mayor or city council), is used in order to control for differences among cities in terms of the competitiveness of races and the presence or absence of strong incumbents, factors that might influence voter turnout year to year.

Figure 5.5 shows that higher levels of voter turnout consistently predict higher levels of protest across all types of conflict. In the third of the cities with the lowest voter turnout rates (where, on average, less than 55 percent of residents voted in 1992), citizens protested artworks 6.7 times on average. In the third of the cities with the highest voter turnout rates (on average more than 61 percent of citizens voted in 1992), citizens protested artworks 10.1 times. This relationship holds true for conservative-only protests as well as wildfires. At the same time, liberal-based protests seem higher in those cities with middle-range voter turnout. In general, though, cities where people vote are also places where people fight over art and cultural expression.

The Effect of Public Opinion on the Emergence of Cultural Conflict

In fall 2004 I taught a freshman seminar at Vanderbilt University that explored the culture wars. On the first day of class, I passed out an anonymous survey asking people why they took the class, which culture war issues they paid most attention to, and whether or not they considered themselves liberal or conservative. The small class was evenly divided among liberals, conservatives, and those students who considered themselves somewhere in the middle. One student, Tom, was a member of the Young Republicans and an ROTC scholar and was particularly vocal and animated, making his opinions known from the very first day of class. In the first few weeks, other students challenged Tom, but over the course of the semester, the climate of opinion in the room shifted dramatically toward the right. Students who shared Tom's opinions spoke up. Those who disagreed stayed quiet. If a visitor had joined the class by the end of the semester, they would certainly have misread the true distribution of opinion. When I privately queried one of the quieter students at the end of the semester, he told me that he didn't feel comfortable speaking out in a room where *most* people disagreed with him.

My students and I experienced what Elisabeth Noelle-Neumann (1984) terms the "spiral of silence." Based on her study of political opinion in Europe, she demonstrates that in the months leading up to a national election, individual voters have an extraordinary ability to monitor and detect slight shifts in the political winds or climate of opinion. When a citizen feels that the opinion climate has shifted away from their own beliefs or preferences, they will be more reluctant to express their views in public. This further reinforces their original perception, as more and more people with opposing views feel increasingly comfortable expressing themselves, while those in the perceived minority increasingly stay quiet. Just like in my class, individuals who perceived that their opinions differed from most of their neighbors and co-workers chose to swallow their views rather than risk social isolation and ridicule. Or as Ted Jelen (1992) has written, "Social approval or approbation serves as a force by which an individual comes into conformity with his or her environment" (692).

The notion of the "spiral of silence" is very much in keeping with much of the research in political science on "context effects." There is abundant evidence—whether looking at anti-busing activists (Weatherford 1980), gay rights activists (Button, Rienzo, and Wald 1997; Linneman 2003), sex education (Hess and Leal, 1999), or pornography (Rodgers 1974)—that "if the political culture does not reinforce political diversity and respect nonconformity, individuals with unpopular views may perceive significant repercussions for expressing their opinions" (Gibson 1992, 343). In fact, Rodgers (1974) found in his investigation of censorship and pornography that "community standards" play a strong role in an individual's decision to join a censorship campaign. Citizens who were offended by what they considered obscene material would not speak out in certain cities for fear of being labeled as "cranks, censors or members of the lunatic fringe" (383). Similarly, Joe Cook, the executive director of the American Civil Liberty Union in Louisiana, told me in an interview that many potential arts censorship cases never get ignited because the ACLU is unable to find a plaintiff who is willing to risk being ostracized by coming forward with a suit (Cook 1999).

In addition to influencing the probability that a parent or citizen will speak out, the public opinion climate can also influence the actions of public officials, who, as noted earlier, are sometimes quite active opponents of cultural works. There is a long line of research in political science that demonstrates the close connection between an opinion climate of an electoral district and the behavior and decisions of elected officials (Glazer and Robbins 1985; Page et al. 1983; Wright, Erikson, and McIver 1987). Paul

Schumaker (1999) finds that local officials gauge the local climate of opinion and try to determine the community's values before getting involved in morality issues.

In short, the climate of opinion in a city should influence the likelihood that citizens, parents, and officials speak out against a cultural presentation that they find offensive or harmful. Challenging a cultural work often requires opposing the decisions of professionals and experts—teachers, librarians, curators, public arts advocates, or corporate managers—who represent legitimate and credible institutions in the community (schools, libraries, city government, radio stations, and movie theaters). Thus speaking out against a cultural presentation and challenging established institutions present certain risks to potential opponents. As Joseph Gusfield (1963) has noted, "Yesterday's moral virtue can be today's ridiculed fanaticism" (180). In short, the probability that a group or an individual will initiate a conflict over art and culture should be greater where local opinion is more sympathetic to the grievance at hand.

How can we measure the local climate of opinion in our sample of cities? The most straightforward approach would be to aggregate individual opinions about a range of moral and cultural issues in each metropolitan area. Unfortunately, such data do not exist for most of the cities in my sample. Nonetheless, there is precedent for using other indicators to gauge opinion climate, especially the extent to which a city is conservative. A fairly large body of evidence suggests that membership in a doctrinally conservative church has independent effects on moral conservatism (Jelen 1993), individual levels of tolerance (Gibson 1992), and the propensity to join in conservative causes (Lo 1982). Additionally, according to Kenneth Wald, James Button, and Barbara Ann Rienzo (1996), "it has been customary to associate social conservatism in a community with the concentration of Protestant fundamentalism" (1162). In fact, they argue that the presence of a conservative climate of opinion influences the likelihood that a city will pass an anti-gay ordinance, using the density of conservative churches as a proxy for "moral conservatism." I use a similar measure, creating a composite "conservatism" measure that combines (1) the number of conservative churches per capita, (2) the percentage of residents who are members of a conservative church, and (3) the number of Christian nonprofit organizations per capita. Interestingly, these measures were also highly correlated with the number of residents in a city who complained to the Federal Communications Commission following Janet Jackson's exposed breast during the Super Bowl halftime show in 2004, which I also include in the index (see methodological appendix for more details).

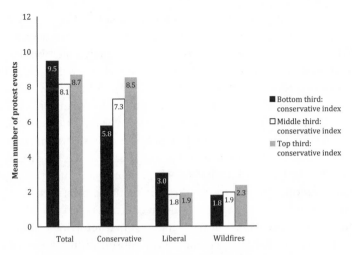

5.6 Comparing number of protest events by levels of conservative index in cities[a]
Note: Mean number of protest events controls for both population size and changes in the foreign-born population, which are two of the strongest predictors of arts conflict. Additionally, the city of Hartford was removed from the analysis because it is an outlier in terms of protest events; the city of Roanoke was removed as an outlier based on conservative index.
[a]Conservative Index includes the following variables: conservative churches per capita; attendance rates at conservative churches; number of nonprofit Christian organizations; and complaints per capita to the Federal Communications Commission following 2004 Janet Jackson Super Bowl halftime performance.

Figure 5.6 provides evidence that both confirms and disconfirms the above hypothesis. Overall levels of protest (which combines liberal, conservative, and neutral-based grievances) are no greater in more conservative cities than less conservative cities; in fact, the opposite seems true (although the differences are not statistically significant). Even if not linked to overall levels of protest, a "conservative" climate of opinion *should* be linked to conservative protests and should work to suppress more liberal-based protests. This is precisely what we find in our analysis: those cities ranked in the bottom third of the conservative index experience 5.8 conservative-based conflicts, compared to 8.5 for the most conservative cities (those ranked in the top third). When we look at liberal-based grievances the opposite is true; more conservative cities had fewer liberal protests (1.9 versus 3.0).

Conclusion

In this chapter I have presented consistent evidence that there is a relationship between a city's political culture and structure and its propensity to

protest art and culture. Arts conflicts are not apart and outside of mainstream political life; rather, like other forms of collective action, these contests are related to the character of a community's civic life—both present and past. In summary I find that arts protests are related to the new political culture (Sharp 2005b; Clark and Inglehart 1998), to past protest activity in a city, to voter turnout, and to a conservative and traditional public opinion climate. Following these findings, I join Robert Sampson and colleagues (2005) in calling attention to the link between protest and more consensual collective action. Sampson and colleagues note that neighborhoods that protest and fight with each other also celebrate and organize together around common solutions. In fact, they suggest that protest itself is a sign of a healthy democracy. They write, "Collective efficacy is best observed under conditions of challenge, reinforcing the idea that resolving conflict is an important part of civic engagement" (677). Most literature on social capital and engagement focuses on how collective action facilitates community solidarity in the process of achieving political outcomes, but even Robert Putnam, the don of the social capital debate, acknowledges the importance of contention in constructing community when he writes, "Whether among gays marching in San Francisco or evangelists praying on the Mall or, in an earlier era, autoworkers downing tools in Flint, the act of collective protest itself creates enduring bonds of solidarity" (in Sampson et al. 2005, 680).

When we read a news article about a person or group complaining about an art exhibit or trying to get a book removed from the library, we should resist either thinking, "How stupid . . . some fanatic is at it again"; or, "Oh no, another example in the ongoing culture war . . . a sign of a fractured America and a disintegrating public square." Instead we should think about Tocqueville and about the long history of Americans leaving their homes in order to shape together, sometimes happily and sometimes with considerable friction, the future of their communities.

This chapter does not fit squarely into existing literatures about contentious politics—it is not primarily about repertoires of contention nor is it about shifting political opportunities or the role and importance of resources for achieving political goals. It is not about framing and mobilizing potential constituents. I do not focus on events or movements. Instead I look at variation in the number of protest events across cities. In most of this book and in much of my analysis, I consider all protest events the same—regardless of repertoires, mechanisms, goals, or political affiliation. But are arts conflicts all the same? Yes and no. All arts conflicts involve actions that challenge the appropriateness of some form of creative expression. All conflicts involve actors who turn their offense into a public claim

to do something. Cultural conflict, as I have defined it, involves contending parties (supporters and opponents of artworks) who have different ideas about the boundaries of permissible expression.

But cultural conflict, like most social phenomena, defies easy generalizations. Some conflicts are more intense than others. Some are disorganized while others involve coordinated action. Some are linked to national movements or national organizations while others are entirely local. Some originate in liberal concerns about how blacks, women, and other minorities are represented in media and art; other protest originates with traditional and conservative members of society. And as we have seen, different actors use different tactics to express their claims. Nonetheless, what this chapter reveals is that much of the variability of cultural conflict can be explained by a city's political climate and structure.

To date scholars have not really dug in to understand the relationships between arts conflicts and other types of political conflicts and how existing theories and descriptions of contentious activity speak to the phenomena of cultural conflict. By taking a broad view and examining variation in conflict across cities, I have shown that arts conflicts are not random acts of offense and acrimony, they are not simply the result of political gamesmanship, and they are not simply the afterglow of an exploded artistic land mine. Rather, arts controversies are connected to important political, social, and cultural features of communities. Having demonstrated that arts controversies are tethered to communities and are important features of democratic life, future research can begin to ask more detailed questions about important differences in processes, mechanisms, and outcomes.

Such conclusions may be discomfiting to civil libertarians who believe that complaints about art and culture are nothing short of ad hominem attacks on the Constitution's most important guarantee—the freedom of speech. Such First Amendment crusaders tend to paint opponents of art as coming from the fringes of society—intolerant and irrational cranks. Such characterizations do not help us understand the social and political basis of cultural conflict, nor do they help us to see how "voice"—no matter how challenging or how cranky—is always better than either violence or silence. Cultural conflict is the result of an active and organized citizenry, it draws upon traditional repertoires of contention, and it serves as a forum for discourse, disagreement, and debate. As Erika Doss writes, "While public art controversy abounds, it is genuinely healthy: It shows the continued vitality of civic engagement . . . and [is] essential to an engaged, democratic culture" (Doss 1995, 34).

Profiles of Contention

According to a 2001 *Wall Street Journal* article, 75 percent of all college graduates that year reported that their choice of where to live was based mainly on the characteristics of the city rather than the availability of a job. Young people recognize that cities have different mixes of amenities, different cultures, different types of residents, and different vibes. Cities are not simply conglomerations of buildings, roads, and jobs. They have very different profiles—some are good places to raise families; others are great places to see theater; still others offer great bike trails and parks. Some cities are environmentally friendly; others are not. Daniel Silver and colleagues (2007) argue, based on a study of amenities, that cities fall roughly into sixteen different profiles of culture, from traditionalist to transgressive, corporate to glamorous, and neighborly to ethnic-based. Richard Florida (2002) argues that cities differ based on their "creativity," measured by a unique blend of tolerance for alternative lifestyles, investment in technology, and a talented, educated workforce.

The fact that cities have distinctive profiles is not front-page news. Well actually it is. Several groups rank cities across a number of different characteristics, attracting widespread media attention. Nashville, where I live, was recently ranked number one by *Kipling's Personal Finance* magazine in terms of "smart places to live"; Salt Lake City was ranked number one for physical health by *Men's Fitness*; and Charleston, South Carolina, was ranked the friendliest city in America by *Travel and Leisure*.

The notion that cities differ in important cultural ways—not simply in size or population, cost of housing or job market characteristics—is a central premise of this book. In previous chapters, I have argued that one important way in which places differ is the extent to which residents fight over art and culture. Different political cultures and different demographics produce

different levels of conflict. Yet cities vary not only in how much they fight but also in what they fight about and in the intensity of these disputes. The idea that there are distinctive "profiles of contention" is consistent with work by political scientists and sociologists who have attempted to label and classify cities based on the types of issues and the style of politics that come to dominate public life. In chapter 5 I discussed Daniel Elazar's (1966) notion of individualistic, moralistic, and traditional cities as well as more recent scholarship on conventional and unconventional cities (DeLeon and Naff 2004; Clark and Inglehart 1998; Lieske 2004; Rosdil 1991; Sharp 2005a). In the next three chapters I suggest yet another way to segment and compare cities in terms of their culture and politics. By examining protest over art and culture, many cities can be classified along three dimensions: *cities of cultural regulation, cities of contention,* and *cities of recognition.* These categorizations overlap with notions of conventional and unconventional culture and new and old political culture. While these other categories have been used to explain political outcomes (such as the passage of certain types of laws or the openness of government to certain types of claims), my goal in the following three chapters is much more modest. The profiles or categories described and explained in these chapters were derived inductively and are intended to provide readers with a useful lens with which to describe and understand some core differences in how disagreements over art and culture play out in communities. Ultimately, I suggest that understanding local differences is necessary if our goal is to facilitate democratic engagement.

In chapter 2 I discussed several different approaches to considering social change and cultural conflict. One perspective conceptualizes conflict as a type of ritual of protest—a way in which relatively homogenous communities police their boundaries. In this account art serves as a boundary marker. Certain types of books, movies, and songs come to represent the outer limits of permissible expression. When a community declares such objects to be harmful, inappropriate, or obscene, the community is, in effect, denigrating the values and lifestyles of those who enjoy the offending item. When community leaders, activists, newspaper editors, and theater owners declare a film like *Showgirls* to be pornographic and obscene, they are publicly critiquing one set of values—say, sexual permissiveness—while upholding a competing set of values, like sexual restraint, traditional gender roles, and normative family values. In many communities there is significant competition surrounding the boundary of acceptability with different values and lifestyles battling for dominance. In other communities, especially places where there is a great deal of consensus around political,

social, and moral values, conflict may take a more regulatory form. Based on agreed-upon standards, citizens and officials attempt to remove or curtail offending objects. Certainly in small towns and close-knit communities, cultural expression that deviates from the norm is often removed or marginalized while individuals who cut against the grain suffer social sanctions. Protest and conflict serve as ways to maintain harmony and affirm the way things "ought to be" (Durkheim 1973, 1982).

Like many small towns, some larger cities are also characterized by a moral order where residents largely agree on the community's dominant values. Such places tend to be predominately white and experience below average levels of immigration. Their populations are stable or declining. Residents are often described as churchgoing, and the vast majority of people lean to the right politically. In spirit these cities resemble Robert Lynd and Helen Lynd's depiction of Middletown (1937) or Zenith, the hometown of Sinclair Lewis's quintessential middle-American icon George F. Babbitt (1961). Cities like Cincinnati, Dayton, Kansas City, and Oklahoma City are cut from this cloth of moral conservatism, traditionalism, consensus, residential stability, and homogeneity. In terms of their profile of contention, these metropolitan areas can be thought of as cities of cultural regulation.

In Sunbelt cities, generally thought of as fast-growing cities in the South and Southwest, I find that the profile of contention is quite different. In these areas, social change is dramatic and creates significant cracks and rifts in the social order. New groups are fighting for more power to determine community life, while established groups are trying to defend their status and hang on to traditional ways of life. Public institutions like schools, libraries, and museums are sites of active conflict as citizens wrestle with emerging and still unsettled notions of community identity and shared values. Rather than policing agreed-upon boundaries of permissible expression, residents of these communities fight about where to draw the lines and over whose voice and values will define the future direction of their community.

In these cities I am tempted to apply the "culture war" metaphor given that struggles tend to be more entrenched, ideologically charged, and polarizing. Yet unlike the culture wars, which depict conflict as arising from a single epic battle waged largely at the national level between religious orthodoxy and secular humanism, these conflicts typically have a more local flavor. They represent local concerns, reflect local political culture, and are triggered by social change at the local level. In cities like Atlanta, Phoenix, Dallas, Denver, Charlotte, Fort Worth, and Richmond, cultural conflict arises from rapid social change, driven in large measure by the arrival

of new immigrants. These cities are fairly conservative when we look at the number of adherents to fundamentalist churches. They tend to elect conservative and Republican officials. At the same time they have sizable pockets of liberal constituents—gay communities and neighborhoods, new creative class workers, and a large, black middle class. These cities are also more racially and ethnically diverse than the midwestern and Great Plains cities described above, and not surprisingly they have a long history of racial conflict and ethnic protest. In addition, these cities tend to have lively arts scenes and a greater than average number of artists. Given the mix of a fairly conservative and traditional majority with an active and vocal liberal minority, these cities are ripe for conflict. Unlike cities of cultural regulation, where conflicts resemble rituals of protest intended to affirm dominant values, cities of contention are characterized by flairs of competition between competing groups with *both* liberal *and* conservative grievances dominating public discourse.

As discussed in chapter 1, more than 25 percent of all conflicts in our seventy-one-city sample involved liberal-based grievances, most of which are rooted in what sociologists and political scientists refer to as identity politics (Dubin 1992; Gitlin 1995; Schlesinger 1998). In these cases historically disadvantaged groups—women along with ethnic and religious minorities—attack art and entertainment they believe mischaracterizes or misrepresents them. For these groups, protest over art often serves to assert their voice and identity and to articulate and take control of how they are depicted in images that circulate in books, movies, fine art, and music. Several cities in our sample are disproportionately represented by these types of conflicts—San Francisco, Cleveland, San Jose, Albuquerque, and Chicago. Compared to other cities, these cities have higher levels of ethnic diversity and have long ago passed through the type of visible and dramatic social change that characterizes today's Sunbelt cities. They have moved into a phase of robust pluralism, where new and emerging groups tend to dominate the public discussion over art and culture. In these cities conservative-based grievances are outnumbered by liberal-based concerns. Rather than rituals of protest or flairs of competition, these cities experience declarations of recognition. In cities of recognition conflict over art is a means to amplify the voice of historically disadvantaged groups seeking recognition and accommodation in the public square.

Not every case in each of these cities fits into this schema, but I identify several key distinguishing features across all cases. These chapters serve as an attempt to categorize the unique narratives comprising each city's profile of contention. My method is not unlike the process my four-year-old uses

when beginning a new hundred-piece puzzle. He sorts the pieces into those with straight edges, background pieces, and subject pieces, though he does not use these words. This strategy helps him make sense of the puzzle, but of course there are other patterns or categories he could use. The following three chapters are my first attempt to inductively categorize cities based upon my intimate knowledge of the different cases. In the process of categorizing, I considered pages upon pages of statistical reports—each ranks the seventy-one cities analyzed in this project along different dimensions (for example, overall conflicts, liberal conflicts, conservative conflicts, wildfires, unilateral actions, involvement of elected officials, levels of demographic change, indices of conservatism and traditionalism, ethnic makeup, and so forth). Then I looked for patterns and possible groupings. These chapters offer in-depth descriptions as opposed to statistical analysis. In contrast to the bird's-eye view taken in earlier chapters, I feel my way around and through the data in order to offer detailed profiles of the kinds of cultural conflict experienced in a range of American cities. In taking this approach, I want to avoid misplaced concreteness. In other words, these ideal types are not to be used as analytically distinct categories for modeling and analysis; rather, they are heuristics to help readers and scholars think about the dynamics of conflict and to begin to pay closer attention to how cities might differ in critical ways. By grouping cities in terms of certain criteria, I have necessarily overlooked important aspects of their uniqueness. A resident of any of these cities might find that a category fits their city like an untailored suit—not perfectly but acceptably. Like all ideal types, these categories are not exact replicas but recognizable reproductions.

Cities of Cultural Regulation: Cincinnati, Dayton, Kansas City, and Oklahoma City

Governments from Ancient Greece to the modern day, from theocracies to liberal democracies, have regulated culture using a variety of tools—from outright censorship and prohibition to government control over production (requiring licenses and "stamps" in order to produce and disseminate art, books, music), from age restrictions to obscenity laws, zoning, and government-imposed "decency" standards like those of today's Federal Communications Commission (FCC). Historically, much cultural regulation has taken place at the level of national governments, but since the beginning of the twentieth century, city governments have been particularly active in regulating culture as well, especially public sites of leisure and entertainment—bars, nightclubs, and dance halls (Adams 1994; Lovatt 1996). Cultural regulation is often thought of as any attempt by public authorities to use voluntary means (such as self-ratings) or coercive means (such as obscenity laws) to restrict the production and distribution of cultural expression. In this chapter I diverge from this more formal definition. In designating places like Cincinnati, Dayton, Kansas City, and Oklahoma City as *cities of cultural regulation*, I am not necessarily saying that all, or even most, cases of conflict in these cities involve explicit efforts by city governments to restrict the production and distribution of culture, although these cities do see a disproportionately large number of government-based regulatory efforts. Instead I want to focus on the idea that cultural protest in these cities originates primarily from conservative-based grievances and groups. Cities of cultural regulation tend to be relatively homogenous with low levels of population change. They have a conservative climate of opinion characterized by general agreement about the city's dominant values. Residents are well aware of this climate of opinion, and elected leaders and activists proceed as if there are agreed-upon standards of decency shared by

most residents. Many protesters evoke the notion of community standards and seem to draw very clear lines between what is acceptable and what is unacceptable and between what they perceive to be local values and those ideas and values that emanate from "outsiders" like professional educators, the American Civil Liberties Union, and the American Library Association among others. Residents and elected leaders in these cities are less involved in divisive ideological clashes than in more routine efforts to protect children from harm or purge their communities of unwanted expression. For this reason many of the conflicts might be described as rituals of protest.

In the Durkheimian tradition (1973, 1982), rituals serve to affirm dominant norms and values. For Durkheim, rituals are stylized patterns of conduct in the presence of sacred objects. These sacred objects (a cross, a crown, a goblet, or special foods) symbolize the ideals of a group; rituals connected to these symbols/objects therefore affirm the values and the moral order of the community. Protests over art and culture can be considered rituals in that they involve individual action (protest) oriented toward symbols (artworks) in an effort to affirm the moral order. In some of our cities, especially those with a long history of anti-pornography crusades, protests over art closely resemble Durkheim's notion of "stylized patterns of conduct." Efforts to crack down on obscenity are predictable, involve routine tactics (such as police raids, obscenity charges, petitions), and often engage the same cast of characters from event to event. Yet protests over art also differ from the forms of ritual that Durkheim describes, which are more explicitly oriented toward religion and notions of the sacred. By contrast I use Durkheimian-inspired notions such as cultural regulation and rituals of protest loosely—more as metaphors than as precise analytical terms.

Table 6.1 shows some of the distinctive properties of *cities of cultural regulation* (CCRs). These cities are significantly more racially homogenous than either of the other two city types. Across all four cities, the average racial heterogeneity is 0.29 (83 percent), compared to 0.40 (74 percent white) in *cities of contention* and 0.52 (62 percent white) in *cities of recognition*. CCRs also experience much slower rates of immigration. The change in the percent of foreign-born residents for CCRs is 5 percent compared to 58 percent and 25 percent. In terms of the climate of opinion, cities of cultural regulation are more traditional than other cities (as measured by subscription rates to family- and home-oriented magazines), and CCRs score higher on the conservative index (as measured in part by rates of church attendance and numbers of fundamentalist churches in a city) than cities of recognition (although not as high as cities of contention). Reflecting this climate of opinion, the vast majority of conflicts on average across these four cities

Table 6.1 Comparing cities of cultural regulation (CCR), cities of contention (CC), cities of recognition (CR)

	Total # of protest events	Total # of wild-fires	Total # of conservative-based protests	Total # of liberal-based protests	Racial heterogeneity	Percent Δ in percent foreign born	Artists per capita	Total # of ethnic-related protests	Cosmopolitan values index	Traditional values index	Conservative values index
Cities of cultural regulation											
Oklahoma City	9.00	4.00	8.00	0.00	0.35	0.24	6.82	0.00	5.30	81.90	0.95
Cincinnati	13.00	6.00	10.00	1.00	0.24	-0.03	6.55	1.00	7.60	77.60	-0.05
Kansas City	14.00	5.00	11.00	1.00	0.29	0.02	7.14	1.00	7.00	83.80	0.31
Dayton	11.00	4.00	10.00	0.00	0.26	-0.05	5.71	0.00	5.50	85.60	-0.05
Average	**11.75**	**4.75**	**9.75**	**0.50**	**0.29**	**0.05**	**6.56**	**0.50**	**6.35**	**82.23**	**0.29**
Cities of contention											
Denver	18.00	8.00	11.00	5.00	0.36	0.10	8.55	5.00	10.70	77.30	-0.29
Forth Worth	18.00	8.00	14.00	3.00	0.40	0.83	6.89	3.00	5.40	66.70	0.56
Dallas	18.00	9.00	14.00	4.00	0.50	0.96	7.51	2.00	7.90	75.80	0.75
Charlotte	13.00	4.00	9.00	2.00	0.35	0.36	5.55	1.00	7.40	81.00	1.29
Average	**16.50**	**7.25**	**12.00**	**3.50**	**0.40**	**0.56**	**7.13**	**2.75**	**7.85**	**75.20**	**0.58**
Cities of recognition											
San Francisco	9.00	4.00	2.00	4.00	0.60	0.27	15.14	3.00	31.90	49.20	-0.88
San Jose	18.00	5.00	6.00	9.00	0.59	0.71	6.63	10.00	15.60	69.10	-0.88
Albuquerque	9.00	3.00	2.00	5.00	0.56	0.23	10.56	1.00	9.10	79.40	-0.45
Cleveland	21.00	6.00	9.00	11.00	0.34	-0.20	6.08	10.00	7.40	75.20	-0.62
Average	**14.25**	**4.50**	**4.75**	**7.25**	**0.52**	**0.25**	**9.60**	**6.00**	**16.00**	**68.23**	**-0.71**

Note: See methodological appendix for details about each of the above measures/indices.

(9.75, or 83 percent) involve conservative grievances rooted in concerns about obscenity, homosexuality, and blasphemy. Finally, these cities are not very cosmopolitan (as measured by examining subscriptions to magazines associated with urban lifestyles or by looking at the number of artists per capita in the city).

Cincinnati, Dayton, Oklahoma City, and Kansas City are typical of medium-sized cities in the Midwest and the Great Plains. This region holds a prominent place in popular American imagination. It is Lynd and Lynd's Middletown (1937), Sinclair Lewis's Main Street (1961), and Dorothy's home sweet home (Baum 1956). It is the America represented in Hallmark greetings cards—sincere, virtuous, and saccharine. Philip Barlow and Becky Cantonwine write, "It's very lack of sophistication and cosmopolitan bustle spare it much temptation and corruption. It is often portrayed as the bastion of values associated with a rural past of austere means, inhabited by people who distinctively value community, practicality, church, family decency, hard labor, and neighborliness" (2004, 13). Political commentator Thomas Frank (2004) has written about the influence of morality and traditional values on midwestern politics, focusing specifically on Kansas and Kansas City. Frank calls Kansas a "burnt-over district of conservatism" and notes that "people in suburban Kansas City vituperate against the sinful cosmopolitan elite of New York and Washington, D.C." (35). Politically, Johnson County (part of the Kansas City metropolitan area) is one of the most intensely conservative counties in the nation. Frank estimates that "registered Republicans outnumbered Democrats here by more than two to one" (49). Johnson County has twenty-one Republicans serving in the state house and only one Democrat (Frank 2004). Finally, Kansas City is headquarters to several conservative religious sects and movements—the Church of the Nazarene, the Unity Movement, and the Reorganized Church of Latter Day Saints—as well as a powerful Christian radio network.

Like Kansas City, Dayton, Oklahoma City, and Cincinnati are also known for their conservatism and commitment to family values. All three cities have active local anti-vice groups and a history of moral crusades against pornography and obscenity. They are, in the words of one editorial writer, "squeamish on the subject of sex" (Cincinnati Enquirer 1996). Cincinnati is perhaps the poster child of CCRs. In 1956 local Cincinnati businessman Charles Keating founded Citizens for Decency through Law and began a crusade against Playboy magazine. Cincinnati is the headquarters of the National Coalition Against Pornography and the place where Larry Flynt was convicted of obscenity charges for distributing Hustler magazine. Cincinnati is home of Simon Leis, who as a county prosecutor and then sheriff spent

most of the 1970s, '80s, and '90s crusading against obscenity. Local adult bookstores, theater productions like *Oh! Calcutta!* and *Hair*, films like *Last Tango in Paris*, and records by rap artists 2 Live Crew were subjected to Leis's campaigns. In addition, Leis is infamous for charging Dennis Barrie, the director of Cincinnati's Contemporary Arts Center, with two counts of pandering obscenity for presenting photographer Robert Mapplethorpe's 1990 retrospective *The Perfect Moment*, which included nudity and themes of homoeroticism. Barrie was eventually found innocent of the charges, but only after Cincinnati had emerged in the national spotlight as a "bastion of traditional values" and the "smut free capital of the country" (Button, Rienzo, and Wald 1997, 47).

The virtuous Midwest and Great Plains, at least as represented by the four cities under investigation here, experienced a disproportionate number of conservative-based grievances.[1] Over the course of four years, thirty-nine protests were initiated by conservative citizens or groups and only two arose from liberal-based groups. In Dayton the most visible campaigns came from several Christian-based organizations including the locally based Christian Family Network and local chapters of the Christian Coalition and American Family Association. Protests were focused on films deemed blasphemous or obscene, like *The Priest* and *Showgirls*, as well as TV shows with homosexual content or nudity, including *Roseanne* and *NYPD Blue*. The most unusual case in Dayton involved the owner of a local Catholic bookstore who, for more than a year, launched an anonymous campaign to vandalize books in local libraries that dealt with the topics of homosexuality or the United Nations. Referred to as the "unipooper" by the local police, his protest typically involved defecating on the reading material and then leaving a note behind that said, ironically, that he was the guardian of decency in the community.

In Oklahoma City several of the nine cases of conflict involved law enforcement officers who conducted local raids to round up allegedly obscene comic books and videos. The city council opposed the scheduled concert of Marilyn Manson. In addition they passed a resolution asking libraries to restrict access to "controversial" books—those containing nudity, profanity, homosexuality, and blasphemy. One book of particular concern was titled *It's Perfectly Normal*, which contains illustrations and descriptions of masturbation. The most intense battle came after police seized copies of the Academy Award–winning film *The Tin Drum* from video stores, libraries, and private homes. The film, about a young boy in Nazi Germany, includes a brief scene in which the boy is portrayed as having sex with a teenage girl.

In Kansas City, students and parents were offended by a high school mural that contained images of evolution. A library director canceled a national traveling exhibit about banned books. A local principal canceled a high school play titled *Dark of the Moon* because of suggestive scenes and the depiction of alcohol, and the superintendent and school board banned the nationally acclaimed book *Annie on My Mind,* about two teenage girls who develop a romantic attachment to each other.

Cincinnati also lived up to its national reputation for cracking down on "obscenity." Police raided a local gay bookstore, confiscated the Italian art film *Salò: Or, the 120 Days of Sodom,* and charged the owners with pandering obscenity. The local county prosecutor pressured the bookstore Barnes and Noble to remove the magazine *Playboy* from plain view, while county commissioners demanded that the local library eliminate the gay newsmagazine *The Advocate.* A local university disavowed an exhibit organized by its art department titled *Immaculate Misconceptions* featuring Catholic artists reflecting on their childhood impressions of Catholicism, and the school board overruled the superintendent of a local school district and ordered Maya Angelou's autobiography *I Know Why the Caged Bird Sings* removed from the reading list of a tenth-grade college preparatory class. The book describes Angelou's trauma of being raped as a child.

In addition to the disproportionate number of conservative-based events (and the virtual absence of liberal-based protests), CCRs share other general characteristics, including (1) the active role of law enforcement officers in efforts to remove films and publications considered obscene, (2) the presence of visible and influential local anti-vice and "pro-family" groups, (3) a strong focus on community standards involving a clear demarcation between outsiders and insiders, (4) a willingness by local officials to quickly remove or condemn offending objects, and (5) a lack of visible and organized opposition in response to attacks on cultural works.

Law Enforcement

In Cincinnati, Sheriff Simon Leis made his reputation for cracking down on pornography, first as county prosecutor (participating in prosecuting several well-known "offenders" including Larry Flynt of *Hustler* and the director of the Cincinnati Contemporary Art Center) and later as sheriff. Leis continued his efforts during the late 1990s, eventually bringing obscenity charges against Barnes and Noble for distributing *Libido: The Journal of Sex and Sensibility.* The case began when an overzealous father sent his eleven-year-old daughter into the bookstore to buy a copy of the magazine, a special issue

featuring erotic photographs. The store clerk sold the girl the magazine, leading the father to contact the local anti-porn group Citizens for Community Values, who in turn contacted Sheriff Leis, who filed charges against the bookstore. The Hamilton County prosecutor decided against prosecuting the case because of the "illegal sting operation" conducted by the girl's father (*Cincinnati Enquirer* 1995). This decision not to prosecute led to a public feud between the crusading Leis and the more cautious county prosecutor. Many residents, local officials, and the editorial board of the newspaper came to Leis's defense, crediting him with ridding the city of obscenity. A local judge was quoted as saying, "I personally think he [Leis] is the reason why our community is such a good family-oriented community" (McWhirter, Curnutte, and Delguzzi 1995). In a letter to the editor, a resident noted that she moved her family to Cincinnati from California to "escape filth of the worst imaginable description" in order to get them "into a healthier environment" (McConnell 1995). And a newspaper editorial writer mentioned Leis's "legitimate attempts to crystallize community standards" and make the city a "zero tolerance" zone for the "pornography culture." Ultimately, Cincinnatians' attitude toward Leis might be summed up here: "Thanks to Leis, Cincinnati enjoys a virtual spotlessness from the stain of hard-core books, films, shows and magazines that blots other cities" (*Cincinnati Enquirer* 1995). While Leis was the ringleader in Cincinnati, he was not alone in his efforts. Cincinnati police raided a local "gay shop" and confiscated the 1975 film *Salò: Or, the 120 Days of Sodom* by well-known Italian director Pier Paolo Pasolini. The film is an adaptation of a novel by the Marquis de Sade and portrays Fascist brutality in World War II. In spite of protests from well-known celebrities, including Martin Scorsese and Alec Baldwin, the city prosecutor filed criminal charges against the store's owners, who pleaded guilty in return for a reduced charge of attempted pandering. Even the local postal service joined the campaign to keep Cincinnati free of obscenity when a postal clerk refused to mail invitations for a local art opening because they featured artistic renderings of nudes.

Law enforcement officials in Cincinnati were not alone in their efforts to reassert cultural boundaries. In Oklahoma City, after a citizen complained about an allegedly obscene comic book, police raided Planet Comics and confiscated copies of *Verotika*, a comic book that contains sexually explicit images, including a scene in which a high school cheerleader gets abducted and raped. Owners of the bookstore were charged with distributing obscenity, and after pleading guilty to the charges subsequently closed their bookstore. Police vowed not to "stop at Planet Comics" in their search for obscene comic books (Owen 1995b). Residents encouraged by the local

chapter of the Christian Coalition called for a broader crackdown, objecting to comic books that teach witchcraft or "show women having sex with animals" (Owen 1995a). One woman concluded, "These are not even comics. Even Catwoman is sexually oriented." And in events strikingly similar to those that unfolded in Cincinnati, upon the encouragement of a local decency group, Oklahomans for Children and Families, the city's attorney general approved a plan allowing local police to raid libraries, video rental stores, and private residencies. During the raid officers seized six copies of the award-winning film *The Tin Drum*. In the spirit of the old TV series *Dragnet*, one of the officers told the press, "The boys located and seized without incident a total of six movies. There is still one at-large at this time, but we will endeavor to find the remaining one as soon as possible. No expense will be spared. No stone will be left unturned" (Parker 1997). Such comments may seem extreme especially in light of the fact that the movie, internationally regarded as an artistic triumph, was eventually found not to be obscene by a federal judge. Yet such comments and measures are not extreme within the context of a *city of cultural regulation* where it is expected that police and law enforcement personnel will routinely purge offending work and where "no expense will be spared" to protect decency and community values.

Local Morality Groups

In *Arresting Images*, Steven Dubin writes about Cincinnati's "tendency to push difficult matters from public view" by "regulating sexual information and conduct" (1992, 183). According to Dubin, accomplishing these goals requires a strong, mutually supportive relationship between "decency groups" and local officials. He writes, "What makes the decisive difference in Cincinnati are seasoned moral crusaders and key government officials who can mobilize against anything that violates their sense of propriety" (183). In Cincinnati moral crusaders are perhaps better seasoned than similar activists in any other American city. Moral crusades have a long history in the city, beginning with the 1934 founding of the Legion of Decency by the archdiocese of Cincinnati to fight for Christian morality in movies. In the 1950s Charles Keating founded one of the nation's first decency groups, Citizens for Decency through Law, whose mission and intent lives on in the contemporary organization Citizens for Community Values (CCV), founded in 1983. Phil Burress, the executive director of CCV, has led numerous high visibility campaigns since the 1980s. A self-acknowledged reformed porn addict, Burress has taken highly visible, pro-Christian, stances on issues ranging from allegedly obscene museum exhibits to the prosecution of the

hip-hop group 2 Live Crew along with a highly visible attempt to repeal a citywide ordinance that prohibited discrimination on the basis of sexual orientation. Burress's group, which *U.S. News and World Report* describes as one of the "largest local grassroots organization of its type in the nation" (Citizens for Community Values 2010), was involved early on in the case against Barnes and Noble for selling the magazine *Libido*. In fact, the case spurred the group to launch a widespread effort to pressure local businesses into removing a range of magazines with objectionable content—including *People, Glamour, Playboy*, fashion publications, and teen comics. Responding to CCV's magazine campaign, the general manager of the Borders bookstore was quoted in the local paper pointing out that she takes great care in limiting access to potentially inappropriate material. At the same time she emphasized that standards are, in a word, local: "We are very much aware that we are operating in Cincinnati and all that entails" (MacDonald 1995).

Finally, Burress's group teamed up with local chapters of the American Family Association and the Christian Coalition in an effort to get the county library board to remove the gay newsmagazine *The Advocate* from their shelves. The issue that provoked initial scrutiny featured a cover depicting genitalia alongside an image of the crucified Christ. Even though the library board eventually voted to keep the magazine on its shelves, CCV and allies were successful at prompting county commissioners to pass a resolution urging the library to remove the magazine and at holding a public hearing that attracted three hundred community members and resulted in a front-page headline—"Gay Magazine Panned at Forum" (Jennings 1995). CCV's efforts, along with notable obscenity prosecutions, has created an atmosphere where citizens and local proprietors understand and respect the "climate of opinion" and perceive decency campaigns as simply the "way things are."

Similar to Cincinnati, in Oklahoma City the local chapter of the Christian Coalition encouraged its members to purchase "obscene" magazines and comic books in order to determine which stores were distributing inappropriate material to children. Oklahoma City had its own homegrown decency group, Oklahomans for Families and Children (OFAC), led by the outspoken Bob Anderson. OFAC began exerting pressure on the metropolitan library system in 1996 to restrict access to books with sexual content, focusing especially on a book about masturbation called *It's Perfectly Normal*. The group pressured the city council to pass a resolution that called for restrictions on "inappropriate" books (Maggio 1997). In addition the OFAC was the first to check out *The Tin Drum*, which it handed over to the police.

Soon afterward the organization encouraged the subsequent police raid and then pressured the district attorney to pursue an obscenity suit. Finally, Bob Anderson and his group circulated a petition to stop a concert by Marilyn Manson, who they felt promoted rape, disobedience, and satanic worship. The petition resulted in a city council resolution asking for the cancellation of a forthcoming Manson concert.

In Dayton the most important source of conflict came from several conservative Christian organizations, including the locally based Christian Family Network and the Christian Life Coalition as well as the local chapter of the American Family Association. These groups organized a boycott of local theaters in response to the film *The Priest*. They also led demonstrations, phone campaigns, and boycotts aimed at pressuring local businesses to stop advertising during TV shows considered too violent, sexually explicit, or vulgar. In addition the coalition of organizations focused its efforts to get MTV dropped from basic cable subscriptions, citing the sexually suggestive nature of many of the most popular music videos. Like other cities of cultural regulation, Dayton had its own local decency group, the Clark County Citizens Against Pornography, who most notably had the film *Showgirls* successfully pulled from a local theater. In CCRs, conflict over culture is forged through local organizations that are uniquely positioned to engage in grassroots monitoring. Rather than protest coming from outside, conflicts are thoroughly local occurrences that unfold through local connections.

Community Standards and Local Control

One common feature across CCRs is a taken-for-granted notion of community standards. Activists and government officials condemn, remove, or restrict artworks in the name of community standards, often referencing "what most people believe" or how their city holds "particular values and ideas" about what is appropriate for children or the larger community. In Oklahoma City the assistant district attorney noted that the case against the comic book *Verotika* "will give citizens of Oklahoma County the opportunity to decide the community standards of what is obscene for comic books" (Godfrey 1995). A distinction between the views of national elites and the views of the local community was made by a mother who successfully incited the district to remove the book *Out of Control* from the middle school library because it contained thirty swear words. She noted that she was bothered that "people at the national level could write good reviews of the book" and greeted the decision to remove the book from the school as

an indication of the city's community standards. Elaborating on the differences between Oklahoma and other American cities, the mother remarked, "Obviously *our standards* are a bit higher here or something. Oklahoma is the Bible Belt. It was apparent after the [Oklahoma City] bombing that people here are stronger in their faith and a little more sensitive. . . . So the words used in that book aren't something *we want here*" (my emphasis) (Brus 1995). Similarly, the mayor of the Village, a municipality within the Oklahoma City metropolitan area, responded to controversy over the library book *It's Perfectly Normal* by positing his community's standards against those of national library elites. The mayor publicly declared, "I call it [*It's Perfectly Normal*] an indecent book, and the American Library Association calls it a decent book. It's a matter of opinion in what is decent and what is not decent. My opinions, and the opinions of this community, are based on God's standards and not human standards" (Watson and Money 1997). Bob Anderson, the leader of the local decency group, echoed the mayor's comments in a local editorial: "It is now time for the metropolitan library system commissioners to quit obediently following the myths of the ALA [American Library Association] and to truly represent the citizens of Oklahoma County." Referring to *The Tin Drum* case, Anderson again emphasized the importance of local standards, remarking, "Library policies should be changed to reflect the values of the citizens of Oklahoma County" (Money 1997). The assumption that there are agreed-upon local standards that are different from national standards is echoed by the newspaper editorial board: "The policy preferences of the ALA are simply not representative of most Oklahomans, particularly in matters of morality and common sense protections for children" (*Daily Oklahoman* 1998). During the same controversy a resident implored the city council to call on the library commission to remove or restrict controversial books in order to "get things back to the way they should be" (Watson 1997). Such a statement implies a presumably "shared" sense of what the community was like before the contamination of books in the library by outsiders.

In Cincinnati, citizens and officials time and again refer proudly to the city's reputation for being tough on pornography. One opinion editorial writer noted that "*most* residents of Greater Cincinnati are a lot like me . . . glad there's not a lot of sleazy porn" (my emphasis) (Purdy 1995). The local newspaper editorial board publicly extolled the city's "zero tolerance for pornography culture" and backed the efforts of the local sheriff to bring charges against Barnes and Noble because prosecuting the store would help "crystallize community standards." If there were any doubt about the paper's

position, an editorial clarified: "While some see such standards as outdated and censorious, Leis [the sheriff] sees them as crucial to 'keeping Hamilton County a nice place to live'" (*Cincinnati Enquirer* 1995). In a different case, when the local prosecutor faced a lawsuit from *Playboy* for attempting to have the magazine relocated at a local Barnes and Noble, the prosecutor responded, "This is not a First Amendment case; this is about our kids. If a bunch of lawyers from New York want to come to Cincinnati and tell us what our kids can and can't read . . . well, I guess we'll find out" (Kaufman and McWhirter, 1995). Echoing these sentiments, one activists involved in trying to get MTV removed from the basic cable subscription wrote in a letter to the editor, "This is precisely why we have always used the terms 'social standards' or 'community values.' It's time to let the cat out of the bag—the community values of Anderson Township are values of morality—morality founded in Judeo-Christian theology" (Scheper 1995).

In Kansas City a school board member defended her vote to remove the book *Annie on My Mind* from the school library because its portrayal of homosexuality was "contrary to the moral standards of the community" (Saylor 1995). Throughout the controversy the school district where the book was removed defended its position by saying it was trying to reflect community values. In the *Annie* case, local control over the content of books in the library was of central concern. Citizens and school board members depicted the "gay agenda" and gay activist organizations as the proverbial barbarians at the gate. One protester remarked, "The values in these books shouldn't be in our schools." Another noted that "if these books are accepted, it won't be long before more are soon to follow that are more graphic. Students will try to experiment who would otherwise not have if these books were not available in their school libraries" (Ebnet 1995). Similarly, another parent remarked, "I know a girl who read the book and afterward questioned her sexuality. I don't want that for my daughter," noting that the community would be better off to follow "the moral guidelines set by God" (Ebnet 1995). In Dayton, after the Clark County Citizens Against Pornography contacted the county sheriff about the screening of the film *Showgirls*, the sheriff in turn called the president of the local theater chain to tell him that "this [Dayton] is a wholesome community. The people from our community who did view the movie feel that it's harmful and that it does not meet our community standards" (*Springfield News Sun* 1995). While notions of community lie at the heart of many of the conflicts in each of the seventy-one cities I consider, in cities of cultural regulation community standards are invoked more regularly and with a sense that the "standards" are clear, crystallized, and shared by a majority of residents.

Responsiveness of Local Officials

Political scientists who have written about morality issues including abortion, gay rights, needle exchange, and pornography focus on the factors that lead some city governments to take aggressive stances on these issues while leaving others to remain uninvolved or unresponsive to citizen demands to "do something" (Sharp 1999). One important factor is whether or not a city is unconventional or conventional. While unconventional cities have large, robust countercultures that challenge traditional societal values, conventional cities, much like cities of cultural regulation, are more inclined to defend the status quo. Comparing them with unconventional cities, Sharp writes, "Conversely, in conventional cities, we would expect official action to be consistent with traditional values and supportive of the conservative, family values agenda promoted by conventional, conservative forces" (1999, 14). With very few exceptions, city officials and responsible public administrators regularly took action or made public statements in support of efforts to restrict or remove offending books, films, music, and fine artworks. In Cincinnati Angelou's autobiography was banned from a tenth-grade reading list after a single complaint, and an exhibit was disavowed by a local university (willing to overlook academic freedom) after complaints from local religious leaders that the title of the exhibit *Immaculate Misconceptions* was offensive to Catholics. Responding to citizen complaints, the county commissioners sent a letter to the library board asking them to remove a gay newsmagazine. In Dayton a local theater pulled the film *Showgirls* after receiving a few dozen complaints and a call from the local sheriff; the YMCA removed art that several patrons considered too violent; and the county clerk's office removed two paintings—one featuring a yin-yang symbol, familiar in eastern religions, and another including a "cow's skull"—from an exhibition. Both paintings were considered satanic by a handful of employees and patrons of the building. In Kansas City school board members voted to remove *Annie on My Mind* from the library; the district attorney immediately confiscated a Jock Sturges book from Barnes and Noble following several complaints from residents; and a high school principal canceled all theater productions with sexual themes and references to alcohol.

In Oklahoma City the city council passed resolutions seeking the restriction of books with sexual themes. They also passed resolutions seeking the cancellation of a Marilyn Manson concert. A school district agreed to remove the book *Out of Control* from a middle school library after a parent complained about profanity, and as discussed above, the district attorney and local law enforcement heeded pressure from a local obscenity group

and confiscated comic books in one case and an award-winning film in another. At the request of a single visitor, the general manager of the state fair demanded that twelve photographic nudes—described by the newspaper as "not particularly offensive" (Aiken 1995)—be removed from an international photo exhibit. In most cases, across each city of cultural regulation, officials, administrators, and managers chose a course of action targeted at removing offending artworks. The few exceptions tended to deal with challenges to library materials—where libraries and library commissioners are steeped in a national professional culture that is ideologically committed to open access and free expression. Yet even in these cases public officials—including council members, state legislators, mayors, and county prosecutors—responded to public pressure by trying, often unsuccessfully, to get libraries to remove and restrict materials. In cities of cultural regulation, the general approach to offensive material is to purge before ponder, eliminate before evaluate, and restrict before review. The tendency in these cities is to push difficult matters from public view (Dubin 1992).

No Defense

CCRs are noteworthy for the general lack of organized and community-based opposition to attacks on artworks. Few people are willing to speak out or challenge assertions that certain material violates community standards. There are a few exceptions to this general rule. High school students tend to protest efforts to place restrictions on their access to books and materials in school. In several cases students—not parents, local activist groups, artist groups, or civic leaders—were the only voices of resistance. Other than students, civil liberty professionals as well as one or two parents backed by the ACLU have opposed efforts to restrict artworks by filing lawsuits—as in the case of *The Tin Drum, Playboy,* and *Annie on My Mind.* When a school district in Oklahoma City removed books from a middle school library, the only protest came from the project director of the local chapter of the ACLU's First Amendment Project. Other than a professional activist, whose job it was to challenge restrictions on free speech, no other citizen or citizen's group came to the defense of the school library or spoke in favor of the book publicly. When a comic book was seized from Planet Comics in Oklahoma City, leading to the prosecution of the store's owners and its eventual closure, there was no protest. No one publicly defended the store or its owners in spite of the fact that the store had a "steady customer base" who were apparently "sad or mad" about the sequence of events. In the end materials were seized, a plea agreement was reached, and the store went out of

business. The community was protected from obscenity without any protest or push back against the authorities. While a local ACLU worker filed a lawsuit against the city in response to raids motivated by the distribution of the film *The Tin Drum*, and national organizations came to his defense ridiculing the city for its censorious actions, no local group spoke out against the city's actions. By the end of the controversy, a group called Citizens Supporting Open Libraries was created (at the instigation of the library director), but the group seemed largely symbolic and was never mentioned again in the press, nor did it show any signs of organized activity.

In Cincinnati, after police raided a local gay bookstore and seized a well-known European film, dozens of national organizations came to the film's defense, but as was the case in other CCRs, no local organizations intervened besides the local ACLU chapter. No gay rights group spoke out, business leaders and video store owners did not come to the shop's defense, and leaders of local cultural organizations were largely silent. Similarly, when attacks were waged on Barnes and Noble for carrying the erotic magazine *Libido*, there was no outcry from the gay community or from local rights organizations. When Northern Kentucky University disavowed the exhibit *Immaculate Misconceptions*, the organizing artist canceled the show, but faculty and community artists did not come together to support the artist or put pressure on the university to change its position. In Oklahoma City, when the city council passed a resolution in favor of banning Marilyn Manson, dozens of anti-Manson protesters attended the meeting but only *one* person "nervously stood before the council to defend the band's music," telling the councilors that she felt "very unpopular" for publicly supporting the music and the band (Lackmeyer 1997). In Kansas City, school board members and local activists were outspoken about their disapproval of gay-themed books in the library, arguing that these materials have detrimental effects on the community. More than three hundred parents packed a school auditorium to demand that the books be removed. Only a lone science teacher defended the books and joined with the ACLU to sue the school district. Few others spoke out besides the author of one of the books, *Annie on My Mind*, who came to town during the trial to talk about the positive lessons of the book's story. An editor of the local paper noted that the ACLU's victory (a federal judge ordered the book returned to the shelves) was "dampened by the high volume of disturbing comments, by both public officials and more than a few regular folks." The editor continued, "What was equally alarming was the lack of outrage over what the board members said about their reasons for wanting the book banned." Responses to the school board's anti-gay comments and censorious actions were "overwhelmingly supportive"

(Saylor 1995). Cities of cultural regulation are not entirely without opposi-
tional voices, but such voices are less organized and, more often than not,
outnumbered considerably. The dominant ethos is that there are agreed-upon
"standards" that need defending, with few people willing to stand up to
articulate a different set of standards or to push back against the dominant
values of the community.

Perhaps not surprisingly, CCRs employ symbolic acts of purging as a
component in their "rituals of protest." In Dayton the Spirit of Life Christian
Church, under the direction of Father Donovan A. Larkin, set blaze to every-
thing from occult materials to a Braille issue of *Playboy* magazine along with
books containing homosexual themes. In 1995 the fifth annual protest took
place in front of the metropolitan library, where the group demanded the
removal of two gay-themed books, *Heather Has Two Mommies* and *Daddy's
Roommate*. Larkin noted that the book burners were trying to "rid themselves
of the tools of Satan" (Wallach 1994). In Kansas City a minister checked out
a copy of the book *The New Joy of Gay Sex* and burned it on the steps of
the library, and a local group burned copies of *Annie on My Mind* in front
of a district school building. Finally, a group of residents in Kansas City
went to several Barnes and Noble stores and demanded the removal of
Sturges's *Radiant Identity* because the book features pictures of nude chil-
dren. One of the protesters took the books off the shelf and proceeded to rip
out offending pages.

Burning and destroying books stand out as extreme forms of cultural
regulation across my sample of cities, but in cities of cultural regulation,
purging belongs to a larger class of events whereby citizens and officials at-
tempt to banish items that fall outside of the range of acceptable expression.
In these cities protesters' arguments make reference to the large gap between
the values and standards of the "national, liberal elite" and local residents.
In many cases local decency groups stand ready to wave the banner of "com-
munity standards" and in doing so rally the troops to put pressure on local
officials to do something to protect residents and their children. By employ-
ing visible forms of protest like purging and by positioning complaints in
terms of local values, the identity of CCRs is reaffirmed through conflict
around culture.

Elected officials, law enforcement officers, managers, and administrators
tend to be extraordinarily receptive to demands from offended groups, often
removing artworks after just a few complaints. When elected officials lack
the authority to remove a book or cultural presentation (for example, when
the complaint falls under the jurisdiction of the schools or libraries), they
will often resort to passing a nonbinding ordinance calling for the removal

or restriction of books, films, exhibits, or concerts. There are pockets of defenders who push back against the impulse to purge and restrict art and culture, but these defenders tend to be professional librarians or representatives of the ACLU rather than activists emerging from local communities. While high school students sometimes stage visible protests against attempts to restrict their access to books and films, most opposition comes in the form of legal maneuvers, often initiated by the ACLU and involving very few local residents. Such legal proceedings, while long and drawn out, actually serve to drain the heat and energy from a dispute—leaving the battle to lawyers and judges in the courtroom rather than activists and citizens in town hall, at school board meetings, and in the streets. While conflict over culture is part and parcel to American life, cities of cultural regulation are involved in ongoing efforts to maintain and regulate the culture and values of the community through public protest over art and culture. CCRs employ unique strategies and engage in protest for reasons that stand in marked contrast to both *contentious cities* and *cities of recognition*.

Cities of Contention:
Dallas, Fort Worth, Charlotte, and Denver

"Today is the first anniversary of one of the biggest earthquakes in Charlotte history. It opened fault lines between conservative Christians and gays, suburban homeowners and uptown executives, people who cling to traditional values and those who would redefine them. Charlotte is a New South city with a fault line running down Main Street" (Brown 1996a). The controversy that unfolded in Charlotte, North Carolina, over the play *Angels in America* raised stark images of earthquakes and fault lines—images that are largely absent from the coverage of conflicts in *cities of cultural regulation* (CCR). In regulating conflicts in Kansas City, Cincinnati, Dayton, and Oklahoma City, residents and city officials rallied around the flag of traditional values. By contrast, in *cities of contention* (CCs) opponents took hold of one corner of the proverbial flag and pulled in opposite directions. Contentious cities—like Atlanta (discussed in chapter 4), Charlotte, Phoenix, Dallas, and Fort Worth—resemble the battlegrounds of James Davison Hunter's culture wars with a disproportionate number of cases involving ideological disputes between, on the one hand, fundamentalism and orthodoxy, and, on the other, cosmopolitanism and secularism. These disputes often involved organized groups of activists on each side, harsh rhetoric, name-calling, strong emotions, visible protest, and electoral politics. Conflicts in *cities of contention* are more likely to polarize communities and reveal fault lines and deep division.

Throughout much of this book I have attempted to provide a more nuanced view of the culture wars by suggesting that arts conflicts are often less ideological, less structured by elite actors, and more rooted in the context of local communities rather than simply reflecting the political and cultural battles being fought at the national level. While many of the protest events described in this section share properties of Hunter's culture wars, the entire

mix of controversies is more complicated than Hunter's imagery suggests. Some conflicts are motivated less by religious concerns and more by issues emerging from identity politics. Some are resolved quickly with little ideological posturing, and some are primarily triggered and organized by everyday citizens and parents rather than professionalized activist organizations. In short, the form and content of the various protest events does not perfectly resemble Hunter's war metaphor. Nonetheless, there is a strong echo of the culture wars reverberating in these cities. In each, residents and elected officials disagree over the character and values of their communities, and they stand up, speak out, and push back in an effort to reassert ideas about permissible and impermissible expression.

I refer to these cities as contentious because of the frequency of protest over art and culture and because of the quality and character of those protests. In terms of frequency, Charlotte, Denver, Dallas, and Forth Worth averaged close to 50 percent more conflicts over four years than the cities discussed in chapter 6 (see table 6.1). Cities of contention also experienced robust increases in the number of new foreign-born residents between 1980 and 1990—a 56.3 percent increase in CCs versus 5.0 percent in CCRs. In addition, CCs are more racially diverse than cities in the middle of the country, with nonwhite populations nearing 25 percent and a racial heterogeneity index of 0.4. The nature of religious commitments and ideology are also different among the South and Sunbelt regions and the middle regions of the country. As noted above, the Midwest and Great Plains states are highly religious and conservative, but conservatism is rooted in tradition, family, and small-town values; it is a polite and buttoned-up conservatism. Heading south toward the Sunbelt, the nature of "conservatism" changes.[1] Residents are more likely to be fundamentalist, evangelical, expressive, ideological, and confrontational. The South stands out for the size of its white evangelical population, almost twice the national average (Wilson and Silk 2005). This conservatism is displayed in table 6.1 (see chapter 6), with cities of contention ranking highest on the conservative index. By contrast, cities of cultural regulation rank slightly higher on the traditional index, perhaps reflecting the different versions of conservatism between the two regions. Within this conservative climate, diverse groups—new immigrants, ethnic minorities, gays and lesbians, and worldly professionals—are ever-expanding in CCs. Compared to the cities described in chapter 6, cites of contention have more artists per capita and are more cosmopolitan (as measured by the reading habits of residents).

James Coleman (1957) suggests that when a conflict erupts in a community, say, over a book in the school library, the community will (1) unite

together against the offense, (2) divide into opposing camps, or (3) unite to-gether to defend the challenged book. The first two strategies map on to the responses often seen in cities of cultural regulation and cities of contention, respectively. In the "opposing camps" case, Coleman suggests that conflict results from "*existing hostility* between two groups in the community" (my emphasis) (6). In other words, cultural conflicts are often lightning rods for the expression of deep-seated and persistent tensions.

Rather than rituals of protest, cities of contention feature flairs of com-petition that are spurred by existing group differences. Groups in a commu-nity—new immigrants, relocated professionals, ethnic groups, established elites, old timers, and newcomers—are locked in competition over the future direction of their cities. Such groups often hold incompatible views about education, popular culture, the role of the arts, urban design, and the image of their communities. In such a climate the assertiveness and visibility of one group will generate antagonistic feelings in competing groups—leading to heightened sensitivity and tension below the surface of community life and sometimes to more explicit reaction and protest. Sociologists have be-gun to recognize that protest and political mobilization is often less about "challengers" who make claims on the government or the state and more about the underlying dynamics between competing groups (Miceli 2005). The struggle between gay rights activists and the Christian right is a good example of the push and pull of opposing parties. These groups are "perfect enemies," propelling each other forward with heated rhetoric and compet-ing claims to the moral high ground (Gallagher and Bull 1996). In cities of contention, protest emerges from the tensions between opposing groups, and specific cases can be traced to prolonged or emerging conflict between adversaries.

Sunbelt cities like Atlanta, Fort Worth, Dallas, Charlotte, and Denver are perfect combustible cocktails of rapid population change, ethnic diversity, strong and politically organized African American communities, transplanted professionals, gentrifying neighborhoods, and arts districts. To intensify matters, these changes are taking place against a backdrop of Christian con-servatism and evangelical zeal. For example, the Fort Worth–Dallas region is a hotbed of religious broadcasting networks and evangelical ministries. In 1980 Dallas hosted the infamous meeting of the Religious Round-table, a key event in the emergence of the New Religious Right. CCs are also home to a disproportionate number of mega-churches—large, evangelical Christian worship centers that have become increasingly influential in lo-cal and national elections and shaping national opinions about a range of social issues. Dallas is not the only city of contention in which conservative

Christian organizations and national ministries feature prominently. Less than sixty miles from Denver, an exemplary CC is the headquarters of Focus on the Family—one of the largest, national religious-right organizations in America. James Baker's infamous televangelist ministry was located in Charlotte, and Kenneth Copeland Ministries, a multimillion-dollar operation with five hundred employees and many affiliated media companies, is located in Dallas.

Liberal and progressive groups and causes emerge within the intensely religious backdrop of the Sunbelt region. As noted in chapter 4, Atlanta is home to an active gay community as well as a sizable and growing black middle class. Denver has a history of progressive city politics—opening the first birth control clinic in Colorado in 1926, approving one of the first city ordinances to ban discrimination on the basis of sexual orientation, and electing both a Hispanic and black mayor in the 1990s. In Dallas gays and lesbians have ascended to important political positions in the State House, in law enforcement, and on the city council and school board. Dallas is home of the Cathedral of Hope, the world's largest gay and lesbian church, located in the Oaklawn neighborhood on Cedar Springs, an avenue of gay bars and LGBT-owned businesses brandishing pink triangles and rainbow flags. To celebrate the first National Coming Out Day in 1988, 450 gay and lesbian residents took out a full-page ad in the *Dallas Morning News* listing their own names. In an even more conspicuous display, gay activists in Atlanta protested Georgia's sodomy laws by placing "gay" inflatable dolls in compromising positions on the grounds of the State House. In addition to the political achievements of minorities and women and the visible presence of gay communities, Sunbelt cities are also known for their "urban avant-garde with advanced technology, postindustrial economic progress, and amenities" (Monkkonen 1988, 235). This is the New South, anchored by technology parks, world-class art museums and symphonies, artist and immigrant communities, gentrified neighborhoods, and business elites who work hard to promote their cities as progressive, creative, and tolerant places in which to live, work, or visit.

"Aspirational" Sunbelt cities of the New South, like American boom-towns of the early twentieth century, are "protean . . . being constantly redefined by newcomers" (Gattis 2006). It is this juxtaposition of the old and the new that is so jarring for longtime residents. Journalist Jim Cobb has noted that a visitor can purchase cracklins (fried pork skin) and caviar within two blocks in Atlanta (Goldfield 1997, 321). Syndicated columnist Garry Wills described the New South as a "particularly bilious compound of the new and the old, of space programs and retirement villas, honky-tonks

and superconservatism" (in Schulman 1993, 341). Southern culture persists amid the new skyscrapers and business parks. Residents retain their southern identity by sporting cowboy boots, driving pickup trucks and listening to country music, and by simultaneously subscribing to a distinct set of political attitudes that resent "government interference, bureaucrats, pointy-headed intellectuals, and 'welfare Cadillacs'" (Schulman 1993, 345). This "bilious compound" has made the South a flashpoint region producing political and religious clashes of pronounced intensity. These clashes, some argue, are even sharper in the "crossroads" region of the South, where the frontier mentality of places like Texas mix with old South ideals resulting in an evangelical zeal to "conquer culture for Christ" and reclaim America against godless secularism and worldliness (Wilson and Silk 2005, 29). Art, entertainment, and education have been caught at the intersection of the "crossroads."

This notion of reclaiming American culture is evident across each city of contention. The vast majority of conflicts in CCs were over art and cultural expression that was deemed pornographic, obscene, harmful to children, violent, or blasphemous (see table 6.1). In Denver religious fundamentalists protested a Halloween night special event at a local Barnes and Noble featuring books about "pagan witches" (Kisling 1995). The store canceled the event as a result of the protest. In a local high school a student from a fundamentalist Christian background objected to a documentary shown in biology class, which included a brief portrayal of evolution as fact rather than theory. The Denver school board removed the film from the curriculum only to reinstate it after vociferous protest from community members. Parents and Christian groups also went after R-rated films shown to high school students, including *Schindler's List* and Bernardo Bertolucci's film *1900*, as well as school and library books that contain profanity, including *My Brother Sam Is Dead* and *Grendel*. Finally, a Colorado state legislator tried, unsuccessfully, to pass a state law that would ban the sale and/or exhibition of lascivious art. The legislation was motivated by the lawmaker's objections to books of photography by Sally Mann and Jock Sturges that feature photographic nudes of children.

In Dallas citizens and parents fought to have books and magazines removed from the schools and public libraries that featured rebellious children (*The Egypt Game*), gay themes (*Out* magazine), and sexual situations (romance novels). School board trustees wanted to adopt a controversial science textbook that promoted intelligent design and creationism. The local public library refused to display a scheduled exhibit that featured a nude painting. Similarly, in Fort Worth parents objected to the book *David*

and Jonathan because of allusions to masturbation. In addition, they complained about the World War II novel *The Last Mission* because it contained profanity and Maya Angelou's *I Know Why the Caged Bird Sings* because it included references to rape and described "a life of immorality" (Berard 1995c, 1995a). A parent even complained about a statue of a school mascot, a male elk, because it was too anatomically correct. The mother argued that the elk caused embarrassment to herself, her daughter, and other female students. Church officials and citizens launched a highly visible protest against a public sculpture, *Caelum Moor*, which featured an assembly of granite rocks that some critics claimed were satanic and lured pagan worshippers to the city.

In Charlotte church leaders and religiously based activists launched a highly visible campaign against the local production of Tony Kushner's award-winning play *Angels in America*, objecting to the play because it featured frontal nudity and themes of homosexuality. Charlotte citizens and elected leaders also sparred over a film festival that was said to include a "disproportionate" number of gay and lesbian films and a library book titled *The Faber Book of Gay Short Fiction*. The difference between these cities and CCRs is not over the kind of culture that animates conflict. Rather, in cities of contention a mobilized segment of the population is willing to stand up and defend these films, books, and artistic renderings as valuable and worthy of support. For some groups the culture that motivates conflict is a valued component of American life.

Unlike cities of cultural regulation, Dallas, Fort Worth, Denver, and Charlotte also featured a fair number of conflicts originating over more liberal or progressive concerns, including issues relating to race and ethnic relations. In Charlotte an African American minister criticized the local YMCA because of a white-skinned Jesus that hung on its walls. The minister wanted a portrait that more accurately depicted Jesus' Middle Eastern background. Similarly, a Charlotte animal rights activist protested an art exhibit that featured a freeze-dried kitten. In Fort Worth African American religious leaders disapproved of a school textbook containing an offensive quote from a nineteenth-century minister claiming the Bible condoned slavery. Activists also objected to a museum exhibit that "misrepresented" the horrors of slavery. In Dallas parents and community leaders protested a schoolbook called *African Folktales: Traditional Stories of the Black World* because it contained negative stereotypes of blacks. They also complained about a school superintendent's decision to suspend a school-related public access cable channel used by students in a predominantly black school because of a questionable television show titled *Understanding Gays*. In response the

NAACP claimed that denying the students access to the cable station was a violation of desegregation laws. Also in the Dallas school system, a student and her parents challenged a school assignment that required her to read the Bible on the grounds of religious freedom.

In Denver several concerns originated from Latino and Native American communities. In one example several Native American tribes asked officials to change a Civil War memorial that celebrates the Battle of Sand Creek in which more than two hundred Native Americans were massacred. A local radio station owner led a demonstration over a painting in a gallery that depicted Mexican war hero Emiliano Zapata dressed in a white miniskirt and holding a straw book and a box of laundry detergent. In addition, ethnic concerns surfaced in a debate over a sculpture commissioned for the Colorado state capitol designed to honor fallen firefighters. The artist, who was of Latino descent, created a design that featured several Latino firefighters helping a white victim. When the government asked the artist to make the figures more ethnically "neutral," a storm of criticism and protest erupted from the artist, local citizens, and an association of black and Latino firefighters.

To summarize, cities of contention are characterized by rapid social change against a backdrop of traditional values. In many instances of conflict, citizens, feeling embattled and assaulted by a national culture that seems out of step with their conservative beliefs, launched protests against art and entertainment that they felt was obscene, blasphemous, and a threat to their communities and families. Yet these cities, unlike cities of cultural regulation, are more racially and ethnically diverse and have more transplanted residents with differing values and lifestyles. Thus, emerging alongside conservative complaints are a fair number of liberal-based grievances, often revolving around books, monuments, or films that offend racial and ethnic minorities.

Cities of contention have other distinctive qualities as well. First, as noted above, protests often take the form of oppositional movements. In cities of cultural regulation it is hard to find groups willing to take a stand and defend artworks that are attacked. This is decidedly not true in cities of contention. Second, in cities of contention, commentators, columnists, reporters, elected officials, and participants are more likely to characterize and frame conflicts using "culture war" rhetoric, emphasizing divisions— lines in the sand, battles, deep rifts, and fault lines. Third and related, in CCs fiery rhetoric emerges as participants show a willingness to denigrate and belittle the opposing side. Fourth, participants and reporters often link specific protests or complaints to larger issues in the community—whether

over race, electoral politics, education policy, or the larger "culture wars."
Arts conflicts are frequently part of deep-seated tensions and cultural and
social dynamics within a city. Fifth, many conflicts explicitly raise issues
regarding a city's image—its national reputation and trajectory. Citizens
and commentators often seem aware that their communities face a "critical
moment" and that their future is on the line. Finally, public "showdowns"
define several of the cases across these four cities. At some point in the
unfolding conflict, both sides show up at a public meeting for a face-off,
where dozens if not hundreds of citizens attend and many make impas-
sioned speeches. Tempers get hot, and tongues get loose.

Strength and Visibility of Opposition

In cities of contention, few challenges go unchallenged. In the absence
of broad agreement over community standards, residents speak out and
resist what they perceive to be the imposition of one set of values (often
conservative and traditional) on the rest of the community. Often the resis-
tance begins with the "presenters" themselves, as when the director of the
Charlotte Repertory Theatre refused to change the production of *Angels
in America* to address concerns about nudity. In an interview with the lo-
cal newspaper, the director remarked, "It [the play] will go on as written.
Nothing has changed. If there is an arrest [based on public indecency laws],
this could become the Constitutional challenge the law needs. We will not
censor ourselves or harm the integrity of the play." One of the actors in
the production declared that he was "willing to go to jail" rather than see
the play changed or canceled. Pro-*Angels* supporters organized pickets to
counter the anti-*Angels* supporters, both of whom marched in front of the
theater before and during the production. The *Charlotte Observer* published
several editorials that strongly supported the theater and the play. In addi-
tion, local directors and board members of a diverse set of cultural institu-
tions spoke out in favor of the production along with ministers and pastors
of progressive churches and the CEOs of several large Charlotte businesses,
including Duke Power and notable Charlotte-based banks. In addition, the
gay and lesbian community took a visible and public stand, organizing pro-
tests by the Lesbian Avengers, N.C. Pride Action Committee, and the Gay
and Lesbian Employee Association. Affirming the notion that oppositional
groups feed off one another, participants in the *Angels* controversy justi-
fied their involvement based on the actions of the "other side." Leaders in
the gay community acknowledged that because of the controversy gays and
lesbians were more "organized" then ever before. One gay activist said that

the controversy "made me realize that other people have got to start speaking up . . . and let the people in the middle know that being gay is not bad" (Morrill et al. 1998). Another activist remarked, "If they hadn't started it, we would never have been in their faces. We didn't start this. . . . As long as they continue to say things, we're going to be there" (DeAngelis and Brown 1997).

The strength of the opposition was palpable in other contentious cities as well. In Denver when the school board voted to remove a video that contained a reference to evolution as "fact" rather than "theory," board members received an outpouring of angry calls and letters that led them to overturn their decision. Hundreds of citizens signed a petition to save the job of a high school teacher who was fired for showing Bertolucci's R-rated film *1900*. In Forth Worth hundreds of parents and citizens wore green ribbons and showed up at school board meetings to protest the board's decision to remove the book *The Last Mission* from Tarrant County middle school libraries, and three hundred residents signed a petition within a week of the board's decision demanding that the book, which chronicles the lives of a group of Jewish teenagers during World War II, be reinstated. Similarly, when trustees in the Burleson school district of the Fort Worth area banned Alexander Solzhenitsyn's *One Day in the Life of Ivan Denisovich*, there was a "torrent of criticism" from residents who opposed the ban. At a public meeting to discuss the issue the newspaper reported that "parents who supported the ban felt 'overwhelmed' by the other side" (Weissenstein 1997). Business leaders and a newly formed community group, Friends of Caelum Moor, came to the defense of a public sculpture that was under attack by twenty local churches because the sculpture's 540 tons of pink granite monoliths were supposedly linked to Satanism. Many citizens in the Fort Worth area spoke out in defense of the challenged artwork even in the face of well-organized and visible campaigns supported by religious leaders in the community.

In Dallas, when school officials canceled a school group's visit to Disney World in response to pressure from the local chapter of the Christian Coalition, thirty parents met with district officials and demanded that they reverse their decision. In Plano, Texas, part of the Dallas metropolitan area, parents formed a new group, Keep Quality in Plano Schools, to oppose efforts by the school board to add a creation science–oriented textbook to the high school curriculum. After trustees were "flooded" with mail and phone calls (one board member said he received more than seventy calls on the issue), they unanimously voted to bar trustees from purchasing copies of the controversial book. This pattern of strong, organized opposition to

perceived censorship, largely absent in cities of cultural regulation, is a defining aspect of cultural conflict in cities of contention.

Battle Lines

Across the four contentious cities, observers and participants repeatedly used culture war language to describe the conflicts taking place in their communities. The *Charlotte Observer* variously described the dispute over *Angels in America* as a "preemptive strike," a "blow up" with plenty of "sound and fury," a "polarized debate," and a "bitter controversy" during which participants "took off their gloves" and exchanged "barbed letters" in the "nastiest political drama in local history" (see T. Brown 1996a and 1996b as an example). More directly and almost torn from a page of James Davison Hunter's book, the newspaper noted that the *Angels* conflict indicated that "Charlotte's culture war is far from over. The debate was the most recent skirmish in a struggle between religious authority and individual freedom" (*Charlotte Observer* 1997). Images of warfare were tossed around by participants in the conflicts themselves. The artistic director of the Charlotte Repertory remarked, "This battle has got to be fought for Charlotte to get to the next artistic level" (Williams, Brown, and Wright 1996). Such sentiments were echoed by a local businessman who supported the theater: "This is a battle, and it's not over. They picked this fight. Already, they have shown they don't have a stomach for it. And we haven't even started" (DeAngelis and Brown 1997). On the other side, a county commissioner who was critical of the play noted that the conflict was creating a "division that was tearing apart the fabric" of the Charlotte community (DeAngelis and Smith 1997).

In Dallas the struggle over the high school textbook *Of Pandas and People* was described using culture war imagery, with the newspaper noting that the two competing sides were "actively looking for people who will help them win the ideological war in Plano schools" (Barrionuevo 1995). Similarly, in Fort Worth conflict over the middle school book *The Last Mission* raised the specter of warring factions. The *Star-Telegram* claimed there was a "line in the sand" separating "the foul-mouth, course meanderings of singers, songwriters, authors, entertainers and other public officials" and the supposedly upstanding and decent members of the community. The newspaper placed the dispute within the larger culture wars, writing, "But the modern-day culture war knows no boundaries. And the latest pop-culture skirmish in the war now happens to fall upon one of Texas' finest school districts" (Raben 1995). After convincing the school board to ban *The Last Mission*, the activist

group Parents Advocating Greater Education (PAGE) noted that the group would continue its struggle to fight for decency. "The battle isn't over. . . . There are other books," said one of the group's leaders (Berard 1995b). Another parent noted, "I've never believed in conspiracies. But this is so pervasive, so profound. I believe there is a real war going on, and I think we're about to get into it" (Berard and Bowen 1995). An opinion columnist described the conflict in similar terms, as a kind of battle between two incompatible positions, "If you believe that words themselves are evil, then line up behind Vaunda Whitacre [parent who initially complained] and check every word in every book. But if you believe, as I do, that words are only important within their greater context . . . that words themselves are not evil, only ideas are . . . and that the idea of censorship for everybody is one of the greatest evils, then line up on the other side. Either way, pick a side. This really is war" (Lieber 1995). The notion of polarization and division was also employed by a newspaper columnist in Fort Worth to describe the conflict over a contested mural painted by a group of Hispanic students, noting that the conflict was "turbulent," fostering "heated debate between white and Hispanic residents, between grown-ups and teenagers, and between neighborhood homeowners and shopkeepers who cater to the Berry [a Hispanic neighborhood] counterculture" (Kennedy 1997).

In Denver a reporter for the *Post* described a public meeting where school board members considered banning a high school film about evolution as a "lion's den," noting that there "was a ferocious atmosphere" and "the troops arrived and the battle was joined" (Makkai 1996). Unlike cities of cultural regulation, activists and observers in cities of contention were quick to characterize their disagreements as epic struggles, drawing on a full arsenal of war-related images and metaphors to make their points.

Name-Calling

When groups fight over the moral high ground in an effort to assert what is good, right, and just for their communities, it becomes tactically important to undermine the legitimacy of opponents. This is done by questioning motives, characterizing the other side as extremists, and connecting opponents to discredited groups and ideas.

For example, in Fort Worth a dissenting school board member who voted in favor of keeping the book *The Last Mission* in the middle school library discredited fellow board members by linking them with fringe elements of society. He asked, "What's going to happen when the next group of skinheads comes by and say they want certain books banned?" (Berard

1995c). A defender of the ban, who also opposed educational reform and "whole language" teaching in her school district, remarked, "I don't know if you can link it [reform] with communism, but there is a thread there" (Berard and Bowen 1995). In the case dealing with the "graffiti art" mural by Hispanic teens, a white resident stood up at a town meeting and described the Latino kids' break dancing as "appalling." She explained, "Hispanic boys were standing all over the sidewalk!" and added that the mural was an act of "vandalism" (Kennedy 1997). Linking youth to crime and deviance and characterizing their behavior as "appalling" served as a rhetorical tactic in the battle to claim the moral high ground.

In Charlotte, especially surrounding the *Angels* controversy, harsh words were exchanged from the very beginning. A reporter noted that "both sides of the debate have circled warily, slinging words instead of swords: obscenity and indecency; hypocrisy and censorship; criminal; slanderer; pervert; neo-Nazi; mean-spirited; narrow-minded; intolerant; bible thumpers; and 'nippy arts bureaucrat'" (Conrad 1997). In a letter to the editor, one local pastor described supporters of the play as people who "appreciate nudity, simulated homosexual acts, vile and vulgar language and Sodom and Gomorrah–type morality." He went on to say that "clean-minded, holy and righteous people" should stay away in order to avoid moral degradation (Willis 1996). One of the commissioners who opposed the play remarked that homosexuality is a "problem" and continued, "If I had my way, we'd shove these people off the face of the earth" (Hurley 1997). On the other side, a pro-*Angels* supporter wrote to the *Charlotte Observer* and described the activism of one local minister in the following way: "He and other small-minded people promote some of the true evils in our society: hate, bigotry and intolerance of others' beliefs" (Derhodes 1996). Another writer noted that "the greatest danger to society comes from the religious crusaders bent on the homosexual holocaust" (Nuzzo 1996). A county commissioner who supported *Angels* compared his fellow commissioners to those in Nazi Germany who "began to identify the Jews and other groups that didn't fit their idea of what was ethical and moral and what represented traditional values at the time" (Kelley 1997).

In Dallas parents who were opposed to a gay magazine in the public library referred to homosexuality as an "abomination" (Becka 1997), and in Denver when a review committee agreed to remove a pro-evolution video from the high school biology curriculum, citizens attacked both committee members and the families who raised the original complaint, calling them "religious fanatics," "know nothings," and "pushy ideologues" with "narrow-minded beliefs" (Posavec 1996). In cities of contention, church

leaders from different denominations trade sharp barbs, fellow county com-
missioners attack one another, and neighbors question one another's mo-
tives and sense of decency.

Web of Connections

Theories about the culture wars suggest that there is a web of concerns con-
necting what might appear on the surface to be unrelated issues, includ-
ing arts and culture, education reform, abortion, gay rights, and popular
entertainment (Hunter 1991). After Pat Buchanan announced at the 1992
Republic National Convention that America was in the midst of a culture
war, journalists and activists alike have been quick to group together a di-
verse array of social and cultural conflicts as evidence of Buchanan's claim.
As Hunter describes it, the issues motivating activists in the culture wars
are rooted in differing worldviews—fundamentalism and orthodoxy versus
secularism and relativism. Cities of contention stand out from other kinds
of cities in the extent to which activists link conflicts to larger issues facing
the nation or their communities.

Many protesters linked arts conflicts to a "gay agenda" that stood in
opposition to American "family values." Others more broadly claimed that
the "wrong" culture has the power to undermine American life. Charlotte's
Rev. Joseph Chambers, a stalwart opponent of *Angels in America*, said that
the play is part of a larger group of events that "should be an example to all
traditional Americans of what the radical gay community and those who
support them intend for this nation." He added, "This drama is not about
art or eight seconds of nudity. It is about the destruction of moral conscious-
ness" (Chambers 1996). Harry Reeder, a local Charlotte minister, wrote an
opinion editorial claiming that the arts community promoted "an aggres-
sive cultural agenda that is absolutely committed to the total reconstruc-
tion of our culture" (Reeder 1997). In Denver a teacher who was fired for
showing an R-rated film to high school students—Bertolucci's *1900*—linked
the disciplinary action to "an anxious community worried about seemingly
out-of-control children, low academic scores, increasing banality of popular
culture as seen on the Springer show, and as seen in the media" (Simpson
1998).

In addition to concerns about the "gay agenda" and general moral de-
cay, several conflicts were linked to fears of secular humanism creeping into
the classroom. In Fort Worth the attack against the book *The Last Mission*
was made from the same group (PAGE) that also opposed critical thinking,
cooperative learning, multiculturalism, and whole language learning. The

battle over *The Last Mission,* which contains profanity, became an opportunity to oppose educational materials and teaching styles understood as undermining traditional education. As noted above, members of PAGE linked the book controversy to notions of "critical thinking," dangerous ideas of "liberating children" from their parents, and the broader influence of "communism." The conflicts over books in Forth Worth also revealed the fear that national outsiders, for example, "liberals" representing the federal government, were trying to impose their values on local schools. In one exchange when a school board member defended the selection of library books—including *The Last Mission*—by pointing out the professional training of school officials, parents erupted with boos and jeers, dismissing the judgment of national experts. In Dallas parents objected to the school board's decision to adopt a textbook, *Of Pandas and People,* that discusses intelligent design and creationism. The supporters of the textbook had previously taken public stands to ban condom demonstrations in biology classes and to support a school board resolution affirming the importance of "traditional moral values" in the classroom. Members of the Citizens Alliance for Responsible Education, who supported the creationism textbook as well as a "traditional values" resolution, argued that a "larger agenda" was at stake. One activist noted that "Plano's long-held reputation for excellence was being infected by national trends," including those that were "pushing elementary school children to do critical thinking," which "leads them to develop values different from their parents" (Barrionuevo 1995). Debates about the biology textbook were clearly embedded in a larger web of issues dividing the Plano school district in Dallas.

Several of the conflicts across the four contentious cities were linked to larger issues of race and diversity. In Fort Worth parents asked to have Maya Angelou's *I Know Why the Caged Bird Sings* banned from a middle school library because the book contained scenes of rape, lesbianism, premarital and extramarital sex, and profanity. Yet some residents felt that the conflict over the book was linked to broader racial struggles in the community. An African American school board member explained, "I subconsciously have to wonder: Could it be the uproar over this is because it is African American in nature?" An African American parent added, "If Southlake [a suburb of Forth Worth] wants to embrace every one of our cultures, this ban is not the move to make" (Berard 1995d). When a local African American minister challenged a state-adopted history textbook because it contained what some considered a "proslavery" passage, he linked the issue to an ongoing concern about the lack of "African American representation at the executive level in the school district" and the lack of racial diversity on the cheerlead-

ing squads in local schools (Lee 1996). When residents objected to a mural painted by Latino students, the conflict brought up deeper concerns about ethnic tolerance. One resident declared at a town hall meeting, "I don't appreciate the police treating Mexicans as second-class citizens" (Ruiz 1997). What distinguishes cities of contention from other cities is that protests are lightning rods that animate broader tensions and disagreements over sources of moral authority, feelings about pluralism and diversity, and visions of community.

Crossroads and Crosstalk

Residents in cities of contention were often locked in bitter disagreement over the future of their communities. As discussed in earlier chapters, cities that experience rapid population change and growing diversity are more likely to fight over art and culture. In Charlotte, Dallas, Fort Worth, and Denver—where population changes were dramatic in the 1990s—activists and the news media often linked arts conflicts to their community's struggle to define and defend its values and vision in the face of change. Residents in these cities found themselves at a "crossroads," and decisions to remove or restrict books, plays, and exhibits were seen as decisive moments in setting the community on one path (characterized by decency and respect for traditional values) versus another (characterized by free expression, cultural vitality, and progressivism).

As described above, the teacher who was fired for showing Bertolucci's *1900* to his high school class in a Denver suburb was quoted as saying that the conflict was a "lightning rod for an anxious community worried about seemingly out-of-control children" (Simpson 1998). In Fort Worth when *The Last Mission* was initially banned, a columnist made reference to the city's population growth when he noted that "the act [removing the book] seemed so unexpected, so out of character with the progressive bedroom community's handling of its fantastic growth so ably" (Lieber 1995). This is precisely what is at stake in many arts controversies—the changing "character" of the community. Clearly, in Fort Worth many critics felt that certain "progressive" ideas of education were out of character for the community. A front-page headline in the *Star-Telegram* read: "Residents Faced with Growth, Image and Educational Decisions" (Mullen 1995). Spilling over from education to public art, the debate over the *Caelum Moor* sculpture was also about community change and the image of the city of Arlington (part of the Fort Worth metro area). Residents who decried the sculpture as satanic were concerned about the city's image. One person explained,

"To me it is very offensive to be known as a town that has statues that are demonic" (Gonzales 1997). Echoing this sentiment a local pastor explained, "Our perspective is that the best for our city is Christian faith and Christian principles, even for those who don't believe" (Doclar and Brady 1996). On the other side, art enthusiasts, business leaders, and others claimed that the sculpture was a "gateway" for a growing, progressive community (Hardee 2000). The newspaper editorial board noted it would be an "embarrassment" if the city removed one of its most prominent pieces of commissioned art (*Forth Worth Star-Telegram* 2000). For many residents and officials, Arlington's future as a traditional or progressive community hung in the balance as the city debated whether to accept or reject a piece of visible public art.

In Charlotte the controversy over *Angels* was repeatedly framed as a struggle over the future of the community. The *Charlotte Observer* editorial page described the city as being at a precarious crossroads with regard to the arts, diversity, and community standards: "This is an increasingly diverse community, still growing and still growing up. Tolerance, being a two-way street, perhaps the best we can hope for is a necessarily uneasy consensus in favor of a necessarily precarious balance. Anything more would force the arts into a box, where they could not flourish and nourish this community—or, at the other extreme, squelch the expression of moral concerns at a time when, in a much larger sense, moral concerns have never been more relevant or more urgent" (*Charlotte Observer* 1996).

Throughout the *Angels* controversy, participants on both side seemed to cry out, in the words of the famous 1950s television game show *To Tell the Truth*, for the "real" Charlotte to "please stand up." One columnist put it this way:

> Charlotte has become the very model of a new Sun Belt City—clean, progressive, tolerant, efficiently governed, prosperous—envied, admired and emulated. Then, in a single week, a majority of county commissioners thumbed their noses at tolerance, and at the community's arts, cultural, business and civic leadership. Suddenly, people were asking: Is this a real turning point, a permanent change? But, there's no evidence that the city and its people have fundamentally changed, or that Charlotte has stopped being Charlotte. (Shinn 1997)

In letter after letter and quote after quote, people referred to Charlotte as an "up-and-coming city," a city that has finally rid itself of its constricting "Bible Belt," a city that is "emerging and enlightened," a "progressive

city." These images stand in contrast to a city that prefers the "Dark Ages," a Bible Belt city that has been "tightened to a constricting and embarrassing straitjacket" (Calabrese 1996), or a place where "yahoos sit on porches in suspenders, felt hats and rocking chairs, shelling peas" (Rothrock 1996). Charlotte mayor Pat McCrory, in describing the conflict over *Angels* as well as a related protest over ads for strip clubs featured in the city's visitors' guide, suggested that the controversies served to "spotlight the moral debate emerging as the city grows." University of North Carolina–Charlotte geography professor Alfred Stuart added, "Like the debate this year over the nude scene in 'Angels in America,' the ad flap is part of Charlotte's struggle to define itself. We are seeing a piece of the larger picture of growing pains as we move from small-town Charlotte to cosmo-Charlotte. There is a kind of cultural frontier out there. We're still struggling to hold on to old values and accommodate new values and new people" (Hopkins 1996).

While the sign at the crossroads is clear, the right direction is not. Many felt like change came too quickly and at too great a cost. Commissioner Bill James wrote, "To put it bluntly, diversity is okay, but perversity is not. You and some of your friends may wish to promote an enlightened new south, but I have no intention of allowing Mecklenburg County to become the southern equivalent of moral sewers found elsewhere in the U.S." (Feeley 1997). A GOP activist acknowledged that times have changed in Charlotte, requiring new boundaries and new "lines" demarcating acceptable behavior: "The tides of time have a way of washing away that line. And the line has to be redrawn over and over and over again in order to see how far we've come and how far we have to go" (Summa 1998). The one area of consensus surrounding the *Angels* controversy was that whatever the outcome, it was, in the words of one county commissioner, "a defining moment in the history of this community and we are about to find out who we really are" (Kelley 1997).

Showdowns

In cities of cultural regulation, as noted above, there was relatively little opposition or push back against attempts to restrict art and culture. When there was resistance, it typically came in the form of lawsuits by professional activists representing civil liberties groups. While these lawsuits were often long and drawn out, they seemed to have the effect of siphoning away some of the heat and fury from a controversy. In cities of contention, in contrast, the most visible disagreements typically reached an emotional crescendo at a public showdown. Charlotte's showdown took place when seven hundred

residents flooded a county commissioners' meeting to argue for and against cutting funding to the city's arts and sciences council. In Denver "more than 300 people tried to cram into a board room that seats only 230" on the evening that the school board debated whether or not to ban a pro-evolution science film (Bingham 1996). In Fort Worth hundreds of residents showed up to a school board meeting wearing green ribbons to show their opposition to censorship and their support for both *The Last Mission* and Angelou's *I Know Why the Caged Bird Sings*. At a Fort Worth town hall meeting, more than 180 angry residents gathered to discuss the fate of the "graffiti art" mural. When the Dallas school superintendent canceled a student-produced television program because of an interview with a transgendered person, more than fifty people showed up at a school board meeting to complain that the decision—affecting a largely black school—was racist. Protesters packed the small board meeting, shouting and chanting and forcing the board to adjourn and reschedule its meeting. More than one hundred people showed up at the council meeting of the city of Lewisville (within the Dallas city limits) to argue over whether the local library should be allowed to carry a gay newsmagazine. Finally, when the Plano, Texas, school board met to discuss adopting a creationism textbook, more than two hundred people showed up at what was described as a "chaotic" meeting, full of "angry residents" who were shouting and blurting out comments. There is no evidence that any of these public showdowns led to violence or arrests. They were, perhaps, relatively civil and tame compared to some of the more strident protests that animate recent American political history—from civil rights to abortion. Yet compared to most other cities, especially cities of cultural regulation, Charlotte, Denver, Forth Worth, and Dallas stood out for the frequency and intensity of public showdowns over art and culture. In these places opponents and supporters of art, books, and films were willing to step up and stand out, bending the ears of public officials and meeting each other in the proverbial public square to bear witness to their cause and concern.

Cities of Recognition: San Francisco, Albuquerque, San Jose, and Cleveland

At the beginning of my freshman seminar on cultural conflict, I instruct the students to write down something they deeply value—a way of life, a philosophy, or a belief—that impinges on public life and about which people disagree. Some students list their belief that "protecting the environment" and living a "green life" is a moral imperative; or that abortion is always wrong; or that marriage is a right that should be available to everyone, regardless of sexual orientation; or that "the word of God" is absolute. Then I ask them to write down a social group with which they most identify—the group that defines, in large measure, how they think of themselves and how they represent themselves to others. Some students list their race or ethnicity, others their country of origin or their religion, and still others choose more temporary and contingent groups like their sorority or fraternity. I continue with the exercise: "Imagine that someone wants to erect a monument in the middle of campus that denigrates the value you most hold dear." Then I ask, "What if the monument instead presents an offensive stereotype of the group with whom you most identify?" "Which monument," I ask, "would you feel most inclined to speak out against? Which monument would inspire you to join a protest, write a letter, or march to the chancellor's office to demand that the monument be removed?" The exercise reveals that insults to identity are often more salient, more powerful, and more troubling than insults to "values." Students, it seems, think they can more easily live with public symbols that present opposing values (even when those values are antithetical to something they believe strongly in) than symbols that attack their personhood or identity. Of course, the two concepts are not distinct. A person's values often emerge from or are linked to group memberships. Nonetheless, when forced to artificially distinguish

between the two—identity versus values—offense is more likely to circle the wagons of identity. In group discussions another crucial issue emerges. Students' willingness to "tolerate" the offending monument varies across identity groups. Some identities provoke greater emotion and more intense reaction than others. In particular, students who identify with groups that face prejudice, stereotyping, or other forms of stigma—ethnic and religious minorities, for example—are more acutely sensitive to insult. It is precisely these threats to personhood and identity that take center stage in *cities of recognition* (CRs)—San Francisco, Albuquerque, San Jose, and Cleveland.

The notion of recognition—or more precisely the politics of recognition—emerges from a rich literature on identity politics and multiculturalism. Political philosopher Charles Taylor (1994) uses the term "politics of recognition" to argue that the government has a responsibility to accommodate the needs and interests of "groups" above and beyond those of individual citizens. Traditional liberal democratic philosophy—in the spirit of Thomas Hobbes, Emanuel Kant, John Stuart Mill, and John Locke—views "individual rights" as the essential foundation for law and government. From this perspective, all individuals are created equal, endowed with inalienable rights and the freedom to pursue their fullest human potential as citizens and workers. According to Taylor though, such "universalistic" criteria—treating all individuals equally based on a common humanity—fails to acknowledge that individuals belong to groups and that group identity is essential to full and equal democratic participation. In short, Taylor argues that an individual's sense of self is formed in relation to their group membership. When a group is misrecognized, misrepresented, or demeaned in some way, individuals who belong to that group experience an identity crisis in which their status, self-worth, and citizenship is challenged. As Nancy Fraser argues, "To belong to a group that is devalued by the dominant culture is to be misrecognized, to suffer a distortion in one's relation to one's self" (2000, 109). Thus preserving and protecting the culture and identity of groups might be necessary to ensure full and equal political participation.[1] The politics of recognition calls for members of "misrecognized" groups to reject dominant images and advocate for self-representation, in effect replacing negative depictions with a self-affirming culture.

In cities of recognition, groups seek an accurate and fair representation of themselves in their city's arts and culture. Unlike Taylor, in this chapter I avoid engaging in debate about the stakes of political representation. For example, I do not claim that eradicating a city of offending images of gays and lesbians will necessarily make gay and lesbian individuals more effective or engaged citizens. Nor do I make a normative claim that group rights

should be considered alongside individual rights. Instead I simply accept Taylor's basic premise that putting forward an "authentic" identity—free of stigma and stereotypes—motivates historically marginalized groups, especially those who live in "hyperplural" and diverse cities like Albuquerque, San Francisco, San Jose, and Cleveland, to protest art and culture.[2]

Sociologists have long argued that subordinate groups in society can exercise power by taking control of the meaning or interpretation of public symbols and cultural presentations such as books, songs, fashion, and media images. Through the creative appropriation of art and media, working-class youth have protested the futility of their class position, women have resisted the abuses of patriarchy, ethnic minorities have protested bigotry and prejudice, and gays and lesbians have forged an identity against a backdrop of marginalization and invisibility (Dubin 1992; Taylor, Rupp, and Gamson 2004; Leblanc 1999). In cities of recognition, when a book, painting, film, sculpture, parade, or monument depicts what might be considered an unflattering, inaccurate, exaggerated, or underrepresented portrait of a social group, members of the group fight to correct wrong impressions, elevate their voice and presence, and otherwise "tell their story." Thus protests over art and culture are part of a long history of attempts by marginalized groups in society to resist dominant narratives and assert their own version of who they are and how they would like others to recognize them.

In addition to the social psychological ideas of self-worth and representation, this chapter also draws on the idea, discussed briefly in chapter 5, of a "new political culture" in postindustrial cities (Clark and Inglehart 1998; Sharp 2005a). Robert Bailey (1999) writes "clashes over identities, values and cultural attributes have taken center stage on the urban agenda" (11). As the demographics within cities skew toward a younger, well-educated, highly mobile, diverse, and creative workforce (centered on technology, new media, law, and financial services), traditional class-based, distributional politics are giving way to identity politics. Rather than arguing for better housing, greater investment in education, or improved working conditions, citizens are often joining together across class lines to advocate for lifestyle issues that tap into their distinctive sense of identity. Kauffman (1990) notes: "Identity itself—its elaboration, expression, or affirmation—is and should be a fundamental focus of political work" (67). New social movements are formed around environmental issues (slow growth, bike paths, "green" building codes); gender and sexuality (gay marriage and women's rights); and ethnicity (multicultural curriculum in public schools). The new political culture also includes religiously based and conservative movements (from prayer in school to English-only campaigns), although most scholars

focus on more liberal and progressive causes. Cities of recognition share many of the characteristics of those cities that exhibit a new political culture; with the exception of Cleveland, the other three CRs (San Francisco, Albuquerque, and San Jose) are quintessential postindustrial American cities—fluid, global, diverse, cosmopolitan urban centers. To the extent that many conflicts in these cities arise from the affirmation of group identity through cultural expression and protest—with people fighting over symbols, language, and meaning rather than material goods and services—we can link these conflicts to the larger changes transforming urban politics in the twenty-first century.

As noted in chapter 2, scholars have written persuasively about the link between arts conflict and identity politics. Steven Dubin (1992) claims that historically disadvantaged groups attack school curricula, museum exhibitions, films, and books as a visible way to demand wider recognition and acceptance. Dubin documents dozens of such protests: Latinos in the Bronx launched a campaign against the film *Fort Apache*, which depicts Latinos as criminals, gang members, and thugs; blacks in New York City protested an exhibit at Artist Space featuring a series of abstract images titled *The Nigger Drawings*; Asian Americans were incensed over the lack of Asian actors playing leading roles in the Broadway show *Miss Saigon*; Arab Americans protested against a song by the Cure based on the Albert Camus novel *Killing of an Arab*; Jewish audience members have repeatedly voiced concerns about unflattering and anti-Semitic depictions of Shylock in Shakespeare's *The Merchant of Venice*; and the National Stuttering Project put pressure on filmmakers to reduce the scenes with a stuttering character in the film *A Fish Called Wanda*. Many of the identity-based controversies recounted by Dubin were staged at the national level and reflect the organizational muscle of various well-established anti-defamation groups, but many of these conflicts also have a local dimension. Across the seventy-one cities in my sample, I find that identity politics is more prevalent in some locales than others. Where diversity and multiculturalism shape the political culture of a city, a higher proportion of protests involve identity and recognition.

Like Dubin, Erika Doss (1995) considers the link between identity politics and arts conflicts. Doss describes a controversy over a proposed mural in the Los Angeles neighborhood of Little Tokyo. The mural, by Barbara Kruger, was to be painted on the outside wall of the Museum of Contemporary Art and was to include a series of expressions within a rectangular banner that resembled the American flag. The mural included sections of the

Pledge of Allegiance along with statements about democracy and economic power, such as "Who is bought and sold? Who is beyond the law? Who is free to choose? Who salutes the longest?" Kruger's intention was to question whether the rhetoric of "patriotism" masks issues of social justice, racism, and economic power. To Kruger's surprise, the local Japanese American community reacted vociferously against the mural, claiming that the Pledge of Allegiance was a bitter reminder of loyalty tests used in internment camps during World War II. Again and again, residents complained that the mural was a "slap in the face," an "unnecessary reminder," an "insult," a "malicious defamation," and "salt rubbed on an open wound" (Doss 1995, 1–11). Doss contends that the reaction of Japanese Americans, in part, arose from Los Angeles's extraordinary levels of multiculturalism. According to Doss, in Los Angeles there "are no commonly held values and views about the meaning of democracy, citizenship, individual rights" (238). The complexities of the multicultural public sphere make controversies over art inevitable. In such environments, groups compete for recognition, seeking to have their story represented fairly and prominently rather than what might randomly emerge in a cultural free-for-all. Interestingly, hyperpluralism does not create a live-and-let-live mentality, as sociologists might expect in dynamic, fluid, and cosmopolitan urban centers. Instead, groups adopt a "tell it this way or no way" approach to culture, especially when the culture in question connects to their core identity.

Conflicts in both cities of cultural regulation and cities of contention often involve issues of identity, but they are less often expressed in terms of group identity. Religious people may object to a play or book about homosexuality because it offends their identity as Christians, but the conflict gets framed not as an issue of group representation but rather as a dispute over values, community standards, or the city's reputation or national image. The city and community are the primary objects of concern rather than how a particular group is represented or perceived within the city. In cities of recognition, by contrast, the conflict itself is framed specifically in terms of group identity. Citizens protest art and culture in an effort to stand up for their group and to achieve recognition and respect along with visibility.

These battles for recognition and respect appear disproportionately in the four cities taken up in this chapter. Across the four cities there was an average of 7.2 grievances over art and media considered offensive to ethnic groups, religious minorities, women, and homosexuals, compared to just 3.5 and 0.5 protests for cities of contention and cities of cultural regulation, respectively (see table 6.1). More importantly, whereas conservative grievances

are four times more likely than liberal concerns to dominate conflict in CCRs and CCs, in cities of recognition conflicts rooted in liberal concerns are as prevalent if not more common as conservative-based appeals.

As is the case in cities of cultural regulation and cities of contention, demographic factors influence the nature of cultural conflict in CRs. Table 6.1 illustrates that San Francisco, Albuquerque, San Jose, and to some extent Cleveland are much more diverse than the other two categories of cities. CRs have a greater degree of racial and ethnic heterogeneity, larger populations of artists, and rank higher on the cosmopolitan index. In addition, cities of recognition are significantly less conservative than cities of contention and cities of cultural regulation.[3] The diversity, cosmopolitanism, and progressiveness of cities of recognition shape the conflict that unfolds over art and culture in these communities.

San Francisco is perhaps the poster child for multiculturalism and progressive politics. "San Francisco values" has become a code phrase used by conservative politicians to disparage opponents who are accused of "being out of touch" with mainstream society. For example, in an online fundraising pitch, former Republican House Speaker Newt Gingrich warned that everything conservatives have worked so hard to accomplish could be "lost to the *San Francisco values* of would-be speaker Nancy Pelosi" (Garofoli 2006). Gingrich and others link such values to sexual permissiveness, the "gay lifestyle," the "coddling" of illegal immigrants, and secular humanism. San Franciscans celebrate their values and point to their spirit of tolerance, ethnic diversity, and expansion. Not surprisingly, Pelosi, maligned above by Gingrich, has deemed San Francisco the capital of the progressive movement in America. Political scientist Richard DeLeon captures the city's unique culture when he writes, "San Francisco is an agitated city, a city of fissions and fusions, a breeder of change and new urban meaning. It is a spawning ground of social movements, policy innovations and closely watched experiments" (1992, 2). In 1980 San Francisco was ranked as the nation's most ethnically diverse large city (Deleon 1992, 14). By the 1990s more than 50 percent of the population was nonwhite. Asian immigrants are the largest segment of the growing metropolis, settling on the West Coast from mainland China, Vietnam, Taiwan, Hong Kong, Cambodia, Burma, the Philippines, Japan, and Korea. This emerging multiculturalism has spurned what Bailey calls the "language of identity," which exists in many major cities but has taken a "grand turn" in San Francisco (1999, 329).

Nearby San Jose, located in Santa Clara County, mirrors San Francisco's ethnic makeup. In Santa Clara County according to 2000 census figures, foreign-born immigrants and their children are 61 percent of the popula-

tion. The county is home to people from 177 of the 194 nations in the world. The largest immigrant and refugee populations come from Mexico, Vietnam, China, India, Iran, and the Philippines. There is also a large local multi-ethnic Islamic community. Fifty percent of households in Santa Clara County speak a language other than English. San Jose, a multi-ethnic city since its founding as a Spanish colonial outpost, has rapidly emerged as one of the most diverse places in the United States (Moriarty 2004). The city's 1970s population was over 80 percent non-Latino whites; today this group makes up less than 30 percent of the city's residents. Approximately one-fifth of the city's current population is Latino, and one-fourth is of Asian descent. The diversity index for San Jose, like San Francisco, indicates that there is a 70 percent chance that any two residents selected at random will belong to different racial/ethnic backgrounds.

San Jose is not at the cutting edge of progressive politics—like San Francisco—but it does have a long history of promoting its multi-ethnic heritage. In the 1960s the city promoted downtown development and tourism by investing in its history as one of the earliest Spanish settlements. This strategy involved reviving La Fiesta de las Rosas parade and uniting the pan-Hispanic community around a mythical shared Spanish ancestry. Identity politics intervened when Chicano activists rejected the city's "unifying story" and boycotted the parade, which they felt "misrepresented" the history of Mexicans and mestizos who built the city under Spanish colonial rule. In a declaration evocative of contemporary identity politics, activists declared that they "were no longer going to turn the other cheek to insults. . . . [W]e know and understand ourselves, our history, better than anyone else" (Rodriguez 1999, 94). The politics of representation was established early in San Jose's history and is intimately related to its emergence as a multicultural community.

Like San Jose and San Francisco, Albuquerque also promotes its multi-ethnic background and rich Pueblo Indian and Hispanic traditions as a way to build civic pride and attract new businesses and tourists. By the 2000 census, non-Hispanic whites were no longer a majority in Albuquerque, representing just 47.7 percent of the population. Hispanics comprised 41.6 percent of the city's inhabitants. While the Native American population is numerically small (2.6 percent), people often refer to Albuquerque as a tricultural city because of the strong cultural presence of Pueblo tradition, represented by nineteen different Pueblo tribes in the Albuquerque metropolitan area. The city actively embraces its multi-ethnic heritage, incorporating multiculturalism into citywide policies related to education, housing, and the arts. For example, the 1995 Albuquerque cultural plan

specifically "promotes the *diversity* and quality" of Albuquerque's "hidden cultural life" (Arts Alliance 2001).

Compared to San Francisco, San Jose, and Albuquerque, Cleveland has a very different ethnic profile. While much more ethnically diverse than the other two Ohio cities in my sample (Cincinnati and Dayton), Cleveland's diversity index does not resemble the West and Southwest cities discussed here. Cleveland has, however, been an important destination for the migration of southern blacks throughout the twentieth century. African Americans comprise close to 20 percent of the metro area's population in 2000 and close to half of the center city's population. While relatively small, Cleveland still boasts of a diverse multicultural heritage, home to 117 ethnic groups speaking more than sixty languages and one of the largest concentrations of Jewish Americans in the nation. Above and beyond its racial and ethnic profile, Cleveland, like San Francisco, has a history of progressive reform movements. Cleveland was at the epicenter of the women's movement in this country in the nineteenth and twentieth centuries. It organized the first state-based suffrage association in the nation, one of the largest women's labor movements, and the first women's pacifist association advocating for the end of war in 1924 (Scharf 1986). Cleveland was also at the "leading edge of liberalism" with regard to race issues for much of the twentieth century (Wye 1986, 135). As historian Christopher Wye notes, "Among cities of equivalent size and time, the Forest City [Cleveland] almost always offered black citizens an urban context that was in the vanguard of prevailing liberal sentiment" (1986, 114). To the extent that race and gender factor into contemporary identity movements, Cleveland has a track record of mobilizing and activating citizens around issues of political and cultural representation.

Importantly, all four cities of recognition have impressive records of electing ethnic minorities to important local offices. Cleveland elected Carl Burton Stokes in 1967, the first African American mayor of a major U.S. city. Since that historic election, "the city's mayors have seemed to reflect every hue of the racial and ethnic spectrum, except white Anglo-Saxon Protestant" (Van Tassel and Grabowski 1986, 179). In 1995 San Francisco elected its first African American mayor, Willie Brown, who previously served as one of the first black elected state assemblymen. San Franciscans also elected the first openly gay man to public office in America, voting Harvey Milk on to the board of supervisors in 1973. San Jose elected California's second Latino mayor, Ron Gonzales, in 1998, and Albuquerque elected one of the nation's first Latino mayors, Louis Saavedra, in the early 1990s. These political victories are important in two respects. First, they are an indication

of the liberal and progressive political cultures of these four cities. Residents of San Francisco, San Jose, Albuquerque, and Cleveland can proudly boast that their cities have been at the forefront of progressive racial and ethnic politics, bolstering their identity as tolerant and inclusive places to live. Second, success in the political arena typically follows a period of growth in the density and scope of ethnically focused institutions and organizations—from businesses and churches to newspapers, civic associations, community centers, language schools, civil rights associations, and various interest groups. This associational infrastructure is an important resource for mobilizing members of an ethnic community around political issues, including elections. A preexisting associational infrastructure can help turn a private offense into a public protest. Such associations serve as sites for debating an issue, exchanging information, organizing protest activity, and supplying necessary resources to mobilize the community. Myria Georgiou notes that it is through such organizations that the politics of representation get "mediated, incubated and mobilized" (2006, 288).

Some political theorists argue that a "politics of recognition" precedes "real" political power, like winning elections or influencing public policy. In fact, Taylor (1994), Fraser (2000), and others claim that without a strong and positive sense of identity, groups who have been "misrecognized" and who suffer negative cultural identities will lack the confidence and respect needed to enter the public square as equal members of the political community. Recognition precedes full political representation. However, in our cities of recognition, the achievement of political gains may actually precede—or at least occur alongside—attempts by minority groups to demand proper recognition. As Robert Merton wrote, "When a once largely powerless collectivity acquires a socially validated sense of growing power (for example, through political gains), its members experience an intensified need for self-affirmation" (1972, 11). In other words, respect may lag behind power. Even while electing mayors and council members, minority groups continue to experience demeaning images of themselves in popular media, books, and fine art. At the national level the election of Barack Obama as the country's first African American president will not suddenly obliterate distorted and distorting images of blacks that continue to circulate in mainstream culture. My suspicion, however, is that the election will activate a new round of identity politics as African Americans seek an inclusive and representative cultural democracy to go along with an increasingly pluralistic political democracy.

In sum, cities of recognition have branded themselves as multi-ethnic enclaves. They celebrate diversity through art, parades, and festivals. They

promote multiculturalism in tourist materials and on their official Web sites. They are at the forefront of demographic changes influencing the United States, and they have demonstrated a persistent pattern of progressive politics, including the election of minorities to important local offices. These cities are cloaked in a multicultural fabric—the modern Technicolor dream coat. But displaying and celebrating the "dream coat" is not without conflict as groups disagree about which colors, fabrics, and patterns to emphasize.

Albuquerque

The majority of conflicts over art and culture in Albuquerque, New Mexico, are rooted in identity politics in which diverse cultural groups promote or attack visible symbols in the community such as artworks and monuments in an effort to gain recognition for their group. Such conflicts are most frequent in cities, such as Albuquerque, with a high degree of ethnic diversity. In fact, in recognition of its diversity, the city has incorporated multiculturalism in a variety of public policies. As a tourist destination, Albuquerque promotes its multi-ethnic background, touting both its rich Pueblo traditions and Hispanic legacy, but this diversity is also a source of contention. In the 1990s, Native Americans, Hispanics, and Caucasian Americans clashed repeatedly over such issues as the ethnic background of the superintendent of public schools, the preservation of local Pueblo religious sites, and rules prohibiting Native American students from wearing native attire at graduation ceremonies. Such conflicts spilled over into the area of art and culture as well, with seven of ten cultural conflicts during the years of this study connected to grievances against work deemed offensive to religious or ethnic minorities.

Perhaps the most striking example of an arts conflict with its roots in identity politics erupted in January 1998 and involved a fight over a proposed public sculpture honoring the Spanish explorer and first governor of the New Spain province of New Mexico, Don Juan de Oñate. The sculpture, which was to be placed in a local park, was commissioned by the city to celebrate the 400th anniversary of the colonizing by Spain of the territory that is now the state of New Mexico. Anticipating that the monument might become embroiled in symbolic politics, the city selected three artists, each representing one of the three major cultural groups in Albuquerque—Native Americans, Hispanics, and Caucasian Americans—to work together on the design. The artists proposed a monument that would feature a fifteen-foot bronze figure of Don Juan de Oñate. In addition the work was to include a series of moccasins leading to and away from the figure of Oñate—a

symbol of the contributions of Indians both before and after the arrival of the Spanish settlers.

In spite of the multi-ethnic team of artists and the complicated mix of symbolism in the final design, the proposed monument led to a protracted debate between Hispanics and Native Americans over how New Mexico's past should be remembered. The Native American community, on the one hand, reacted vociferously to the proposed figure of Oñate, who they say massacred Acoma Indians and in one raid cut off the right foot of male members of the tribe. For this group, the proposed sculpture would dishonor their history and their contribution to the community. As one Native American representative said, "We feel that healing should come out of this monument. We do not need another fetish to injustice hung around our necks" (Reed 1998d).

On the other hand, the Hispanic community was concerned that Native American advocates were seeking to change the meaning of the sculpture, which they felt should rightfully celebrate the Hispanic legacy in Albuquerque. A spokesperson for the anti-Hispanic Defamation League explained, "Frankly, the Acoma Indians have no place in the memorial. After 400 years, the Spanish people should be able to stand up and say: 'It's our anniversary. We have made it'" (Reed 1998a). The debate over the sculpture spanned more than three years and involved a series of public forums, conflict resolution workshops, and debate among members of the city council, the mayor, and the local arts board. At the final public meeting, members of the city council voted on a compromise to keep the statue of Oñate but to place it in a less visible location in front of the city's art museum. At this final meeting a Hispanic resident told the council, "If your family is of Spanish descent, this is a personal attack on you, your family and your heritage" (Potts 2000). A group of American Indians reacted to the final decision by praying silently in front of the city chamber. Many wept openly (Potts 2000). In a city marked by a higher-than-average degree of ethnic diversity, this case highlights the role of identity politics in battles over art, with Hispanics and Native Americans vying with each other over whose symbols and whose history would dominate the public square in Albuquerque.

In another example of identity politics, the mayor of Albuquerque objected to a mural at the public library that he said contained an image that looked like a Spaniard stabbing a Mayan Indian. Concerned that the image would offend people of Native American descent who might see it as a symbol of hatred, he demanded that the arts council take steps to paint over the offending portion of the painting. In another case the mayor, along with local Latino residents, criticized the design of a sculpture selected by

the local arts board to serve as a gateway to Barelas, a Latino neighborhood in Albuquerque. The sculpture design, proposed by a Caucasian artist from Ohio, included three large abstract rings made of stone and steel. In response to the proposed design, one resident objected, "It's my opinion that Hispanic history should be done by a Hispanic artist who understands Hispanic culture and history" (Nash 1999). Members of the community ultimately selected an alternate design created by a local Latino artist that included a representation of Latino railway workers and a woman crossing a river. In essence the controversy reflected the efforts of a large and growing community of ethnic residents who demanded an artwork that would honor and celebrate their unique history and identity. Again and again, public artworks became rallying points around which ethnic minorities sought to legitimate their past and assert their future in Albuquerque.

In addition to ethnic diversity, Albuquerque also has a diverse religious community, with an especially strong Jewish population. In fact, the local Jewish Federation wielded enough political clout to convince the city to place a large sculpture in the downtown Civic Plaza to commemorate the victims of the Holocaust. The proposed sculpture generated objections from local veterans groups who felt that the work would be more appropriate in front of a synagogue or on private property. Some members of the Jewish community agreed, fearing that such a visible symbol of Judaism placed in a multicultural city like Albuquerque would engender resentment and anti-Semitism. Nonetheless, most Jewish residents defended the monument, and the director of the Federation claimed that "it is very important for the memorial to be erected in a public place where many people will see it" (Asher 1997). This event represented a complex mix of identity politics—the Jewish community seeking public affirmation and recognition of its past; a Latino mayor supporting the campaign as a gesture of goodwill to an important constituency; local veterans opposing the memorial as "out of place" and "inappropriate" for Albuquerque's public square; a small minority of Jews seeking a less visible way to honor Holocaust victims and fearful of stoking resentment within such a diverse city; and, to intensify matters, a group of Arab Americans showing up at the dedication ceremony to protest the sculpture, claiming it wrong to honor Jewish victims when, they alleged, millions of Iraqi civilians have been killed because of U.S. foreign policy.

Cleveland

In Cleveland, Ohio, eleven out of twenty-one conflicts reported in the press revolved around identity politics. In particular, gender and sexuality fea-

tured prominently in three cases—a campaign against a billboard described by critics as sexist; protest over the NC-17 film *Showgirls*, which some opponents claimed demeaned women; and a demonstration by the Cleveland Gay and Lesbian Community Center outside a church where a gospel duo was singing a newly released, anti-gay song, "It's Not Natural."

In the billboard case a local rabble-rouser and one of the Cleveland's "most prolifically offensive sign painters" (*Plain Dealer* 1996), erected a five-by-twenty-foot billboard in front of his store that lampooned 150 women who were part of a lawsuit against owners of a local mall. In the suit the plaintiffs claimed the owner willingly allowed "peeping toms" to watch women through bathroom vents (O'Malley 1996). The billboard featured a set of eyes peeping through an air vent at two pigs standing in front of toilets. The text read, "The so-called victims are so ugly they should be glad someone took the time to watch them." In addition, the sign referred to the female litigants as "feminazis." Community members called the billboard racist, sexist, and lewd. One of the women participating in the suit claimed that she was additionally "violated" by the sign and its depiction of her as a pig. Another claimed that the sign caused "emotional distress"—echoing the idea that misrepresentation can cause members of maligned groups to suffer significant distress. The injunction filed against the sign painter was denied by a county court. The judge overseeing the claim defended the sign painter's First Amendment rights but ironically levied critiques firmly rooted in the language of identity politics. As quoted in the press, the judge admitted, "As a Jew, as a feminist, I am offended" (O'Malley 1996). At a neighborhood meeting a local resident argued that the billboard was an offense to the community and, more specifically, an offense to the community's notion of itself as a progressive and tolerant place; and at a public meeting one resident said that the sign was not representative of a place where "most people are open to other people, or try to be." In cities of recognition, residents protest art as a way to defend a city's multicultural identity (Fried 1996). Ironically, it is in those places where diversity and tolerance are most valued that residents may be the least tolerant of ideas that challenge notions of inclusivity and tolerance. This approach to cultural life is reminiscent of graffiti spray-painted on a wall by the banks of the Seine River in Paris: "It is forbidden to forbid."

In addition to conflicts revolving around sexism, religious minorities initiated two controversies in Cleveland. One involved a student and his family who, with the help of the ACLU, demanded that a portrait of Jesus Christ that hung at the front entrance of a public elementary school be removed. The second case involved a proposed boycott, initiated by the American

Jewish Committee of Cleveland, against a local German heritage newspaper that published stories denying the existence of the Holocaust and also denigrating Jews. In this case, identity politics guided the responses of both German and Jewish residents. Many German residents opposed the newspaper because it purposely linked their identity as Germans with a history that has been condemned by much of the world. The way in which "Germans" were represented and perceived in the local media became a key battle for these residents. Jewish residents objected to the newspaper because it was blatantly anti-Semitic in its denial of the Holocaust, a historical point of reference that is essential to American Jews' identity. As the director of the local chapter of the American Jewish Committee said, "Jewish people are *hurt* by such articles and they need to be ended" (my emphasis) (Miller 1996). This explanation does not appeal to wider conceptions of morality and decency but rather to the specific "hurt" experienced by members of a particular ethnic and religious group.

Depictions of race in schoolbooks, exhibits, and museum brochures were also a source of conflict in Cleveland. Several parents protested the inclusion of *Huckleberry Finn* in an eleventh-grade high school English class. In another case a group of African American employees at a local insurance firm organized a petition demanding the removal of paintings hung in their office building that were thought to depict black children as "pickaninnies," according the curator of the exhibit (Pincus 1996). In yet another case the mayor of Cleveland, Michael R. White, raised concerns that an invitation to the opening of the city's new Rock and Roll Hall of Fame and Museum, which featured two white women on its cover, excluded ethnic groups who had made important contributions to the history of rock and roll. Finally, the local NAACP forced an elementary school to remove the game *Freedom* from school computers. The game, which teaches about the Underground Railroad, was said to also include stereotypical images of African American slaves. As the president of the local chapter of the NAACP remarked in the local paper, "Both my grandmother and grandfather were slaves and largely uneducated. But they never called children 'chile,' and did not substitute 'I'se' for 'I' or the like" (Sartin 1997). A demeaning portrait of a particular group, even when rendered using language and images of a begotten era, reestablishes a stigma that marginalized groups feel compelled to confront. In cities of recognition, getting history right is the foundation of many conflicts, especially in the context of public institutions like schools.

Three Cleveland protests revolved around concerns of Native American residents. The first case involved the vandalism of a statue of Christopher Columbus, which was spray-painted with the word "invader" (Miller 1995).

The second instance centered on a protest by a Cleveland-based artist initiated to contest the image of Chief Wahoo used by the Cleveland Indians as a mascot for the professional football team. The third case concerned a photograph exhibit by Andres Serrano of Native American children that included images that were "grotesquely" out of proportion and text that referred to Native Americans as "noble savages" (Jones 1996).

San Jose

In San Jose nine of the eighteen protests identified in the *San Jose Mercury News* involved grievances lodged by ethnic minorities. Several protests involved the large and growing Vietnamese community. Vietnamese émigrés—many of whom fled from communist rule—protested several exhibits and performances that involved artwork or artists from Vietnam. Beginning in 1993 émigrés forced the cancellation of an exhibit of Vietnamese artists at the San Jose Museum of Art. In 1994 protesters staged a fiery demonstration against Thanh Lan, a Vietnamese singer who was labeled as a communist sympathizer. In 1995 the same groups opposed a traveling puppet show from Vietnam as well as a theater performance at San Francisco State University by a Vietnamese director and writer. In 1996 hundreds of émigrés demonstrated against another traveling exhibit at the San Jose Museum of Art—titled *An Ocean Apart*—that included artworks by Vietnamese and Vietnamese Americans. In every case activists accused the artists or exhibit sponsors of supporting propaganda aimed at presenting a positive image of Vietnam. The protesters perceived any attempt to complicate the "good and evil" narrative, which pitted the oppressive communists against a liberated and free Vietnamese American community, to be naive at best or a blatant betrayal at worst. Identity lies at the heart of these disagreements.

As suggested above, for some Vietnamese American émigrés, identity is largely contingent on their opposition to communist Vietnam and their affiliation with American freedom and democracy. At rallies and demonstrations, protesters sang "The Star-Spangled Banner" and waved American and South Vietnamese flags. Plays, exhibits, and music that celebrate or recognize Vietnam's "other story" by emphasizing cultural exchange rather than cultural conflict undermine this pro-American identity. At the heart of several controversies was the perception that sponsors, theaters, universities, and museums were "insensitive" to Vietnamese American experiences, including painful memories of oppression and war. But there is no single Vietnamese American experience. Some younger Vietnamese are interested in exploring traditional Vietnamese culture, while other Vietnamese Americans

travel back and forth to Vietnam and maintain strong ties with family and friends still living there. Still others conduct business with Vietnamese merchants, attend international conferences with Vietnamese scholars, or read and enjoy Vietnamese magazines, books, and videos. Many Vietnamese Americans in San Jose welcomed the exhibit and attended in spite of the jeers and chants of "traitor," "turncoat," and "communist" from demonstrators outside of the museum (Tran 1998). Protest over Vietnamese art in San Jose was intended to send a strong anti-communist message to the Vietnamese government. As one demonstrator remarked, "Our protest forces them [the government] to reexamine themselves and to ask 'if we are right, then how come our fellow Vietnamese are protesting against us?'" (Tran 1995). The demonstrations were also aimed at fellow émigrés and were intended to clarify the meaning and identity of a growing and diverse Vietnamese American community in San Jose. For many, but not all, émigrés in San Jose, "authentic" Vietnamese American experience was forged through struggles against the brutality of the Vietnamese government. And any celebration of the "culture" of Vietnam that failed to acknowledge these struggles was considered an insult to Vietnamese American identity and way of life.

Like Cleveland, San Jose also experienced protest over school material perceived as offensive and demeaning to African Americans. *Huckleberry Finn* found itself in the hot seat again when parents of a black student, along with the San Jose African American Parent Coalition, asked that the book be removed from reading lists at East San Jose schools or be replaced with a version in which racially offensive language had been deleted. According to local news reports, the coalition argued that the use of "nigger" more than two hundred times in the book was "damaging to their children's self-esteem" (Suryaraman 1995). The effects of what Fraser calls the "stigmatizing gaze of a culturally dominant other" are at stake in cities of recognition (2000, 109). After heated debate both in the newspaper and at school committee meetings, a review committee recommended that the book be kept on required reading lists. The school district rejected the recommendation and voted to remove the book from the curriculum, although teachers were still permitted to assign it as long as students were given an option to read a different book or to read a version stripped of offending language. The African American Parent Coalition also organized a protest against the book *The Cay*, by Theodore Taylor, which chronicles the life of a young white boy who overcomes racial prejudice. The book was assigned to seventh-grade classes in the Oak Grove School District and was considered offensive because of the depiction of a black character who is described as "ugly with pink-purple lips and a face that couldn't be blacker" (Slonaker 1995b). The

charge leveled against the book was that it bombarded students with racial stereotypes, damaged their self-esteem, and in effect destroyed a sense of community.

Several protests arose over how Latinos should be represented in public art, including a dispute over a public sculpture honoring a Latino figure skating champion from San Jose and an effort by a group of students to paint a mural in their high school that depicted the positive contributions of Latino culture. In both cases the conflict arose less in response to a sin of commission (for example, the presentation of an offensive stereotype) and more over a sin of omission (for example, the absence of representation or the lack of voice). In the first instance the San Jose arts commission wanted to erect a sculpture at the municipal sports arena to celebrate the achievement of five world-class figure skaters with ties to San Jose. The sculpture included portraits of the skaters along with quotes that were derived from interviews with each. The figure of world champion Rudy Galindo was to be accompanied by the text, "It's hard enough being a Mexican American skater when the judges are looking for an all-American strong boy." Skating enthusiasts in San Jose were upset over the politically pointed statement and convinced Galindo to edit the statement to the ethnically neutral, "I never imagined when I started skating that I would be the National Pairs champion twice with Kristi Yamaguchi, or that one day my hometown would cheer me on to win the United States Men's Championship" (*San Jose Mercury News* 1995b). The artists and the arts commission refused, arguing that the original words celebrated Galindo's triumph and struggle and would serve as an inspiration to Latino youth. Further, proponents of the original design wanted to protect the integrity of the artistic process and freedom of expression.

The Latino community came to the defense of Galindo and argued that the artists were taking advantage of Galindo because he was Latino, demanding that they "respect" his wishes and edit the original statement. In an ironic twist white artists and art commissioners were arguing for "true" representation of the struggles of Latino athletes—drawing on the skaters' own words to reveal the authentic experience of Latino figure skaters. Meanwhile the Latino community argued that the artists were disrespecting Galindo and Latinos by not yielding to their wishes. The politics of representation in this case were less about representation than about deference. Regardless of the content of the sculpture, the important point for the Latino community was self-determination. As one letter writer to the newspaper remarked, this conflict "demonstrates once again that Mexican Americans do not get the respect they deserve. Why can't he [Galindo] say whatever he wants?" (Vargas 1995).

In the second case a group of San Jose seniors at Lincoln High School wanted to erect a mural in the main quad of campus to celebrate Latino culture and boost "the esteem" of the 48 percent of the student population that were of Latino descent. The mural was a student-led response to the fact that Latinos, as a group, were the poorest academic achievers on campus and had higher-than-average rates of expulsion. The students sought a positive representation of their community and selected an off-campus Latino artist to help with the mural project. The school principal rejected the proposal because the students did not involve art teachers who taught at the high school, all of whom were white. The students circulated a petition and collected 486 signatures supporting the effort to employ a Latino artist. One student noted that the controversy was itself a symbol of the lack of respect afforded to Latinos at the school: "Latinos on this campus want to bring out our culture in a respectful way. They should be telling us 'good job.' It's about time someone tells us we're doing something good" (Garcia 1998).

San Francisco

In San Francisco four of the nine protests recorded in the press revolved around identity politics. In one case two school board members recommended a quota for the district's high school reading list. Four of ten books assigned, they argued, should be written by nonwhite authors. One of the proponents said, "In a district that is nearly 90% students of color, the point of education is not to glorify Europe, but to let students see themselves in the curriculum" (Barton 1998). In another case Native Americans objected to a fiberglass statue of an American Indian warrior in front of a discount tobacco store. Opponents argued that the image tied Native Americans to alcohol and tobacco and was offensive, racist, and unacceptable. In yet another case a group of feminists in San Francisco demonstrated in front of a theater showing the premiere of Oliver Stone's film *The People vs. Larry Flynt*. The film chronicles the 1970s public obscenity trial of Flynt, the publisher of the adult magazine *Hustler*. The protesters argued that the film glorified Flynt, whom they contended was a misogynist and child abuser, and also promoted pornography, in effect glamorizing violence against women. Protesters carried signs that included a picture of a man driving a jackhammer into a women's vagina with the question, "Why do we glamorize this in America?" (Solis 1996). Another protester agued, "I urge those who share our outrage at the appallingly one-sided and distorted

picture . . . to campaign against the sexist male critics who have nominated the film for all manner of prestigious awards" (Russell 1997). In this case the "politics of representation" sought to challenge the notion that Flynt was a hero who pursued freedom of expression and First Amendment rights, emphasizing instead the idea that pornography stokes misogyny and violence against women. Protesters also attacked Hollywood and the mainstream media, rejecting the opinions of "sexist male critics" and demanding that women gain greater power in deciding which films get celebrated and honored.

The fourth case in San Francisco was the most contentious and garnered significant press coverage. When the city of San Francisco rebuilt its main library in a more modern downtown facility, they pledged to convert the old facility—the Old Main Library located in the Civic Center—into the home for a new Asian Art Museum. In the loggia of the old library were fourteen decorative landscapes flanking the grand staircase painted in 1929 by Gottardo Piazzoni, one of San Francisco's leading painters of his day. The Asian Arts Commission, overseeing the new art museum, wanted the original murals removed because the paintings did not provide the right context for viewing Asian art. The director of the museum wrote, "Cultural sensitivity requires that Asian art be shown from an Asian point of view, not displayed in the context of American or European art" (Brechin 1997). Yet many in the art community and the city more broadly rejected this idea, contending that the murals reflected the multicultural history of the city. As one resident wrote to the paper, "To gut the old Main Library, to remove its magnificent loggia, to remove the Piazzoni murals to accommodate the Asian Art Collection would be an egregious violation of cultural and historical values. This must not happen" (Kasten 1998). Ultimately, the debate was about the value of the "Asian point of view." Should the museum be free from interference or distraction of Western art and, for that matter, from the opinions of non-Asians in the community? Supporters of the museum argued that this was to be "their museum," designed to represent the crowning achievements of Asian American culture.

In addition to the disproportionate number of liberal-based events (for example, those based in the concerns of women or religious and ethnic minorities), several common themes emerge across cases in cities of recognition. First, public officials avoid taking a public stand against identity claims. Second, protesters argue that "misrepresentation" causes real social-psychological damage. Third, notions of "respect" surface often, with offending artworks and presentations decried as a "slap in the face" of the offended

group. Fourth, protests emerge from organizations and activists who are advancing a broader agenda in the city. Finally, the notion of diversity and multiculturalism is, itself, an object of contention and disagreement.

Avoidance

Political scientists who study identity politics discuss three possible responses by public officials to group-based claims that center on identity or cultural values. Officials can (1) reject the claims, (2) they can endorse the claims and pursue policies that remedy the supposed grievance, or (3) they can avoid the issue altogether (Sharp 1999; Button et al. 1997). In cities of regulation, government officials chose option 2 and were extremely responsive to claims against artworks that were deemed offensive to community standards. In fact, in many cases officials themselves led the charge against offending artworks, books, or films. By contrast, in cities of contention public officials were often split over issues, taking public stances that were politically divisive and fueled the fire of electoral competition. It was not uncommon for school board members or city councilmen to attack one another in highly public ways. Yet public officials in cities of recognition were more likely to *avoid* taking a strong position on issues related to identity grievances (option 3). A typical response from a mayor, school board member, principal, or council member was to note that an issue would be considered carefully by recognizing and respecting the multicultural context of their city and the sensitivity of all involved. For example, urging harmony, the mayor of Albuquerque responded to the controversy over the sculpture of the Spanish conquistador Don Juan de Oñate by saying that "this is a time for us all to come together as one community to recognize the contributions of our ancestors to the rich and cherished *common* culture we share today" (my emphasis) (*Albuquerque Tribune* 1998). Similarly, the president of the school board in San Jose responded to the protest over *Huckleberry Finn* by saying, "We all know there's been an injury to the black community nationally and locally. We have an obligation to handle the issue in a way that promotes healing" (Suryaraman 1995). This is not to deny that many people spoke out against attempts by minorities to edit or censor existing representations or to insert non-mainstream "stories" into museums, curricula, films, and libraries. People leveled charges of "political correctness," arguing that opponents were too sensitive or that acceding to the demands of one group would lead to a slippery slope. "Where will it end?" asked one writer to the newspaper, responding to San

Francisco's attempt to institute a quota for nonwhite authors in the high school curriculum (Yanowitz 1998). While individual citizens sometimes pushed back against the claims of minorities, "the politics of recognition" was often devoid of formal politics. Elected officials were more likely to be found on the sidelines or playing the role of mediator rather than jumping into the heat of the controversy. Conservatives often argue that this reticence reflects the victory of "identity politics" over the past three decades, as people are increasingly wary to publicly criticize or refute the claims of minorities for fear of being labeled "racist," "sexist," or "bigoted." Yet this avoidance tactic on the part of elected officials is probably smart politics in a multicultural city. The rise of coalition-style electoral politics in big cities—especially in majority-minority cities where ethnic minorities represent more than half of the electorate—requires rhetoric of inclusion and cultural tolerance. In order to govern effectively, urban leaders cannot afford to alienate multi-ethnic, multi-class coalitions. Avoiding the "politics of representation" helps officials maintain fragile multi-ethnic electoral coalitions.

Words *Can* Hurt You

Scholars of identity politics claim that "misrepresentation" can cause emotional and psychological trauma for members of minority groups, resulting in a diminished sense of self when interacting with others in both social and political life (Fraser 2000). Unlike many of the conflicts in the other two types of cities, protests in San Francisco, Albuquerque, Cleveland, and San Jose often directly reference the pain, suffering, and hurt of minority groups. In this respect, unlike conflicts that revolve around more general concerns for morality, decency, tradition, or a city's image or brand, identity grievances are more personal. Parents argued that it was "hurtful" for their children to have to read *Huckleberry Finn* out loud, noting that it was "damaging to their children's self-esteem" (Suryaraman 1995). One parent remarked, "I think people are finally getting it [the damage caused by the word 'nigger']. For me, each sound of the word 'nigger' rings out like the sound of rifle fire, as the bullet tears through the face of Dr. King" (Beckett 1995). Similarly, Jews argued that they were "hurt" by articles that denied the existence of the Holocaust; Native Americans felt "demeaned" by the Indian warrior in front of the cigar store; Muslims argued that the unending barrage of anti-Islamic images in films was having "a real impact on the ordinary lives of Muslims," describing the movie *The Siege* as "honey poured on razor blades" (Hinds

1998), echoing Japanese Americans' critique of the Pledge of Allegiance mural as "salt poured on an open wound" (Doss 1995).

Respect and Self-Determination

In many cases when artworks misrepresent a community, it is perceived not only as hurtful but also as disrespectful. Time and again protesters claimed that a perceived slight was a "slap in the face"—words used by Japanese Americans in Little Tokyo to protest the Kruger mural (Doss 1995) and by Chester Steven, the president of the African American Parent Coalition in reference to the school board decisions to keep the book *The Cay* on the seventh-grade reading list. Steven remarked, "This is a slap in the face . . . especially when people can do the right thing and when they opt not to" (Slonaker 1995a). In San Francisco the director of the Asian-Pacific Democratic Club remarked in reference to the Piazzoni murals, "To display the murals in the most prominent place, the entrance, is intolerable; it's a slap in the face of the community" (Hamlin 1997). Latino high school students in San Jose talked about wanting a mural that presented "respectful" depictions of their culture and heritage. In Cleveland a Native American mother complained that Serrano's photographs were not "dignified representations," and critics of the Wahoo mascot told reporters that the image "trivializes a proud race of people. It mocks us. It does not honor us in any way" (Jones 1996).

It is interesting that the particular expression "slap in the face," on the one hand, resonates so forcefully with groups who find themselves defending their identity against perceived slights and offenses. Institutional racism and bigotry is a form of violence—an assault, abuse, and exploitation of a subjugated people. A "slap," on the other hand, is more like an embarrassing insult between people who are otherwise equal. There is an assumption of respect that is breached or denied by a slap. In multicultural communities, where minorities have achieved political power and where the community ethos embodies respect and inclusion (like in our cities of recognition), a perceived offense to one's group identity *and* an unwillingness to remove an offending image or object can carry the real sting of an unexpected and humiliating smack across the face.

In addition to bearing witness against disrespectful images, minority groups also engage in "resistance identity" or the "politics of presence" (Castells 2004; Phillips 1998). Manuel Castells argues that when groups are devalued or stigmatized, they assert their identity by the "exclusion of the excluders by the excluded" (9). In short, such groups, practicing

"resistance identity," will argue that dominant members of society (for example, whites) should not be allowed to make decisions or participate in cultural projects that seek to portray the dominated group's identity or heritage. Only black artists can depict black history; only Latino artists can tell the story about Hispanics in the United States; only women can accurately depict the struggles of women. Similarly, the "politics of presence" insists that "nonmembers are unable to properly understand the experiences of group members . . . and that a multicultural democracy requires moral deference to the marginalized" (Phillips 1998; McBride 2005, 499). It is inappropriate, or more precisely "disrespectful," to question or to challenge the ways in which a group wishes to see itself portrayed in art and media. This form of resistance appears throughout the cases in cities of recognition. In Albuquerque, residents of the largely Hispanic neighborhood of Barelas objected to a proposed public sculpture by a non-Hispanic artist. When the statue of Don Juan de Oñate was being debated and plans for the sculpture scaled down, a Hispanic resident remarked at a public meeting, "To not build this memorial is to deny Hispanics their place in history. How dare you, an Anglo [referring to a council member] cut back funding for a statue of Hispanics" (Potts 2000). Here moral deference is at work—with advocates for the sculpture attempting to marginalize Anglos and reduce or diminish their input—excluding the excluders in Castells's terms.

Another example comes from San Francisco, where the director of the new Asian Art Museum noted that the museum should also use only Asian architects because "non-Asians are attempting to tell the Asian Art Museum experts what is Asian art" (Brechin 1997). In arguing for the removal of *Huckleberry Finn* and *The Cay* from the reading lists at San Jose schools, black activists demanded moral deference because only African Americans can understand the hurt caused by certain words or depiction. The director of the African American Parent Coalition told reporters, "The word 'nigger' has meaning for African American people that no one else can really get inside of," adding that a story about slavery from a white viewpoint is not "adequate. . . . Accounts of slavery by Black authors are more powerful and accurate" (Dunridge 1995). In each case, whether minority groups are arguing about the content of artworks (for example, protest over specific depictions), about the process of producing artworks (for example, protest over the selection of artists), or about the right to debate whether or not something is offensive or damaging (for example, whites have no right to argue that "nigger"—when used in historical context—is not really offensive), respect and self-determination lie at the heart of the claims made by and on behalf of marginalized groups.

Connections to a Larger Agenda

In cities of contention, participants often linked their protest to larger dis-agreements taking place in their community or nationally—broader issues of school reform, national culture war issues linked to "the gay agenda," or racial cleavages in the community. Likewise, in cities of recognition, arts protests are often connected to a deeper agenda—gay, black, Hispanic, or otherwise—being promoted by existing community organizations and ac-tivists. Native American Bob Haozous, whose proposed sculpture for the University of New Mexico was rejected because of his inclusion of barbed wire, claimed that the university's position was related to broader issues of injustice and immigration. The barbed wire was meant to represent the many people who have been held behind razor wire for the reason of their affiliation with race and culture—Jews, blacks, Apaches, and Mexicans. Hao-zous claimed that the rejection of his sculpture was because "they [Anglo-Americans] don't want to see the holocaust against brown people, about what they're doing to them on the border" (Rodriguez 1996). One reporter in Albuquerque connected several arts protests to other issues of represen-tation in the community, specifically debates over whether the positions of the new president of the University of New Mexico and the new super-intendent of public schools should be filled by an Anglo, Hispanic, or Na-tive New Mexican.

In the case of the proposed quota for minority authors for high school reading lists in San Francisco, one school board member who supported the quota made a direct connection with larger racial issues in California. In the context of a public meeting, he noted, "In light of the racial injus-tice in California's recent votes to ban affirmative action and health care for undocumented immigrants, the board is sending a message across the country that it is a new day" (Asimov 1998). Efforts by the African American Parent Coalition in San Jose to rid schoolbooks of offensive racial language were repeatedly linked to larger issues of the success of African American students in school. The coalition charged the school district and teachers with indifference to black students—citing failing grades, lack of college preparatory courses in mostly black schools, and an overall hostile environ-ment. The editors of the *San Jose Mercury News* (1995a) claimed that the coalition's position on *Huckleberry Finn* was partly born out of its frustration with these larger issues and that "black parents and their children are under assault in this society" as "a growing coarseness marks discussion of race . . . leaving many black and other minorities feeling wounded." In other words, debates over *Huckleberry Finn* are just the tip of the much-larger iceberg

of race relations both in San Jose and in the United States. Ultimately, "the politics of recognition" is not independent of larger political battles. Protests over art and culture that involve identity politics flourish in cities where activists have a history of mobilizing around broader issues of race and gender, where existing organizations (like anti-defamation groups, civil rights groups, and special interest school groups) exist, and where minority groups feel they have the efficacy and capacity to "send a message" both locally and nationally.

The Diversity of Diversity

San Francisco, San Jose, Albuquerque, and Cleveland are cities that celebrate and promote their multicultural identity. These are progressive, tolerant, and cosmopolitan cities with a history of inclusion. In each, multiculturalism is a citywide value and has become part of their urban brand. Throughout the documented cases of protest, city leaders and residents made reference to their diverse communities—either as justification for artworks that celebrate ethnic or religious minorities or as a defense for the need to change, restrict, or remove books and artworks that are offensive. Yet consensus around the importance and value of multiculturalism does not preclude residents from fighting over the idea of multiculturalism itself—a concept that means something different to different members of the community. These cities are so diverse that diversity itself is a subject of contention.

In some instances the source of disagreement came from within an identity group, splitting group members on either side of an issue. For example, in Albuquerque the Jewish Federation of Greater Albuquerque wanted to erect a Holocaust memorial to help the *diverse* community of Albuquerque learn to respect cultural and religious differences and remember the atrocities of the Holocaust, but Café Europa, a local group of Holocaust survivors, felt a memorial was inappropriate and worried that it would create "backlash" against Jews. As one member remarked, "To single out Jewish people within a multicultural state would only lead to ill feelings and anti-Semitism" (Asher 1997). In this case the notion of "multiculturalism" was itself contested. Some Jews felt it meant publicly honoring their heritage, while others felt it meant respecting the identities of others by not "singling" one group out from the rest.

Albuquerque's controversy over the proposed Don Juan de Oñate sculpture, commemorating the 400th anniversary of the arrival of the Spanish explorer, is another example of how the idea of multiculturalism can cause splintering and fracturing. In commissioning the sculpture, the city

intentionally sought to celebrate its multicultural history, choosing a team of three artists to represent the three dominant cultures of New Mexico— Anglo, Native American, and Hispanic. But as one of the artists admitted after months of controversy, "400 years of living together has not brought Hispanic and Indian communities closer" (Reed 1998c). For Hispanics, the sculpture was an opportunity to highlight the Spanish influence on the city and state, which they believed was often overshadowed by recognition of Native American culture. For Native Americans, Oñate, known for brutal treatment of indigenous people, was a symbol of oppression and a "fetish to injustice" (Reed 1998b).

As in the case of the Jewish community, we see deep and painful splits among Albuquerque's ethnic groups. Nonetheless, the commitment to the broader theme of diversity allows the community to honor their disagreements—with Hispanic activists arguing that infighting is a good sign, an indication that the Hispanic community is a diverse group willing to work for social change. As a representative of the Mexican American National Women's Association remarked in the newspaper, "We may not speak with one voice, but that just shows we have a lot of strong voices." This idea is echoed by a newspaper editorial that argued that "the recent disagreements are valuable in reminding the larger community that Albuquerque is home to people of not only diverse viewpoints, but of diverse understandings of what it means to be Hispanic" (Milligan 1998).

In San Jose a conflict between mainland Vietnamese and the San Jose Vietnamese American community showed cracks in the city's multicultural foundation. Museum officials and art critics argued that an exhibition featuring paintings from Vietnam would help promote understanding and exchange across cultures—a worthy goal of any multicultural city. Yet many Vietnamese Americans understood their multicultural city differently and demanded that city leaders respect their painful history and celebrate their commitment to America by rejecting any exchange with communist Vietnam. Members of the Vietnamese community in San Jose were divided on this issue. Many attended the exhibition and wrote or spoke about it positively, while others stood outside the museum and shouted at their fellow émigrés who they considered traitors for even acknowledging art from the communist regime in Vietnam.

The debate over the Piazzoni murals in San Francisco's Old Library reveals how "diversity of diversity" can exacerbate tensions over culture. Both sides in the debate appealed to the notion of San Francisco's multicultural identity to argue their side. Nancy Boas, an activist in favor of leaving the murals in the new Asian Art Museum, explicitly noted that there are differ-

ing notions of diversity, remarking, "The subject of the mural's appropriateness has not been resolved. There are subtle issues of the multicultural heritage of San Francisco that we should examine before any decision is made" (Baker 1997). At a public meeting one supporter agreed, arguing, "The murals reflect the multicultural heritage that has always existed here. The Asian should embrace those murals." A local art critic wrote, "In arguing that the murals by a Swiss-born Italian American artist have no place in a museum of Asian art, the museum does itself the disservice of trying to pretend that multiculturalism is not here to stay, when everyday life in America tells us otherwise" (Baker 1997). On the other side, supporters of the Asian Art Museum contended that multiculturalism requires deference to the desires of the Asian community to present a "pure" Asian museum. Emily Sano, the director of the museum, took the argument of multiculturalism in an entirely different direction, accusing supporters of the Piazzoni murals of not recognizing that an Asian art museum *is* multicultural, even without the presence of Western art. In a letter to the editor Sano wrote, "The Asian Art Museum is a true panorama of multiculturalism—more than 12,000 art objects representing more than 40 cultures throughout Asia. It is regrettable that when people speak of multiculturalism, there is a tendency to register 'Asian' as one cultural entity" (Sano 1997). In yet another interesting twist, Sano's argument proved vulnerable to its own logic—many Asian Americans disagreed with one another publicly over the fate of the Piazzoni murals. Almost everyone involved in the debate agreed that multiculturalism was an abiding value for the city, but they disagreed on what this meant and how it should be reflected in decisions about art and architecture in San Francisco.

Like cities of regulation and cities of contention, cities of recognition exhibit common and distinct characteristics with regard to protest over art and culture. At the same time the boundaries between regulation, contention, and recognition sometimes blur. For example, identity politics are not entirely absent from cities of regulation or cities of contention, and attempts to regulate culture by invoking "community standards" can and do occur across all three city types, as do disagreements between traditional and progressive forces over the future of a city. Regardless of similarities a distinct "culture of protest" influences the shape and structure of cultural conflict in each type of community. Perhaps the most straightforward explanation for variation across the three types of cities has to do with diversity. Cities with the least amount of diversity are the most traditional and are most likely to *regulate* culture, police the border of decency, and advance agreed-upon community standards. As communities become more diverse, both

economically and demographically, they face a crossroads, with traditional members *contending* to hold on to a way of life that is increasingly challenged by newcomers who hold different values and who have a different vision for their cities. Once a community passes a threshold of diversity, identity politics takes hold as emerging ethnic groups demand to be *recognized* on their own terms. Diversity and multiculturalism become a source of controversy as citizens and leaders debate and shape the ideal community to meet their own conception of what it means to live with difference. Such a narrative, as compelling as it is, oversimplifies how and why protest activity varies. There are certainly other factors that complicate the story: different religious configurations in each city, the history of ethnic and racial relations, the political power of different interest groups, the strength and presence of connections between local chapters and national social movement organizations, and city-specific political dramas that influence the dynamics of protest. Yet complexity does not diminish the fact that patterns exist. None of us may live in a place that feels unequivocally like a *city of regulation, city of contention,* or *city of recognition*. But with some critical distance we might recognize the dynamics in our own cities as indicative of the themes examined here.

On Air, Our Air:
Fighting for Decency on the Airwaves

The preceding chapters have examined the structure of cultural conflict in American cities. The book's argument thus far has been built atop a mountain of data. I have examined 805 cases of conflict over art and entertainment in seventy-one American cities, reported in more than 10,000 newspaper articles, along with survey data from three national surveys representing 75,000 respondents. Looking out over a widening landscape of protest and contention, patterns emerge below. We have seen that levels of cultural conflict vary across cities, that cities can be distinguished by three dominant "profiles of contention," and that local political and institutional context can influence levels of conflict. Our data reveal a strong connection between social change and protest over art and culture, and this pattern is borne out at both the city and the individual respondent levels. For example, cities experiencing rapid changes in immigration fight more over art and culture; *and* individuals who worry more about immigration and the pace of social change are more likely to favor restrictions on the content of books and television.

From the beginning I have employed a mountaintop perspective—high above the action. This approach stands in contrast to the existing writing and analysis of protest over art and culture that has focused disproportionately on the particularities of cases—the personalities of various stakeholders, the maneuvering of political and religious elites, the specific and often graphic nature of the offending art object, and the excesses of rabble-rousing artists (Dubin 1992; Bolton 1992; Rothfield 2001). In these analyses it seems as if every protest emerges from the perfect storm. Yet only by getting beyond individual and particular stories can we see and confirm larger patterns that give us insight into both the causes and the consequences of arts protest.

Other scholars, like James Davison Hunter (1991), have also taken a broader look at conflict by focusing on large climate changes in our culture—the analogical equivalent to global warming. Hunter argues that we have witnessed the heating up of the culture wars over the past few decades, with fundamental shifts in the balance of elements and atmospheric conditions (values, public opinion, discourse). In contrast, I look at differences across cities rather than changes over time. Standing in front of a data-driven weather map, I draw jigsaw-shaped patterns of red, blue, green, and yellow—shifting fronts, high-pressure areas, and differing levels of precipitation. While pointing at my abstracted map, I confess a certain distance from the real and revealing conditions on the ground.

This chapter is my attempt to zero in on the experiences and attitudes of real people who are in the trenches, actively engaged in struggles over U.S. culture. I position the voices of parents, grandparents, and citizens to speak for themselves. Interviews with parents and citizens who have joined local chapters of the Parents Television Council, a group dedicated to "cleaning up the airwaves," echo three important earlier findings: protests over art and culture arise from the struggles of individuals to understand and define their communities in the face of social change; they serve as important democratic means by which residents respond to and engage these changes; and they are a form of expressive politics, a way to speak out and stand up.

The Janet Jackson Wardrobe Malfunction

On the evening of February 1, 2004, I was watching professional football's championship game with friends and family at one of the millions of Super Bowl parties across the nation. Close to 90 million viewers watched Super Bowl XXXVIII, featuring the Carolina Panthers and the New England Patriots. Viewers and partygoers were undoubtedly indulging in chili, chicken wings, and other traditional football game fare; they were entertained by the hard-fought game, won by the Patriots with a field goal in the final seconds; and they were amused by some of the year's most eye-popping television advertisements (rolled out to a massive viewing audience at a cost of $2 million per thirty-second spot). In addition to the game, viewers encountered what has become a highlight of the Super Bowl, the halftime show—an on-field extravaganza featuring fireworks, a high-tech light show, mass audience participation, and hit musicians surrounded by hundreds of choreographed dancers. But something was different about Super Bowl XXXVIII's halftime show, which featured performers Justin Timberlake and Janet Jackson. It did more than entertain; it caused a fire-

storm across America. At the conclusion of the song "Rock Your Body," and orchestrated to the lyrics "I'm gonna have you naked by the end of this song," Timberlake coyly ripped off a piece of Jackson's wardrobe to reveal her exposed breast and nipple. After the performance I walked into the kitchen and told my wife that I thought I had just seen Janet Jackson's breast in the halftime show. I was unsure about what I had seen and no one else at the party seemed to notice the wardrobe malfunction—perhaps not surprisingly since, as it turns out, the exposed nipple was on the air for nine-sixteenths of a second. I promptly forgot about the incident until "Nipplegate"—a popular phrase coined by late-night television hosts and newspaper columnists—hit the headlines in the days following the game. The chairman of the FCC, Michael Powell, called the incident a "classless, crass and deplorable stunt" and called for a "thorough and swift" FCC investigation (Salant 2004). Close to 540,000 Americans sent letters and e-mails to the FCC complaining about the supposed indecency. Eventually the FCC issued the broadcaster, CBS, a $550,000 fine, the largest in the agency's history. The fine was overturned by a federal appeals court and the case, as of this writing, is slated to be reviewed by the U.S. Supreme Court.

The Janet Jackson case poses a special challenge to my argument. First, the episode was truly national in scope—90 million viewers were potentially exposed to the offending nipple. Could my community-oriented approach to cultural conflict provide insight about such a large-scale national protest? Moreover, the reactions to Janet Jackson seemed immediate and visceral: viewers were shocked by the intrusion of nudity—if only fleeting—into what seemed like good American family entertainment. Given that the outrage seemed national in scope, it followed that the publicly recorded reactions—for example, the letters signed and sent to Washington—would likely be randomly distributed across the nation. Why would an exposed nipple offend families in Raleigh, North Carolina, any more than families in Pittsburgh, Pennsylvania? With data from the FCC, I reviewed the number of complaints received from every zip code in the nation. When I aggregated complaints to the city level, I discovered that there were indeed big differences between Raleigh and Pittsburgh. In Raleigh there were 1.2 complaints filed for every 1,000 residents; in Pittsburgh, there were one-fourth of that number, or 0.36 complaints for every 1,000 residents (see table 9.1). Interestingly, many of the most contentious cities revealed earlier in this book—Atlanta, Dallas, Fort Worth, Charlotte, Raleigh, Nashville, and Phoenix—were also home to larger than average numbers of complaints. The data demonstrates that rates of immigration were positively correlated with higher numbers of complaints, echoing findings in chapter 3. Other factors,

Table 9.1 Complaint letters and e-mails filed with the FCC

	Complaints per 1,000 residents	Total number of complaints		Complaints per 1,000 residents	Total number of complaints
Akron, OH	0.46	302	Lexington, KY	0.81	328
Albany, NY	0.19	165	Louisville, KY	0.77	734
Albuquerque, NM	0.38	226	Memphis, TN	0.92	924
Allentown, PA	0.34	201	Milwaukee, WI	0.29	411
Anchorage, AK	0.52	118	Minneapolis, MI	0.57	1,451
Atlanta, GA	0.85	2,512	New Orleans, LA	0.40	509
Austin, TX	1.23	1,037	Newark, NJ	0.19	393
Baltimore, MD	0.28	662	Norfolk, VA	0.53	764
Bangor, ME	0.71	65	Oklahoma City, OK	1.11	1,067
Baton Rouge, LA	0.83	437	Omaha, NE	0.61	392
Boston, MA	0.16	506	Philadelphia, PA	0.21	1,035
Buffalo, NY	0.26	307	Phoenix, AZ	0.79	1,775
Charleston, SC	0.58	296	Pittsburgh, PA	0.36	866
Charlotte, NC	1.05	1,224	Portland, OR	0.60	908
Chicago, IL	0.24	1,813	Providence, RI	0.17	191
Cincinnati, OH	0.54	829	Raleigh, NC	1.17	1,005
Cleveland, OH	0.25	550	Richmond, VA	1.32	1,141
Columbia, SC	0.60	271	Riverside, CA	0.39	999

City			City		
Columbus, OH	0.51	690	Roanoke, VA	0.68	153
Dallas, TX	1.02	2,723	Sacramento, CA	0.51	687
Dayton, OH	0.58	548	Salt Lake City, UT	0.67	715
Denver, CO	0.49	792	San Diego, CA	0.49	1,217
Des Moines, IA	0.47	184	San Francisco, CA	0.11	171
Detroit, MI	0.38	1,624	San Jose, CA	0.28	422
Evansville, IN	0.84	235	Santa Rosa, CA	0.14	53
Forth Worth, TX	1.18	1,604	Seattle, WA	0.52	1,062
Fresno, CA	0.33	253	Springfield	0.28	54
Grand Forks, ND	0.54	56	St. Louis, MO	0.56	1,408
Greensboro, NC	0.94	990	Syracuse, NY	0.35	257
Harrisburg, PA	0.59	345	Tacoma, WA	0.39	227
Hartford, CT	0.15	177	Tallahassee, FL	0.59	138
Houston, TX	0.93	3,104	Tampa, FL	0.56	1,158
Kansas City, MO/KS	0.84	1,333	Tulsa, OK	1.16	820
Knoxville, TN	1.03	606	West Palm Beach, FL	0.37	317
Las Vegas, NV	0.52	446	Wichita, KS	1.57	760
Nashville, TN	1.33	1,355			

like the region of the country (the South), and, not surprisingly, the average number of children per household were also positively related to complaints. Consistent with previous findings, "conservative values," measured by either the number of evangelical churches in a city or by our conservative index (see methodological appendix), were not significantly related to the number of complaints originating in each city. There seems to be significant local variation in what might otherwise appear to be a national outpouring of sentiment. And, importantly, that local variation is related to important structural characteristics of cities—from the number of children in households to the rate of immigration.

The Parents Television Council

The Parents Television Council (PTC), a nonprofit, nonpartisan national advocacy organization, claims some credit for the reaction to the Super Bowl halftime show. Founded in 1995, the organization aims to "ensure that children are not constantly assaulted by sex, violence and profanity on television and in other media" (Parents Television Council 2008). The organization employs a multileveled approach to this end. Lobbying efforts are mobilized by national offices of the PTC located in Los Angeles. The PTC regularly sends out action alerts to their 1.3 million members encouraging them to send e-mails (processed en masse through their Web site) to the FCC, congressional leaders, and national corporate headquarters. In addition, the PTC employs grassroots efforts through a system of local chapters that direct efforts toward local programming and sponsorship.

Despite the fact that many Americans have never heard of the organization, the presence of the PTC in varying cites accounts for much of the variation in the number of complaints received by the FCC across American cities. As discussed in chapter 5, there is an organizational and institutional context that influences levels of protest, and the PTC provides some of the organizational muscle needed to generate citizen activism around issues of decency. Yet PTC membership and protest levels are not perfectly matched, and large numbers of complaints came from cities without active PTC chapters (Knoxville and Atlanta, for example); organizational membership alone cannot explain fully the variation in the Nipplegate protest. Even as organizational membership is highly correlated to protest, we must still ask why the Parents Television Council is more active in some places than others if we hope to grasp the local dimensions of cultural conflict. Why does the council's "call to action" seem to resonate more with residents of some cit-

ies? And what explains the local dimension of the PTC's work? After all, television and entertainment are decidedly national and international. Local network affiliate stations have very little influence on the content of their programming; everything flows from Los Angeles and New York, where programmers make decisions, select shows, and decide on time slots with almost no input from affiliate stations. There are only a handful of cases over the past ten years where a few affiliate stations preempted national programs in deference to their local audiences.[1] The same is true about the distribution of video games (another target of the PTC), which sell largely through big-box retailers like Target, Walmart, and Best Buy. Again, local store managers have little influence over what they stock.

Locally coordinated environmental protests typically target specific issues like toxic waste dumped into nearby streams or rivers and are motivated by NIMBY (Not in My Backyard) concerns. In contrast, there are few local environmental groups organized around such universal problems as global warming—issues better left to national and international organizations. To the extent that Hollywood is seen as polluting "our" airwaves and corrupting family entertainment, the issue of cleaning up entertainment in America, which is pervasive and omnipresent, seems more akin to global warming than to the problem of backyard sludge. So why do local activists get involved in the PTC's work, and more specifically, how do they link their involvement to social change, community, and political participation?

The Parents (and Grandparents)

In order to learn more about the motives and perceptions of grassroots activists, I worked with a research associate to conduct interviews with approximately thirty-five PTC members across eight U.S. cities. In four of those cities we conducted focus groups with six or more participants; in the remaining four cities, due to both financial and time restrictions, we conducted interviews by telephone with chapter directors. Many of those interviewed were parents of young children; however, almost an equal number had children who were grown. Some participants were grandparents, and a select few had no children of their own. The average age of those interviewed was approximately forty-three. Two-thirds of the respondents were women. All women who participated were mothers. Even though participants went to great lengths to describe the organization as bipartisan and nonsectarian, in essence non-ideological, on average, participants self-rated themselves as 7.9 on a scale of 1 to 10, with 10 being very conservative. And

while most of the participants did not explicitly invoke politics or religion, it was clear that there was considerable overlap between membership in the PTC and membership in other Christian right organizations like Focus on the Family, the Family Research Center, and the Eagle Forum.

In spite of these connections, participants seemed aware that their effectiveness depended on keeping partisan politics and religion at a safe distance from their work. As the Northern City director noted: "Our work has nothing to do with politics, nothing to do with religion, nothing to do with morality. It's completely based on science." In Farm City, a group participant emphasized, "It's not Republican or Democrat, it [the PTC] covers everybody because it is basically our kids." For these parents, culture war politics are peripheral to their emphasis on "speaking up," which they conceptualize as voicing truth and representing the interests of children generally. Additionally, activists make a point to distinguish between censoring and censuring—they want to raise awareness, put pressure on producers and advertisers, and get the government to enforce regulations that protect family viewing hours, but they do not want to ban programs or restrict the viewing options of adults. Again these activists do not want to appear as ideologues or partisans; they carefully navigate traditional culture war rhetoric in order to present themselves as concerned citizens who represent mainstream opinion.[2] Participants became involved with the PTC through two primary routes. Most chapter directors contacted the national headquarters after experiencing "moral shock" from something they saw on television. Social movement scholars discuss the importance of moral outrage and shock as inducements to join movements—from civil rights to animal rights, AIDS activism, and peace movements (Jasper 1998; Goodwin, Jasper, and Polletta 2001). Past studies find that potential recruits become emotionally involved in an issue after witnessing something traumatic or upsetting, discovering evidence that challenges basic assumptions about the world, or confronting an image or story that "awakens" their sense of injustice and outrage (Laraña, Johnston, and Gusfield 1994). And activists often have compelling and emotionally resonant stories about their "conversion" into a movement. This emotionally charged drive for change is evident in the stories of PTC chapter directors. For instance, Lucy, from Blue City, described her "aha" moment, as she referred to it:

In 2006 while I was pregnant with my son, and my husband and I were in bed watching television, and *Nip/Tuck* came on, and it was right when *Nip/Tuck* just got picked up. And the story line covered a woman whose husband was over in Iraq, and she was having an affair with her dog, and she wanted

reconstructed plastic surgery in her nether areas to make it more pleasurable. And this was on at 9 o'clock at night on basic cable, and I just remember covering my belly with my hands going, "Oh my gosh. I cannot even imagine my son ten years from now. I can't imagine what the state of television will be like." . . . So as soon as I had him, I called the PTC and I asked for an application.

Tom, the director from Northern City, told a similar tale about his involvement:

It was when, on Christmas Eve, we were decorating the tree. It was a very homey scene so to speak. I had a little Christmas music on the television. I turned it on and the very first thing that popped on was a dirty program about teenagers having sex, and this was on Christmas Eve. It was like Ebenezer Scrooge yelling, "Bah Humbug!" That was kind of a wake-up call. Then, I saw, years ago, this full-page ad with Steve Allen[3] and I said, "Oh, somebody is doing something about this." So that was the first step, waking up. The second step was joining the PTC.

Echoing this emphasis on "aha moments" and "waking up," Mary Ellen from Capitol City recalls:

I'd been getting the PTC e-mails, but then one day my son—this was last year; he was ten—came downstairs and said "Mom, I think I saw something inappropriate on TV." He's telling me. On one of his shows. So he explained what it was and he didn't want to tell me because it was kind of embarrassing . . . girls' bodies. I said, "I am done with this. I am sick of having to protect my kid from every angle when you think you should be safe." So right then and there, I started my own group.

While many activists told variations of the above "conversion stories," others talked about harboring long-standing concerns about the media and described themselves as easy targets—"grateful" and "relieved" when they found out that a group like the PTC existed and was doing "something." Many of these recruits stumbled across a newspaper advertisement, like the full-page Steve Allen advertisement cited above; others were recruited directly by the local director either at a public event—for example, a PTC-sponsored booth at a local fair—or through previous social ties. For most of the directors, their "aha" experiences with media led them to contact the PTC national headquarters, who responded by inviting them to form local

chapters. The tenure of our eight directors varied from one year to close to ten years.

The Activities of Local Chapters

Local chapters exist more in the virtual than the real world; that is, they correspond and organize their activities largely through e-mails and Listservs, and some chapters maintain very rudimentary Web sites. For many chapters, our focus group was their first occasion to meet one another in person. But even in the absence of regular meetings, the directors and a few of the more active members successfully organized local campaigns, wrote letters, attended public meetings, and participated in a variety of local efforts on behalf of the organization.

Contacting local businesses that advertise during television shows identified as particularly offensive is a common tactic of activists. In Green City the local director spoke at a shareholder's meeting for the Burger King Corporation, complaining to the CEO and marketing director about the content and placement of their advertisements. Another director called a local billboard company to complain about an advertisement displayed above a public school for the Eddie Murphy movie *Norbit*. In the advertisement, according to the Green City director, Murphy is depicted "in character with his breasts and behind, bared behind, leaning over the other character." In another case a PTC member left voice-mails for the CEO of Dunkin' Donuts; still others wrote opinion editorials, contacted elected officials, set up booths, and handed out PTC material at local health fairs or community festivals or spoke to parents and neighbors at area schools, a Rotary Club meeting, or church functions.

Activists are encouraged by small victories that demonstrate that people listen to their pleas and take their cause seriously. In the case of Burger King, the director reported that she "started seeing changes . . . the CEO came over to me and said, 'Thank you for coming. I spoke to the marketing people . . .' And, we definitely saw a shift . . . they listened." In the case of Dunkin' Donuts, the director reports, "This good man [the CEO] called me from his vacation home in Florida and we spoke for about an hour. And what it shows is that there are so many people out there that care about this, and it's not just the cold-hearted directors and scriptwriters." The Eddie Murphy billboard described above was apparently taken down, local car dealers have pulled advertisements, and activists reported again and again that parents approached them and offered effusive gratitude for raising their

awareness and giving them hope. According to one activist, a woman had allowed her four-year-old son to watch the animated show *Family Guy* (one of the main targets of PTC campaigns) until she learned more about it from the local chapter. PTC members spoke of "empowering" parents about the scope of the problem and the "sense of relief" that citizens feel when they learn of the PTC's work. The director of the Blue City chapter remarked, "Every parent I speak to takes every word I say very seriously, and they want to hear more. I haven't met a parent yet who hasn't stood there with their mouth open going, 'This is on TV?' "

Broad Concerns: Children, Culture, and Society

Local members of the PTC characterize their concerns at three levels. First, they are worried about the direct impact of indecent programming on the behavior, attitudes, and development of children; second, they see the content of today's entertainment as a harbinger of cultural decay; and third, they fear the media is partially responsible for a larger social collapse.

At the level of the individual child, PTC members referenced the negative effects of the media on kids' levels of aggression, on their cognitive and social development, and their hopes and aspirations. Several parents referred to scientific studies to prove their points. One woman from Sunshine City noted:

> There's brain development. . . . I mean, I've seen the graphics about all those little things that grow off of your brain when you are getting out and doing things as opposed to watching . . . but the images come at you [from television] and as a young person your brain is not designed to take them in that way and it shuts your brain down into a lower form of functioning so that when you try to speak to a child who is staring at the television, they don't hear you.

A parent from Capitol City referenced a study from a doctor in Minnesota:

> From his findings, basically what he has said is that children up to about fifteen to seventeen do not really have discernment, and so the things that they see they accept; but they don't really discern the ramifications or the consequences or the effect it's going to have on themselves or on other people. We have children seeing all this material but have no idea how to judge it or

to understand it. What are we feeding them? We're feeding them experience, but we're not feeding them any discernment, any judgment. And this lack of judgment or discernment turns into a type of slow-working poison.

As a Capitol City parent put it: "You make brownies; all these brownies are good, there's only a little bit of poison in there. There is only a little bit. Well how many brownies do you have to eat before the poison starts affecting your system?"

The effects they worry most about are related to violence, suicide, consumerism, and behavior characterized as inappropriate and unhealthy. In Sunshine City a focus group participant remarked, "It's not a coincidence that we have kids coming to school with these crazy ideas about hurting people and bringing guns and all that stuff. We are changing their minds and the way they see the world, and the way they cope with problems and cope with the world just by nature of what we're inundating them with every single day." In Capitol City a PTC member similarly voiced concern about television's effect on illegal and "inappropriate behavior": "Oh, it's very subtle, but in those shows it is very common to have this inappropriate behavior and even the small mores that are perhaps not big, but when children no longer see that theft or inappropriate behavior or insolence or disrespect is acceptable because it's funny, then you're treading into very dangerous waters." In addition to concerns about television's effect on behavior, the director of the Blue City chapter raised concerns about consumerism and childhood: "Today, they are just so inundated with greed, and I see these big gaping voids in their lives that they're trying to fill with stuff. And I think that can be eliminated a lot of the time by getting rid of this crap on TV that really fuels the fire."

While many parents worry about their own kids, PTC members are particularly concerned about the effect of television on disadvantaged kids. Sociologist Amy Binder (1993) found that critics of hip-hop music in the 1980s framed their arguments in terms of how the music was "harmful to society" because of the danger that other people's kids—largely minority kids—posed for society at large. Similarly, PTC parents consistently evoked the "harmful to society" frame; they worried that poor and minority youth will imitate the violence and disrespect they see on television, putting "everyone" at risk. Some participants wondered about the effects on disadvantaged kids, not because of their potential "harm to society," but because television presumably reinforces a "lack of hope and inspiration." In this framing, television obliterates hope by impeding a child's ability to imagine a better future. As one participant noted:

How do you expose them to something better than the media? If we don't give these kids hope, this is our future, this is our world's future, our children. How do we give them exposure to what they can be, to what they can do, to what they can experience in a successful life if they don't see it? That's what the media is. Unfortunately, it's probably the only experience some of them are going to get. It may not be my children's future. I may never have a grandchild, it doesn't make a difference. It's the world's future. It's these children.

She continues: "You have to have something out there, and unfortunately . . . much of what is out there exposes them to worse than what they've already experienced. Gives them no hope. Why do you think we have teen suicides? I mean goodness sakes, we offer them no hope." Others lament the loss of childhood innocence. As the Blue City director remarked, "I really just want to get back to the place where it's a simple life. Kids can come home from school, throw their backpacks down, watch a funny cartoon with their cookies, before their homework. You can't do that anymore."

In addition to worrying about individual children, PTC members worry about the general decline of American culture, evoking notions of a "race to the bottom," a "steady slide into the gutter," and other images of cultural ruin. As one participant in Green City recalled, "When I was growing up, you didn't hear any four letter words, even hell. You didn't see all the explicit types of action and obscenities. It just progressively got worse." Respondents complained about profanity, disrespect, gratuitous sex and violence; and they were aghast that television programs no longer clearly distinguish good guys from bad guys, calling attention to shows where serial killers, adulterers, and people who cheat and steal are depicted as heroes. Overall, parents described themselves as "David" fighting the media "Goliath." These activists are engaged in a battle to save our culture—or as a member of the Big City chapter put it, "I see the PTC as just one piece of a bigger cultural battle," continuing:

I remember a poem that my mom said . . . something about how the first time something horrible comes into their view, they shut it out; then they beckon toward it; then they accept it; then they celebrate it; and then there's nothing wrong with it. And it's like that's how we are with homosexuality, and trios and all this kind of stuff—stuff that you think will never get on TV. Our culture will never get to that point. And then they slowly start bringing it in, slowly; and then we're celebrating it . . . and all of sudden you are wrong if you think anything is wrong with it.

This concern positions television as a destructive force not simply in the lives of individual children but also to shared cultural values.

Participants expressed grave concerns that excesses in the media reflect and cause a larger breakdown in America's social fabric, as evidenced through exacerbating social problems. In the Northern City focus group a participant states: "For each of these problems, I can directly link them to the misuse of television—child abuse, child obesity, crime, disease, domestic violence, drugs and alcohol, mental illness, poverty, pregnancy, rape, and suicide." During this same discussion, another PTC member expressed a similar sentiment: "I'm really upset about what television has done—the tenfold increase in our nation's incarceration rate; the huge increase in domestic violence rate. I have a list of who knows how many social problems that have increased." These trends are, perhaps, the most concerning to PTC participants because they suggest the global power of media in affecting large-scale social change.

In earlier chapters I discuss social change as an underlying condition for protests over art and culture. In the case of the PTC members, social change is not just the backdrop for their activism, producing a vague sense of unease; rather, social change is front and center and is explicitly and repeatedly invoked during the focus groups. In chapter 2 I use the analogy of adolescence to characterize the type of disrupting social change that cities experience when undergoing rapid transitions. One of our focus group respondents made the same comparison:

> I mean it's like our nation went through teenage years; but instead of coming out smarter, I think we got dumber. I think we threw them [our morals] out and threw them so far out that rather than the society coming back and saying "no," instead we say, "I think it's okay, we'll try that." So I think that the culture as a whole, and the country as a whole, began to accept what was unacceptable.

The large-scale social changes that PTC members worried most about involve attitudes and behaviors about sex, family life, and violence. Frequently, respondents talked about the rise of single-parent households, the number of children born out of wedlock, and the increasing promiscuity of young kids.[4] One respondent in Farm City noted nostalgically:

> I'm a '60s guy, so when you look at the '60s, when you had someone get pregnant they just sort of disappeared. You never knew about the guy, but the

girl would just go someplace else. It was a shame and embarrassment for the family and for the girl. And now you've got preschools *in* the high school [to take care of the children of teen moms]. That's just a generation and a half. It's acceptable. So the standards come from somewhere [referencing television and the media].

Participants also provided very vivid accounts of violence—repeatedly bringing up lurid stories. Across several focus groups people referenced the news account of a group of teenagers on Long Island, New York, who acted out scenes from the violent video game *Grand Theft Auto*—physically assaulting bystanders, robbing people, and engaging in "carjacking." PTC members also mentioned school shootings and other acts of random violence, all of which they link to violence in the media. For these parents and concerned citizens, social problems are caused by media exposure as well as by the fact that too many children are not getting the care and attention they need from adults. Of course, from their perspective, the two are related. Respondents argue that the television functions in loco parentis, with busy parents using television as a babysitter. As a consequence, kids not only lose the benefit of caring and attentive parents but also experience a "double deprivation" by being exposed to television and media that promote immoral behavior.

Bringing It Home: Social Change and Community Life

The culture wars, as typically described by scholars, result from broad shifts in worldviews and growing disagreement about the "nature and meaning of America"; but I contend that the most disruptive shifts in America are ones that are unfolding in people's local communities. People may harbor latent concerns about changing social mores, but these concerns do not erupt into public protest unless they are reinforced and activated by real-world experiences. Citizens are compelled to speak out when social change is palpable, visible, and when it confronts them walking out their front door, riding the bus, buying groceries, and picking up their kids from school. One respondent from Blue City pointed to the change in girls' fashion, citing a recent experience at the local mall: "These girls are wearing bustiers with nothing underneath. The lowest hip-hugging jeans where you could see their derrieres stick out, stripper platforms. It was unbelievable. And being involved with the PTC, I recognize these clothes as knockoffs from MTV and tween shows." Another respondent in Orange City described his personal experience confronting social change on the streets of his community:

When I was growing up, you would not see people of the same sex sharing any kind of emotional interaction on the street, in restaurants, on the bus, and certainly not in the schools. Not only homosexual activity but even heterosexual activity. It was inappropriate. . . . There isn't a day that goes by now when you don't see that—whether homosexual or heterosexual or transgendered people who are cross-dressers walking down the street.

PTC members are clearly discomfited by these daily encounters with behaviors and appearances that seem out of place and inappropriate *in their local contexts*.

Social movement scholars discuss the importance that emotions play in recruiting and sustaining activists—focusing on such negative emotions as indignation or outrage as well as on the positive feelings of solidarity, loyalty, and sense of purpose that come from being part of a cause (Jasper 1998; Goodwin, Jasper, and Polletta 2001). In the case of protest over art and culture, the voices of PTC members point to another strong emotion that inspires participation, namely, "discomfort"—the feeling you get when a familiar environment becomes less familiar. Discomfort emerges when media invades familiar settings, like home, and confronts viewers with images, language, and stories that are surprising, unexpected, and out of place in the safe confines of the living room. Often PTC members talk about the discomfort, shame, and embarrassment they feel when they are forced to discuss a Viagra commercial with a son or daughter or when something they consider indecent, raunchy, or depraved—like Janet Jackson's nipple—confronts them unexpectedly. More importantly though for our activists, they feel uncomfortable by what they actually see, hear, and confront day to day in their communities.

Discussants feel discomfort in the face of the incivility, aggression, and disrespect exhibited by the young people in their communities. As the director of the North City chapter put it, "Some people are confused because they think it's about the fact that we're offended. The real issue is not that we don't want to be offended; the problem is that we don't want to be shot in some dark alley." Participants offered many examples of kids acting violently in their own communities—from simple disrespect of authorities to fighting and attempted murder. The director of the Northern City chapter recalled, "A good friend of mine was in class one day and a student got onstage with a shotgun, and as my friend was running for his life, he was shot in the neck and airlifted to the hospital. . . . I am really upset about what television has done. " A woman from Sunshine City lapsed into a disturbing

tale about her son, who was attacked by a group of teenagers because the boys were "bored." "That was fun; it was entertainment for them. Well, their idea of entertainment was shaped somewhere." In her story the police eventually arrived, but only after she and her husband had tried to break up the fight, resulting in her husband being physically assaulted. She concluded: "The fact that they had no regard for adults, for the police, for anybody else, that absolutely blows me away." Respondents feel unsafe in their own communities—largely because they fear that kids are out of control. Another woman from Sunshine City remarked:

> The other day there was a group of kids in the neighborhood and they walked back and forth to the pool. They had congregated on a corner, my dog barks like crazy, and I almost went out there and said, "Can I help you with something? You are kind of in my yard." But I was scared to go out there. They looked like decent kids, but I thought okay, if I make these kids mad I actually thought they might come back later and let the dog out or throw something over the fence or key my car. I was actually fearful. I thought golly, I can remember when I was a child and an adult saying, "Slow down," and you would go, "Oh yes, sir . . ." No longer. There's no respect anymore.

These vivid accounts of violence in their own communities draw attention to the perceived threats and real dangers PTC members face every day. As one member from Farm City remarked, "You're just not safe anymore." But importantly, as the above quote from the activist in Sunshine City demonstrates, people feel uncomfortable in their own communities because they can no longer speak out as responsible adults. They talk nostalgically about a time when neighbors and adults could enforce rules and demand respect. For these activists, their communities have become unfamiliar places, with their own role (as responsible adults) undermined and diminished. Protesting the media is a strategy for regaining control and for claiming some moral authority in an otherwise shifting landscape.

In chapter 2 I demonstrate a link between concerns about social change, especially immigration, and favorable attitudes toward greater restrictions of books and television programs. Not surprisingly, cities that experience rapid rates of immigration are more likely to fight over art and culture. While these findings are statistically robust, critical readers might be suspicious that the correlations and conclusions are based on either indirect measures or on a level of analysis that is too broad to say anything meaningful about what motivates individuals to protest something in their own communities.

Do activists and protesters understand their concerns and motivations through the prism of social change? Do they explicitly link their concerns to immigration?

In most cities focus group participants connected immigration to increased social problems and moral and cultural decline. And participants believe that the "problem with immigrants" is related, in part, to the type of media they consume. A women from Capitol City described how her son came across an advertisement for *Girls Gone Wild*—"a thirty-minute infomercial featuring underage girls on spring break, drinking, exposing themselves, making out with each other"—while he was eating breakfast at seven in the morning. Casually the woman mentioned that she thought the advertisement was on a Spanish station. This offhanded remark turned out to be the tip of a much broader and well-articulated concern about immigrant culture. A few minutes later this Capitol City mom expounded about how immigrants were changing her daughter's school:

> It was a great school, don't get me wrong, but now when I walk into her school everything is in Spanish and I think the level of learning has just gotten so easy for her. A lot of the kids that have moved in now are here illegally. They're not at the same level that she is, so the standards have gone down. And Sally is just flying through school now. And she is also the minority. She said, "Mom, I wish I was Spanish. I'm the only girl that doesn't speak Spanish in my school." I think it's had a major impact on our community, and the things that concern me are what they see on television, how they're impacted at school. These kids are probably watching a whole different program than what she's watching. It's culture shock. They're probably tuning into the Spanish shows which are by far worse.

She continues when asked whether the shows are really worse: "Oh yes. I can't understand them, but I just page through them. Wow! They seem to just be quite a bit worse. But I think that's had a major impact on Capitol City in the last six or seven years. Major. And our jobs." A male respondent adds: "And culture too. The many sex offenders, a lot of them if you traveled much in Mexico, some of the shacks they live in, and you've got twelve, fifteen people living in one room. . . . They're doing that up here too. It's just a real culture change."

Another participant from Capitol City discussed the "poverty culture" that accompanies immigration: "The poverty culture has a total different tolerance and a total different focus in its life. Therefore what they experi-

ence and what they tolerate, and what they are hoping for and what they will settle for is different." She continues:

> Yes, moment by moment. Their goals, their issues, their focus is very much on moment-by-moment things. Well, if you have a moment-to-moment culture, it's like going through a hurricane. Yes, you can be seen in the street in your pajamas because you're running from a tornado. But when you come to school, you don't come in your pajamas. You're no longer in that stress. But when you have a poverty culture, what is tolerated, what is acceptable, what is for them the norm is very different than what a different culture is going to have. So it is going to influence the culture because then the students who are not from that culture say, "Well, why should I be held to a higher standard? If they can do that, why can't I?" So I think there is a dramatic change in the culture. It's very insidious. There's more people acting out the same things they see in the movies.

A schoolteacher from Capitol City continues:

> So it makes a big difference. I have so many girls who become pregnant. One girl already had her second child. All the other kids in class were so excited. They were going to have a baby shower. I mean, they're thrilled about this. To them she has really gone someplace. So you have a whole different set of standards, which again is being elevated as a good thing. So it really does impact the kids.

After expressing concerns about the changes caused by immigration, participants in Capitol City acknowledged that this was a "red flag" that compelled them to speak out and become involved. The schoolteacher continues: "I think it makes it more important in some ways because though they [immigrants] watch their own television and they have their own subculture, which is very strong with them, it influences the kids who are surrounded by them, both in the neighborhood and at school. Therefore what they see becomes more acceptable because it's what they're already familiar with."

Social change and immigration generated feelings of discomfort among respondents. After discussing the issue of immigration and the "Mexican ghetto," one participant from Capitol City acknowledged, "It's my country and I think my culture is a comfort for me. I can go to another country, but that's not my country." For this PTC member, activism becomes a strategy

for dealing with the discomfort of being surrounded by foreign culture. In Blue City, at the end of the interview the chapter director, without prompting, began an ad hoc attack on immigration: "We are swimming, trying to find our way above water, while people who are not here legally and not done things right are getting free medical care, free housing, and that really upsets me." Similarly, in Green City the chapter director noted that her community had changed dramatically in recent years, referring to the city's "uncontrollable growth," adding:

> We're a little overburdened in population. And I'm sure that has contributed a big factor in the changes we've seen here. I wouldn't blame it on what we're seeing on TV . . . but it's definitely a factor. It's just generally that we have a big mix of cultures here, so it's very difficult. We have a lot of aggression on the streets. I live in a very small area, and honestly I try to stay pretty much close to home.

In Farm City parents emphasized that the community was divided between West Farm City and those living in the South; as one resident noted: "I think people in West Farm City live in a different world than the people in South Farm City, because the South Farm City people speak Spanish." This person goes on to describe West Farm City residents, on the one hand, as being churchgoing and family oriented, where there is a "standard of decency that basically is to uphold good citizenship and virtues and things like that." In South Farm City, on the other hand, "family values have deteriorated a great deal, partly because of the media, because the traditional family is not the norm." Respondents in this focus group go on to describe "babies having babies," guys who "wear pants almost falling off," and kids whose parents just put them in front of the "TV all day and leave them alone." One woman described these changes as an "invasion." A father in the same group noted that "we are seeing the erosion of so many things over the years. I told my wife the other day it's kind of like being in a different world; I don't recognize this country anymore."

While immigration was not the predominant theme in all focus groups, the issue arose in more than three-quarters of the conversations. Respondents attributed changes in their communities to the influx of foreign-born residents. They generally described these changes in negative terms and emphasized social and moral breakdown. From this perspective, negative behavior is caused by immigrant culture and the quantity and type of media and entertainment that immigrant children watch. PTC members worried that the behavior and lifestyle of immigrant children—or more broadly that

of the "poverty culture"—will bleed over and influence their own children's behavior. Put another way, the concern is that children raised in immigrant cultures lack moral guidance, making these youth more susceptible to the violence they see on television and therefore a greater threat to commit acts of violence in their own communities. This "invasion" of a foreign culture magnifies PTC members' discomfort, *as if* they were living in another country—surrounded by a different culture, different values, different social norms, and different lifestyles.

I Can't Sit Quietly By: Expressive Protest

For decades scholars have described social movements as entirely rational and strategic (Zald and McCarthy 1979). Activists pursue their goals by applying resources (money, attention, volunteers) toward influencing public opinion and shaping public policy. Social movements and collective action are instruments used by the powerless to challenge the powerful in society. But scholars who examine the cultural and emotional dimensions of protest and activism have revised and challenged this instrumental view of social movements. Participation in a social movement can be emotionally rewarding, it can serve as an outlet for anger or frustration, and it can serve to affirm a person or group's identity (Polletta and Jasper 2001). Activism itself, apart from the explicit goals of a movement, offers participants the satisfaction of joining together, taking part in collective rituals, telling stories, speaking out, and forging common bonds. Scholars describe the emotional dimensions of protest as a form of "expressive politics," as opposed to instrumental politics, although most acknowledge that social movements and political activism typically involve both dimensions (Bernstein 2002).

The work of the PTC chapters and their members provides powerful evidence of expressive politics. Scholars who have studied this form of politics—from feminism and gay rights to Black Power—focus primarily on the process by which participation in protest builds affective ties between protesters, movement activists, and the larger group to which activists identify. Protest can also serve to avow publicly one's lifestyle and worldviews. By joining an environmental movement, for example, a person can effectively declare, "This is who I am, what I believe, and how I choose to live." Activists who join the PTC certainly do so in part to form allegiances with like-minded citizens; they also, no doubt, affirm their identity by committing to a cause that reflects who they are and what they believe. Yet unlike other forms of expressive politics, identity and group solidarity seems less important than personal voice. For PTC members, protest serves as a way to "bear

witness"—a personal source of redemption and meaning in an otherwise baffling and troubling world.

Author and Nobel Prize winner Eli Wiesel (1986) discusses the profound shame that people feel at having done "nothing" in the face of atrocities. Bearing witness—telling stories, erecting monuments, writing poetry, participating in a candlelight vigil, public prayer—is a way to testify to injustice and condemn collective sin. As Wiesel writes: "There may be times when we are powerless to prevent injustice, but there must never be a time when we fail to protest. None of us is in a position to eliminate war, but it is our obligation to denounce it and expose it in all its hideousness." This notion of bearing witness is also explored by Michael Young (2006), who suggests that the "expressive dimensions" of modern social movements have their historical roots in the abolitionist efforts of evangelicals across the United States in the middle of the nineteenth century. In particular, evangelical Christians bore witness to the nation's collective sin of slavery through confessional protests—public acts of personal redemption, conversion, and prayer. Wendy Griswold (2000) discusses how writers and novelists in Nigeria, through their stories, bear witness to the modernization and social change that confronts contemporary West Africans. In the introduction to this book, I point to the work of political philosopher Joel Feinberg, who connects "offense" to the feelings of guilt and shame, emotions experienced when people are implicated in a public spectacle. He contends that we are offended by public nudity, for example, because we feel ashamed and guilty for being part of someone else's humiliation or degradation. Similarly, PTC members feel ashamed and guilty of the public spectacle and indecency created by the media. They feel complicit in the collective "sin" of exposing young people to harmful material as well as society's general indifference to the well-being of children. In short, by "speaking out" PTC members bear witness to the social change enveloping their communities and to what they see as broader cultural decline. They also renounce a way of life and forms of art and entertainment that are antithetical to what they view as decent, normal, healthy, and good.

The religious sense of bearing witness—as Michael Young describes it—is evident in several statements from PTC members. One woman from Big City remarked, "I was so shocked, as a Christian parent, God gave me this responsibility and I am going to be all by myself right there in front of Him, and I will have to account for what I did." For this mom, staying quiet was not an option. As a PTC member she spoke out in part to account for the sins society has committed against our children. Along the same lines, a participant from Farm City remarked, "It's a matter of you do what you think is

right, regardless of outcome." Another parent from Farm City noted, "We've created the world that we live in and we need to take ownership of that. . . . Children lead these destructive lives because of some of the things we've allowed to happen. . . . It's just somebody has got to do something to try and protect our kids." Echoing Wiesel's sentiment expressed above, a male from Farm City declared: "Evil will prevail when good people do nothing." All of these comments invoke the idea that regardless of outcome, many PTC members feel they cannot just sit quietly by and are, instead, morally obliged to bear witness to the sins of today's media.

Similar to the idea of bearing witness, other participants talked about speaking out as a way of either finding one's own voice, raising general awareness, or discovering a "shared" voice with other concerned citizens. They assert that the PTC has provided them a platform to discover their voice. One participant from Big City compared the PTC's work to efforts of the then U.S. vice presidential candidate Sarah Palin: "Well, Sarah Palin has given new life to our energy in this nation as far as having a voice. We can each do that. I know I am speaking to the choir, but forget about somebody beating you over the head. Just go speak your heart and everybody around you is going to be glad you said something, and then they might say something." Expressing one's voice is seen as critical for raising awareness. PTC members worry about the "silent majority," those citizens who care about the decline of our culture but are either unaware of its consequences or lack the courage to speak out. In Big City a participant remarked, "I don't think we're small in numbers, I think we're just small in vocal numbers." In Capitol City a women remarked, "They [Hollywood] know there's a silent majority; a silent majority who assumes that the next guy is going to say something . . . which really they don't." In response to this comment, a fellow discussant declared, "We need to wake up the silent majority." So speaking out—not unlike "coming out" in gay communities—provides activists with a way to reach people who might otherwise stay quiet. A woman in Capitol City noted that before she became involved in the PTC she wondered whether there was "anybody in Big City that's seeing what I see and cares? Where are all you moms?" Speaking up is the first step toward finding those other caring and concerned moms. The director of the Green City chapter reinforced this idea that "voice" can help overcome isolation: "A lot of people believe that there's nothing they can do, so they need to know, yes, one person can make a difference. I think they feel alone . . . like no one else feels this way so I guess I am wrong. But they're not. They need to start getting out there and realize that there are other people out there that feel the way they do."

Apart from its role in combating the spiral of silence and raising aware-
ness, speaking out is also a form of *personal* expression.[5] As a woman from
Sunshine City remarked, "I want to be able to express myself. I have an idea
of culture and the way it should be, and I feel strongly and passionately
about the way." Others talked about wanting people in their community to
"know their feelings." After asking the owner of a local greeting card store
to remove certain explicit cards from their rack, a man from Capitol City
said, "I'm sure nothing ever happened . . . the cards are still in the same
spot they were when I complained. And whether I did some good or not, I
don't know. But, at least they *know my feelings*." Again and again focus group
participants noted the importance of "talking to people," "saying what you
think," and "speaking your mind." Activists discovered that people "listen,"
"pay attention," and "show them respect" when they voice their concerns.
Here again we see how important the expressive dimensions of protest can
be for participants above and beyond their strategic goals of "cleaning up
the airwaves." By speaking out, participants signal their dissent, saying in ef-
fect, "Not everyone here agrees with how things are." They also believe that
their dissenting voice needs to be heard above the din of noisy culture. Or to
put it differently, as one member in Big City noted, "We just need to break
through these walls of silence." In addition to finding and expressing their
voice, PTC members feel compelled to get involved as a way to get a partial
fix on a bewildering problem and deal with a source of great anxiety. One
of the first techniques learned by ballet dancers is the idea of "spotting"—
fixing your eyes on something stationary as you do a pirouette or free spin.
Without proper spotting, dancers lose their balance and coordination. For
PTC members, speaking out about television and entertainment is a way for
them to "spot" in an otherwise dizzying world of social and moral change.
Most activists acknowledged the challenges they face, describing the media
environment as pervasive, out of control, and rapidly getting worse each
year. As one activist remarked, "It will be hard to get the genie back in the
bottle," referring to the fact that media seems more edgy, more sexual, and
more violent with each passing year. In order to prevent feeling hopeless,
washed up in a sea of permissiveness and social change, PTC members reg-
ister their complaints with neighbors, local businesses, the Federal Com-
munications Commission, and anyone else who will listen. In so doing
they keep their eyes fixed on a cause that allows them to feel some sense of
control and stability. As a Capitol City respondent noted, "We've just got to
keep outing the good. Because some people are going to cling to that good
and some are going to toss it away. And bless their hearts. But for us that

[*sic*] believe in good, to keep putting it out, to give people hope, to turn their eyes up and not just centered on themselves."

Participants explicitly recognized the hopelessness that parents and "ordinary" people feel when confronting the media. As the director of the Blue City chapter noted, "Parents say, 'What am I supposed to do about it [television content]? I can't stop this.'" She describes parents as overwhelmed, ready to roll over: "Okay, you win, I can't do this anymore. I'm giving up." By voicing concerns, PTC members feel they are offering themselves and others hope and possibility. As the director of the Northern City chapter said, "It shows that people out there really, really care. As long as there is activism out there, work is going to get done and results are going to pay."

After asking herself rhetorically whether her efforts can possibly make a difference given the scope of the problem, a mom from Farm City stated:

> Well, I can talk about it, because it's an anxiety for myself . . . and so, by talking about it I can relieve that. And going a step farther and talking to my representative and having people come to a meeting or sending out advertiser letters. I'm actually doing something. Now will it make a difference? I don't know. But at the end of the day when I go to bed, I can say, Lord, I did the best I could today; and that's all that is asked of us. So being a member of the PTC, that's one aspect of it for me; it is a release. It is actually trying to do something to make a difference.

This notion of doing something in the face of difficult odds is eloquently summed up by the director of the Northern City chapter: "I go with the philosopher who says that it's better to light a candle than to curse the dark, and so no matter how much darker it gets, we can always light a candle."

A final theme that emerges from the group discussions is the link between social change, protest, and democracy, a theme I will return to in the conclusion. Many participants see their activity as integral to their role as citizens in a democracy. After noting that she had strong opinions about what counts as good and bad culture, a member from Sunshine City remarked, "But you don't have to feel that same way. Maybe I change your mind. I'm not scared for you to change my mind. But having that freedom to express makes us the great country that we are." Another PTC member from Blue City echoed this sentiment, "What we're doing is completely the embodiment literally of the First Amendment. We're speaking our minds, and we're going after something we are unhappy about." A participant from Capitol City linked her PTC work with her duties as a citizen: "We got to

keep doing good. There is so much yuck out there, there really is. And this nation is such a great nation . . . what it was founded on and established with. And I just want to keep it that way. You know? I just do."

The directors in Northern City and Blue City worry that the volunteer spirit in America is dying out. As the Blue City director describes it:

> Raising awareness is first and if I have to do that by writing and making cold calls, great. The second thing I want to do is get parents involved. I want to get back to that place in time where we do what we're entitled to and sit at the doors of our senators and congressman and demand action on this issue. People aren't doing that anymore. They are casting their votes, but they're not doing anything and that's ridiculous. That's ridiculous.

She continues:

> What it [PTC] does is get parents involved again and it gets them involved in their communities and their schools. I remember a time when parents' night at the schools was so packed that there was no parking. Now parents don't even show. It gets parents involved. It gets neighbors a common bond and they talk to each other and say, "I don't agree with this. Let's fight together on this." I think that's a really good way of strengthening the ties of morality in this country by banding together and fighting for something we think is really important. That's really what America is made of. Think of all the great things that have happened in American history. It just comes from one person saying, "This is unacceptable." That is how things happen. That's how things improve in this country. Things fall apart when everybody keeps to themselves and turns the other cheek and shuts the door at night.

Getting people to work together to fight the media not only holds the potential of "cleaning up the airwaves"—PTC's stated goal—but, perhaps more importantly, it also promotes democracy through "strengthening ties of morality."

Interviews with PTC members confirm several broad themes that have emerged over the course of writing this book: First, protest over art and culture is a response to social change. Second, this protest is inherently local. Third, cultural protest is an important part of democracy. In spite of the global scale of today's media, activists feel like its impact can be felt most directly in their own communities, providing detailed accounts of social breakdown involving violence, teen pregnancy and promiscuity, and disrespect for authorities. PTC members also link this social breakdown to the

content of media and to the growing presence of immigrants, nontraditional families, and people living in poverty, who are attributed with destructive media habits, poor parenting skills, or both. Activists are motivated to speak out and bear witness primarily for the benefit of local audiences—especially local businesses and residents. While they may or may not have long-term success turning back the tides of change, PTC members take solace in local victories: getting neighbors to take note of their concerns, convincing local sponsors to pull advertising, and simply gaining a platform, whether through a letter to the local paper, a table at a local fair, a speech at the library, or an invitation to talk to the Rotary Club. These local victories give participants a sense of voice, which, I contend, is a critical way in which citizens confront social change in a democracy. The opposite of "voice," in Albert Hirschman's words, is "exit"—which happens when people pull away from public life (Hirschman 1970). In a world of dizzying social change, these activists are following the dancers' technique of spotting—keeping their eyes focused squarely on the problem of media excess and centering themselves on themes of decency and respect.

Reflections on the Future

In one of the earlier focus groups, during a moment of candid honesty, one participant said, "You know, these are *my* opinions. This is how *I* see the media. Perhaps you should talk to kids. Ask them what they think about today's media. Maybe they have a different perspective." In this spirit I conclude this chapter with findings from a focus group consisting of fifteen freshmen (eighteen- and nineteen-year-olds) in my seminar class at Vanderbilt University. After the students reviewed the PTC's Web site, I asked them to reflect on their own experience with media and, specifically, to think about whether society would be better off if there were more restrictions on the content of music, films, television, and video games. In general, students were almost universally against any restrictions on content. Most of them reported having almost unlimited access to television, films, and music while growing up. One student noted, "It is impossible to keep kids from watching or listening to stuff. If they can't get it at home, they can get it at their friends' houses, on their iPods, or at school." My students acknowledged that the media is full of sex and violence, but most of the students felt that they "could handle it," meaning they could distinguish good from bad behavior, respectable characters from those deserving disapproval, and fantasy from reality. Young people, as represented by my students, maintain an ironic distance from their entertainment. As one student noted, "I

watched this movie where a women was walking around naked for fifteen minutes while someone was trying to kill her. It was so ridiculous, I just had to laugh. Eventually, if Hollywood keeps including gratuitous sex and violence, it is going to backfire. It's just dumb." Not surprisingly, students see themselves as critical viewers and media consumers.

Interestingly, while celebrating their *own* critical distance, they acknowledge that the media can have a negative influence on others. One student was concerned that her eight-year-old brother was acting aggressively because of his exposure to violent video games. Another student acknowledged that kids were dressing more suggestively because of television, noting, "I am disgusted when I see a six-year-old girl wearing a skimpy outfit; that's just gross." Echoing the concerns of activists in the PTC focus groups, students felt that the pervasiveness of sex and violence in entertainment and media was making people numb to such images.

Students hold contradictory positions on the media, seeing it as harmful to some in society but not to them personally. They feel inoculated from the harmful effects of media largely because of their upbringing, pointing to the fact that they would often talk about television shows with their parents, and that their parents had given them a solid foundation from which to judge right from wrong. Yet they recognize that some young people do not have the benefit of strong parental guidance or support, acknowledging that regardless of socioeconomic background some kids grow up without the direction and guidance of engaged and involved parents.

The solution, they suggested, involves greater public debate around morality and the media. They believe that such debates, even if at times polarizing, will raise awareness among parents who might not otherwise think about their responsibility to help children approach media and television critically. The students mainly called on parents, but also journalists and even government officials, to "censure" material by publicly denouncing media depictions that challenge widely held values—such as those that glorify violence. Rather than seeking solutions that reach consensus around appropriate content, the students wanted to see schools give greater attention to helping students be more critical when watching television. A few noted that they had taken a course that introduced a critical approach to media, focusing on the business incentives and marketing ploys of advertisers and the potential consequences on audiences. Yet students were not willing to cede any *control* to authorities, especially government. All of the students were against censorship in any form. Above all else they felt entitled to decide for themselves, acknowledging that such decisions would best be made on top of a strong moral foundation. Students seem to be calling for media

literacy more than media restrictions; censure rather than censorship; and moral conversation and debate rather than quiet acceptance.

It is possible that today's youth will become more concerned about media content as they get older and confront the challenges of raising children, but, I suspect, the idea of regulating the media will become less relevant to rising generations. As one student noted, "It's too late. We are already over it," referring to the sexually revealing clothing featured on television. While the PTC might not see its membership ranks swell as current college students enter adulthood, activists should be heartened by the fact that my students share some of their concerns about media and are open to debate and conversation about its potential harmful effects. Regardless of political position, religious orientation, or stance toward the First Amendment, American democracy will be improved if more people of all ages feel compelled to speak out about the state of America's cultural life. Staying quiet, as one PTC member put it, "is not an option. . . . It is our culture and we should make it what we want it to be."

Art and Cultural Expression in America: Symbols of Community, Sources of Conflict, and Sites of Democracy

It was Monday morning and I was standing in my closet picking out a shirt and tie for work. Sam, my four-year-old son, was sprawled on the bedroom floor tossing a foam football clumsily into the air. He summoned my attention, "Daddy, Daddy. Look at me." "Hey," he said. "Let's go outside and play ball together." Regretfully, I told him it would have to wait until after work. He asked if I could stay home today, just this once. "I can't do that, Sam. I have to go to work to finish writing my book." He had known I was writing a book but had never paid much attention. Today he asked, "What is your book about anyway, Dad?" I replied, "You know, people don't always agree about what type of television shows should be on TV, which songs should be on the radio, or what paintings should be hung in museums. The things that some people like, others really dislike." "Oh," he said, losing interest fast. I pressed on, "Sam, what would you do if you were in charge and people didn't like something—some show or some type of art?" Without blinking, he asserted, "I would just get rid of it." Adjusting my line of inquiry, I said, "But what if half of the people liked it and the other half didn't. What would you do, then?" Sam considered the question and said confidently, "I would just tell the people who don't like something to just walk by and not look at it." It seemed like such a clear-eyed view of cultural conflict. Why, after all, can't people just "walk by and not look"?

Sociologists offer a number of answers to this puzzle. First and foremost, artworks are symbols. They not only mean what they say (for example, the explicit message), but they also "stand in" for a constellation of ideas, values, and definitions about the nature of reality. Most of us can live with words, images, and sounds that we do not like. In fact, as suggested in the introduction, we are surrounded by discomfiting culture and media all the time. There is always something to offend someone. For the most part we

embrace a "live and let live" attitude; we adopt Sam's solution and look the other way. Yet when art and media take on heightened and contested symbolic meaning, "letting live" can become more difficult. A clear example of a contested symbol would be the controversy over the Confederate flag that flew over the South Carolina State Capitol from 1962 to 2000. The flag itself is both reviled and revered. On the surface, some like its colors and others find them ugly. On a deeper level, traditionally minded citizens are drawn to the flag because it represents a bygone era; the more modern-minded prefer a symbol less burdened with historical baggage. At yet a deeper level, some celebrate the flag because it represents a certain story about the old South—its struggles, its way of life, and its courage and conviction. Others detest the flag because they interpret the old South differently, focusing instead on slavery, Jim Crow laws, and racial injustice. Finally, for some the flag represents an entire way of life—community-oriented, rural, and genteel—that is under assault in the twenty-first century; for others it represents continued discrimination, racism, a threat to full citizenship, and an obstacle to progress and modernity. The Confederate flag takes on a constellation of meanings, ideas, and values that together represent ideas about community, identity, and progress. By 2000 when the debate over the flag was at its most intense, it had become a powerful symbol, and the decision about whether it should stay or go, fly or fold, had significant repercussions—potentially making it easier or harder for many in South Carolina to "live and let live" and still feel welcome in their community (Webster and Leib 2001).

Like the flag controversy, protest over art and culture reveals the power of symbols to disrupt community life and engage local passions. The controversy in Atlanta (discussed in chapter 4) over a sculpture intended to honor the city's first black property owner, Mary Combs, reflected the artwork's symbolic power to signal whether Atlanta was still beholden to the old South or whether it was a new South city. In Albuquerque a proposed sculpture to honor the Spanish explorer Don Juan de Oñate proved to be a powerful symbol of whether the city would recognize its proud Hispanic legacy or the struggles and persecution of its indigenous Pueblo population. In Fort Worth the decision to keep or remove the *Caelum Moor* sculpture, an assembly of granite rocks some claimed were satanic, became a symbol of whether the city was a world-class and modern metropolis or whether it was a community dedicated to traditional religious values. In Dallas the conflict over a controversial book that contained an offensive quote about slavery was a symbol for deeper racial tensions in the community that centered on the inclusion and representation of blacks in the administration of the city's schools. When a Kansas City school board banned the lesbian-themed book

Annie on My Mind from school libraries, and when a local group burned copies of the book in front of a district school building, the symbolic importance of the book was clear—its presence in the library affirmed the legitimate place of gays and lesbians in the community; its removal symbolized that Kansas City was a place committed to traditional notions of family.

Symbols: Change and Community Identity

Sociological theory emphasizes the importance of symbols for constructing community. Physical symbols (for example, flags, logos, football teams, architecture, public art, and memorials) as well as mental constructs (for example, shared history, common stories, collective representations, and community standards) provide people with an "imagined community" (Anderson 1991).[1] The boundaries of such imagined communities must be policed regularly, and protest over art can serve to demarcate the border between those people and ideas that deserve inclusion and those requiring censure or disapproval. In *cities of cultural regulation* (see chapter 6), arts conflicts serve exactly this function: they are rituals of protest that sort, cleanse, clarify, and enforce and reinforce agreed-upon standards and fault lines.

Artworks also serve as symbolic representations or signposts of a city's future. In *cities of contention* (see chapter 7), citizens find themselves at crossroads faced with extraordinary demographic change. In such places residents battle over their city's image and brand—struggling between notions of the old and new South, ideas of traditionalism and progressivism, small-town values versus those of a bustling metropolis. A city's identity often seems to hang in the balance as citizens debate whether or not to embrace or reject a gay-themed play at a publicly funded theater, a concert by shock-rocker Marilyn Manson at a public arena, or a community parade celebrating the Confederacy. In *cities of recognition* (see chapter 8), historically disadvantaged groups—ethnic and religious minorities, women, and gays and lesbians—attack art and entertainment as a way to exert control over how they are depicted in books, movies, fine art, and music. By taking control over symbols of representation, such groups seek respect, recognition, and influence in their communities, ultimately redrawing boundaries to be more inclusive.

Symbols often become contested during times of uncertainty. Not surprisingly, the most contentious cities in my study were those communities experiencing rapid social change: cities with the most growth in immigration in the 1980s experienced almost twice as many instances of protest as those cities with the slowest rate of immigration.[2] As Robert Merton

reminds us, in unsettled times "differences in the values, commitments, and intellectual orientations of conflicting groups become deepened into basic cleavages" (Merton 1972, 9).

This link between social change and cultural conflict is demonstrated at the community level, as noted above, as well as at the individual level. Chapter 2 illustrates how individuals who worry about the pace of social change or, more specifically, the growing presence and demands of immigrant groups, are more willing to restrict controversial books in the library. They are also more receptive to increased government regulation of television content. While the analysis presented in chapter 2 is based on aggregate data from large-scale national surveys, chapter 9 arrives at a similar conclusion by talking to parents and citizens who join local chapters of the Parents Television Council (PTC), a national organization whose mission is to clean up the airwaves and promote more family-friendly entertainment. In focus groups across the country, people discussed how their involvement with the PTC was linked to concerns about *changes* in their communities—increased violence, teenage promiscuity, lack of respect for adults, and incivility. Importantly, PTC members linked these changes to a rise in immigration, noting that immigrants have a different culture and a different style of parenting. From their perspective, immigrant children are exposed to harmful and explicit media without the benefit of attentive parents to help them navigate right from wrong. The result, according to focus group participants, is behavior that threatens the community—teen pregnancies, violence, and disrespect.

Sociology of Emotions: Discomfort and Protest

Related to people's concerns about the pace of change in their communities are a host of feelings and emotions that motivate people to get involved in protests over art and culture. Sociologists have long recognized that emotions are key factors in influencing individual behavior and social relations. Experiences of anger, disgust, pride, joy, anxiety, and shame can help determine a range of social actions—the decision to court or shun a relationship; to celebrate or conceal certain aspects of one's identity; and, for our purposes, to join a protest over art and culture. In studying cultural conflict—from temperance to pornography to art—sociologists have focused on "status anxiety" and have argued that individuals compete with one another over status and esteem, celebrating cultural expression that elevates their own lifestyle and beliefs while denigrating the culture of competing groups—whether immigrants or urban dwellers or small-town people (Gus-

field 1963; Page and Clelland 1978; Zurcher and Kirkpatrick 1976). In using status as a key concept, sociologists have acknowledged the important role of emotions—low status or high status is linked to feelings of self-respect and pride. Yet this work has not *explicitly* identified, studied, or offered insight into how emotions like self-esteem and respect play out in the day-to-day lives of activists or citizens who become involved in a conflict. In my own work, participants and activists routinely articulate their positions in emotional terms. People express moral outrage at artworks they find offensive; some express anger and indignation; others say they feel a "loss of control" over their children, their community, or the broader culture. Many feel "affirmed" by the opportunity to speak out against an artwork that they find offensive or inappropriate. Parents and citizens who join the PTC to bear witness to offensive media and entertainment place emotions front and center in their work.

Perhaps the most important emotion that motivates activists and under-girds many conflicts over art is shame. Sociologists have long acknowledged the important role of shame in shaping human behavior. Erving Goffman (1955) describes how people are motivated by "saving face" in their daily interactions with one another; Charles Cooley (1922) argues that we feel ashamed by a negative judgment or image that we feel others have formed about us; Norbert Elias (1978) notes that manners are a means of regulating and reducing shame and embarrassment (Scheff 1988, 2010). Joel Feinberg (1985) argues that we feel ashamed by public spectacles—like public nudity or explicit television or public artworks—because we feel implicated in the spectacle. We are drawn into the humiliation of the person being exposed and come to see the whole situation as embarrassing for all involved. Many of the focus group participants discussed in chapter 9 also expressed feelings of shame—speaking of their complicity in passively accepting the growing depravity and degradation endemic in media and culture. They also talk about more direct and personal shame that arises when they have to explain a sexual reference or image to their children.

Feinberg notes that we feel shame when an unflattering stereotype is directed at a member of our group. For example, Haitians were particularly upset—or ashamed—when the film *How Stella Got Her Groove Back* referenced Haitian immigrant males as being sexually promiscuous and carriers of the AIDS virus. African American students in a high school English class talked about feeling ashamed when other students read the word "nigger" out loud during a class discussion of *Huckleberry Finn*. And time and again activists with traditional values were highly conscious of how others viewed them—working hard to distance themselves from such labels as censor,

bigot, and zealot. I would argue that many of these activists experience a triple sense of shame. First, they feel ashamed of witnessing a public spectacle that they consider to be indecent. Second, they feel ashamed that they hold values at odds with mainstream culture. Finally, they feel ashamed to publicly stand up for those values and be judged by others to belong to the fringe of society. Feeling shame about one's place vis-à-vis the larger culture does not preclude feeling proud about one's activism. While feelings of shame may motivate protest, feelings of pride and determination help sustain activists in their difficult and often unwelcome work.

Sociologists Thomas Scheff (2010), Helen Lynd (1961), and Helen Lewis (1971) have linked the emotion of shame to "fears of social dislocation, of being adrift from understanding and being understood by others." As Scheff argues, the constellation of "shameful feelings"—from embarrassment to humiliation to feelings of inadequacy—are united by a common feeling of a threat to the social bond. Shame is often produced when people feel estranged or alienated from the larger culture. This is precisely the feeling that emanates from my focus groups with PTC members, and it is the feeling that gets expressed by protesters at town hall, library board, and school board meetings. When a book or film or art exhibit is legitimated by schools, museum curators, theater owners, or newspaper editorials, opponents feel a sense of alienation. They feel self-conscious about their beliefs and wonder how it is that others in their community can be so tolerant of ideas and images they find abhorrent. Self-doubt or shame is certainly a likely and powerful emotion in such situations. As Helen Lynd (1961) discovered, sharing one's shame with others by finding like-minded neighbors who also feel belittled and ashamed can be a powerful way to regain some sense of being understood and accepted. This idea is expressed by activists in my study who describe the importance of finding others who share their beliefs and the power of discovering that they are not alone.

My findings suggest that when a community experiences rapid population changes, often signaled by the arrival of new immigrants, residents begin to feel uneasy and anxious. But importantly, these feelings are not simply personal and individual, they are linked to people's images of themselves in the context of their communities. Social change forces people to consider whether they truly "belong" in their community, whether their lifestyle and beliefs remain important and valued, and whether they will be respected and held in high esteem for their choices and their tastes. When people emotionally react to a book, film, play, exhibit, or song, they are not merely defending an ideological position or responding to an automatic and visceral offense. People are feeling ashamed—in the full complexity of

that emotion—and are seeking others in affirmation of a social bond and a sense of community. They want to feel comfortable again and to feel a sense of belonging. As Quentin Schultze (2003) argues, protesters who feel "vulnerable and beleaguered" will "argue for a place in the broader culture" (31). Protesting, joining with others, finding like-minded neighbors, and expressing one's voice are important techniques for overcoming and transcending emotions of shame, vulnerability, and discomfort—feelings that are rarely conscious but nonetheless operate powerfully below the surface. I have not spent time assessing the social psychology of activists. In fact, much of my analysis is based on newspaper reports and focus groups. These sources are far too thin to provide the kind of rich and multilayered details that more intense ethnography or rigorous psychometrics might provide. Nonetheless, it is clear that people are fighting over a sense of community, that they are anxious about social change, and that they are affirmed in their efforts to speak up and to connect with others of like mind. These experiences fit the theory of shame outlined by Scheff and explored by other sociologists over the past seventy-five years. In addition to shame and discomfort, there may be other powerful emotions implicated in arts protests (for example, indignation, fear, loss). I leave it to future scholars to better understand the nature of the emotions that surround and motivate protest over art and culture.

Cultural Conflict and Democratic Life

In many ways opponents who wish to curtail art and culture face significant hurdles. First, the Constitution makes it difficult for public entities (like schools, state-run museums, and libraries) to terminate an exhibit or presentation simply because someone finds it offensive. Many local school boards, city governments, and library boards have faced long and costly legal battles when they have disregarded the guarantees of the First Amendment. Second, popular culture is only getting more permissive, violent, and sexually explicit over time. People have greater access and more exposure to challenging, provocative, and potentially offensive content than ever before. As one member of the Parents Television Council (PTC) remarked, "The genie is out of the bottle." It is unlikely that we will ever return to a more puritanical culture. Instead, our culture will likely continue to get noisier and harder to reign in and control. In such a context, what role can protesters hope to play in influencing policy and business practice or reversing what they see as moral and cultural decline? Why do people stand outside of a Marilyn Manson concert and hold a prayer vigil if there is little

chance of stopping the concert from taking place? Why do parents take on Hollywood when studio executives and programmers seem to turn a deaf ear and continue to produce films and television shows that disregard local standards or morals?

Sociologists argue that individuals participate in rallies and demonstrations, sign petitions, and speak at public hearings as a way to express their views, to be heard, to "take a stand" (Jasper 1998; Goodwin, Jasper, and Polletta 2001). Throughout this book activists have expressed such sentiments, but consider the following example. In a local newspaper a parent in the local group Citizens for Family Friendly Libraries in Atlanta remarked, "The two cases [two separate efforts to remove offensive books] show that people are realizing that they have a right to *express* their grievances" (Ippolito 1995). In response to the same controversy, another citizen wrote to the newspaper: "The people that want to protect their children also have a right to say what they want in this country—we are citizens, too, and I am tired of being told that I don't speak for anyone—I speak for me—and if you do not like it, that's tough. I won't be silenced" (Cox 1997). These are powerful statements—affirmations of the link between citizenship, democracy, and voice. By speaking out, these activists are, in effect, validating their roles as citizens and asserting their place in the community.

Political economist Albert Hirschman (1970) has written about the value of "voice" as an instrument to improve the quality of firms and businesses as well as the quality of government and public goods. Hirschman argues that there are two possible responses when people are dissatisfied with a product or service. They can either complain (voice), or they can simply stop consuming or engaging with the product or service (exit). Exit rather than voice is the American tradition—"dissatisfaction with the surrounding social order leads to flight rather than fight, to the withdrawal of the dissatisfied group" (108). He continues, "Why raise voice in contradiction and get yourself into trouble as long as you can always remove yourself entirely from any given environment should it become too unpleasant?" (108). In fact, in response to protests, arts advocates and cultural professionals often tell opponents that they are free to look the other way, turn off the TV and radio, or read a different book. In effect, arts professionals suggest that people are always free to exit if they don't like something, but Hirschman argues that voice is often a better option than exit because it provides valuable information to leaders and managers about how to improve the quality of goods and services. Voice also solidifies the practice of democracy. More importantly, in matters of public goods (like the provision of art and culture),

people have a stake in the larger public interest. Even parents who turn off the dial still feel invested in improving the quality of television because they will ultimately have to live with the consequences of what they see as growing incivility and coarseness in the media and in society. For many, exit may not be a viable option. Furthermore, in the realm of culture, the process of exit creates separate silos, with people consuming only the culture that fits their tastes and sensibilities. Without a shared culture, many would argue, democracy will wither. As evidence in this book suggests, when people choose to exit from the cultural life of their communities rather than speak up, they are left feeling alienated and estranged.

Echoing Hirschman, Georg Simmel (1955) argues that voice is far better than indifference, which he suggests is "purely negative" and a drain on social and political life (14). When people voice their opposition, he argues, it makes them feel that they are not "completely victims of the circumstance." Without such a corrective, he goes on, people "withdraw at any cost" (9). Simmel sees contending voices as essential to democracy and as a vital part of social life. Simmel's claim is similar to James Coleman's argument (1957) that community conflict is actually a sign of healthy engagement. According to Coleman, high levels of protest and antagonism indicate that people are engaged and care about the future of their communities.

Like Simmel and Coleman, I see protest over art and culture as a healthy and vital part of democratic life, especially during times of social change and unrest. Robert Wuthnow (2006) expands this idea when he writes:

> Controversies about values also reinforce values. This is true especially for those who feel their own values are threatened by another group or by the wider culture and for this reason rededicate themselves to the preservation of their particular values. . . . The health of civil society depends on periodic renewal of the population's commitment to core values, and such renewal comes about through rituals and controversies as through more routine mechanisms. . . . The resulting debates become occasions for talking publicly about such issues as freedom of expression, standards of aesthetic evaluation, decency, morality, and a variety of other issues. In a pluralistic democracy, it is unnecessary for these debates to result in agreement. (335)

In other words, it is the process of speaking out and debating our public culture—the "ritual of controversy"—that affirms public life.

It is one thing to celebrate voice, but if protests over art and culture are similar to other culture war issues, then, according to James Davison Hunter

and other critics, the voices in the debate risk being shrill, polarizing, and fractious. As the argument goes, extreme voices come to dominate public discourse, fringes pull at the middle, sound bites and distortion characterize debates, and public life is diminished. Hunter (1991) is pessimistic about the impact of what he considers extreme politics and notes, "Cultural conflict is inherently undemocratic. . . . When cultural impulses this momentous vie against each other in public life, tension, conflict and perhaps even violence are inevitable" (4).

Based on my evidence from one specific front in the culture wars—protest over art, media, and entertainment—I hold a more optimistic view of the value of cultural conflict. In chapter 5 I show that protest over art is more frequent in those places where the political culture is conducive to collective action. Such a context is characterized by the emergence of an unconventional political culture, a history of protest, and an active and engaged citizenry. Arts protests draw on similar repertoires of contention as other forms of collective action and emerge in places where civic life is robust. In other words, conflict over culture is part and parcel, rather than peripheral, to democratic life.

By focusing on political context, I contend that arts conflicts are not that dissimilar to other forms of political contention. As noted in chapters 1 and 5, the discourse and rhetoric deployed in local arts protests is more civil and "in bounds" than the culture war frame might suggest. Most protests in my study were not fights to the finish. Instead, participants often took reasoned positions, acknowledging the need for compromise or at least recognizing that the other side has a right to its opinion. In response to a protest in Minneapolis over a Marilyn Manson concert, a defender of the shock rocker wrote to the newspaper:

> I am an avid supporter of this band and believe their performances should be seen before being protested. However, I would like to express my thanks to the various Christian groups, for their demonstrations were both peaceful and civilized. . . . I myself had a very pleasant conversation with a small group of demonstrators and walked away feeling a better understanding of each other's viewpoints. One comment made was that the protesters were not trying to stop the concert but to "bring God's attention and the awareness of him to the area." Something they have a right to do, as much as I have the right to enjoy the performance. After all, freedom of speech and religious choice are two of the reasons we live in the United States. (Nightshade 1997)

This statement is exceptionally genial, *but* it is not unusual.

In Cincinnati, in response to protests over Maya Angelou's *I Know Why the Caged Bird Sings*, the superintendent of public schools acknowledged the value of dialogue and of engaging people in deliberation, noting, "I think it is a terrific challenge. We have to reach out to our community and bring people together" (Bricking 1996). In the same case the newspaper editorial staff acknowledged that "Lakota [the school district where the book was challenged] is having the kind of community conversation school boards and parents are supposed to have" (*Cincinnati Enquirer* 1996). In Kansas City, where the school board was sued for removing the book *Annie on My Mind*, civility rose to the top even in the midst of passionate feelings and emotions. The author of the book acknowledged that protesters were "well intentioned and believe passionately in their positions." In a similar spirit an area science teacher who brought the suit against the school board explained, "I believe everybody in this case is in it for the students. It's pretty simple. It's for democracy" (Ebnet 1995). A high school student who joined the suit as a plaintiff remarked, "Most of the responses from my schoolmates have been good. But I have had students tell me that they didn't support our case. And they have a right to their opinion. Students should let their opinions be known. Everyone has that right, the school district as well" (Gross 1995a). After losing the case, the superintendent admitted, "I think bringing this to a conclusion will help people have a better understanding of what we, the local school board, can and cannot do. It's an experience to grow from. Even though we lost, there were a lot of things from the case that turned out in a very positive way for us" (Gross 1995b). In a separate case in Kansas City, after a controversy over two high school plays—*Dark of the Moon* and *Romeo and Juliet*—the principal of the school remarked, "All concerned have gained a better understanding of the need to respect everyone's views on matters of taste and morality, be they liberal or conservative. 'How do you respond when someone offers an opposing view?' That is the lesson" (Hendricks 1999).

Even in the most intense battle of the 805 conflicts in my study, civility and respect seemed to rise like a phoenix from the ashes. In Charlotte, North Carolina, the play *Angels in America* created a firestorm that included more than five hundred newspaper articles, dozens of public meetings, demonstrations outside the theater, threats of a public indecency prosecution, injunctions, and eventually the complete withdraw of county funds from the arts and sciences council. Nonetheless, time and again, citizens, public officials, religious leaders, and the arts community argued that the debate itself was healthy and important. In one letter to the editor, a resident wrote:

Charlotte needs more productions like *Angels in America*. What a wonderful experience it is for our community. Local officials have a new issue on which to pontificate. The *Observer Forum* is filled with interesting letters. Liberals and conservatives have an opportunity to demonstrate. And, most importantly, we all have the opportunity to discuss an intellectually challenging topic—freedom of artistic expression. (McMullen 1996)

On opening night a member of the audience remarked, "I think this has been a good thing. We've been talking about this a lot in our family. Even though some people oppose it, I think we've been able to understand everybody's position a little better" (Williams, Brown, and Wright 1996). In an opinion editorial a local church leader explained:

I believe that the people in our community who object strenuously to certain aspects of the play—as well as those who support its free portrayal—are on a journey for wholeness. We all want protection from situations and circumstances we view as threatening, and our search leads us in directions similar to those of the people portrayed on stage: to anger, to power, to love, to religion, to posturing against "the enemy," to struggle in an attempt to live. And, from struggle comes growth and—we hope—wisdom. (Gloster 1996)

The local theater critic argues that *Angels in America* "forced citizens, artists and politicians, the religious right and left, audiences and taxpayers to confront an issue that has heretofore been glossed over." He continues:

The arts folks will probably insist on freedoms guaranteed them by the U.S. Constitution. The religious right will probably continue to believe that an authority higher than the Constitution compels them to challenge those rights. But the process of hashing out differences is fundamentally a good one for this community, which too often tries to avoid healthy confrontation. For all the messy and embarrassing uproar, "Angels in America" is the one of the best things that Charlotte has ever done for itself. (T. Brown 1996a)

When debate strikes a genuinely collegial tone, it reveals what democratic debate can look like in its best form. Even at its worst—when rhetoric is harsh and uncivil—I would argue that conflict typically produces positive democratic outcomes. While people may have deeply held convictions and feel passionately about whether a cultural object should be available, restricted, or prohibited, they can often live with the final decision made by public officials, school administrators, librarians, theater owners, and

museum directors. After all, contending parties are fighting over words and symbolic objects as opposed to issues that have immediate consequences on their livelihood, like tax law or economic development plans. In the realm of symbols, it may not be necessary for opponents to arrive at a politically satisfying compromise—what deliberative theorists would call middle ground. Instead, in the spirit of expressive politics, critics and dissenters of offensive art might simply be seeking a forum to speak out, and this includes shouting, proffering sound bites, and deploying harsh rhetoric. Protesters need not participate in rational deliberation in order to feel affirmed in their beliefs, reengaged in community life, and more sensitive to the deeply held convictions of opponents. From the standpoint of democracy, arts protests provide citizens with an opportunity to exercise their voice, take a visible stance, and demand respect and recognition in their community. Emboldened by finding one's voice, citizens can then proceed to more deliberative and more substantive democratic participation. In the epilogue I offer some principals of engagement to help artists, activists, and public officials move from voice to more substantive deliberation.

I argue that protests over art and media frequently emerge when individuals and groups experience discomfiting social change in the context of their own communities. Fighting over symbols, reacting to perceived offensive art, and speaking out on behalf of the community are natural and democratic responses to the uncertainties caused by immigration and other social changes. By speaking out, people are bearing witness to what they view as unacceptable forms of expression, and they are declaring that their voice, opinion, way life of life, and values still matter in the community. These protests are a form of expressive politics, and their symbolic and emotional dimensions are potentially more important than achieving their stated policy objectives.

Reflections on the Culture Wars

Previous research and writing about the culture wars emphasizes the national profile of cultural conflict—the battle between religious and political elites over the symbols that define American life. These are depicted as epic battles, waged and won by national social movement activists and politicians who deploy divisive and polarizing tactics that include sound bite politics, ideologically hardened positions, and attacks on the legitimacy of opposing viewpoints. While Hunter, the progenitor of the culture war thesis, acknowledges that "the culture war does not manifest itself at all times in all places in the same way and is . . . very often local in its expression,"

his thesis circles back to the importance of national actors, common tactics, and themes of nationhood and American life more generally (Hunter and Wolfe 2006, 30).

The evidence presented in chapter 1 and throughout the book offers a somewhat different view. I have already noted the discourse of compromise, civility, and respect that surfaced in many of the conflicts. Additionally, most protests over art do not involve highly visible moral crusades. When compared to high-profile campaigns at the national level, the protests in my sample are less well organized, typically initiated by parents or citizens rather than by political or religious actors, and involve less strident and publicly visible tactics. In fact, rarely do local protests resemble true culture war politics—sustained, organized, and coordinated attacks from both the left and right aimed at embroiling communities in strident, polarizing, and fractious debate. The evidence suggests that nationally coordinated protests do not attract much fury locally. These protests might help attract press attention and raise money, but they do not seem to gain any traction at the local level.

To borrow a phrase from Tip O'Neill, the longtime Speaker of the U.S. House of Representatives, perhaps "all politics," or at least all arts conflicts, are ultimately "local." Protests over art and culture typically originate from local concerns and grievances, target works that are produced and/or disseminated locally, and play out in local venues—city-based newspapers, town halls, and school auditoriums. Given the frequency of local disputes, it is likely that the average American would be more familiar with efforts to ban a book from the library, prevent a local concert, or protest a new public sculpture on Main Street than they would be with a controversy or dispute surrounding the National Endowment for the Arts (NEA), the Motion Picture Association of America, or the release of a misogynist hip-hop CD. In fact, low levels of interest in national arts controversies might explain the fact that in spite of highly visible attacks on the NEA at the national level during the 1980s, popular opinion in favor of government funding for the arts actually increased between 1980 and 1990 (DiMaggio and Petit 1999). Paul DiMaggio and Becky Petit conclude that for most Americans national arts issues are low salience; that is, they are not issues that people spend a lot of time thinking about, and they are probably not issues that, when push comes to shove, they care much about. Yet when neighbors fight over art and culture locally, they are struggling to determine whose lifestyle, beliefs, and identity will be affirmed and whose will be denigrated, whose voice will be heard and whose will be silenced. Citizens also measure themselves and

their communities against national trends, but most social comparisons or assessments of one's social position take place locally.

In addition to focusing mostly on national actors and events, the culture war perspective also highlights a growing values divide in America. Protests erupt in part because orthodox and tradition-minded citizens have very different conceptions from liberals and progressives about the purpose, meaning, and value of art. The former sees art as representing transcendental notions of beauty, as adhering to standards of excellence, and as deriving value from external sources—experts, the market, God. People who hold a progressive viewpoint see art as a form of self-expression and self-development, as an avenue for questioning and critiquing society, as a means to recognize and honor diverse points of view, and as a resource for addressing issues of social justice. In this formulation protests over art are ultimately a battle over differing views about truth, authority, and beauty. This account is not entirely incorrect. Values and worldviews often lie at the heart of arts conflicts, but more importantly, I argue that artworks call into question people's understandings of their community, their sense of place, and their ideas about belonging and fitting in. Protest erupts not only when art offends our moral sensibilities—our *worldviews*—but also when it challenges our *place in the world*, or more specifically our place in our community.

Based on the above proposition, I suspect that many protesters are asking themselves questions such as: "Is this a place I feel comfortable?" "Can I express my opinion without feeling like an outcast?" "Can I say a prayer before a meal in a public place without people looking at me like I am a fanatic?" "Can I celebrate my ethnic or sexual identity free from the judgment of my neighbors and free from stigma and stereotype?" "Can I speak up at the local PTA without feeling like I am the only one who holds my particular opinion?" Winning or losing these local cultural battles affects how members of a community feel about where they stand with regard to others. It is less about contending with a worldview and more about contending with one's neighbors about judgment, recognition, acceptance, belonging, and voice. In this respect my perspective is fundamentally Durkheimian. In conflicts over art and culture, people are motivated as much (if not more) by their sense of belonging and community than by their ideology and faith. My thesis is premised on the idea that we—activists, neighbors, citizens—are social beings before we become moral beings.

New York Times columnist David Brooks summed it up perfectly in a column that attempted to debunk the notion that hot button culture war issues are ideological battles. It is worth quoting him at length:

Most people of course don't see these [culture war] issues through an ideological lens. They see social issues through a more fundamental prism. They are aware that they live their lives amid a web of relationships, which they treasure. They seek to preserve the sense of civic order that gives security to their lives—not some abstract thing called community, but the specific community they inhabit. People are seeking the [political] positions that will help them preserve the invisible bonds of community. Most people, even on these hot button issues, gravitate toward positions that seem to best preserve unspoken communal understandings.

He concluded, "There are fewer and fewer culture warriors in America. Most people want order and peace" (Brooks and Collins 2009).

Artworks can bring to the surface these unspoken communal understandings, calling attention to fault lines and frayed relationships and disrupting a sense of security and order.

Cultural Sociology and the Study of Arts Conflict

This book is about protest over art, but it is decidedly *not* about art and only *peripherally* about protest. The book largely ignores the question of whether the contested artworks in this survey are good or bad. In contrast to other sociological accounts of arts conflicts, this book does not spend much time investigating the specific symbolic content of artworks or how and why certain images, sounds, and words offend or challenge norms of acceptability. While I spend considerable time discussing the political context for arts conflicts and their potential impact on democracy, I do not study the dynamics of collective action. In particular, I do not focus on the strategies and resources deployed by protesters nor do I focus on the political opportunities facing activists or the interaction between protesters and institutional structures like the press, government, and nonprofit or advocacy organizations. Instead this book treats arts protest as a critical site for negotiating the contours of community life, an area rich for advancing several lines of inquiry for cultural sociologists.

One area of emphasis for cultural sociology has been the social meanings that are constructed around artworks. Scholars in this tradition have focused on how the meaning of books, theater, music, and film vary across contexts (time and place) and depend on the interpretative frameworks of different groups. Cultural sociologists have extended this work to understand how art and media serve to construct communities—from little league baseball teams to teams of workers, from suburban neighborhoods

to urban street corners, and from music scenes to religious cults. In studying communities, scholars look for ways in which groups construct shared meaning around different forms of expression—language, collective stories and myths, styles of dress, manners, and music. This shared culture builds solidarity and group attachment. It also delineates the boundaries of a community or group. Scholars emphasize the ways in which artworks reflect the zeitgeist of a community—its spirit, shared history, trajectory, agreed-upon values, and norms.

Far fewer sociologists of culture have focused on the contested nature of art and, in particular, how such conflict explicitly links to community life. Those who have focused on arts protests tend to view such conflicts as part of larger ideological and political clashes taking place at the national level. In the spirit of James Coleman (1957), whose groundbreaking work on community conflict has largely been overlooked by cultural sociologists, my book focuses on the ways in which arts protests are implicated in broader community dynamics. In doing so I have followed Coleman's advice to compare communities side by side in order to understand differences between them as well as to identify some of the structural preconditions of conflict. Communities differ in important ways when it comes to disagreements over art and culture, including the overall levels and intensity of protests. Additionally, some cities fight over art to reinforce agreed-upon community standards. For others, community standards are very much open to debate, and artworks come to symbolize differing views over a city's future. Still in other cities, newly enfranchised and growing minority groups fight over art in order to secure recognition and respect for their group. Cities also differ in terms of their history of protest, their political culture, and, importantly, their rates of social change—all factors that influence the intensity, frequency, and style of conflict. In the latter case, cities fight over art when citizens feel besieged by a growing population of immigrants who bring with them different cultures, different lifestyles, and different values. Protest over artworks becomes a way to challenge or reassert community norms and values in the face of such dramatic change.

Even in our global and technologically wired world—where art and media seem omnipresent, infinitely diverse, and mobile—instances of artistic expression still matter for people locally, where they serve as symbols of belonging and acceptance, markers of place and identity, and forums for voice and engagement. Sociologists must continue to study the nexus of culture, community, and conflict. In an increasingly interconnected and multicultural world, our disagreements over art and culture may tell us a great deal more about community life than the art we canonize, celebrate,

and honor. As we debate the permissible boundaries of expression, we also activate and nurture democracy. Protest over art serves as a critical way for citizens to voice concern and to confront change. Freedom of expression is indeed at stake in controversies over art, but perhaps the freedom that matters most is not the freedom of artists but rather that of citizens who protest and defend artworks as a way to shape together the cultural life of their communities.

Reflections on Cultural Policy, Democracy, and Protest

The preceding chapters have explored arts protest through a sociological lens, paying particular attention to the function of art in the symbolic construction of communities. I have highlighted how arts conflicts have important expressive and emotional dimensions that help citizens negotiate the contours of community life and identity in the context of rapid social change. People speak out against offensive books, films, music, theater, and visual arts as a way to reinsert themselves into community life and to overcome feelings of estrangement from the larger culture. These findings provide sociologists as well as others who care about America's cultural life with new tools to analyze future protests. But apart from its scholarly contribution, I believe this book can also help policy makers, arts leaders, and citizens think about day-to-day policies and decisions regarding art and arts conflicts. After all, the events recorded in this book are a snapshot of real protest and contestation taking place in communities across the nation. These skirmishes confront arts leaders and policy makers daily, requiring them to make difficult decisions about how to best advance the public interest. This epilogue is intended to provide an initial bridge between the ideas in the book and the policies and practices of artists, arts leaders, citizens, and public officials. I do not consider these concluding reflections to be prescriptive. Instead I intend to be suggestive of new approaches to and new thinking about cultural conflict. I welcome future debate and dialogue about the place and relevance of art and artists in our communities and the nature of free expression and democracy.

On February 20, 2009, a *New York Times* headline read, "Tamer Version of 'Rent' Is Too Wild for Some Schools" (Healy 2009). The article begins: "Theater directors and students at more than 40 high schools across the

country have selected a new show for their big springtime musical this year: 'Rent: School Edition,' a modified version of the hit Broadway musical that, while toned down, remains provocative by traditional drama club standards." The article notes that at least three of the planned productions (in California, Texas, and West Virginia) had been canceled after administrators and parents raised concerns about portrayals of homosexuality, drug use, and HIV. The drama director at one of the schools expressed concern because he had hoped the play would help his school and community combat growing homophobia. The original producer of the play added, "Like it or not, we are right smack in the middle of an enormous cultural shift right now, and the shift will give way to acceptance of homosexuality and gay characters." The *Times* article also quotes school administrators who worried that the show was not appropriate for all ages and that it might not appeal to community standards.

In many ways this is a typical story of an arts protest—a provocative New York play causes a stir in communities across the United States. The article depicts a conflict arising from differing ideas about morality and standards. In particular, changing social norms about sexuality are colliding with traditional notions of parenting, childhood, and decency. An arts advocate might read the article and be aghast that three schools decided to censor the play—preventing their kids from performing it and their local communities from seeing it. By contrast, a member of the American Family Association might focus instead on the thirty-seven schools that permitted the performance, concluding that this is yet another sign that America has lost its way. Worried about cultural decline, such a reader might ask, "Where are the good, decent high school plays like *Hello Dolly* or *Guys and Dolls* or *Oklahoma*?" The newspaper solicits quotes from both sides, and whether you are "pro-arts" or "pro-decency" (which are false dichotomies), you will likely come away from reading the article affirmed in your prior opinion about the nature of the conflict.

My study requires us to interrogate this account. We should ask what is different about the three schools that chose to cancel the production. At first glance the cancellations cannot be attributed to predictable regional differences (north versus south) or to simple political generalizations (red versus blue states). The play was performed without incident in schools in big northern cities as well as smaller cities in Missouri and Mississippi. But the article hints at some distinctive differences across the schools and acknowledges that underlying tensions around homosexuality and episodes of homophobia in the community preceded the cancellation of the play in one community. The article also quotes a principal at a West Virginia

school who noted that her community is "a bit back in the woods," adding, "I know drugs are out there, I know children are having babies at 12, I know teens are having sex and must have safe sex. But, I don't know if *we* need 'Rent'" (my emphasis) (Healy 2009). If we systematically examine the variation across the forty schools, I suspect we would find consistent patterns to help explain where conflict erupted and where it did not. The story that would emerge may be less about the larger national shift in morality—and the expected potholes and protests along the way—and more about shifts in demographics and accompanying social and cultural change taking place in *specific* school districts and communities. When a principal is quoted as saying, "Yeah, I know all that bad stuff exists, but *we* don't need 'Rent,'" it is worth asking what her conception of "we" is and how *Rent* disrupts or disturbs this conception.

Based on the findings in this book, reporters, newspaper readers, arts leaders, and policy makers must make an effort to get beyond the narrative that relies on the following oversimplifications: (1) art is shocking, (2) morality is shifting in America and traditional values are under assault, (3) people get offended by shocking art that challenges traditional morality, and (4) polarizing protest ensues. This is true to some degree, but the analysis presented in the preceding pages complicates this account. An alternative or supplementary explanation based on the evidence presented here emerges: (1) communities are changing; (2) art and other symbols of community life amplify and call attention to growing uncertainty; (3) people react to art in order to clarify boundaries of permissible expression and to voice concern; and (4) the dynamics of protest differ based on the trajectory of a community, its rate of social change, and its political and institutional context.

If I could rewrite the headline for the *New York Times'* article about *Rent*, it might read: "Communities Struggle with 'Rent': Cancellation of Show Reflects Local Concerns." My analysis in this book shifts attention away from the default explanation based on a "culture war" frame: morality, competing worldviews and values, and the power of intentionally provocative art to pit traditionalists against progressives. Instead, my approach focuses first on the community and asks: What is happening locally to induce this reaction? Is the protest or reaction part of a dominant pattern of *cultural regulation*? (See chapter 6.) Or does the conflict emerge from a juxtaposition of different values and worldviews that are competing for legitimacy in the context of rapid and uncertain social change as in *contentious cities*? (See chapter 7.) Have a set of prior events or circumstances prepared a place to be ripe for conflict and protest? What are people trying to say to one another

when they protest or speak out about a work of art? How does their protest relate to how they see the trajectory of their community—where it has come and where it is going? How does an art event disrupt or challenge dominant narratives about community? Why does the default American creed "Live and let live" get trumped in some contexts and not others?

The Twentieth-Century Approach to Arts Conflicts

Arts conflicts cannot be reduced to complaints over "offensive art," nor can they be explained fully by a focus on competing worldviews and ideologies. Instead we must recognize the role these protests play in the ongoing negotiation of community life. As arts leaders this requires moving beyond old assumptions about and approaches to cultural conflict. Our twentieth-century approach, discussed in detail below, emphasized the independence and autonomy of the artist; the expertise and professionalism of curators, librarians, artistic directors, and cultural managers; and an absolute and unerring commitment to the First Amendment.

When artists are challenged by the public; when their vision is dismissed as being prurient or obscene; when they are asked to defend their intentions or their methods; and when they are asked to make adjustments, revisions, or edits to their work, they and their representatives typically respond by focusing on the necessary "independence and autonomy" of art. They draw upon discourses of modernism that celebrate the free and sovereign spirit of the artist (Fraser 2001). They claim that artistic freedom is a hallmark of democracy, noting that artists are often in the vanguard of social change. As the argument goes, if artists are to be visionaries, social critics, and hand-maidens of change, they cannot be constrained by existing social mores or standards; they must be allowed to "push the envelope." In defending the artists in the *Sensation* exhibit (discussed in chapter 1), Brooklyn Museum director, Arnold Lehman, echoes this claim when he says that artists "should be the primary protected species of the human race" (Fraser 2001). But as some critics maintain, such arguments are inherently undemocratic because they place the artist and their work outside or above society, free from the pushes and pulls of daily life, political compromise, and notions of accountability and responsibility (that is, what some might call community standards).

There are many good reasons to maintain a modernist commitment to art and artists, but we must recognize that when we defend artworks by saying that artists "need no defense," then we are shutting down debate rather

than encouraging and legitimating a range of voices and concerns. In so doing, art becomes less relevant to the lives of many citizens and in many cases is perceived as an "unfamiliar (and threatening) object in familiar space" (Tepper 2000). Additionally, defending art by shielding it from public criticism leaves critics alienated and feeling apart from the cultural life of their communities; they essentially have "no say," and a lack of voice is the prelude to disengagement and exit (Hirschman 1970).

A second prominent tactic in the defense of artworks is to claim professional authority or expertise (Fraser 2001; Levine 2000). This argument relies on the following logic: Librarians, curators, teachers, and theater directors are experts in their respective fields. They are trained professionals who maintain and abide by a set of shared professional ethics and standards that are promulgated by national associations, licensing boards, and professional societies. Because of their expertise, knowledge, and obligation to maintain national standards, elected officials and citizens must trust these professionals to do what is in the best interest of the community. Politicians should get out of the way and let professionals do their jobs—select books, decide on exhibits, fund artists, design programs, and teach children. As the argument goes, arts professionals are no different from doctors who are allowed to do their jobs without undue public interference, engineers who are allowed to build roads and bridges without their decisions being subject to public debate, and judges who administer the law without having to justify their rulings in the court of public opinion. We may disagree with the decision of professionals, but we accept their decisions and respect their authority. We give them the space they need to do their work independent of public and political pressure. In many areas we conclude that professional practice trumps public engagement. While claims to professionalism and authority can seem undemocratic, most of us recognize the importance of allowing certain designated experts to do their jobs without undue interference. In fact, as Max Weber (1973) noted, deferring to experts is a rational and efficient way to run modern societies. We simply could not get our collective work done if we did not place the judgment of professionals and specialists above the judgment of the common person. Yet when cultural professionals use their expertise to diminish or sideline their critics by claiming to "know best," they may, intentionally or not, dampen public engagement and diminish the voice of concerned citizens. As an expressive and symbolic act, artistic work might require a greater sensitivity, awareness, and accountability to public opinion than the work of engineers, doctors, and judges. Likewise, the symbolic importance of art and media for

community identity places extra importance on dialogue, debate, and public conflict when making and adjudicating decisions about our expressive life—even when such debate happens at the expense of efficiency, rationalism, and expertise.

The third line of defense employed by cultural leaders is to stand firmly behind the First Amendment and the principles of free speech. In cases where the government appears to have created overly burdensome restrictions on protected speech or when the government restricts art and culture on the basis of its content or viewpoint, cultural leaders often join forces with civil liberties organizations to threaten or pursue litigation. As many scholars note though, there are abundant gray areas in First Amendment law where the line is blurred between permissible and impermissible acts of restriction (Schauer and Garvey 1995). Regardless of these complexities, cultural leaders almost always frame conflicts in terms of the First Amendment. Taking an absolutist position, they argue that any attempts to curtail artistic expression violate the founding principles of the United States, a country whose founders believed in a robust marketplace of ideas. First Amendment absolutists always put the rights of individuals above the needs of the community. Any state-sponsored attempts to restrict art or culture create chilling effects that diminish the creativity and expression of artists. Furthermore, from this perspective individuals have a right to consume whatever culture they wish without interference from the state, and no one has a right to impose their tastes and morality on others. Such First Amendment absolutists also reject any corporate restrictions on art and culture—like the ban on the Dixie Chicks music by country music radio stations in 2002.[1] For these cultural leaders, the First Amendment is often the largest tool in their tool kit for defending artworks and artists against attacks. Like the concept of the free and autonomous artist as well as the deference to professionalism and expertise, the First Amendment is an important and vital guarantor of liberty and creative expression. However, like the defenses noted above, a nonreflexive embrace of the First Amendment in the face of any challenge to an existing artistic presentation can often serve to silence opponents and cut off democratic debate. Peter Levine (2000) argues that when artists and politicians resort to a high constitutional principle to settle questions of public support for the arts, they essentially conclude that the public has no "business deliberating about particular works of art or about arts policy in general" (2). When the First Amendment settles everything, public deliberation becomes irrelevant. It is worth asking whether the First Amendment has become a *convenient* defense in everyday situations rather than a *vital* defense in extraordinary circumstances. Does every arts conflict require

labeling opponents as censors and enemies of free expression and the First Amendment?

These three approaches to cultural defense—the free and autonomous artist, the expert and professionally independent arts administrator, and a reliance on the unerring and expansive powers of the First Amendment— emerged in response to unique challenges and pressures facing a twentieth-century arts system. Modernism arose in response to the deadening impulses of early twentieth-century bureaucracy and standardization. Modernism and the avant-garde were also reactions to fascism and the state-run culture of the Soviet Union and Eastern Europe. During the cold war, America's free and autonomous art system—from jazz music to Hollywood to Jackson Pollock—represented unfettered liberty and the promise of American democracy and capitalism (Saunders 2000). Thus a deep and abiding commitment to the free and autonomous artist arose from a complex aesthetic, social, and political context.

The rise of professionalism in the arts, the second strategy described above, arose in the late nineteenth century in the shadow of the Enlightenment. Artists and arts leaders attempted to distance art from religion by increasingly aligning themselves with the rational world of science. Like doctors and scientists, arts administrators saw a rise of professionalism as critical to their own autonomy and authority in a modern world (Blau 1991, 1996). The twentieth century witnessed extraordinary growth in the nonprofit arts sector as tens of thousands of new nonprofit arts organizations formed in communities across America. These new organizations were increasingly run by professionals who boasted arts management, law, and business degrees and who were tied to other professionals across the nation through any of dozens of newly formed professional arts service associations. The growing scale and size of nonprofit arts organizations happened alongside the expansion of libraries and the growth of library science degrees, along with the rise of national networks and professional associations for school administrators. Together these trends resulted in a remarkable growth in professionalism across the ranks of cultural leaders and managers. Such professionalism facilitated growing budgets, expanding facilities, and the perceived need for efficient and effective administration. As the cultural sector grew by leaps and bounds in the twentieth century, savvy administrators used their own authority and credentials to keep critics at bay, to secure the support of key community leaders and funders, and to build and entrench their organizations.

The twentieth century also witnessed the rise of "free speech" activism and the establishment of several national organizations dedicated to

protecting and advancing the First Amendment (the American Civil Liberties Union, the Freedom Forum, the Office of Intellectual Freedom of the American Library Association, the Berkeley Free Speech Movement, and the National Coalition Against Censorship) (Walker 1999). Free speech activism began in the United States in the late nineteenth century in response to the efforts of moral crusader Anthony Comstock to eradicate obscenity and prosecute "free lovers and infidels" (Beisel 1997). Comstock was successful at passing the first national obscenity law in 1873. Locally he worked tirelessly to establish anti-vice societies in communities and cities across the country. He targeted art dealers, booksellers, radical abolitionists, and anarchists. The libertarians who opposed Comstock eventually organized into what became the American Civil Liberties Union in 1917. Initially their work focused on providing legal aid and advice to conscientious objectors during World War I who were being prosecuted for espionage and sedition (Walker 1999). Even apart from promoting free speech in times of war, civil libertarians were confronted by attempts to suppress speech throughout the twentieth century, including the comic book trials of the 1930s, repeated efforts by Congress to call hearings aimed at intimidating the film and music industries, and widespread McCarthyism. Artists and writers found themselves in the crosshairs of moral crusades and overzealous censors. In a world of relatively narrow gates—where culture was produced and distributed by a few national broadcasters, publishers, arts organizations, and film studios—government efforts to intimidate, prosecute, repress, and ban offensive speech were particularly menacing. First Amendment absolutism evolved in the context of significant threats to artistic freedom. In such a context the vigorous defense of the First Amendment relies on the slippery slope metaphor that posits that even small attempts to ban or restrict expression (for example, removing one book from the library, covering up an offensive picture at an exhibit, or implementing age restrictions) can set a precedent for more dramatic and consequential acts of censorship. From the perspective of First Amendment absolutists, Americans can never let their guard down—if "we" do, so the argument goes, before we know it we will be slipping down the slope toward a society where civil liberties are trampled and opposition to the government squelched (Powe 1979).

A Twenty-First-Century Approach to Arts Conflict

I am sympathetic to the old arguments and I believe they have served the arts community well over the past several decades, but it is worth asking whether we need a new approach to cultural conflict and protest in

the twenty-first century. We are facing a world where the production and distribution of culture has changed dramatically. Our communities are experiencing demographic changes like never before, and globalization challenges us to reconsider the importance of localism.

New media has democratized culture and led to a renaissance of art, art making, and expressive life (Tepper and Ivey 2007). As I have argued elsewhere, we are in the midst of a significant transformation in America's cultural life. This transformation includes the explosion of cultural choice, the breakdown of boundaries between high and popular culture, the rise of participatory art making, the decline of cultural authority, and the abundance of "anytime, anyplace" mobile culture. As a result of these changes, our cultural landscape is getting a lot noisier—more voices, more diversity, and more opportunities for more people to express themselves. In theory this should lead to greater conflict and protest as everybody's lifestyle and cultural tastes will be threatened by someone, somewhere. Yet this multimedia and multimediated environment also makes it more difficult to silence voices. We are no longer limited to three broadcast stations, a handful of local radio channels, one dominant news source in every city, and limited shelf space at the local bookstore. While capturing attention and audiences may be more difficult in this noisy landscape, it is hard to imagine a situation today in America where artistic expression could be silenced effectively.

In March 2009 a local principal in La Grande, Oregon, decided to prohibit the production of the play *Picasso at the Lapin Agile*, written by Steve Martin, that explored themes of creativity in science and art (Mason 2009). The principal felt the play was too raunchy for his community. In response, a local college offered its theater to the high school students and drama teacher to produce the play as originally intended. The new space was adequate, the news coverage boosted local interest in the work, and the artwork was produced and performed without incident. For every alternative stage in the physical world, there are hundreds and thousands of alternative venues online. YouTube, the ubiquitous online multimedia public square, has been the site for hundreds and thousands of films, videos, plays, music, and other artworks that have sought an audience outside mainstream venues. NBC's popular late night show *Saturday Night Live* has evaded FCC restrictions by airing sanitized skits on television and then directing people to the unedited versions online. In a YouTube world, we must question whether it is necessary to defend every artwork by standing behind the impenetrable shield of the First Amendment. Rather than threatening litigation and lawsuits, arts leaders and advocates could embrace conflict,

engage with protesters, and when necessary spend their creative energy finding alternative means to distribute and disseminate challenged artworks. In saying this I recognize that there continue to be significant free expression hurdles—including the large number of Americans who still favor restricting or banning unpopular speakers and books from schools, libraries, and public spaces; the consequences of the Patriot Act and issues of privacy; the de facto threats to free speech by corporate consolidation; and the decline of fair use and overzealous intellectual property enforcement.[2] There are many First Amendment battles yet to be won, but in the world of art and entertainment the prominence of the First Amendment has, at times, overshadowed other legitimate concerns and approaches to cultural conflict.

Against this backdrop of noisy culture, our communities are experiencing unprecedented change. The waves of immigration in the 1980s and 1990s continue to crest well into the early twenty-first century. As a result, non-Hispanic, white Americans will approach minority status within decades and even sooner in our larger, more diverse cities. Not only are we experiencing record-breaking migration, but also scholars and social critics have been tracking growing trends toward globalization since the 1980s. These trends include free trade, outsourcing, cross-national labor flows, global media companies, interconnected economies and global finance, the rise of international NGOs, and the free exchange of culture among citizens of the world. Globalization, its critics argue, has eviscerated local communities— families no longer live together in the same place but are, instead, spread across the globe; local newspapers are owned by media conglomerates who care more about efficiency and profit than serving their communities; firms and corporations are no longer tied to communities and move to wherever labor and capital are cheapest; local DJs are disappearing from radio stations, as consolidated media companies rely on computer-generated playlists rather than the instincts of local programmers. Democratic theorists like Robert Putnam (2007) worry about local civic engagement. Putnam argues that increasing levels of diversity in our cities—both demographic and cultural—are making residents less trusting and less likely to engage in civic life. Communitarians worry that we have lost our capacity to put the needs of our communities above our own individual needs (Etzioni 1993). They lament the loss of a moral center, agreed-upon community standards, and a sense of commitment to the common will. Advocates of a new localism—drawing on insights originally set out by Alexis de Tocqueville—argue that the quality of social relations in a community is critical to effective self-government. For example, trust, shared values, and norms are the social glue that allows citizens to work together to clean up the local environment,

build a park, improve schools, or create a vibrant and engaging local culture (Putnam 2000).

At the same time, local communities and cities are under extraordinary pressure and strain. The evidence from this book suggests that people fight over art as a way to confront these changes, to negotiate norms and shared values, and to articulate a vision for their communities. To be clear, I do not think that arts protest necessarily brings people together to ultimately affirm some romantic conception of community life nor necessarily concludes with a satisfying compromise for all citizens. Such protests are not necessarily models of deliberative democracy. But for those citizens who are actively protesting or defending an artwork—including books, films, plays, exhibits, songs, sculpture—these conflicts are critical arenas for exercising voice and for taking part in public life. *Acts* of creative expression help define community life; *reactions* to creative expression are equally defining and consequential. This dynamic has no doubt been true for centuries, but given the centrifugal cultural and social forces of our times, the value of arts protest in shaping communities may be more important now than ever before. If this is true, as my data suggest, our twentieth-century approach to cultural conflict must be revisited and revised for a twenty-first-century reality. Rather than only, or even primarily, considering the interests of artists, arts professionals, and the First Amendment, arts leaders must place equal weight and emphasis on the democratic value of arts protest in helping communities negotiate social change if we wish to see the arts and community life flourish together. The old arguments—the autonomous artist, the expert professional, and the unerring commitment to free speech—each serve to diminish and silence opposition. Instead, arts professionals need a way to include and incorporate the voice of critics—no matter how cantankerous or challenging—in the process of creating, curating, and presenting our shared, but not necessarily agreed-upon, cultural life.

In the arts we need a serious and sustained discussion about what a twenty-first-century approach to cultural conflict might look like. Arts conflicts seem trapped in an outdated mold: free speech versus censorship, permissiveness versus community standards, restrictions versus full access, the artist versus the general public, experts versus the great unwashed. But we don't live in an either/or world—new technology, changing demographics, and globalization contribute to a "more and more" world. Perhaps we can have more art, more controversy, more protest, more conversation, more obstacles, more alternatives, more community, and more democracy. This book is not the place to launch such a discussion. Nonetheless, a few basic principles and practices emerge from the work presented here.

Principles and Practices of Engagement

Avoid Inauthentic Responsiveness

Communitarians like Amitai Etzioni argue that government, corporations, and nonprofits must be responsive to the basic needs of their communities (Etzioni 1993). In unresponsive communities, individuals will come to feel alienated, which Etzioni defines as an "incapacity to share in control" of community life, government, and the marketplace (Etzioni 1968). In the case of arts conflicts, I have argued for the importance of protest and "speaking out" as a means to combat alienation and estrangement from the cultural and social life of one's community. Arts leaders publicly support the right for opponents to speak out, sometimes going so far as to convene public meetings to provide an outlet for grievances and concerns. But Etzioni warns against setting up an *appearance* of participation and responsiveness, while, in fact, engaging in the discourse and practice of exclusion (which he refers to as *inauthentic* responsiveness). It is not sufficient to allow people to speak if we fail to take their voices seriously and, on occasion, adjust our behavior and arguments to accommodate their concerns. Albert Hirschman (1970) echoes this concern when he suggests that if institutions are not responsive to voice, then voice "can become the mere 'blowing off of steam' as it is being emasculated by the institutionalization and domestication of dissent" (124). The twentieth-century approach to cultural conflict did not leave much room for accommodation and responsiveness. In the twenty-first century, we need new techniques for accommodating challenging voices while at the same time nurturing the vitality and vision of artists.

Move beyond Voice to Substantive Democracy

Given the expressive and emotional dimensions of protest over art, I contend that in many cases simply allowing credible avenues for voice and dissent is sufficient, even if in the end critics fail in their attempt to restrict expression. At the same time we should remain concerned with the quality of dissent. If protest is ultimately about negotiating our shared cultural lives, then our public discourse must move beyond sound bites, indignation, and accusation. Instead, as James Davison Hunter (1994) argues, people must find "common ground," which he distinguishes from "middle ground." Substantive democracy does not require compromise, but it does require acknowledging the legitimacy of other people's beliefs and recognizing that those beliefs may be sacred to those who hold them. Citing democratic

theorist Benjamin Barber, Hunter argues that such speech entails "listening no less than speaking, is affective as well as cognitive, and is not cloistered in the domain of pure reflection, but brought out into the world of action" (35). Substantive democracy is much more than dialogue; it is passionate engagement between opposing sides who each care deeply about the future of their community and who are seeking ways to "agree to publicly disagree" (35). In elaborating the notion of substantive democracy, Hunter draws on Walter Lippman's (1989) idea that freedom of speech is much more than the liberty to "exploit ignorance and incite the passions of the people" (Lippman 1989, 126). Freedom of speech not only permits artists to provoke their audiences, but it also requires them to subject their expression to criticism and debate. As Lippman argues, "The right to speak is protected by a willingness to debate" (127). Drawing on Lippmann's ideas, Hunter provides a few propositions that artists, critics, protesters, and arts managers should consider when engaging cultural conflict. First, "Those who claim the right to dissent should assume the responsibility to debate" (Hunter 1994, 239). An artist whose work challenges social conventions must be willing to debate and defend the work publicly, and a critic who seeks to remove or restrict an artwork must also be willing to defend and debate his or her position. Accusing an artist of indecency or blasphemy and then refusing to listen and take seriously the artist's defense and position is, in Lippmann's terms, an abuse of freedom of speech.

A corollary to this is the injunction that "those who claim a right to criticize should assume the responsibility to comprehend" (Hunter 1994, 239). In countless cases across my seventy-one cities, critics and protesters sought restrictions on artworks, books, and films with no firsthand knowledge of the contents of such artworks. They criticized without seeking to engage the material seriously, which from Lippmann's perspective violates principles of substantive democracy. A third proposition is that "those who claim the right to influence should accept the responsibility not to inflame" (239). With regard to arts conflict, cultural leaders should present controversial artworks in ways that avoid intentionally and recklessly smashing people's hot buttons. Many critics of the Brooklyn Museum's *Sensation* exhibit (discussed in chapter 1) contended that the museum director and staff (through signage, advertisements, and promotions) intentionally sought to inflame passions and generate controversy. Substantive democracy is not well served when controversy is intentionally inflamed through propaganda and showmanship with the hope of generating larger audiences and increasing revenues and exposure for artists and arts institutions. Finally, Hunter argues that "those who claim the right to participate should accept the responsibility

to persuade" (239). Artists, cultural leaders, and critics must be willing to move from voice to influence and persuasion, which means that arguments must be "more than private convictions shouted out loud" (239).

Take Responsibility for Offense

In Atlanta a mother objected to the showing of an R-rated film in a public high school. The film *Outbreak* was presented as part of a social studies class and was intended to teach about public health. The parent was offended by the harsh language in the film and sought future restrictions on R-rated films in the school, but, perhaps more importantly, she sought an apology from the school. The principal's response to the request, quoted in the newspaper, was, "I didn't feel compelled to apologize. If you apologize, that indicates that you've done something morally or ethically reprehensible, and I find neither in this case" (Stepp 1995). What does this exchange tell us about the nature of cultural conflict? Why is an apology so important for the mother? Why is an apology so hard for the principal to offer? The apology represents the apogee of cultural and symbolic conflict; it represents a public statement that can either affirm or reject a person's right to make a claim and have that claim taken seriously. If the principal had said, "I am sorry your daughter was offended, and we should take greater care in the future to prepare students and their families for potentially difficult films." Or, "I am sorry that she was offended. In this case, part of the goal of the assignment was to show how civility breaks down in a moment of crisis—and the use of harsh language is a powerful example. I recognize that you might disagree with this instructional technique, and you have a right to voice your concerns; perhaps there are other ways to get the point across and I'm sure Mr. Brown [the teacher] will consider this in future assignments." But such an admission, as the principal's quote suggests, implies guilt, and in the realm of words and symbols, publicly acknowledging that you are partly responsible for someone else's discomfort or offense is essentially conceding ground to the enemy. In this case it would mean relinquishing some professional authority, being stripped of one's impenetrable expertise, and recognizing that all decisions are open to critique and criticism and, in some cases, reversal. For the principal and her staff, an apology of any kind would, no doubt, open up a floodgate for many more future complaints from other parents, thereby making her life and the lives of her teachers more difficult. Yet validation is precisely what the parent is seeking in this case—a sense that she has a voice and a say and that local institutions and the people who run them will listen. Apologizing is, more than anything,

a sign of respect and a signal that the aggrieved party has a right to his or her emotions and reactions. The consequence of opening the floodgates is cumbersome for public officials and their staffs because it sets a precedent for future claims and criticism; but if such officials see their role not only as caretakers of culture and education (protecting art, media, and books at all costs) but also as caretakers of community, they would see the importance of affirming, accommodating, and welcoming difficult, bothersome, and often-times disagreeable protest.

Keep the Debate Local

This book underscores the local dimensions of cultural conflict. Nonetheless, in a large minority of cases national organizations along with political and religious leaders attempt to influence, stoke, or inflame local debates. As Hunter (1991) argues, when national actors get involved in conflicts, debates often become more simplified, clichéd, and ideologically polarizing. In contrast, when a debate is mainly local (among neighbors who work together and live together) and when it is conducted within institutions that are enmeshed into community life, opposing sides are more likely to acknowledge complexity, treat each other civilly, and maintain a commitment to substantive democracy. Local leaders are better able and more invested in facilitating and mediating conflict than national organizations like the ACLU or the American Family Association. In his defining work on communities, James Coleman (1957) discusses how the density of local social relations and interactions can play a mediating role in community conflict. The more interactions—both affirming and difficult—people have with one another locally, the less likely they are to take strident and polarizing positions. At the local level people feel a greater sense of responsibility and accountability to one another and are more likely to respectfully disagree.

The Grievance Box

In my study conflicts tended to stay "within bounds" in those cases when there was an established process in place for airing and adjudicating grievances. Under such conditions protesters and defenders of artworks were less likely to resort to uncivil rhetoric and name-calling, politicians were less likely to enter the debate in an ad hoc way and inflame the conflict, and participants were less likely to resort to lawsuits as a way to resolve disagreement. A *grievance box* is simply a metaphor to describe the range of practices and processes that officials routinely use to validate and respond to local

concerns about media, art, and education. Such practices might include an official library citizen review committee; regularly scheduled public hearings of school boards, city councils, and library boards; ongoing forums sponsored by the local newspaper or by local cultural organizations; special committees or taskforces created by a mayor or city executive. In the case of broadcasting, public comment is collected through the routine process of license renewals—a terrific, yet underutilized, point of access for concerned citizens. In each case, rules for engagement must be clear, opportunities to register complaints must be ample, and citizens must perceive public officials or cultural leaders to be responsive and committed to a process of listening and deliberating.

The Ballot Box

When protests erupt over an artwork, politicians should avoid getting embroiled early in the debate. Evidence presented in chapter 1 suggests that political interference can often turn a brushfire into a full-blown wildfire, with contending parties resorting to more polarizing language and intractable positions. Politicians and appointed officials cannot stay on the sideline indefinitely and in many cases must eventually weigh in with a decision about whether to remove a book, continue to subsidize a theater, relocate a sculpture, or cancel a concert at a public venue; but such decisions should be made only after a fully participatory public debate. This does not mean that art should be free from politics. Instead, politics should enter the debate post hoc, rather than preemptively. Cultural administrators must be free to make decisions and exercise judgments in seeking to present art and culture to their communities. They must be willing to enter debate, listen to concerns, facilitate conversations, and seek out and engage the voice of protesters. They must also offer their most compelling case for why their selection of an artwork, book, play, or exhibit is appropriate, responsible, and in the best interest of the community. If they fail to convince the public, residents have a right and responsibility to use the political process to exercise their voice and hold officials responsible. Holding officials accountable might include putting pressure on them to appoint new library board members, seeking the reduction of public funding for particular arts organizations, or asking board members to sanction a school principal. When members of the public feel that officials and administrators have not been responsive to their concerns, they should organize politically to replace those officials with others who are more sympathetic to their views. Ultimately, the ballot box is the guarantor that our cultural institutions serve the public interest.

In Charlotte, when protest erupted over the play *Angels in America*, the local arts community defended their right to produce the play and went forward with an unedited version of the production. While they argued that the play was in the best interest of the community, they failed to persuade local county commissioners, who voted, in response to the *Angels* controversy, to withdraw all public funds to the city's arts and sciences council. While I might disagree with the extreme nature of the commission's response, commissioners were using their legitimate authority as stewards of public funds to shape Charlotte's cultural life. Supporters of the arts in Charlotte regrouped, enlisted the business community, raised new funds to cover the shortfall in the council's budget, and started a political action committee to defeat the commissioners who voted against the arts. The political action committee succeeded, and not a single commissioner who had voted to defund the arts was reelected. Ultimately, funding was restored at a higher level and citizens in Charlotte, led by a powerful coalition of business leaders, embraced the value and relevance of the arts to an extent not seen before the controversy. The Charlotte case demonstrates the power of the democratic process to hold administrators and elected officials responsible for the decisions they make about a community's cultural life.

Cultural Graffiti

In addition to considering the above strategies for improving dialogue and debate, artists and arts leaders can employ creative means to recognize and include oppositional voices. A recent Pew Survey of Teen Media Use reports that 19 percent of all online teens find content online (for example, music, photographs, videos) and then remix it into an original creation (Lenhart and Madden 2005). This is an example of what I see as the growing trend of cultural graffiti, whereby audiences overlay their own ideas and voice on top of and alongside other people's creative work and projects. We live in a culture of mash-ups, remixes, mob tagging, open source, wikis, and other forms of creative appropriation. At a 2005 exhibit at the Museum of Modern Art in New York, a visitor decided to create his own somewhat irreverent podcast of the show, offering other visitors a chance to download and listen to his unofficial audio tour in addition to or instead of the official tour provided by the museum's professional curator (Kennedy 2005). New media allow for countless opportunities to amplify, juxtapose, and engage the voice of critics and other citizens who want to offer a contrasting creative vision. How can we build new platforms and incorporate technology in ways that allow serious and thoughtful debate and engagement around

cultural work? Artists and arts professionals *need not* have the last word; rather, the artists' vision should be the first word in a series of overlapping and contrasting conversations. At the same time we must avoid a twenty-first-century Tower of Babel. To do so cultural engagement should be facilitated by skilled professionals who can help set the terms of the debate and focus the conversation on substantive issues. This will require arts leaders to cede some professional authority in order to avoid shutting down conversation by appealing to expertise. They must also keep the big guns of the First Amendment holstered when possible, drawing them only in exceptional circumstances when freedom is threatened and voice suppressed.

The Alternative Venue

In an attempt to be authentically responsive to community concerns, arts leaders may at times find that changes to an originally planned artistic presentation are necessary. But being responsive does not necessarily mean silencing the voice of artists. As the previous case of Steve Martin's play demonstrates, in some instances arts advocates can confront protest and restriction responsively by relocating artworks. *Saturday Night Live*'s use of the Internet to air controversial skits provides us with another example. Relocating a presentation is not always possible for site-specific work or for works whose technical requirements make it difficult to find alternative venues; but for many presentations (for example, books, television shows, exhibits, and concerts) alternative spaces—whether online, in corporate offices, at community centers, in churches, and at universities or community colleges—can offer compelling options. In fact, the creativity involved in identifying and converting an alternative space might actually generate more excitement and attention for the work than its originally conceived space. There are many cases when seeking an alternative venue is not possible, but arts leaders and artists should not dismiss the possibility simply out of a sense of duty and obligation to first principles, like the autonomous artist or freedom of expression. There are many instances where artists and arts leaders can heed community standards while at the same time challenging those standards through alternative sites and creative channels of distribution.

Prioritizing Voice over Exit or Silence

We live in a noisy culture; disagreements abound and protests are part and parcel of community life. In a society as pluralistic as ours, cultural conflicts

will necessarily increase with the proliferation of groups and lifestyles. One line of argument says that these disagreements are getting shriller and that we are living in a war zone of irreconcilable differences: red and blue states; new versus old; a world of decency, respect, and control versus one of self-expression, challenge to authority, and rampant individualism. These are epic battles, sometimes violently won or lost, and what hangs in the balance for those who subscribe to this culture war thesis is the integrity of the First Amendment, separation of church and state, respect for religion, and the well-being of our children. Without some effective mediation (which often seems illusive), we will see things get worse. The fear is that the fabric of America—its common will and shared journey—will be torn asunder.

Others see fights over art and culture as simple irritants—pebbles in the shoe of American democracy. In a free country we should expect people to speak out, complain, protest, and challenge. Further, we live in a culture of complaint. Americans are opinionated, and we feel entitled to share our opinions when our sense of right and wrong has been breached. But according to this argument, arts conflicts do not amount to much more than a war of words (rather than one of sticks and stones)—small offenses, experienced daily. These offenses sometimes get inflamed but never amount to much in the end—a book is challenged, a film is shown amid protesters, a sculpture is hated at first and then beloved, a mural is painted over. But these shouts and murmurs, grievances and gripes, do not create enduring problems for their communities. People go on with their lives, go to work, take their kids to soccer, consume the art and culture they like, and avoid the things they don't. When it comes to art and culture, citizens typically are not chaining themselves to trees, pledging themselves to causes, trying to change the political system, and fighting for rights and social justice. Arts conflicts, while certainly engaging differing opinions, do not typically involve significant attempts to undermine or secure power.

Based on the first line of reasoning, arts and cultural conflicts are canaries in the mine—symptoms or signals of much broader social and political problems. Yet perhaps such conflicts are just noisy birds outside of democracy's window—distracting, disharmonious, and annoying but not really threatening or ultimately very meaningful. This book takes a middle ground. I don't subscribe to the culture war thesis nor do I dismiss arts conflicts as just noisy and distracting. These protests are responses to real tensions and social change, and they represent the struggles of Americans as they seek to shape their communities.

This book also raises fundamental issues that sociologists and political philosophers have struggled to understand since the beginning of the modern

era. How do we balance our rights as individuals with our responsibilities as members of a community? Are there reasonable limits on expression? Can communities establish and enforce standards that may restrict individual freedom in an attempt to promote other potentially worthy public interest goals (like promoting civility, decency, respect, and public health)?

As a sociologist I approach these questions with a deep sensitivity to the power of symbols. Works of art are not just expressions of individual speech that circulate freely in the marketplace of ideas. Movies, films, books, sculptures, and flags are part of our shared culture. They constitute our collective identity and comprise our common story, they embody our values and our vision, and they reflect our ideas about beauty and truth. Moreover, these cultural objects often occupy public spaces, and they circulate through public or quasi-public institutions like schools, libraries, museums, and theaters. Because culture is shared and because our shared institutions make decisions about culture, debates about art and media are almost always debates about community, identity, and democratic life. In the tradition of Karl Marx, Émile Durkheim, Georg Simmel, Erving Goffman, and virtually all classical sociology, I approach arts conflicts with an overriding concern for alienation—the process by which some individuals feel estranged from political and community life. Because of its powerful symbolic role, the public display and presentation of art can produce both feelings of engagement and feelings of estrangement. If you are a war veteran, then an exhibit at the local museum that features the American flag strewn across a toilet might produce feelings of alienation (as well as other emotions like anger and indignation). If you are gay or lesbian, then a local production of *Angels in America* might make you feel more accepted and more connected to the local community. If you are African American, then reading *Huckleberry Finn* in class might make you feel estranged. A Jew might find Mel Gibson's *The Passion of the Christ* disaffecting; a Christian might find the film empowering and affirming. These examples are not only about personal offense. Instead they highlight how art and the resolution of arts conflicts can dramatically influence where people stand in relation to the larger community and whether they feel like insiders or outsiders. Arts conflicts will almost always entail losers and winners. Some citizens will feel validated by decisions to present and/or restrict art, while others will feel diminished by those same decisions. The challenge is to make everyone feel like insiders in the process—everyone has a stake, everyone's voice is considered and respected, and everyone has motivation to continue to engage in future debates. We must prioritize, in the words of Albert Hirschman (1970), voice over exit.

I want to be clear. I am not advocating consensual art. In general I favor

controversy over compromise, but I believe that free expression and social responsibility need to be more forcefully integrated. Artists, educators, librarians, curators, filmmakers, and producers should continue to challenge and push audiences to see the world differently. They should use their venues and voices to open up dialogue, present diverse points of view, and celebrate culture from the margins. Artists and arts leaders should also be accountable for their decisions through democratic means. If their choices violate the public trust, the public has every right to challenge them at the ballot box—voting library board members out of office, seeking the dismissal of a principal, or voting to reduce public subsidies to the local arts council. Citizens must feel free to brazenly challenge the decisions of curators, producers, and artists. At the same time, cultural leaders must tirelessly defend their choices. Over time the vigorous defense of art will guarantee its relevance in public life. When cultural leaders hide behind the veil of professional expertise, the First Amendment, and modernist ideas about "art for art's sake," they effectively marginalize their critics and isolate themselves. In so doing they place the interests of art above the interests of the public. This might be a defensible position to take in some contexts, but I suspect it is not sustainable as a broad approach to art and public engagement in the twenty-first century.

Methodological Appendix

Not Here, Not Now, Not That! is a multi-method study of protest over art, culture, and media in the United States. The majority of the book focuses on cases of conflict that took place in U.S. cities in the late 1990s. Analysis in chapter 9 includes data from focus groups conducted in the summer and fall of 2008. The book draws on fourteen separate sources of data, from U.S. Census data to the *City and County Data Source Book*, to data from the National Endowment for the Arts, the National Center for Charitable Statistics, the Federal Communications Commission, the American Bureau of Circulation, the American Religion Data Archive, the General Social Survey, the Social Capital Community Benchmark Survey, DDB Worldwide Communications Lifestyle Survey, and data provided by other scholars (Button, Rienzo, and Wald 1997; and Olzak and West 1991). Given the range of data and techniques of analysis, this methodological appendix is intended for those readers who wish to see how variables were constructed and/or detailed statistical models.

The chapter begins with a general introduction to the techniques used to collect and analyze the protest data from each city between the years 1995 and 1998. Then I introduce the variables, descriptive statistics, and additional statistical models employed for each chapter.

City-Level Protest Data

THE SAMPLE. Seventy-one metropolitan statistical areas (MSAs) have been selected for this study (see the list below for the MSAs). This represents a random sample within a truncated universe of possible cities. Because this study relies on the use of electronic newspaper search engines (LexisNexis, Dow Jones, and Dialog), the population of cities includes only those where

a daily newspaper was available online, and in full text, during the time period under investigation (1995–98).[1] At the end of 1998, when the design for this study was first conceived, there were ninety-nine such cities.[2] Each of these cities was assigned a random number by which they were sorted in ascending order. The research team began collecting data for the first city on the list—Charlotte, North Carolina—and, given limited resources and time, worked its way through the first seventy-one metropolitan areas. The final sample includes cities ranging in size from Chicago with over seven million residents to Springfield, Illinois, with a population just under 175,000. The sample is also geographically diverse, ranging from cities in the Northeast to the South, Southwest, Midwest, and Pacific regions of the country.

Cities included in final protest data file

1	Akron, OH	27	Fresno, CA
2	Albany, NY	28	Grand Forks, ND
3	Albuquerque, NM	29	Greensboro, NC
4	Allentown, PA	30	Harrisburg, PA
5	Anchorage, AK	31	Hartford, CT
6	Atlanta, GA	32	Houston, TX
7	Austin, TX	33	Kansas City, MO/KS
8	Baltimore, MD	34	Knoxville, TN
9	Bangor, ME	35	Las Vegas, NV
10	Baton Rouge, LA	36	Lexington, KY
11	Boston, MA	37	Louisville, KY
12	Buffalo, NY	38	Memphis, TN
13	Charleston, SC	39	Milwaukee, WI
14	Charlotte, NC	40	Minneapolis, MN
15	Chicago, IL	41	Nashville, TN
16	Cincinnati, OH	42	New Orleans, LA
17	Cleveland, OH	43	Newark, NJ
18	Columbia, SC	44	Norfolk, VA
19	Columbus, OH	45	Oklahoma City, OK
20	Dallas, TX	46	Omaha, NE
21	Dayton, OH	47	Philadelphia, PA
22	Des Moines, IA	48	Phoenix, AZ
23	Denver, CO	49	Pittsburgh, PA
24	Detroit, MI	50	Portland, OR
25	Evansville, IN	51	Providence, RI
26	Forth Worth, TX	52	Raleigh, NC

53 Richmond, VA	63 Springfield, IL
54 Riverside, CA	64 St. Louis, MO
55 Roanoke, VA	65 Syracuse, NY
56 Sacramento, CA	66 Tacoma, WA
57 Salt Lake City, UT	67 Tallahassee, FL
58 San Diego, CA	68 Tampa, FL
59 San Francisco, CA	69 Tulsa, OK
60 San Jose, CA	70 West Palm Beach, FL
61 Santa Rosa, CA	71 Wichita, KS
62 Seattle, WA	

Locating Cases of Conflict: Electronic Newspaper Searches

The aim of this research was to collect a total census of cultural conflict events, or as near to a full census as possible, in each of the seventy-one MSAs from 1995 to 1998. The vast majority of research on other types of protest and conflict activity—ethnic conflict, political protest, and violence—relies on newspaper reports of such activity (Gurr 1968; McAdam 1982; Olzak 1989; Shorter and Tilly 1974; Spilerman 1970). There are many known biases in newspaper accounts of conflict events—including the fact that larger events are more likely to be covered than smaller events. Also, news routines affect coverage as do "attention cycles" and the competition for the "news hole" (Gans 1980; McCarthy, McPhail, and Smith 1996; Oliver and Myers 1999). And Oliver and Myers (1999) recently discovered that the location of an event matters—conflicts in downtown areas get more coverage than less centrally located events. Also, the political orientation of the newspaper itself can influence coverage—liberal-leaning papers are more likely than conservative papers in the same city to cover protest events. In spite of these limitations, it is broadly acknowledged that newspapers provide the most complete account of events for the widest sample of geographical or temporal units (Olzak 1989).

Using the work of Charles Tilly, Doug McAdam, Susan Olzak, and others, this research draws exclusively on newspaper reports to identify cases of conflict in each of the seventy-one metropolitan areas. As mentioned above, we rely on city-based regional papers that are available for online, full-text searches. In cities with two major papers, we chose the one with the larger circulation. Following a method developed by Paul DiMaggio et al. (1999) to study the incidence of public conflict over the arts in Philadelphia from 1965 to 1998, we relied on a complex search algorithm that included both "art and media" words (artist, sculpture, dance, music, film . . .) as well as

"protest" words (conflict, outrage, protest, petition, censor . . .) in order to identify stories related to controversies over cultural expression.[3] A typical search of a city newspaper in a single year would return approximately five hundred stories, all of which registered two or more of the necessary art and conflict words from our algorithm. Unfortunately, the vast majority of those stories, approximately 95 percent, met the criteria from our algorithm but were not relevant to an arts controversy—such as a story about the "*art of prize fighting*" or a review of a movie that discusses "the primary *conflict* facing the *film*'s protagonist.*" The 5 percent of "relevant hits" were put aside and reviewed later to determine if they met established criteria for deciding whether an event is a public conflict over art and media. These criteria will be discussed in more detail below.

POTENTIAL SOURCES OF ERROR USING NEWSPAPER SEARCHES. There are three potential sources of measurement error when gathering data in this fashion. First, individual researchers could simply miss relevant articles when scanning headlines and keywords. Second, the search algorithm could fail to pick up stories where relevant art and conflict keywords are missing. Third, some conflict cases might go unreported for many of the reasons cited above (various forms of media bias). Can we determine the extent of measurement error in the data collected for our seventy-one-city sample? By comparing the number of conflict stories identified by each researcher working independently on the same city, we determined that our inter-rater reliability was approximately 90 percent. In other words, on average, nine of ten possible conflict cases reported by the newspaper were identified correctly by the entire group of researchers.

DiMaggio et al. (1999) searched for conflict cases in Philadelphia using Dialog, an online database, and the *Philadelphia Inquirer*'s archive of clippings. Using several diagnostics, they concluded that no systematic bias was introduced through the use of the online database as opposed to the more traditional method of wading through paper archives or examining newspapers page by page. Thus we are confident that any measurement error introduced by using online databases is relatively modest. And even if our final census of conflict events is not 100 percent comprehensive, there is no reason to believe that our error rate would be different from city to city.

Nonetheless, even if our inter-rater reliability is high and there are no sources of systematic bias introduced by the use of online search engines, it is quite likely that not every case of arts and cultural conflict is actually recorded by the press.[4] Can we make a reasonable estimate of the accuracy

of the count in each city? One way to test our results is to triangulate them with cases of conflict identified by other sources. Up until 1996, People for the American Way (PFAW) compiled a compendium, *Artistic Freedom under Attack*, that documented cases of conflicts over art and cultural expression throughout America. Similarly, the National Campaign Against Censorship (NCAC) reports on a variety of controversies over art in culture in their quarterly newsletter. Both organizations rely on information collected from national newspapers, but many cases are also identified via reports from individuals and organizations in the field. By comparing the conflicts identified by these two sources with the cases identified by our research team, it is possible to get a quick reading of whether or not the search strategy missed a large number of potential events. When examining events that took place in a subsample of forty-eight cities, we find that, combined, the PFAW and the NCAC sources revealed twenty-two cases of conflict between 1995 and 1998. Of those twenty-two cases, our researchers identified nineteen, or 86 percent. None of the three cases that we missed were reported in the newspaper (thus we did not miss them due to human error—the oversight of a researcher—or instrument error related to an imprecise search algorithm). The three "missing" events were all very small and involved a simple complaint by a patron wishing to have an offensive artwork removed. One case involved an R-rated film at a local library, another involved a nude drawing in a private gallery, and the third involved a painting of a handgun in a café. In all three of the cases, there was no protest beyond the initial grievance, nor did any of the events involve organized actors or collective action of any kind. The cases we missed were minor skirmishes—certainly not full-blown conflicts. Thus it appears that our search strategy, while not perfect, is fairly robust.

There is one other possible source of error that could introduce systematic bias in our findings. Oliver and Myers (1999) find that liberal newspapers are more likely to cover rallies and other kinds of protest events than are more moderate or conservative papers. When examining the coverage of cultural conflicts in two newspapers in the same city—the *San Francisco Chronicle* and the *San Francisco Examiner*—we also found that the more liberal paper, the *Chronicle*, reported more cases of conflict than did the *Examiner*. In particular the *Examiner* failed to report on two demonstrations—one by feminists protesting the movie *The People vs. Larry Flint*, and the other by Native Americans who objected to a statue of an Indian warrior used for the purposes of promoting a cigar store. If this were true for other cities as well, then we might find that cities with more conservative newspapers are likely to have fewer reported conflicts over the arts and culture (or possibly more

protests originating in conservative concerns). This would introduce bias into our findings.

The example in San Francisco and the results from Oliver and Myers's study in Madison, Wisconsin, suggest that conservative papers are likely to underreport liberal-based protests—those that are seeking to draw attention to issues involving minorities, women's rights, and gays and lesbians. In our study, by contrast, the majority of conflicts over art and media are initiated by individuals with grievances based in conservative viewpoints, challenging a cultural work on the grounds that it is obscene, vulgar, blasphemous, or otherwise dangerous to children and youth. One would expect that any bias that works to deflate the number of reported incidences in conservative newspapers would be less pronounced in the case of art and cultural conflict, as these controversies more often than not tap into conservative concerns.

Ideally we would have an objective measure of the extent to which a city's newspaper is conservative or liberal and then control for this source of bias by including the measure in our analysis. As a proxy we created a dichotomous variable that indicated whether or not a city's newspaper took an editorial stance favoring the restriction of a cultural work that was deemed blasphemous, obscene, violent, or vulgar. Newspapers that took such a position are, more likely than not, conservative-leaning news organizations. Thus if Oliver and Myers's theory is correct, we would expect cities with such newspapers to have fewer reported conflict events. In fact, there is no relationship between whether or not a newspaper is conservative leaning and the number of reported conflicts over art and media. While it might be useful to investigate more closely the differences in how arts and cultural conflicts are covered by conservative and liberal-leaning newspapers, for the purposes of the research at hand it seems such differences have little influence on the total number of conflicts reported in each city.

One final point, if we have missed cases of conflict that went unreported in the local press, most likely these cases were, as identified above, mere sparks (small events that typically do not get beyond a single complaint). Conflicts involving multiple actions, collective actors, formal organizations, elected officials, public demonstrations, or public meetings have a high probability of making it into the press and into this study. To evaluate the potential source of error introduced by variability in coverage of small events, several analyses in chapters 3 and 5 used the total number of conflict events in a city as well as the total number of events that were coded as being larger than mere sparks, as dependent variables. In most cases the choice of dependent variable made little difference. In multiple regression analy-

sis we report the findings using the more strict criteria where the smallest events are removed. In summary, while there are several sources of error related to using newspapers to identify cases of conflict over art and media, previous analysis, as well as the author's own research, suggests that such error is minimal and does not introduce systematic bias into our findings.

Identifying Instances of Public Conflict over Art and Media

Given that this research involves multiple research assistants collecting cases of public conflicts over art and media across many different sites, it is essential to have a clear and consistent definition of what it is that we are after.

WHAT IS A PUBLIC CONFLICT OVER ART AND MEDIA? The definition used for this research is very nearly identical to the one used by DiMaggio et al. (1999) in their study of Philadelphia-based conflicts. Nonetheless, there are areas in which the two studies differ, as our criteria for including a case were refined by the research team as we waded through actual examples of conflict during the first few weeks of the project. We summarize our own working definition below.

WHAT IS A CASE? A case of public conflict over art and media consists of a set of events that begin with the presentation (or promised presentation) of some cultural work to which someone takes umbrage (DiMaggio et al. 1999). A conflict begins, therefore, with an *initiating action* against a cultural work. Such an action might include any form of censorship by a public official or responsible administrator, such as preventing, removing, or otherwise restricting a cultural presentation.[5] Or it could simply include the public airing of grievance against the presentation—including a formal objection lodged by a citizen as well as actions that are more collective, such as petitions, mass meetings, boycotts, lawsuits, and public hearings.

WHAT ARE "ARTWORKS" AND "CULTURAL PRESENTATIONS"? Our definition includes three types of cultural presentations.

1 "Artwork"—any form of music, visual art, literature, dance, theater, film, or mixed media work. We make no distinction between high and popular arts. A symphony concert, a novel by Mark Twain, and a Mapplethorpe exhibit would count, as would a rap song, a comic book, or a Disney film or video. The definition includes most every type of artistic presentation, including stand-up comedy and performance art.

We also include conflicts over genres in addition to specific works of art. In some cases, for example, conflict involved diffuse campaigns against particular genres (e.g., rap music or Disney films) rather than a particular object, film, book, or performance (DiMaggio et al. 1999). However, the specific genre of art must be mentioned explicitly. For example, we did not include a case where a city councilman was trying to reduce the budget of the local arts center because its programming was "geriatric" and was geared toward traditional arts. His categories are too obscure. If he had said "classical music" or "opera" or "musicals," we would include it as a case. Likewise, we would not include a case where someone objected to "young person's music"—we would include it, however, if the objection was to hip-hop or rock.

The definition of artwork does not include graffiti, unless taggers clearly self-identify (and were taken seriously by at least some art-world spokesperson) as artists (note: DiMaggio et al. make this distinction). We also exclude advertising art (e.g., Calvin Klein ads) and architecture. Ads for artistic events (e.g., the brochure for a play or opera) would count as well as book jackets, album covers, and magazine covers—if the conflict was over the artistic content of the cover.

We decided to exclude fights over video games in our definition. This was a difficult choice. The graphical presentation of many video games is clearly artistic. And many video programmers consider themselves artists. Nonetheless, most conflicts over video games focus on participatory violence. Parents complain that like toy guns, the games teach children to act violently. The conflict is less about the creative expression of the programmers and more about the actions of the children playing the games. Thus, these conflicts are more about toys and games than about cultural presentations. If the programmers, however, defend the games by making reference to the game's artistic quality, as in the case of graffiti, we would include the controversy.

We decided to exclude all fights over talk-radio shows (e.g., Howard Stern) because of the difficulty of distinguishing those that might be considered stand-up comedy (Stern) from those that were more news oriented (Limbaugh).

2 "Cultural presentation"—any nonfiction book, exhibit, or film of an educational nature that attempts to interpret some aspect of culture or history. Fights over a school textbook that portrays Native American history in an unfavorable light would count, as would fights over a particular science book that has explicit photographs of the human anatomy. We would also include conflicts over historical exhibits, such as the recent controversy over

the *Enola Gay* exhibit at the Smithsonian. Generally, we include conflicts over most educational and cultural materials made available in libraries, schools, museums, and galleries.

We do not include general school curriculum battles, unless the conflict includes reference to the appropriateness of a particular book or filmstrip. We also exclude conflict over nonfiction books, articles, or essays that would be considered news analysis or current events, including cartoons in newspapers. So, for example, we would not include conflict over the appropriateness of a newspaper headline or the use of a provocative news photo in a magazine or broadcast. Nor would we include a protest, for example, at a book signing by former General Colin Powell (here the book is nonfiction, but it is not a piece of cultural/historical interpretation).

3 "Commemorative displays/objects"—all items that are meant to commemorate a person, place, or an event. This category includes parades; however, the conflict over a parade must involve an objection to some artistic expression or cultural presentation connected to the parade and not just the theme of a parade (e.g., gay pride). We do not include fights over city logos or flags, but we do include fights over commemorative plaques or memorials, as these are historical/interpretative presentations.

We decided to exclude cultural presentations involving the "sex industry"—fictional films and books produced for adult entertainment as well as nude or erotic dancing. However, we consider controversies over the magazine *Playboy* to be cultural conflicts rather than sex industry conflicts. Our main justification is that *Playboy* depicts itself as an arts and culture magazine. The publisher promotes the quality of the magazine's photography and fiction writing. Finally, unlike other types of adult entertainment (sex videos), *Playboy* is often available at public libraries, suggesting that the magazine has important educational and cultural content. We exclude all conflicts over Internet access at public libraries.

WHAT WOULD BE CONSIDERED A "GRIEVANCE" AGAINST A CULTURAL PRESENTATION? We are only interested in conflicts that have, at their root, objections to the perceived meaning embedded in a cultural presentation as well as objections to certain artistic styles (e.g., abstract art). Therefore we select only those cases where the object of contention is the content, style, or form of a cultural work. We exclude arguments about the community spiritedness of a cultural organization or whether or not the director of a museum was involved in a sexual harassment case, or whether a museum's board of trustees is sufficiently diverse.

We also exclude conflicts where the grievance is about the noise or traffic congestion created by the presentation of some artwork (e.g., a concert), or about the impact on "green space" of a proposed public artwork or cultural facility. An exception is when there is some reference in the article, or the researcher has good reason to believe, that objections to noise and traffic are partly rooted in grievances against the particular type of art that is being presented. Thus, for example, if a local resident complains about an upcoming punk rock concert because of its supposed noise but is reported as saying, "Please, no more punk rock thugs in our neighborhood," then we would count the conflict as a case. We also exclude violations of sign-code ordinances (like a flower shop that painted flowers on its exterior wall) unless the violator (e.g., the shop owner) claims the mural was a piece of art.

We include conflicts where the grievance is over the process of commissioning an artwork or cultural presentation if the protest is directed against a particular art object. Thus, for example, we included the protest by African American artists in Kansas City to the selection of a white artist to create a sculpture to honor jazz legends. Here the grievance is against the artist or the commissioning process, not the content of the art. However, the implication is that the meaning of the work is influenced (and diminished) by the fact that the selected artist was not African American.

We do not include conflicts over general policies for funding or commissioning artworks—e.g., protest over cuts in arts funding—unless the conflict includes reference to a particular cultural object or genre (as in the case of the commissioning process for the jazz sculpture above).

HOW AND BY WHOM ARE GRIEVANCES EXPRESSED? Forms of public conflict include demonstrations, boycotts, public statements, mass meetings, public hearings, lawsuits, and the introduction of legislation or new administrative policy. Like DiMaggio et al. (1999), we do not include purely individual expressions of disapproval—e.g., the criticism of a film by the paper's movie critic or a single letter to the editor by a disgruntled citizen. We would, however, include a series of letters to the editor if these appear to be part of an organized letter-writing campaign. In other words, if there is any collective orientation to a conflict, we would include it as a case.

We also include grievances that are initiated by individuals acting alone when their actions represent the interests of a collectivity, group, or organization, and we also include individual actions when a citizen or parent lodges a complaint through formal channels (a letter to a congressman or city councilman, or a phone call or letter to the manager of a cultural facility

or a member of the school board). We do not, however, include individual letters to the editor as an official grievance against a cultural work. Acts of censorship by a city official, library administrator, museum director or curator, or the owners of an exhibition space would be considered a "grievance" even if these actions are not contested. We also include unsigned editorials that represent a newspaper's editorial board stance. And we include actions or statements made by public officials and political candidates (e.g., press releases, speeches) if such statements are not brought about purely by the questioning of a reporter.

THE LOCATION OF CONFLICT. The initiating action or grievance against a cultural presentation (demonstration, public meeting, petition) has to occur within the metropolitan area (all counties and towns included in the Office of Management and Budget [OMB] definition of an MSA) under consideration; or it must be organized by local residents, local government officials, or the leadership of local organizations.[6] The cultural object can be exhibited, performed, or broadcast in any location, so long as the protest itself is local. Finally, like DiMaggio et al. (1999), we include proposed legislation by elected officials representing an MSA constituency, even when those proposals and statements are registered formally in Washington, DC, or in another city (e.g., the capital city) on the grounds that they were intended, in part, for citizens/constituents residing in the city under investigation.

TIME FRAME FOR CONFLICT. We include all conflicts where some action (either an initial grievance or some response to a grievance) took place from January 1, 1995, to December 31, 1998. We do not include cases where the only action to take place within the four-year time frame is a court decision. For example, if a conflict were to remain dormant for a decade, only to be resolved (i.e., by court order) in 1996, we would not include it as a case.

In summary, public conflicts over art and cultural expression begin with a grievance against an artwork or a historical, interpretive, or commemorative presentation. We are interested in fights over the content of arts and humanities presentations, broadly defined. The official *actors* in a conflict can be individual parents or citizens, elected officials, or representatives of organizations. A grievance can take the form of an individual act of censorship—as when a gallery owner removes a controversial drawing. It can also originate in a complaint to an official or administrator by someone who demands that the offending object be removed or restricted. Finally, a grievance

can include simply bearing witness to a cultural presentation, without necessarily requesting that the presentation be altered. Conflicts over art and media must involve local citizens and they must have taken place in 1995, 1996, 1997, or 1998.

While this research is about arts conflicts and conflicts over other types of cultural presentations (nonfiction books, humanities exhibitions, commemorative items), for the purposes of simplifying diction and style we will often refer to such conflicts as "arts conflicts" or "conflicts over artistic expression" or "controversies over artworks." The use of the words "art" and "artworks" throughout the book imply a larger category of conflict that includes both artworks and other types of cultural presentations.

Coding Cases of Conflict

Having identified every case of conflict over art and media reported in the press in our seventy-one-city sample, our next step was to code each event so as to allow useful comparisons across cities as well as to generate some general statistics about patterns of conflict across the nation. In this effort we benefited immeasurably from the coding scheme worked out by DiMaggio et al. (1999) for their study of Philadelphia-based conflicts. Our coding book (available upon request) is nearly identical to the one produced by DiMaggio et al. But, as with the search algorithm and the criteria for selecting cases, our coding scheme changed as the research team reviewed individual cases of conflict and tried to rethink some categories to better fit our data. Like DiMaggio et al., we code entire "cases" rather than "events"—the more typical unit of analysis for scholars of event history (McAdam 1982; Olzak, Shanahan, and McEneaney 1996; Tilly 1995). We are not interested in the details and dynamics of a particular event (e.g., a single demonstration or protest act); we are interested in the range of actions and actors who participate over the course of a conflict. This might involve multiple actions occurring over several months or years both in opposition to and in support of a cultural presentation. Because our analysis is one level more abstract, or general, than the analysis of single events, the categories of our coding scheme are also broader and provide less narrative information about the exact sequence of events or the relationships between various actors.

Chapter One

Chapter 1 examines frequencies of and relationships among variables measured at the "case" level. Our unit of analysis is each of the 805 cases. In

subsequent chapters the unit of analysis is the city itself (where individual cases are aggregated to the MSA level).

Variable Descriptions, Chapter One

In this chapter, several variables are employed both as dependent and independent variables, so all variables are simply listed below in order of appearance rather than listed separately as dependent and independent variables.

PRIMARY GRIEVANCE. The *main* concern expressed by protesters of an artwork or media presentation.

POLITICAL VALENCE. *Liberal valence*: Those protest events where the primary grievance against a work of art was that it was offensive to ethnic minorities, women, or religious minorities. *Conservative valence*: Those protest events where the primary grievance against a work of art was that it was blasphemous, anti-family, vulgar, or indecent. *Neutral valence*: Those protests where the primary grievance was based on aesthetic preference, location, or other reasons not associated with the concerns expressed above (liberal/conservative).

PARTICIPANTS AGAINST ARTWORK. Any group or individual who expresses concern about an artwork or media presentation at any point during a controversy.

INITIATING ACTOR AGAINST ARTWORK. Group or individual who is responsible for launching a protest—the first individual or group to write a letter, organize a petition, speak at a public meeting, or otherwise lodge a formal complaint against an artwork or media presentation.

NATURE OF ACTIONS AGAINST ARTWORK. The strategies and tactics employed by those who oppose an artwork or media presentation.

PROTEST OUTCOMES. The fate of an artwork or media presentation as the result of the protest. Is the work restricted? Are there new laws or policies put in place? Are public funds withdrawn? Lawsuits resolved?

NUMBER OF ARTICLES. The total number of articles about a single conflict case published in the city's largest newspaper. This figure excludes letters to the editor as well as articles in which the controversy was not the main subject of the article but was only mentioned in passing.

NUMBER OF GROUPS/ACTORS. The total number of *different types* of groups and individuals who participate publicly in the controversy, either as critics or supporters of an artwork. A protest might involve many different groups/individuals, such as a parent, a candidate for public office, a neighborhood association, a church, and the newspaper editorial board.

INTENSITY OF PROTEST. A measure that combines the number of groups/actors who participated in the controversy along with the number of newspaper articles published about the controversy. Intensity includes four categorical variables: *Ember* (1 or 2 actors and/or 1 article), *Spark* (3–4 actors and/or 2–4 articles), *Brushfire* (5–6 actors and/or 5–8 articles), *Wildfire* (7 or more actors and/or 9 or more articles).

CULTURAL WORK IS RESTRICTED, TERMINATED, OR ALTERED. An artwork or media presentation is canceled, removed, moved to another location, restricted by age or time of presentation, presented alongside a warning sign, etc.

CONFLICTS ARE TWO-SIDED. Protest involves people or groups who came out publicly both *for* and *against* an artwork.

UNCIVIL DISCOURSE. Those cases in which opponents or supporters of an artwork attempt to discredit opponents by labeling them in any of the following ways: intolerant, bigoted, narrow-minded, uneducated, elitist, self-serving, hypocritical, dishonest, censor.

TARGETING POPULAR CULTURE. Protest targets fictional films, pop music concerts, music broadcasts, fictional television, recorded music, comedy, and pageants.

CONFLICTS INVOLVE COURT SYSTEM AND LAWSUITS. Protest involves either an opponent or defender of an artwork/media presentation seeking legal redress—suits could involve First Amendment cases, violation of church/state, libel, obscenity, public indecency, etc.

LOCAL, NO RELIGIOUS ACTORS. Protest is initiated by local citizens or groups and does not involve national actors or groups in any way; it also does not involve any religious organizations or individuals (no churches, religious organizations, priests, ministers, rabbis, etc.).

LOCAL, RELIGIOUS ACTORS. Protest is initiated by local citizens or groups and does not involve national actors or groups in any way; local religious organizations or leaders get involved (local minister, neighborhood synagogue or mosque, etc.).

NATIONAL, RELIGIOUS ACTORS. Protest involves a national, religiously based group (e.g., the Church of Scientology or the Southern Baptist Association) or an individual at the national level with an explicit religious profile (e.g., Rev. Donald Wildmon of the American Family Association).

NATIONAL, NO RELIGIOUS ACTORS. Protest involves a national group or an individual operating at the national level, such as a national media celebrity or a national interest group like the Parents Television Council or the American Civil Liberties Union.

Note: Some of the cases coded as national actors involve local actors but not vice versa; and some of the cases coded as religious actors also involve nonreligious actors but not vice versa. In essence religious and national actors trump nonreligious and local actors for the purposes of fitting cases into one of the four categories.

ELECTED OFFICIALS PARTICIPATED IN CONFLICT. Protest involves an elected official—school board member, city councilman, mayor, congressman—who gets involved in the conflict in any official capacity (as an opponent, a defender of an artwork, or as a neutral player trying to bring sides together).

COLLECTIVE ACTION. Protest involves some collective action—either through existing formal organizations, newly formed organizations, or coordinated activity across separate individuals (with no formal group structure).

Notes on Tables, Chapter One

Table 1.1 (see chapter 1) displays the total number of protest events for each city for the top fifteen and bottom fifteen ranked cities (in terms of highest and lowest number of protest events). This table does not take into account population size, which is very strongly correlated to protest levels—bigger cities tend to have more conflicts over art. The definition of what constitutes a "protest event" can be found on page 293 of the appendix.

Tables 1.2 to 1.9 are simple frequency tables and are based on the coding of 805 separate cases of conflict. In some tables the percentages do not add to 100 because items in the table were not exclusive; i.e., a case might have several different types of challenges, different grievances, different actors, etc.

For table 1.10 we used a multivariate General Linear Model. The procedure provides analysis of variance for multiple dependent variables by one or more factors or covariates. In this model, we are investigating whether the mean score across a number of factors is different for the four different groups of interest—those cases that involve only local/nonreligious actors; those cases that involve only local actors, some of whom have a religious affiliation; those cases that involve national actors, some of whom have a religious affiliation; and those cases that involve national actors who have *no* religious affiliation. We are looking at the adjusted mean scores after controlling for whether or not the protest involved "collective action"—organized groups of people as opposed to one single complaint from a parent, citizen, or official. We control for collective action so that my comparisons across groups are not influenced by the distribution of "minor" complaints—those complaints that involve a single disgruntled person.

So, for example, the GLM procedure allows us to see whether those conflicts that involve national religious actors also involve a greater or smaller percentage of elected officials than those conflicts that are local—local both with and without religious involvement. Using the "difference of means" test, we can see whether the percentage of elected officials involved in one type of conflict (national/religious) is significantly different from the percentage of elected officials involved in a different profile of conflict (local/religious).

Table 1.11 also uses the multivariate General Linear Model. This model also includes the covariate of "collective action." In this case, rather than comparing conflicts that involve local, national, and religious leaders, we are looking at differences among those conflicts that involve elected officials and those that do not involve elected officials.

The bulleted list titled "What factors increase the likelihood that a conflict will become a wildfire?" is based on findings from a binary logistic regression model. The model predicts the likelihood that an event will be a "wildfire"—which includes those events that involve at least seven different types of actors and/or are covered by no fewer than nine newspaper articles. Logistic regression is used to predict the presence or absence of an outcome, in this case "wildfires." The coefficient in the regression model predicts the

Table A.1 Predicting whether or not a conflict event is likely to be a wildfire based on types of participants, grievances, and discourse: Binary logistic regression

	B	Sig.	Exp(B)
Elected officials participated in conflict	2.001	0.000	7.397
Conflict involved schools or public libraries	0.835	0.001	2.305
Conflict involved court system and lawsuits	1.424	0.000	4.155
Local/national/religious profile			
Local		0.152	
Local/religious	0.764	0.022	2.147
National	0.196	0.616	1.217
National/religious	0.256	0.418	1.291
Uncivil discourse	1.076	0.000	2.933
Political valence			
Liberal		0.326	
Neutral (1)	−0.233	0.501	0.792
Conservative (2)	0.232	0.394	1.261
Collective action	1.597	0.000	4.936
Constant	−4.531	0.000	0.011

Dependent variable: Whether or not a protest event is a wildfire.

log odds ratio that an event will be a wildfire. When we "exponentiate" the log odds ratio, we get the odds ratio that a wildfire will occur in the presence of our "predictor" variables (as compared to the absence of the predictor). In this model we include the following covariates: presence or absence of elected officials; the involvement of schools or libraries; the involvement of courts; the presence of discrediting labels ("name-calling"); whether or not a protest involved "collective action" as opposed to single, unconnected complaints; whether a conflict was local or national or involved religious actors; and the political valence of the initial grievance (conservative, liberal, or neutral).

The binary logistic regression model is shown in table A.1.

Chapter Two

Chapter 2 examines the relationship between an individual's disposition to restrict unpopular art and media and a variety of personal characteristics—education levels, political ideology, religiosity, sense of community, and, importantly, beliefs about immigrants and the impact of social change. The analyses are drawn from three large national surveys (described below). In chapter 2, our unit of analysis is the individual survey respondent, as opposed to cases of protest (chapter 1) or cities (chapters 3 and 5).

Data Sources and Variable Definitions

Social Capital and Community Benchmark Survey (Saguaro Survey)

Survey and data documentation can be found at the Roper Center for Public Opinion Research at http://www.ropercenter.uconn.edu/data_access/data/datasets/social_capital_community_survey.html.

Dependent Variable

BAN UNPOPULAR BOOKS. A variable measuring whether the respondent agrees with the statement that "a book that most people disapprove of should be kept out of the public library."

 0 = Disagree (somewhat or strongly) (76%)
 1 = Agree (somewhat or strongly) (24%)

Independent Variables

GENDER
 0 = Female (59%)
 1 = Male (41%)

EDUCATION. Highest grade of school or year of college completed.
 1 = No college (baseline category) (33.8%)
 2 = Some college (32.5%)
 3 = College graduate (33.7%)

IMMIGRANTS ARE TOO DEMANDING. Variable is derived from the statement: "Immigrants are getting too demanding in their push for equal rights."
 0 = Disagree (somewhat or strongly) (65%)
 1 = Agree (somewhat or strongly) (35%)

AGE. Continuous variable representing the age of respondent at the time of interview (mean age = 45).

POLITICAL AND SOCIAL IDEOLOGY. Continuous variable representing self-rating to the following question: "Thinking politically and socially, how would you describe your own general outlook?" The variable range is 1 to 5, with 1 representing very conservative and 5 representing very liberal (mean = 2.8).

RACE.
 1 = White, non-Hispanic (baseline category) (75.6%)
 2 = Black, non-Hispanic (12.7%)

3 = Asian (2.5%)

4 = Hispanic (9.2%)

GENERAL TRUST. Variable is derived from the question: "Would you say that most people can be trusted or that you can't be too careful?"

0 = Can't be too careful (46.5%)

1 = Most people can be trusted (53.5%)

SENSE OF COMMUNITY. Variable is derived from the question: "Does living in your city give you a sense of community?"

0 = No, does not give me a sense of community (19%)

1 = Yes, it gives me a sense of community (81%)

LENGTH OF RESIDENCY. The number of years the respondent has lived in their community. Ordinal variable from 1 (less than 1 year) to 7 (all my life) (mean = 3.57).

INCOME. This nominal variable includes the following categories:

0 = 20K or less (baseline) (15.3%)

1 = > 20K and < 20K (15%)

2 = < 30K (unspecified) (1.2%)

3 = 30K to 49,999K (25.6%)

4 = 50K to 74,999K (20.1%)

5 = 75K to 99,999K (10.9%)

6 = 100K or more (11.9%)

7 = Over 30K unspecified (0.5%)

RELIGION IS IMPORTANT. Variable is derived from the statement: "Religion is very important in my life."

0 = Depends, disagree, or strongly disagree (21.1%)

1 = Agree or strongly agree (79.9%)

CHILDREN AT HOME. Whether or not the respondent has children under the age of eighteen living in their household.

0 = No children (60%)

1 = Children (40%)

Notes on Tables, Chapter Two (Social Capital and Community Benchmark Survey)

The bulleted list titled "Saguaro Survey" (see chapter 2) is derived from a binary logistic regression using data from the Social Capital and Community Benchmark Survey. The model predicts the likelihood that an individual will agree with the statement that a book that most people disapprove of should be kept out of the public library. The coefficient in the regression model predicts the log odds ratio that someone will be in favor of removing a book given the presence of the following predictor variables: beliefs about immigration, political and social ideology, religiosity, gender, education, age, race, the size of city of residence, income, and whether or not the respondent has children living at home. These variables are described in greater detail above.

Table A.2 Predicting support for restricting unpopular library book: Binary logistic model

	B	Sig.	Exp(B)	−2 Log-Likelihood Difference
Gender	0.01	0.87	1.01	0
Education (baseline = no college)		0.00		166
Some college	−0.57	0.00	0.57	
College graduate	−0.87	0.00	0.42	
Immigrants are too demanding	0.82	0.00	2.27	628
Age	0.02	0.00	1.02	198
Political and social ideology	−0.35	0.00	0.70	310
Race (baseline = White: non-Hispanic)		0.00		578
Black (non-Hispanic)	−0.35	0.00	0.70	
Asian	1.14	0.00	3.11	
Hispanic	0.61	0.00	1.85	
General trust	−0.20	0.00	0.82	527
Sense of community	0.33	0.00	1.39	17
Length of residency	−0.04	0.03	0.96	13
Income (baseline 20K or less)		0.00		33
> 20K and < 20K	−0.20	0.02	0.81	
< 30K (unspecified)	0.30	0.27	1.35	
30K to 49,999K	−0.28	0.00	0.76	
50K to 74,999K	−0.45	0.00	0.64	
75K to 99,999K	−0.55	0.00	0.57	
100K or more	−0.59	0.00	0.55	
Over 30K unspecified	−0.34	0.03	0.71	
Religion is important	0.92	0.00	2.51	128
Children at home	0.22	0.00	1.25	13
Constant	−1.72	0.00	0.18	

Dependent variable = Respondent agrees that unpopular book should be kept out of the library.
N = 10,171
Data source: Social Capital and Community Benchmark Survey.

The binary logistic model is presented in table A.2. The Exp(B) is the log odds ratio for each coefficient. The –2 Log-Likelihood (–2LL) Difference (column 3) represents a goodness of fit statistic based on the full model (all independent variables entered into the model) versus the reduced model (removing the variable of interest). For every set of independent variables we calculate the –2LL Statistic (the probability that the observed values of the dependent variable may be predicted from the observed values of the independents). This statistic is similar to the sum of squared errors in OLS regression and represents the unexplained variability. The –2LL Difference then is the –2LL Statistic for the full model minus the –2LL for the reduced model. The larger the –2LL Difference the greater the contribution that the chosen independent variables make in explaining the outcome, in this case willingness to remove a pro-gay book from the public library. *Note:* In order to compare –2LL Statistics, we keep the sample size the same across all reduced models.

DDB Lifestyle Survey

Survey and data documentation can be found at the Saguaro Seminar Web site, Harvard University, at http://www.bowlingalone.com/data.htm.

Further background on the survey can be found in the appendix of Robert Putnam's *Bowling Alone: The Collapse and Revival of American Community* (2000).

Dependent Variable

GOVERNMENT CONTROL TV. A dichotomous variable based on whether the respondent agrees with the statement: "The government should exercise more control over what is on television."

 0 = Disagree (definitely, generally, moderately) (65%)
 1 = Agree (definitely, generally, moderately) (35%)

Independent Variables

EDUCATION. Highest grade of school or year of college completed.

 1 = No college (baseline category) (48.4%)
 2 = Some college (27.8%)
 3 = College graduate (23.8%)

WISH FOR THE GOOD OLD DAYS. Variable is derived from the question: "I often wish for the good old days."

 0 = Disagree (definitely, generally, or moderately) (48%)
 1 = Agree (definitely, generally, or moderately) (52%)

AGE. Ratio variable representing the age of respondent at the time of interview (mean age = 46).

CHANGING TOO FAST. Variable is derived from the statement: "Everything is changing too fast today."
 0 = Disagree (definitely, generally, or moderately) (37%)
 1 = Agree (definitely, generally, or moderately) (63%)

AGAINST ABORTION. Variable is derived from the statement: "I am in favor of legalized abortion."
 0 = Agree (definitely, generally, or moderately) (45%)
 1 = Disagree (definitely, generally, or moderately) (55%)

RELIGION IS IMPORTANT. Variable is derived from the statement: "Religion is an important part of my life."
 0 = Disagree (definitely, generally, or moderately) (30%)
 1 = Agree (definitely, generally, or moderately) (70%)

PEOPLE ARE HONEST. Variable is derived from the statement: "Most people are honest."
 0 = Disagree (definitely, generally, or moderately) (66%)
 1 = Agree (definitely, generally, or Moderately) (34%)

RACE.
 1 = White (baseline category) (93.9%)
 2 = Black (4.7%)
 3 = Asian (0.7%)
 4 = Other (0.6%)

CITY SIZE.
 1 = Rural and towns < 50K (baseline category) (25%)
 2 = Central city/SMA 50K–500K (9%)
 3 = Non-central city/SMA 50K–500K (10.6%)
 4 = Central city/SMA 500K–2M (11.2%)
 5 = Non-central city/SMA 500K–2M (16.9%)
 6 = Central city > 2M (9%)
 7 = Non-central city > 2M (18.2%)

GENDER.
 0 = Female (55%)
 1 = Male (45%)

CHILDREN. Are there any children living in the home?
 0 = No (47%)
 1 = Yes (53%)

INCOME. This variable measures household annual income and includes fifteen categories—with 1 = under $10,000 and 15 = $100,000 or more. The variable is included in analysis as a continuous interval variable—with the mean at 6.4 (approximately $37,500).

Table A.3 Predicting support for increased government control of TV: Binary logistic regression

	B	Sig	Exp(B)	−2 Log-Likelihood Difference
Education (baseline = no college)		0.00		39
Some college	−0.16	0.00	0.86	
College graduate	−0.18	0.00	0.83	218
Wish for good old days	0.39	0.00	1.47	576
Age	0.02	0.00	1.02	375
Changing too fast	0.58	0.00	1.78	302
Against abortion	0.46	0.00	1.58	202
Religion is important	0.43	0.00	1.54	50
People are honest	0.19	0.00	1.21	57
Race (baseline = white)		0.00		
Black	0.33	0.00	1.40	
Asian	0.71	0.00	2.03	
Other	0.33	0.02	1.40	
City size (baseline = rural < 50K)		0.41		6
Central city 50K–500K	−0.05	0.32	0.95	
Non-central city 50K–500K	−0.04	0.35	0.96	
Central city 500K–2M	−0.04	0.33	0.96	
Non-central city 500K–2M	0.00	0.98	1.00	
Central city > 2M	0.04	0.48	1.04	
Non-central city > 2M	0.04	0.34	1.04	
Gender (male)	−0.17	0.00	0.84	45
Children at home	0.00	0.94	1.00	0
Income	−0.04	0.00	0.96	109
Constant	−2.48	0.00	0.08	

Dependent variables = Respondent agrees that the government should exercise more control over what is on TV.
N = 46,523
Data source: DDB.

Notes on Tables, Chapter Two (DDB)

The bulleted list in chapter 2, titled "DDB Survey," is derived from a binary logistic regression equation using data from the DDB. The model predicts the likelihood that an individual will agree with the statement that the government should take more control over what is on television. See description above (bulleted list titled "Saguaro Survey") regarding the interpretation of the coefficients and the –2 Log-Likelihood Difference.

The General Social Survey

Survey and data documentation can be found at the National Opinion Research Center (NORC) at http://www.norc.org/GSS+Website/.

Dependent Variable

REMOVE BOOK. Response to the question: "If some people in your community suggested that a book written in favor of homosexuality should be taken out of your public library, would you favor removing this book or not?"
 0 = Not in favor (65%)
 1 = Favor (35%)

Independent Variables

IMMIGRATION UNITE. Variable is derived from the question: "What do you think will happen as a result of more immigrants coming to this country? Making it harder to keep the country united?"
 0 = Not too likely or not at all likely (36%)
 1 = Very likely, somewhat likely (64%)

POLITICAL VIEWS. Categorical variable is derived from the question: "We hear a lot of talk these days about liberals and conservatives. I'm going to show you a seven-point scale on which the political views that people might hold are arranged from extremely liberal—point 1—to extremely conservative—point 7. Where would you place yourself on this scale?"
 1 = Extremely liberal, liberal, slightly liberal (baseline category) (27.2%)
 2 = Moderate, middle of the road (38.7%)
 3 = Slightly conservative, conservative, extremely conservative (34.1%)

ABORTION. Variable derived from the statement: "Please tell me whether or not you think it should be possible for a pregnant woman to obtain a legal abortion for any reason."

0 = Yes (40%)
1 = No (60%)

GENDER.
0 = Female (56%)
1 = Male (44%)

EDUCATION. Highest grade of school or year of college completed.
1 = No college (baseline category) (55.2%)
2 = Some college (23.3%)
3 = College graduate (21.5%)

AGE. Ratio variable representing the age of respondent at the time of interview (mean age = 45).

RACE.
1 = White (baseline category) (81.9%)
2 = Black (13.8%)
3 = Other (4.4%)

PLACE SIZE (LOGGED). This variable measures the population of the respondent's place of residency to the nearest 1,000 of the smallest civil division listed by the U.S. Census (city, town, other incorporated area over 1,000 in population, township, division, etc.). We use the logarithmic transformation because city size is not normally distributed.

SOUTH. This variable is derived from GSS variable region.
1 = South Atlantic, E. South Central, W. South Central (35%)
0 = Other (65%)

INCOME. This variable is entered as a continuous variable from 1 to 7 based on the following categories:
1 = $1 to $15,000 (8.1%)
2 = $15,001 to $25,000 (7.6%)
3 = $25,001 to $50,000 (19.5%)
4 = $50,001 to $75,000 (17.5%)
5 = $75,001 to $100,000 (14.6%)
6 = $100,001 to $150,000 (16.9%)
7 = $150,001 to highest (15.7%)

FUNDAMENTALISM. This categorical variable represents the fundamental-ism/liberalism of respondent's religion (based upon their religious denomi-nation, more information about coding can be found in Appendix T, GSS Methodological Report, No. 43).

1 = Liberal (baseline) (25.4%)
2 = Moderate (42.7%)
3 = Fundamentalist (31.9%)

Notes on Tables, Chapter Two (GSS Survey)

The bulleted list titled "GSS Survey" is derived from a binary logistic regres-sion equation using data from the General Social Survey. The model pre-dicts the likelihood that an individual will favor removing a "pro-gay" book from the public library. See description above (bulleted list titled "Saguaro Survey") regarding the interpretation of the coefficients and the –2 Log-Likelihood Difference.

Table A.4 Predicting support for removing pro-gay library book: Binary logistic regression

	B	Sig.	Exp(B)	–2 Log- Likelihood Difference
Immigration unite	0.67	0.00	1.96	18
Political views (baseline = liberal)		0.01		11
Moderate	0.39	0.03	1.47	
Conservative	0.59	0.00	1.80	
Abortion	0.80	0.00	2.23	30
Gender (male)	0.25	0.07	1.29	3
College (baseline = no college)		0.00		31
Some college	–0.66	0.00	0.52	
College gradate	–1.00	0.00	0.37	
Age	0.02	0.00	1.02	25
Race (baseline = white)		0.03		6
Black	0.16	0.43	1.18	
Other	0.85	0.01	2.34	
Place size	0.02	0.79	1.02	0
South	0.40	0.01	1.49	7
Income	–0.02	0.62	0.98	0
Fundamentalism (baseline = liberal)		0.00		75
Moderate	0.07	0.70	1.07	
Fundamentalist	0.63	0.00	1.88	

Dependent variables = Respondent favors removing a "pro-gay" book from the public library.
N = 1,342
Data source: General Social Survey.

Chapter Three

Chapter 3 examines the relationship between city-level variables (demographics, religion, political culture) and the rate of protest across the seventy-one cities in our sample. The primary research question is "What makes some cities more contentious than others when it come to fighting over art and culture?" The data for this chapter come from newspaper reports of protest events, described in more detail above in the notes to chapter 1.

Variable Descriptions, Chapter Three

TOTAL NUMBER OF CONFLICTS. The total number of public conflicts over art and media per city from 1995 through 1998.

RESIDUALS OF TOTAL NUMBER OF CONFLICT EVENTS. This is the residual number of conflict events remaining after we have controlled for population size (logpop). This variable measures the difference between the mean number of protest events predicted if we only knew the population size of a city and the actual number of protest events taking place in a city. A positive residual means that there were *more* events in actuality than would have been predicted based on a city's population size alone. A negative residual means that there were *fewer* events in actuality than would have been predicted based on a city's population size alone.

TOTAL NUMBER OF CONFLICTS (NO EMBERS). The total number of public conflicts over art and media per city, excluding those cases that involved only one newspaper article and/or a single complaint from a citizen or parent acting independently of a group or organization with no follow-up action or reaction. We omit those protest events with the least visibility and those with no collective or organized dimensions. We do so to reduce measurement error, as newspapers are less likely to systematically cover such stories resulting in differences across cities that might be attributed to chance (whether a random, single complaint gets picked up by a reporter), rather than underlying structural differences.

TOTAL NUMBER OF CONSERVATIVE-BASED CONFLICTS (NO EMBERS). Those protest events where the primary grievance against a work of art was that it was blasphemous, anti-family, vulgar, or indecent. Again we exclude cases that involved only one newspaper article and/or a single complaint from a citizen or parent acting independently.

SOUTH. This variable represents those cities that are geographically located in the southern region of the United States. The variable includes the following: Atlanta, Austin, Baton Rouge, Charleston, Charlotte, Columbia, Dallas, Fort Worth, Greensboro, Houston, Knoxville, Lexington, Louisville, Memphis, Nashville, New Orleans, Norfolk, Raleigh, Richmond, Roanoke, Tallahassee, Tampa, Tulsa, and West Palm Beach.

PERCENT COLLEGE GRADS. Percentage of a city's residents who have graduated from college. (From: U.S. Census Bureau; 1990 Census of Population and Housing; using State of the Cities Data Systems; http://webstage1 .aspensys.com/SOCDS/SOCDS_Home.htm. April 1999.)

Note: for this variable and several other demographic variables below, we use the 1990 Decennial Census. It would be inappropriate to use 2000 figures since the protest events in the sample occurred prior to 2000 (1995 thru 1998). In addition, as others have argued, population statistics often have a "lag" effect on social phenomena (whether looking at crime statistics; employment trends; or political outcomes). Many social processes are "sticky" or inelastic—e.g., the behavior of people and institutions change more slowly than the context in which they operate.

CITY SIZE (LOGGED). The natural logarithm of a city's population in 1990. (From: U.S. Census Bureau; 1990 Census of Population and Housing; using State of the Cities Data Systems; http://webstage1.aspensys.com/SOCDS/ SOCDS_Home.htm, April 1999.) We use the logarithmic transformation because city size is not normally distributed. The transformation makes visualizing data easier and it also deals with nonlinearity in the relationship between population size and number of protest.

PERCENT HISPANIC. Percentage of a city's residents who are Hispanic in 1990. (From: U.S. Census Bureau; 1990 Census of Population and Housing; using State of the Cities Data Systems; http://webstage1.aspensys.com/ SOCDS/SOCDS_Home.htm, April 1999.)

Note: This variable is included as a control so that we can determine the independent effect of immigration (percent change in percent foreign born) separate from the effects of the ethnic makeup of a city (immigration rates and percent Hispanic are correlated).

PERCENT CHANGE IN PERCENT FOREIGN BORN. The percent change in the percent foreign born in a city between 1980 and 1990. The formula = (Total

Foreign Born 1990 – Total Foreign Born 1980) / Total Foreign Born 1980. We use the rate of change rather than the absolute change for theoretical reasons. A 3 percent change in foreign-born residents in a city that starts off in 1980 with only 3 percent foreign born (thus, a 100 percent increase) should have a much larger impact on perceptions of change than a 3 percent change in a city that starts off in 1980 with 15 percent foreign born (a 20 percent increase). Change will be more noticeable when there are fewer foreign born to begin with.

PERCENTAGE OF HOMES WITH CHILDREN UNDER EIGHTEEN. The percentage of households in a city (MSA) in 1990 that have children under eighteen residing in the home.

GAY RIGHTS ORDINANCE. This is a binary variable indicating whether a city had passed a gay rights ordinance that was still active on the books as of 1997. A gay rights ordinance could include a range of public acts and proclamations from legal protections for gays and lesbians to more symbolic ordinances that affirm the dignity, respect, and equality of all residents, regardless of sexual preference. The data come from a study by James Button, Barbara Rienzo, and Kenneth Wald (1997).

NUMBER OF CONSERVATIVE CHURCHES (LOGGED). This variable measures the natural logarithm of the total number of conservative churches in a city. Like city size, we use the logarithmic transformation because number of churches is not normally distributed (long right tail). The transformation makes visualizing data easier and it also deals with nonlinearity in the relationship between number of churches and number of protests. The following churches were included in our definition: Advent Christian, Baptist (all denominations), Christian and Missionary Alliance, Churches of Christ, Christian Reformed Church, Church of the Nazarene, Seventh Day and Church of God, Christian Scientist, Conservative Congregational, Evangelical Free Church of America, Free Methodist, Independent Fundamentalist, Church of the Foursquare Gospel, Lutheran (Missouri Synod, Wisconsin Evangelical), Open Bible, Christian Brethren, Salvation Army, Wesleyan Church, Independent Charismatic. Pentecostal churches were not included as conservative because, while conservative in doctrine, members of these congregations tend not to be involved in the traditional conservative-based challenges to cultural expression. The definition used above is based on Wald et al.'s scheme (1996). The data come from Churches and Church

Table A.5 Descriptive statistics for variables in chapter 3

	N	Minimum	Maximum	Mean	Std. Deviation
Total number of conflicts	71.00	1.00	37.00	11.34	6.26
Total number of conflicts (no embers)	71.00	0.00	25.00	9.76	5.31
Total number of conservative-based conflicts (no embers)	71.00	0.00	18.00	5.90	3.40
Residuals of total number of conflict events	71.00	−9.84	19.95	0.00	4.92
South	71.00	0.00	1.00	0.35	0.48
1990 population	70.00	91,629	7,410,858	1,392,818	1,220,000
City size (logged)	71.00	11.43	15.82	13.83	0.86
% College graduate	71.00	0.13	0.35	0.22	0.05
% Hispanic	71.00	0.00	0.37	0.06	0.08
% Change in % foreign born	71.00	−0.27	0.96	0.16	0.28
% Homes with children	71.00	0.10	0.15	0.13	0.01
Gay rights ordinance	71.00	0.00	1.00	0.48	0.50
Number of conservative churches (logged)	71.00	3.47	7.38	5.55	0.84

Membership in the United States, 1990. Glenmary Research Center, Mars Hill, NC, at http://www.thearda.com/archive/CMS90CNT.html.

Table A.5 presents the basic descriptive statistics for each variable.

Notes on Tables, Chapter Three

Table 3.1 presents a ranking of cities based on the total number of conflicts per 1 million residents in the metropolitan statistical area.

Table 3.2 presents a ranking of cities based on residuals of total number of conflict events. As noted in the variable description above, this is another way to rank cities by conflict events, controlling for population size.

Table 3.3 presents the top fifteen and bottom fifteen ranked cities in terms of the main social change variable: *Percent change in percent foreign born*.

Table 3.4 examines the predicted number of conflict events (*Total number of conflicts—no embers*) for cities that fall in the top 10 percent (90th percentile) and bottom 10 percent (10th percentile) for the following independent variables: *Percent change in percent foreign born, city size (logged), percent college grads, percent Hispanic, percent of homes with children, and number of conservative churches*. The table also looks at the predicted number of events for those cities *with a gay rights ordinance* and those without, and those cities in the *South* and those in other regions.

The predicted number of conflict events is derived from a Poisson re-

gression analysis. Given that counts of events (*total number of conflicts—no embers*) cannot include negative counts, normal regression analysis cannot be used to model the data. Moreover, the variance in the number of conflict events is greater than the mean (over dispersion), which requires the *negative binomial* distribution for modeling the relationship between the independent and dependent variables (Barron 1992). It turns out that the Poisson regression results and the negative binomial results are virtually identical (similar coefficients and similar goodness of fit measures). I report on the Poisson results because they are easier to interpret. In particular, the exponentiated coefficients are "incident rate ratios"—or the predicted rate of an event given the relevant independent variables. To find the predicted rates for each independent variable in table 3.4, I multiplied the coefficient for the value of the variable at the 10th percentile as well as at the 90th percentile, while multiplying the remaining continuous independent variables by their mean value. For the binary variables (*South* and *gay rights ordinance*), I multiplied the coefficient by 1 (indicating that the city was in the South and had a gay rights ordinance). The final predicted rate is the exponentiated value of the sum of all values above. Column 1 presents the incident rate ratio (predicted number of conflict events) when each continuous independent variable is at the 10th percentile (and the binary variables are held at 0); column 2 presents the incident rate ratio when each continuous independent variable is at the 90th percentile (and the binary variables are held at 1). The Poisson model for table 3.4 is shown in table A.6.

Table 3.5 examines the predicted number of *conservative-based conflict events—no embers* based on the same independent variables examined in table 3.4. The analysis presented in table A.7 is identical to the analysis used

Table A.6 Predicting total conflicts: Poisson model for table 3.4

Parameter	B	Std. Error	Sig.
(Intercept)	−2.854	1.3777	0.038
South	−0.195	0.1181	0.098
City size (logged)	0.327	0.0997	0.001
% College graduate	0.05	1.0014	0.96
% Hispanic	−1.672	0.7141	0.019
% Change in % foreign born	0.732	0.229	0.001
% Homes with children	4.724	4.7582	0.321
Gay rights ordinance	0.337	0.1049	0.001
Number of conservative churches (logged)	−0.035	0.0951	0.716

Dependent variable: Total number of conflict events—no embers.

Table A.7 Predicting conservative-based conflicts: Poisson model for table 3.5

Parameter	B	Std. Error	Sig.
(Intercept)	−3.759	1.7761	0.034
South	−0.162	0.1485	0.276
City size (logged)	0.317	0.1279	0.013
% College graduate	−0.685	1.3251	0.605
% Hispanic	−2.465	0.933	0.008
% Change in % foreign born	0.836	0.2893	0.004
% Homes with children	13.885	6.2381	0.026
Gay rights ordinance	0.275	0.1334	0.04
Number of conservative churches (logged)	−0.106	0.1219	0.383

Dependent variable: Total number of conservative-based conflict events—no embers.

for table 3.4, only with a different outcome variable—*conservative conflicts* as opposed to all *conflict events.*

Chapter Five

Chapter 5 examines the relationship between a city's political culture (history of protest, unconventional political culture, voter turnout, religious makeup) and the rate of protest across the seventy-one cities in our sample. The primary research question is: "How does a city's political culture influence its rates of protest over art and media?"

Variable Descriptions, Chapter Five

TOTAL ORGANIZED OR OFFICIAL EVENTS (TOTAL). The number of conflict events in each city in which the initiating or subsequent action against the artwork originated from a formal group, a public official, administrator, or a coordinated group of individuals. This variable is similar to the one used in chapter 3 (*total number of conflict events—no embers*), with a slightly more stringent criterion for inclusion. We use this variable, rather than the absolute total number of events, because we are looking at the influence of political culture in this chapter, and theoretically we would assume that events of some collective dimension will be more related to political culture than individual ad hoc grievances.

TOTAL NUMBER OF CONSERVATIVE-BASED CONFLICTS (CONSERVATIVE). Those protest events in which the primary grievance against a work of art was that it was blasphemous, anti-family, vulgar, or indecent.

TOTAL NUMBER OF LIBERAL-BASED CONFLICTS (LIBERAL). Those protest events in which the primary grievance against a work of art was that it was offensive to women, ethnic minorities, or religious minorities.

WILDFIRES. Those protest events that consisted of seven or more different actors (representing different groups, public officials, or administrators) and/or nine or more articles. These conflicts were typically the most intense and visible.

CONSERVATIVE INDEX. This index measures the conservative climate of opinion in a city. The index, following Wald, Button, and Rienzo (1996), captures protestant fundamentalism as well as overall religious climate. The index also includes a measure of the complaints per capita sent to the Federal Communication Commission following a controversial halftime performance on CBS during the 2004 Super Bowl game. The variables included in the index are (1) number of religious nonprofit organizations (not churches) per capita (*Source:* National Center for Charitable Statistics; 1992 Business Master file); (2) number of conservative churches per capita (*Source:* Churches and Church Membership in the United States, 1990, available at the American Religion Archive—www.thearda.com)[7]; (3) number of total churches per capita (*Source:* same as above); (4) percentage of residents who are members of conservative congregations (*Source:* same as above); and (5) the number of complaints per capita received by the Federal Communication Commission (*Source:* data made available to the author by a senior FCC official in 2007). The index is the sum of all standardized variables divided by 5. The index has a very high reliability score—Chronbach's Alpha of 0.85—indicating that all elements of the scale are highly correlated.

UNCONVENTIONAL POLITICAL CULTURE. This variable is a scale composed of six other variables (based on Sharp's scale, 2005) and measures the extent to which a city's political culture is conducive to identity and lifestyle politics. It includes the percentage of a city's residents who are college graduates; the percentage who work in creative occupations[8] (based on total employment); the percentage of nontraditional family households (single sex, single parent, and unmarried with children); the percentage of women in the labor force; percentage of labor force comprised of professional artists (*Source:* 1990 Census of Population and Housing; State of the Cities Data System; the percentage of artists comes from a 1990 Census extract provided by the National Endowment for the Arts, Washington, DC). The scale is the sum of all standardized variables divided by 6. The scale has a very high

reliability score—Chronbach's Alpha of 0.83—indicating that all elements of the scale are highly correlated.

TRADITIONAL LIFESTYLE. This index is a scale based on subscriptions to a set of magazines that represent a traditional home and family orientation. The index was created by conducting Principal Component Analysis on subscription rates to magazines in each metropolitan statistical area. The analysis revealed two distinct patterns of subscription rates: (1) traditional, based on subscriptions to *Better Homes and Gardens, Country Living, Family Circle, Ladies' Home Journal*, and *Reader's Digest*; (2) cosmopolitan, based on subscriptions to *Architectural Digest, Atlantic Monthly, Bon Appétit, Gourmet, Vanity Fair, Vogue*, and the *New Yorker*. These two "components" were orthogonally related— e.g., those cities that had higher subscription rates to the cosmopolitan magazines tended to have lower rates to the traditional magazines and vice versa. The rotated components matrix (see table A.8) shows that items included in one component (cosmopolitan) are typically negatively related to the second component (traditional) and vice versa. The variable *traditional lifestyle* is based on the percentage of the population that subscribes to the five magazines considered "traditional" based on the PCA analysis. The percentages were summed together and then divided by 5 to obtain an average subscription rate. (*Source:* The percentages come from a 1992 report of subscription rates for each MSA produced from the American Bureau of Circulation.)

Table A.8 Factor analysis for magazine subscriptions by city: Rotated component matrix[a]

	Component	
% of subscribers in MSA	Cosmopolitan	Traditional
Architectural Digest	0.799	−0.496
Atlantic Monthly	0.837	0.168
Bon Appétit	0.913	−0.059
Better Homes and Gardens	−0.061	0.827
Country Living	0.006	0.843
Family Circle	−0.071	0.805
Gourmet	0.953	−0.191
Ladies' Home Journal	−0.255	0.883
The New Yorker	0.879	−0.076
Reader's Digest	−0.298	0.708
Vanity Fair	0.913	−0.310
Vogue	0.850	−0.353

Extraction Method: Principal Component Analysis.
Rotation Method: Varimax with Kaiser Normalization.
[a]Rotation converged in 3 iterations.

Notes on Tables and Figures, Chapter Five

In this chapter I use two basic statistical techniques. Figures 5.1 to 5.6 are derived from analysis using multivariate general linear modeling (GLM, SPSS) similar to ANOVA, where I examine the effects of both factor variables (dichotomous or categorical) as well as covariates (continuous). The analysis provides me with the means of each dependent variable of interest for each subgroup represented by the factor variable. The means are calculated with the covariates held constant at their mean value. Separate models are run for each factor variable of interest. Unless the factor was a dichotomous variable (e.g., *South, ethnic conflict, gay rights ordinance*), I divided the factor into three categories—cities that fall into the bottom third, middle third, and top third of the factor score/index/measure. So, for example, I examine the mean number of protest events (predicted) in each city for those cities in the top third of the *conservative index*, the middle third, and the bottom third, while holding constant *percent change in percent foreign-born population* and *population size (logged)* at their mean values. *Percent change in percent foreign-born* and *population size* are chosen as control variables because they are the strongest and most consistent predictors of arts protests across *all* models.

The second statistical technique, reported in table A.9, uses a generalized linear modeling (GENLIN, SPSS) that expands the general linear model so that the dependent variable is linearly related to the factors and covariates via a specified link function. Moreover, the model allows for the dependent variable to have a non-normal distribution. As discussed in the methodological notes to chapter 3, when a dependent variable is a "count" of events (like the number of protest events over four years), adjustment must be made for the fact that the variable is truncated at zero (one cannot have negative counts) as well as overdispersed (variance is larger than the mean). I tested both the negative binomial distribution as well as the Poisson distribution and arrived at identical results. The Poisson distribution is somewhat easier to interpret, so I include those analyses in table A.9. Using the Poisson regression, I control for all independent variables at the same time, and rather than create categorical variables in order to compare means I use continuous variables to represent all indices (*unconventional political culture, traditional, conservative*) as well as *voter turnout* rates.

Below I provide a table of nested models (from the Poisson regression) that includes the B-coefficients of each independent variable for both *total organized or official events* as well as *total conservative-based events*.

Table A.9 represents analysis from generalized linear models using a Poisson distribution. The models are nested, with Model A representing the most parsimonious model and Model F representing the full model. Because there are several cities where the number of *ethnic protests* is unknown, we do not include this variable in the final model in order to preserve the larger sample size.

The analysis below suggests the following findings:

· Larger cities have more protests over art (see *population size*), likely because they have more people, more art, more media coverage, and more opportunities for conflict. The effect of city size is smaller when we examine only conservative-based protests.

· Cities with higher rates of immigration in the 1980s have more protests over art in the 1990s (see % *change in % foreign born*).

· Cities in the *South* appear to have more conflict (Models A–B), but once we account for *traditional lifestyles*, being located in the *South* appears to have no consistent effect on protest levels. People in southern cities do not appear to protest more often once both traditionalism (lifestyle) and conservatism (religious beliefs) are taken into account.

· Cities with high levels of *unconventional political culture* are no more likely to protest over art and media than those with more conventional political cultures.

· Across all models, cities with *traditional lifestyles*—based on subscription rates to community and family-oriented magazines—are much more likely to experience protest over art and media.

· Cities with *gay rights ordinances* have higher levels of protest; possibly because such cities have a visible gay community that serves to highlight social change and threaten established notions of community life. Additionally, the passage of a gay rights ordinance might indicate that a community has a history of political activism (which may translate into current activism and protest).

· Cities with a history of *ethnic protest* (around civil rights, housing, schools, etc.) have higher levels of *overall* protest activity. However, *ethnic* protest does not predict levels/rates of conservative-based protests (see Model D Cons). This is to be expected because conservative-only events do not include any protests organized around ethnic concerns.

· Cities with higher levels of citizen activism (measured by *voter turnout rates*) are more likely to fight over art and media in their communities.

· Finally, cities with a higher *conservative index* are much more likely to have higher levels of conservative-based protest events, but not necessarily more protest events overall (conservative, neutral, and liberal).

Table A.9 Protest regressed on political culture variables: Poisson regression

	Mod A Total	Mod A Cons	Mod B Total	Mod B Cons	Mod C Total	Mod C Cons	Mod D Total	Mod D Cons	Mod E Total	Mod E Cons	Mod F Total	Mod F Cons
Population size (log)	0.377***	0.259***	0.385***	0.265***	0.435***	0.312***	0.241**	0.187**	0.403***	0.304***	0.406***	0.337***
% Change in % foreign born	0.491***	0.555***	0.435***	0.559***	0.615***	0.681***	0.711***	0.538***	0.655***	0.682***	0.641***	0.551***
South	-0.215**	-0.032	-0.203**	-0.049	-0.225**	-0.04	-0.218*	0.104	-0.099	0.112	-0.125	-0.127
Unconventional political culture			0.009	0.001								
Traditional lifestyle					11.91***	11.85***	13.50***	12.61***	9.796***	9.636***	9.487***	6.836*
Gay rights ordinance							0.375***	0.356***	0.239**	0.242**	0.239**	0.257**
Ethnic protest -70s & 80s[a]							0.241**	0.063				
Voter turnout (1992)[b]									1.258**	1.305**	1.19**	0.674
Conservative index											0.029	0.265***
Intercept	3.124	-1.74	3.23	-1.80	-4.89	-3.44	-2.64	-1.99	-5.19	-4.10	-5.16	-3.87
N =	69	69	68	68	69	69	61	61	68	68	67	67

Dependent Variables: Total number of organized or official events (omitting those that involve only single, unorganized complaints from citizens). Cons = Total number of protest events based on conservative grievances (blasphemy, obscenity, indecency, etc.).

[a] Several cities have missing values when examining ethnic protests: Allentown, Pennsylvania; Anchorage, Alaska; Bangor, Maine; Grand Rapids, North Dakota; Santa Rosa, California; Tacoma, Washington; Akron, Ohio; Fort Worth, Texas.

[b] In the models including *voter turnout*, Anchorage, Alaska, is omitted because of missing data—election data is not aggregated to the MSA level in Alaska (it is only available at the district level).

* = significant at the 0.1 level (two-tailed).

** = significant at the 0.05 level (two-tailed).

*** = significant at the 0.01 level (two-tailed).

Note: In the above models we have removed Hartford, Connecticut, and Roanoke, Virginia. Hartford was an outlier (more than 3 SD from the mean) and a high-influence data point in terms of the dependent variable (*total organized or official events*). Roanoke, Virginia, was an outlier in terms of the independent variable *conservative index*, based in large part on its much higher-than-average number of conservative churches.

Chapters Six, Seven, and Eight

The majority of analyses in these chapters comes from newspaper accounts of protest events in the twelve chosen case study cities—Oklahoma City, Cincinnati, Kansas City, Dayton, Denver, Forth Worth, Dallas, Charlotte, San Francisco, San Jose, Albuquerque, and Cleveland. These cities were chosen based on the authors' familiarity with the types of protests in each city. The cities fit the inductively produced typology of *contentious cities*, *cities of cultural regulation*, and *cities of recognition*.

In order to provide some contextual information about each of the case study cities and to be able to compare basic demographics and protest levels across cities, table 6.1 provides descriptive statistics for a range of city-level variables. Table 6.1 also provides the average count, percentage, or score for each of the three groups of cities.

Variable Descriptions, Chapters Six, Seven, and Eight

The following variables are included in table 6.1.

TOTAL NUMBER OF CONFLICTS. See appendix—chapter 3—for variable description.

TOTAL NUMBER OF WILDFIRES. Count of protest events where there were seven or more different types of actors involved (representing different constituents) and/or nine or more articles written about the case in the newspaper.

TOTAL NUMBER OF CONSERVATIVE-BASED CONFLICTS—NO EMBERS. See appendix—chapter 3—for variable description.

TOTAL NUMBER OF LIBERAL-BASED CONFLICTS—NO EMBERS. Those protest events where the primary grievance against a work of art was that it was offensive to ethnic minorities, women, or religious minorities. Again we exclude cases that involved only one newspaper article and/or a single complaint from a citizen or parent acting independently.

RACIAL HETEROGENEITY. A measure of the racial diversity of the city based on the Gibbs Martin Index (see Blau and Schwartz 1984, 227), using proportions of white, non-Hispanic; black, non-Hispanic; other races, non-

Hispanic; and Hispanic. The data come from the U.S. Census Bureau, Census of Population and Housing; using State of the Cities Data System.

PERCENT CHANGE IN PERCENT FOREIGN BORN. See appendix—chapter 3—for variable description.

ARTISTS PER CAPITA. A measure of the percentage of people in a city in 1990 who indicated that they worked in an arts profession (music, visual art, entertainment, design, broadcasting, theater, etc.) as their primary or secondary job. The data come from the U.S. Census Bureau 1990 Census extract of artists labor force, available from the National Endowment for the Arts, Washington, DC.

TOTAL NUMBER OF ETHNIC-RELATED PROTESTS. A measure of the number of protest events in a city where the primary or secondary grievance against an artwork was that it was offensive to ethnic minorities.

TRADITIONAL LIFESTYLE INDEX. See appendix—chapter 5—for variable description.

COSMOPOLITAN LIFESTYLE INDEX. This index is a scale based on subscriptions to a set of magazines that represent an urban, cosmopolitan, and fashion-based lifestyle. The index was created by conducting Principal Component Analysis on subscription rates to magazines in each metropolitan statistical area. The *cosmopolitan component* is based on subscriptions to *Architectural Digest, Atlantic Monthly, Bon Appétit, Gourmet, Vanity Fair, Vogue,* and the *New Yorker.* The variable *cosmopolitan lifestyle index* is based on the percentage of the population that subscribes to the seven magazines considered "cosmopolitan" based on the PCA analysis. The percentages were summed together and then divided by 7 to obtain an average subscription rate. (*Source:* The percentages come from a 1992 report of subscription rates for each MSA produced by the American Bureau of Circulation.)

CONSERVATIVE INDEX. See appendix—chapter 5—for variable description.

NOTES

INTRODUCTION

1. This time period is also an artifact of my methodology. The electronic archives of many city newspapers—the source for identifying conflict events—only go back to the mid-1990s. Furthermore, by the beginning of 2000, many newspapers removed their archives from the three largest databases—LexisNexis, Dow Jones Interactive, and Dialog—and began to operate proprietary databases, each of which used different search algorithms and indexed their articles using different terms. By 2000 or 2001 it was impossible to conduct identical searches across a large number (fifty to seventy-five) of major city newspapers. Finally, in 2001, the Supreme Court ruled against the *New York Times* in *Tasini vs. the New York Times*, concluding that nonstaff, contract journalists would need to be paid a percentage of profits earned from the sale of their archived articles. The *Times*, and most other newspapers, responded by removing the articles of these journalists from their digital archives—thus leaving a large gap in the electronic record beginning in 2002. In sum, 1995–98 represents one of the few moments in history when a study of this type, using electronic news archives to identify protest events in a large number of American cities, could have been completed.

2. Actually, the unit of analysis in this study is the metropolitan statistical area (MSA), which includes both central cities and adjacent suburban counties.

CHAPTER ONE

1. Disney was not the only target of campaigns aimed at revealing anti-family subliminal messages. Former leader of the Moral Majority, Jerry Falwell, alerted his members to the fact that a character from the BBC-originated kids' show—*Teletubbies*—was gay. He wrote, "He is purple—the gay-pride color; and his antenna is shaped like a triangle—the gay-pride symbol. . . . As a Christian I feel that role modeling the gay lifestyle is damaging to the moral lives of children" (BBC News 1999, news.bbc.co.uk/2/hi/entertainment/276677.stm).

2. The *Sensation* controversy was discussed in 1999 at seminars at New York University and Princeton University as well as at the 2000 annual meeting of the Sociology of Culture section of the American Sociological Association and at a conference hosted by the University of Chicago in February 2000.

3. See the introduction to the People for the American Way's four-volume series, *Artistic Freedom under Attack* (1992, 1994, 1995, 1996), for an elaboration of these ideas.

4. The *primary grievance* describes what it is about a cultural work that someone objected to. In many cases there were multiple primary grievances, as when a religious group criticizes a film for being both blasphemous and obscene. In these cases, coders were instructed not to designate either as *primary*. If the vast majority of comments reported in the press dealt with blasphemy while only a few mentioned obscenity, then the former would be coded as *primary* and the latter would be recorded as *other grievance*.

5. Often people will object to *indecent material* because it is *harmful to children*. In these cases, priority is given to "what they object to" (the indecency) rather than "for whom they object" (the children).

6. This final percentage comes from a separate analysis not presented here.

7. The percentages in this table reflect the "expected mean" for each comparison group, taking into account (e.g., controlling for) whether or not the conflict involved some collective action (e.g., more than just an individual, uncoordinated complaint). In the section describing table 1.10, the noted percentages are not actual frequency statistics; they are the results of the General Linear Model and thus are predicted or expected counts.

8. This is true in large part because our definition of wildfires includes those events with more than eight different types of actors—and of the possible eighteen "types of actors," ten included categories of organizations that would automatically qualify the event as involving collective action.

CHAPTER TWO

1. These percentages are for people who stated an opinion; 3.5 percent of all respondents neither agreed nor disagreed with the statement. All analysis in this chapter excludes respondents who fail to state an opinion one way or another.

2. Correlations between "concern over immigration" and a disposition to ban or restrict culture might have been even greater if the object under consideration were more directly related to new immigrants (e.g., lowrider cars, certain types of dress or music, etc.).

CHAPTER THREE

1. The only exception to this is that in later analysis I remove what might be considered "sparks"—those conflicts that involved a single grievance launched by an individual citizen without any organizational affiliation and without any follow-up action or reaction. In other words, there may be good methodological reasons for removing protests that are limited to a parent or citizen writing to the school board, contacting a gallery owner, calling a local radio station, or showing up to a town hall meeting to express concern about some cultural presentation. In particular, these types of complaints—which get no traction in terms of follow-up or shared public concern—have a less reliable chance of being picked up by the newspaper. Therefore, including them in the analysis is a source of potential error; Atlanta may appear to have many more conflicts than Chicago, but it may be an artifact of more "sparks" getting picked up randomly by the press. As it turns out, all subsequent and substantive findings reported in this chapter are borne out regardless of whether we include or remove "sparks" from the analysis.

2. I am looking at percentage change in the percent foreign-born residents in a city

rather than absolute changes in percentage. The reason we look at the percent change is so that we get a sense of the rate of change; that is, a positive change of 2 percent (the proportion of foreign-born citizens rises by 2 percent) is much more significant for a city that begins with only 4 percent foreign born than one that begins with 20 percent foreign born. The 2 percent will appear more dramatic for the city whose baseline number of foreign-born residents is comparatively lower; that is, its rate of change is faster, even if its absolute change might be identical.

3. I look at percent changes in percent foreign born (rate of change) between 1980 and 1990. I use this time frame, rather than 1990–2000, for two reasons. First, population changes may have a lag effect on rates of cultural conflict. That is, perceptions of change may actually lag a few years behind actual changes in demographics. Thus, changes that take place in the 1980s may begin to surface in the form of protest in the 1990s (the time frame for which I collected the events in this study). Second, the time frame for collecting data is from 1995 to 1998; therefore, if we use 1990–2000 data, we will risk measurement error. Conceivably, most population change for a particular city could take place in the last two years of the decade—years outside of the time frame used for collecting protest events. Thus, 1990–2000 data could reveal rapid population changes for some cities when, for the years of my study, changes might, in fact, have been much more modest.

4. The model used for this analysis examines the number of protest events for each city, excluding what I have deemed sparks, single complaints by an individual with no connection to an organized follow-up. I used this more restrictive definition to eliminate measurement error, as discussed in note 1 above.

5. In this analysis "typical" means that we assign the mean value of all variables (across all cities) and then vary the variable of interest—assigning the 10th percentile and 90th percentile values for comparison purposes. So, for example, we can examine the predicted number of conflicts for a city in the 10th percentile in terms of population size and a city in the 90th percentile; for all other values—change in foreign-born residents, percent college grads, percent Hispanic—we simply use the average value for the seventy-one-city sample.

6. In addition to living in the South and number of conservative churches, I also created an index for each city based on the American Conservative Union's (ACU) rating of congressmen who represent districts contained within the city. Cities with high ratings were represented by congressmen who, on average, scored high on the ACU's rankings. Cities with low ratings had more liberal congressmen. Cities in between had either a mix of conservative and liberal congressmen or had congressmen whose votes were rated somewhere in the middle. Like the other measures of conservative values, this variable had no effect on the number of protest events.

7. Given the importance of religion and traditional values for predicting individual responses to regulating art and media (see chapter 2), why do we not see a relationship at the city level between conservative values—measured by the presence of evangelical and fundamentalist churches—and protest levels? There are many possible explanations for this finding—all of which are tentative given the level of analysis. First, it is possible that the presence of evangelical and fundamentalist churches is a poor measure of the overall conservative climate of opinion. Evidence suggests that there are far more Americans who hold fundamentalist values, such as belief in the inerrancy of the scripture, than there are those who regularly attend fundamentalist and evangelical churches. Some cities, for a variety of reasons, might have a strong organizational base (many churches) but lack significant numbers of adherents and

vice versa. Second, as discussed in chapter 6, cities with a large religious popula-
tion and a clear set of community norms may preemptively regulate or restrict art
and expression. In such places controversies get nipped in the bud and may never
become fodder for public debate, resulting in lower levels of protest. Finally, many
evangelical and fundamentalist churches provide an alternative space for culture and
leisure outside the mainstream. It is possible that adherents to such churches have
chosen to "exit" (in Albert Hirschman's terms, see conclusion) the cultural life of
their cities, finding safe harbor in their churches rather than voicing their concerns
in the public square.

CHAPTER FOUR

1. This figure comes from the analysis of a pooled sample of respondents across many
 years of GSS data—1972 to 2006. Primary analysis conducted by author and avail-
 able upon request.
2. Data come from the survey of congregations, American Religion Data Archive, and
 from the Business Master File at the National Center for Charitable Statistics in Wash-
 ington, DC. Primary analysis conducted by author and available upon request.

CHAPTER FIVE

1. Although, as we will see in chapter 9, activists do link the content of media with
 tangible quality of life issues—including schools, public safety, and health.
2. The *creative class* is a term used by Richard Florida (2002) to describe workers whose
 jobs involve producing new intellectual property rather than services or material
 goods. Florida focuses on knowledge workers in media, entertainment, and art as
 well as software programmers, database and systems engineers, and other profes-
 sionals tied to the intellectual property sector.
3. This figure as well as figures 5.2 to 5.5 are based on a General Linear Model that
 controls for population and percent change in foreign-born residents—both vari-
 ables that have a strong influence on the number of conflicts in a city and that are
 also correlated with a city's conservatism. A more detailed explanation of methods is
 available in the methodological appendix.
4. Wildfires are those conflicts that attract the most press attention (more than nine
 newspaper stories) and have the most number of different groups participating
 (more than seven).
5. A few scholars, in fact, have pointed out that certain forms of engagement, volunta-
 rism, and group membership can lead to *asocial* outcomes—gangs, militias, nativ-
 ist groups, right-wing movements, and other forms of factionalism (Berman 1997;
 Lipset and Raab 1978; Marx and Wood 1975; Portes 1998). While conflicts over art
 and culture cannot be compared to the types of violent conflicts generated by gangs
 and nativist groups (e.g., hate crimes), they do seemingly represent the flip side of
 the civic engagement coin—political action that is defined by intolerance, a clash
 of values and interests, and a desire to suppress the opinion or voice of those with
 whom one disagrees. Thus, according to Peter Nowak and colleagues (1982), "mod-
 els of political participation must be evaluated within the context of conflict as well
 as consensus" (334).
6. The notion of *civic culture* comes from Gabriel Almond and Sidney Verba's 1965
 book, *The Civic Culture: Political Attitudes and Democracy in Five Nations, An Analytic
 Study*. This study found that countries with a healthy civic culture also had higher
 levels of political participation and a thriving associational life.

CHAPTER SIX

1. Oklahoma City is not officially considered the Midwest or Great Plains and is more often than not classified as a southern city. Nonetheless, both economically and culturally it shares a great deal with cities in the Great Plains, like Kansas City, Dayton, and Cincinnati.

CHAPTER SEVEN

1. In this chapter, I often refer to the four contentious cities as Sunbelt cities. Denver is not officially a Sunbelt city, but it shares characteristics of other Sunbelt cities—including high rates of growth, the relocation of urban professionals, and a larger-than-average religious community.

CHAPTER EIGHT

1. It is interesting to note that Taylor was particularly interested in language policy and debates concerning French-speaking citizens in Quebec.
2. *Hyperplural* is a term used by Frederick Wirt to describe the political culture of San Francisco in Robert Bailey's *Gay Politics, Urban Politics* (1999), p. 285.
3. Cleveland is a bit of an outlier, compared to San Jose, San Francisco, and Albuquerque. It is less diverse than the other three cities today, although it was a comparably diverse city early in the twentieth century as a major center for black migration. Interestingly, African Americans achieved political power in Cleveland before most other major U.S. cities. The city is also less cosmopolitan and has fewer artists per capita than other cities of recognition. Nonetheless, the culture of reform, protest, liberalism, and diversity in Cleveland stands in stark contrast to Cincinnati and Dayton, which are discussed in chapter 6. The frequency and content of "identity-based" grievances clearly situate Cleveland as a city of recognition.

CHAPTER NINE

1. Examples of programming that was canceled in some local markets include the 1991 PBS documentary *Tongues Untied* and ABC's presentation of *Saving Private Ryan* on Veteran's Day in 2004.
2. This image is a stark contrast with how the PTC has been characterized by opponents, like Seth MacFarlane, the creator of *Family Guy*, an off-colored, politically incorrect animated series on the Fox network. MacFarlane lashed out against the PTC when interviewed for the San Francisco–based gay-oriented magazine the *Advocate*: "Oh, yeah. That's like getting hate mail from Hitler. They're literally terrible human beings. I've read their newsletter, I've visited their website, and they're just rotten to the core. For an organization that prides itself on Christian values, they spend their entire day hating people." From Bent Bozell's syndicated column, February 4, 2008, "Hollywood Hate Mail," at www.mediaresearch.org/BozellColumns/entertainment-column/2008/col20080204.asp. My own experience interviewing PTC members and analyzing focus group transcripts does not conform to this stereotype. I found the focus group participants to be earnest and sincere. They are not ideologues or hate mongers. They deploy reasoned arguments, demonstrate an ability to see the issues as complex, recognize that others will disagree with them, defend the rights of adults while maintaining their commitment to protecting children, and generally come across as concerned citizens. Some participants may be religious zealots, they may be partisans, and they may be intolerant of certain lifestyles, but these passions did not drive our conversations. I recognize the possibility that participants may have pulled

their ideological punches given the context of the discussion—an interview for a book written by a Vanderbilt sociology professor. Nonetheless, my observations and instincts tell me that MacFarlane has grossly mischaracterized this particular group of activists.

3. Steve Allen is a well-known comedian and actor. He was the host of NBC's late night television show *The Tonight Show* in the 1950s. In 1998 Allen published full-page ads in national newspapers promoting the organization.

4. Throughout this section I report directly on the perceptions of respondents with no reference to actual trends; in fact, rates of teen pregnancy, sex, drug use, and other social problems are improving modestly over this period.

5. Elisabeth Noelle-Neumann discusses the idea of the spiral of silence in her book, by the same name, on public opinion and the fear of isolation (1984).

CONCLUSION

1. A community is imagined in the sense that most residents will never meet one another face-to-face, nor will they have any intimate grasp of the institutions, economy, or politics that comprise its day-to-day workings.

2. While immigration is strongly correlated with arts protest, people do not actually fight over cultural activities explicitly associated with immigration in most instances. By contrast, in the temperance campaigns of the early twentieth century, crusaders attacked drinking in order to challenge Catholic immigrants for whom drinking was a popular pastime. Rather, immigration, in my study, is simply a proxy for broader social change.

EPILOGUE

1. In 2003, the lead singer of the Dixie Chicks made a negative comment about then-president George W. Bush at a concert in Europe. The comment, picked up on the news wire, created a firestorm of controversy across America. Many country music listeners called their local stations demanding that the Dixie Chicks be kept off the air. Cumulus Media, which owned fifty country radio stations across the country, made a corporate decision to stop playing the Dixie Chicks' music.

2. In the 2005 State of the First Amendment Survey, sponsored by the Freedom Forum (results available at www.cpanda.org), many Americans favor broad restrictions on speech. For example, 38 percent said musicians should not be allowed to sing songs that some might find offensive, 47 percent said that the government should be allowed to restrict scenes depicting homosexual characters on television, and 46.5 percent agreed that the government should be allowed to restrict scenes that may be offensive to religious groups.

APPENDIX

1. Not every newspaper was available on all three online databases, so in order to maximize our sample size, we used all of them—LexisNexis, Dow, and Dialog. To rule out possible bias introduced by using one or the other of the three available instruments, we conducted separate searches of the same city with all three devices. While we found minor differences in the number of articles retrieved by each, we concluded that the inter-instrument reliability was quite high, diminishing the chance that any systematic bias was introduced by using one or the other of the electronic databases.

2. Over the last two decades a large number of the available newspapers have canceled their contracts with LexisNexis, Dow Jones, and Dialog and are now only available

online through their own proprietary search engines. Typically, these services charge steep fees for retrieving full text articles. Additionally, their search engines are not designed to handle the type of complex algorithm used in the LexisNexis and other searches—making it impossible to get comparable results today.

3. The final algorithm used in the searches was as follows: "date is ___ and ([art or artist or artw! or ballet or choir or cine! or concert or danc! or exhibit or film or gallery or lyric or hip hop or librar! or monument or movie or mural or museum or music or novel! or painting or photograph or playw! or poem or poet or porn! or rap or sculpture or song or smut or statue or tel! prog! or theater or video] w/20 [ban or banned or banning or boycot! or censor! or conflict or controvers! or demonstrator or dispute or free! expres! or injun! or objected or obscen! or outcry or outrage or outraged or petition or protest or pub! hear! or rall! or remove or removal or restrict or restriction]) or ([book w/10 ban or bann! or censor! or protest or remov! or restr!]) and not section (spo! or trav! or obit!) and not byline (assoc! or serv!) and not dateline (wash! or new york!)."

4. Oliver and Myers (1999), for example, found that only 52 percent of conflict events that occurred in Madison, Wisconsin, in 1994 were actually covered by the media.

5. How do we distinguish between unilateral acts (i.e., censorship) against a cultural work and normal editing/selection decisions made daily by librarians, bookstores, and curators? The basic criterion is whether or not the action against the cultural work is a sin of "omission" or "commission." On the one hand, an action in which an object is removed from a library or an exhibition is clearly a case of "commission" and would count as an action against a cultural work. On the other hand, if a library or record store chose not to order a certain book, album, or video this would be a sin of omission and would not count unless that decision was subject to protest by local residents. In the case of radio stations, if the radio station has a long-standing policy against playing music with obscene lyrics, then not playing a certain rap song is a sin of omission and would not count as a case. If they ban a certain song or institute a new policy in reaction to a certain song or genre, this is a sin of commission—a distinct action against a particular song or genre.

6. It is not the "response to an action" but the "initiating action" that determines if a case meets the criterion of being "local." For example, if a local group protested Bob Dole's statement against rap music, this would not count as a case because the initiating action was Dole's statement, and this was national, not local. Also, if a national organization, such as the National Organization of Women (NOW), issued a statement to the press expressing a grievance against misogynist lyrics, this does not count as a protest for the city in which its national headquarters is housed (e.g., Washington, DC).

7. Advent Christian, Baptist (all denominations), Christian and Missionary Alliance, Churches of Christ, Christian Reformed Church, Church of the Nazarene, Seventh Day and Church of God, Christian Scientist, Conservative Congregational, Evangelical Free Church of America, Free Methodist, Independent Fundamentalist, Church of the Foursquare Gospel, Lutheran (Missouri Synod, Wisconsin Evangelical), Open Bible, Christian Brethren, Salvation Army, Wesleyan Church, and Independent Charismatic.

8. Creative occupations are roughly approximated by the percentage of people working in technical and professional jobs. The scale also includes the percentage of the labor force comprised of professional artists.

WORKS CITED

Adams, Mary Louise. 1994. Almost anything can happen: A search for sexual discourse in the urban spaces of 1940s Toronto. *Canadian Journal of Sociology* 19:217–32.

Adler, Judith. 1975. Innovative art and obsolescent artists. *Social Research* 42:360–78.

Aiken, Charlotte. 1995. Nude photos prompt fair warning. *Daily Oklahoman*, 12.

Albuquerque Tribune. 1998. Mayor urges harmony for 400-year celebration, A3.

Alexander, Kathy, and Dana Dratch. 1993. Let public vote on changing flag, lawmakers say. Taking sides: Because of the outcry against the proposal, legislators feel they can't support it. *Atlanta Journal and Constitution*, February 4, G1.

Almond, Gabriel Abraham, and Sidney Verba. 1965. *The civic culture: Political attitudes and democracy in five nations, an analytic study*. Boston: Little, Brown.

Anderson, Benedict R. 1991. *Imagined communities: Reflections on the origin and spread of nationalism*. New York: Verso.

Apple, R. W. 2000. On the road, a city in full: Venerable, impatient Atlanta. *New York Times*, February 25.

Arendt, Hannah. 1958. *The origins of totalitarianism*. New York: Meridian Books.

Arts Alliance. 2001. Cultural plan for the city of Albuquerque. Albuquerque, NM: Arts Alliance, Inc. Accessed online at www.cabq.gov/publicart/documents/culturalplan.pdf on February 9, 2010.

Asher, Ed. 1997. Survivors fear sculpture will engender resentment. *Albuquerque Tribune*, July 10, A1.

Asimov, Nanette. 1998. San Francisco high schools to get diverse authors list. *San Francisco Chronicle*, A15.

Bailey, Robert. 1999. *Gay politics, urban politics: Identity and economics in the urban setting*. New York: Columbia University Press.

Baker, Kenneth. 1997. Murals may leave old library. *San Francisco Chronicle*, E1.

Baker, Wayne E. 2005. *America's crisis of values: Reality and perception*. Princeton, NJ: Princeton University Press.

Balloch, Jim. 1998. CTV rules put on hold by council. *Knoxville News Sentinel*, July 29, A3.

Bannon, Lisa. 1995. How a rumor spread about subliminal sex in Disney's *Aladdin*." *Wall Street Journal*, October 24, A1.

Barlow, Philip, and Becky Cantonwine. 2004. Introduction: Not Oz. In *Religion and public life in the Midwest: America's common denominator*, ed. Philip Barlow and Mark Silk. Walnut Creek, CA: Altamira Press.

Barrionuevo, Alexei. 1995. "Quality" education debated: Citizen groups face off over what should be taught. *Dallas Morning News*, H1.

Barron, David N. 1992. The analysis of count data: Overdispersion and autocorrelation. *Sociological Methodology* 22:179–220.

Barry, Dan, and Carol Vogel. 1999. Giuliani vows to cut subsidy over "sick" art. *New York Times*, September 23, A1.

Barton, David. 1998. Classic debate. *San Francisco Chronicle*, C1.

Baum, F. 1956. *The Wizard of Oz*. New York: Grosset and Dunlap.

Becka, Holly. 1997. Library to keep gay magazine: Lewisville council seeks section for young adults. *Dallas Morning News*, A17.

Beckett, Jamie. 1995. East San Jose teens won't have to read Huck Finn. *San Jose Mercury News*, A21.

Beisel, Nicola. 1990. Class, culture, and campaigns against vice in three American cities, 1872–1892. *American Sociological Review* 55:44–62.

———. 1997. *Imperiled innocents: Anthony Comstock and family reproduction in Victorian America*. Princeton, NJ: Princeton University Press.

Bell, Daniel. 1996. *The cultural contradictions of capitalism*. New York: Basic Books.

Bellah, Robert, Richard Madsen, William Sullivan, Ann Swidler, and Steven Tipton. 1985. *Habits of the heart: Individualism and commitment in American life*. New York: Harper and Row.

Bender, Thomas. *Community and social change in America*. New Brunswick, NJ: Rutgers University Press.

Berard, Yamil. 1995a. "Caged Bird" to stay on Carroll shelves: Board reverses ban on WWII book. *Fort Worth Star-Telegram*, 1.

———. 1995b. Carroll board to study proposed book ban: Parents disagree on offering biography at middle school. *Fort Worth Star-Telegram*, 25.

———. 1995c. Carroll removes war book: School trustees side with parents, overruling a staff recommendation, and pull a veteran's story from a middle school library. *Fort Worth Star-Telegram*, 1.

———. 1995d. Parents speak on book ban: Southlake group backs traditional curriculum. *Fort Worth Star-Telegram*, 17.

Berard, Yamil, and Bill Bowen. 1995. Teaching debate divides districts: NE Tarrant school board races may be influenced. *Fort Worth Star-Telegram*, 1.

Berman, S. 1997. Civil society and political institutionalization. *American Behavioral Scientist* 40:562–74.

Berninghausen, David. 1975. *Flight from reason*. Washington, DC: American Library Association.

Bernstein, Mary. 2002. Identities and politics: Toward a historical understanding of the lesbian and gay movement. *Social Science History* 26 (3): 531–81.

Binder, Amy. 1993. Constructing racial rhetoric: Media depictions of harm in heavy metal and rap music. *American Sociological Review* 58:753–67.

Bingham, Janet. 1996. School board restores "evolution" video. *Denver Post*, A01.

Birch, Thomas. 1995. The raw nerve in politics. In *The cultural battlefield: Art censorship and public funding*, ed. Jennifer Peter and Louis Crosier. Gilsum, NH: Avocus Publishing.

Blau, Judith. 1991. The disjunctive history of U.S. museums, 1869 to 1980. *Social Forces* 70 (1): 87–105.

———. 1996. The toggle switch of institutions: Religion and art in the U.S. in the 19th and early 20th centuries. *Social Forces* 74 (4): 1159–77.

Blau, Peter, and Joseph Schwartz. 1984. *Crosscutting social circles: Testing a macrostructural theory of intergroup relations*. Orlando, FL: Academic Press.

Bolton, Richard. 1992. *Culture wars: Documents from the recent controversies in the arts*. New York: New Press; distributed by W. W. Norton.

Bozell, Brent. 2008. Hollywood hate mail. Accessed online on February 13, 2010, at www .mediaresearch.org/BozellColumns/entertainmentcolumn/2008/c0120080204.asp.

Brechin, Gray. 1997. Piazzono murals. *San Francisco Chronicle*, A20.

———. 2007. Art vs. art. *San Francisco Chronicle*, March 11, A18.

Bricking, Tanya. 1996. Angelou book is most banned: Autobiography has many admirers too. *Cincinnati Enquirer*, September 28, A1.

Brooks, David, and Gail Collins. 1999. Guns, gays and abortion. *New York Times*, online blog Opinionator, June 3.

Brown, Larry. 1996. Exposing "private" feelings. *Atlanta Journal and Constitution*, May 10, G2.

Brown, Tony. 1996a. "Angels" forced us to talk, and the dialogue continues. *Charlotte Observer*, September 15.

———. 1996b. Theater aims to avert storm over "Angels" Drama. *Charlotte Observer*, 1A.

Brus, Brian. 1995. Middle school takes book from shelves. *Daily Oklahoman*, 1.

Bullard, R. D., G. S. Johnson, and A. O. Torres, eds. 2000. *Sprawl city: Race, politics, and planning in Atlanta*. Washington, DC: Island Press.

Button, James W., Barbara Ann Rienzo, and Kenneth D. Wald. 1997. *Private lives, public conflicts: Battles over gay rights in American communities*. Washington, DC: CQ Press.

Button, James W., Kenneth D. Wald, and Barbara Ann Rienzo. 1999. The election of openly gay public officials in American communities. *Urban Affairs Review* 35:188–209.

Calabrese, Linda. 1996. Readers respond: "angels" legal issues not settled, court order on play could lapse next week. *Charlotte Observer*, A4.

Campbell, Angus, Philip E. Converse, Warren E. Miller, and Donald E. Stokes. 1967. *The American voter: An abridgment*. New York: Wiley.

Campos, Carlos. 1995. Fulton County will have no part in '96 Roswell festival: Commission wary of Civil War link. *Atlanta Journal and Constitution*, December 21.

Carmilly-Weinberger, Moshe. 1986. *Fear of art: Censorship and freedom of expression in art*. New York: Bowker.

Carpentersville English-Only protest. 2007. YouTube. Produced on July 5, 2007, and accessed on February 8, 2010, at http://www.youtube.com/watch?v=AcR9pATY8Rg.

Carter, Bull. 2004. Many who voted for "values" still like their television sin. *New York Times*, November 22, A29.

Carver, Stuart. 1994. Whistler vs. Ruskin: The courts, the public, and modern art. In *The Administration of Aesthetics*, ed. Richard Burt. Minneapolis: University of Minnesota Press.

Castells, Manuel. 2004. *The power of identity: The information age*. New York: Wiley-Blackwell.

Chambers, Joseph. 1996. The trouble with "Angels." *Charlotte Observer*, A12.

Charlotte Observer. 1996. Sanity prevails, both sides can learn from arts funding debate, A12.

———. 1997. What kind of city? Commissioners' vote contradicts the spirit of Charlotte, A18.

Cincinnati Enquirer. 1995. Porn wars: Book case a loser from page one, A06.

———. 1996. Judging a book: Lakota parents have a right to study what students read. October 2, A14.

Citizens for Community Values. 2010. About us. At http://www.ccv.org/aboutus.aspx. Web site accessed on February 9, 2010.

Clark, Terry Nichols, and Vincent Hoffmann-Martinot, eds. 1998. *The new political culture.* Boulder, CO: Westview Press.

Clark, T. N., and R. Inglehart. 1998. The new political culture: Changing dynamics of support for the welfare state and other policies in postindustrial societies. In *The new political culture,* ed. T. N. Clark and V. Hoffmann-Martinot, 9–72. Boulder, CO: Westview Press.

Cohen, Anthony. 1985. *The symbolic construction of community.* London: Routledge.

Coleman, James Samuel. 1957. *Community conflict.* New York: Free Press.

Conrad, William J. 1997. Charlotte joins an age-old debate: Art and controversy, together again. *Charlotte Observer,* F1.

Cook, Joe. 1999. Interview with Joe Cook, director of the Louisiana chapter of the American Civil Liberties Union. Personal interview with Steven Tepper, Princeton, NJ.

Cooley, Charles H. 1922. *Human Nature and the social order.* New York: Scribners.

Cosby, Connie. 1997. It's a local decision. *Atlanta Journal and Constitution,* March 30, J9.

Cox, Joan. 1997. I speak for me. *Atlanta Journal and Constitution,* August 24, J9.

Crane, Diana. 1987. *The transformation of the avant-garde: The New York art world, 1940–1985.* Chicago: University of Chicago Press.

Crawford, Keith. 2010 [1974]. Godless books: The 1974 Kanawha County textbook controversy. Article available online at http://insectman.org/testimony/godless-books .htm.

Daily Oklahoman. 1998. Spinning the "drum." *Sunday Oklahoman,* 10.

DeAngelis, Mary Elizabeth, and Tony Brown. 1997. Arts-funding vote haunts commissioners. *Charlotte Observer,* C1.

DeAngelis, Mary Elizabeth, and Dean Smith. 1997. Vote to cut money for arts looks assured. *Charlotte Observer,* A1.

DeLeon, Richard E. 1992. *Left Coast city: Progressive politics in San Francisco, 1975–1991.* Lawrence: University Press of Kansas.

DeLeon, Richard E., and Katherine C. Naff. 2004. Identity politics and local political culture: Some comparative results from the Social Capital Benchmark Survey. *Urban Affairs Review* 39:689–719.

Derhodes, Kim. 1996. Letter to the editor: No wonder Chambers lacks respect of majority. *Charlotte Observer,* A12.

DiMaggio, Paul, and Becky Petit. 1999. Public opinion and political vulnerability: Why has the National Endowment for the Arts been such an attractive target? Princeton, NJ: Princeton University Center for Arts and Cultural Policy Studies, Working Paper Series No. 7.

DiMaggio, Paul, Lynn Robinson, Brian Steensland, and Wendy Cadge. 1999. Public conflict over the arts: A case study of the Philadelphia area, 1965–1997. American Sociological Association, Los Angeles.

Dionne, E. J., Jr. 1990. Who's winning the culture wars? Censorship: Redrawing the lines of tolerance. *Washington Post,* G1.

DiPasquale, D., and E. Glaeser. 1998. The L.A. riot and the economics of urban unrest. *Journal of Urban Economics* 43 (1): 52–78.

Dobrzynski, Judith H. 1997. Battles over funds for arts felt at local level. *New York Times.*

Doclar, Mary, and Matthew Brady. 1996. Witchcraft link called ludicrous: The woman who commissioned Caelum Moor says she is disgusted by controversy over the stones. *Fort Worth Star-Telegram,* 1.

Doss, Erika Lee. 1995. *Spirit poles and flying pigs: Public art and cultural democracy in American communities.* Washington, DC: Smithsonian Institution Press.

Douglas, Mary. 1966. *Purity and danger: An analysis of concepts of pollution and taboo*. London: Routledge and K. Paul.

Dubin, Steven C. 1992. *Arresting images: Impolitic art and uncivil actions*. London; New York: Routledge.

Duffy, Haze. 1995. *Competitive cities: Succeeding in the global economy*. New York: Routledge.

Dunridge, Larry. 1995. Letters to the editor: Huck Finn's Jim is an American hero. *San Jose Mercury News*, C6.

Durkheim, Émile. 1947. *Division of labor*. New York: Free Press.

———. 1951. *Suicide: A study in sociology*. New York: Free Press.

———. 1973. *On morality and society*. Chicago: University of Chicago Press.

———. 1982. *Rules of the sociological method*. New York: Free Press.

Ebnet, Matthew. 1995. Battle of gay novel embroiled in much larger war. *Kansas City Star*, C4.

Elazar, Daniel J. 1966. *American federalism: A view from the states*. New York: Thomas Y. Crowell.

———. 1994. *The American mosaic: The impact of space, time, and culture on American politics*. Boulder, CO: Westview Press.

Elias, Norbert. 1978, 1982, 1983. *The civilizing process*. Vols. 1–3. New York: Pantheon.

Erikson, Kai. 1966. *Wayward Puritans: A study in the sociology of deviance*. New York: Macmillan.

Etzioni, Amitai. 1968. Basic human needs, alienation and inauthenticity. *American Sociological Review* 33 (6): 870–85.

———. 1993. *The spirit of community: Rights, responsibilities, and the communitarian agenda*. New York: Crown.

Feeley, Jeff. 1997. Letters intensify arts funding debate official; museum chief remove gloves. *Charlotte Observer*, C1.

Feinberg, Joel. 1985. *Offense to others: The moral limits of criminal law*. New York: Oxford University Press.

Fiorina, Morris. 2004. *Culture war? The myth of a polarized America*. New York: Pearson Longman.

Fischer, Claude S. 1976. *The urban experience*. New York: Harcourt Brace.

Fleishmann, Arnold, and Jason Hardman. 2004. Hitting below the Bible Belt: The development of the gay rights movement in Atlanta. *Journal of Urban Affairs* 26 (4): 407–26.

Flint, Kate. 1995. *The woman reader, 1837–1914*. New York: Oxford University Press.

Florida, Richard. 2002. *Rise of the creative class*. New York: Basic Books.

Frank, Thomas. 2004. *What's the matter with Kansas? How conservatives won the heart of middle America*. New York: Metropolitan Books.

Fraser, Andrea. 2001. A "Sensation" chronicle. *Social Text—67* 19 (2): 127–56.

Fraser, Nancy. 2000. Rethinking recognition. *New Left Review* 3:107–20.

Fried, Ian. 1996. People opposed to signs on shop discuss strategy. Cleveland *Plain Dealer*, B4.

Gallagher, John, and Chris Bull. 1996. *Perfect enemies: The religious right, the gay movement, and the politics of the 1990s*. New York: Crown.

Gans, Herbert J. 1980. *Deciding what's news: A study of CBS evening news, NBC nightly news, Newsweek, and Time*. New York: Vintage Books.

Garcia, Edwin. 1998. Latino pride goes to the wall; students push for mural. *San Jose Mercury News*, B1.

Garofoli, Joe. 2006. Three dirty words: San Francisco values. *San Francisco Chronicle*, A1.

Gattis, Tory. 2006. Cities of aspiration. Houston Strategies Blogspot. Friday, September 29. Accessed at houstonstrategies.blogspot.com/2006_09_01_archive.html on February 9, 2010.

Georgiou, Myria. 2006. Cities of difference: Cultural juxtapositions and urban politics of representation. *International Journal of Media and Cultural Politics* 2 (3): 283–98.

Gibson, J. L. 1992. The political consequences of intolerance: Cultural conformity and political freedom. *American Political Science Review* 86:338–56.

Gitlin, Todd. 1995. *The twilight of common dreams: Why America is wracked by culture wars.* New York: Metropolitan Books.

Glazer, A., and M. Robbins. 1985. Congressional responsiveness to constituency change. *American Journal of Political Science* 29:259–73.

Gloster, Gary. 1996. After shouts die down, let us journey toward healing our community's painful struggle over "Angels in America." *Charlotte Observer*, April 8, A11.

Godfrey, E. 1995. Comic shop owners face charges. *Daily Oklahoman*, 10.

Goffman, Erving. 1955. On face-work: An analysis of ritual elements of social interaction. *Psychiatry: Journal for the Study of Interpersonal Processes* 18:213–31.

Goldfield, David. 1997. *Religion, race and cities: Interpreting the urban south.* Baton Rouge: Louisiana State University Press.

Goldin, C., and L. F. Katz. 1999. Human capital and social capital: The rise of secondary schooling in America, 1910–1940. *Journal of Interdisciplinary History* 29:683–723.

Gonzales, Christy. 1997. City to explore moving stone sculpture to TCJC. *Fort Worth Star-Telegram*, 3.

Goodwin, Jeff, James Jasper, and Francesca Polletta. 2001. *Passionate politics: Emotions and social movements.* Chicago: University of Chicago Press.

Graves, Dean M. 1997. No limit on morality. *Atlanta Journal and Constitution*, April 3, J2.

Green, John Clifford, James L. Guth, Corwin E. Smidt, and Lyman A. Kellstedt, eds. 1996. *Religion and the culture wars: Dispatches from the front.* Lanham, MD: Rowman and Littlefield.

Griswold, Wendy. 2000. *Bearing witness: Readers, writers, and the novel in Nigeria.* Princeton, NJ: Princeton University Press.

Gross, Andale. 1995a. Both sides in trial want focus to shift. *Kansas City Star*, December 30, A1.

———. 1995b. Students still in district played big part in book trial. *Kansas City Star*, December 2, A6.

Gurr, Ted Robert. 1968. Urban disorder: Perspectives from the comparative study of civil strife. *American Behavioral Scientist* 11 (4): 50–55.

Gusfield, Joseph R. 1962. Mass society and extremist politics. *American Sociological Review* 27:19–30.

———. 1963. *Symbolic crusade: Status politics and the American temperance movement.* Urbana: University of Illinois Press.

Halle, David. 2001. The controversy over the show "Sensation" at the Brooklyn Museum, 1999–2000. In *Crossroads: Art and religion in American life*, ed. Alberta Arthurs and Glenn Wallach. New York: New Press.

Hamlin, Jesse. 1997. Murals' fate again debated. *San Francisco Chronicle*, C4.

Hansen, Art. 2005. Black and white and the other: International immigration and change in metropolitan Atlanta. In *Beyond the gateway: Immigrants in a changing America*, ed. Elzbieta M. Gozdziak and Susan F. Martin. Lanham, MD: Lexington Books.

Hardee, Gary. 2000. Caelum Moor II for an Arlington gateway? *Fort Worth Star-Telegram*.

Harer, John B., and Steven R. Harris. 1994. *Censorship of expression in the 1980s: A statistical survey.* Westport, CT: Greenwood Press.

Harris, Lyle V. 1996. The Arts: Planned memorial stirs controversy. *Atlanta Journal and Constitution,* April 24, B12.

Healy, Patrick. 2009. Tamer "Rent" is too wild for some schools. *New York Times,* February 19, A1.

Heins, Marjorie. 1993. *Sex, sin, and blasphemy: A guide to America's censorship wars.* New York: New Press; distributed by W. W. Norton.

———. 2001. *Not in front of the children: Indecency, censorship, and the innocence of youth.* New York: Hill and Wang.

Hendricks, Mike. 1995. Cultural civil war draws concerns of conservatives: They perceive a moral decline in the U.S., with many issues as dividing lines. *Kansas City Star,* 1.

———. 1999. Culture war still ongoing at Northwest. *Kansas City Star,* January 25, B1.

Hess, F. M., and D. L. Leal. 1999. Politics and sex-related programs in urban schooling. *Urban Affairs Review* 35:24–43.

Hinds, Julie. 1998. Terrorism film is under attack: Arabs, Muslims claim stereotyping. *San Jose Mercury News,* A1.

Hirschman, Albert. 1970. *Exit, voice, and loyalty.* Cambridge, MA: Harvard University Press.

Hopkins, Stella. 1996. We're not the naked city, critics of guide ads argue. *Charlotte Observer,* C1.

Hu, Winnie. 1999. An outspoken church defender. *New York Times,* November 2.

Hunt, Alan. 1996. *Governance of the consuming passions: A history of sumptuary law.* New York: St. Martin's Press.

Hunter, James Davison. 1991. *Culture wars: The struggle to define America.* New York: Basic Books.

———. 1994. *Before the shooting begins: Searching for democracy in America's culture wars.* New York: Simon and Schuster.

Hunter, James Davison, and Alan Wolfe. 2006. *Is there a culture war? A dialogue on values and American public life.* Washington, DC: Brookings Institution Press.

Hurley, Jolynn. 1997. "Letter to the editor: Bill James, have you met Hoyle Martin? *Charlotte Observer,* A12.

Ippolito, Milo. 1995. Library book, school text voted out. *Atlanta Journal and Constitution,* June 15, J03.

Ivey, Bill. 2008. *Arts Inc.: How greed and neglect have destroyed our cultural rights.* Berkeley: University of California Press.

Jasper, James. 1998. The emotions of protest: Affective and reactive emotions in and around social movements. *Sociological Forum* 13 (3): 397–424.

Jelen, Ted. 1992. Political Christianity: A contextual analysis. *American Journal of Political Science* 36:692–714.

———. 1993. The political consequences of religious group attitudes. *Journal of Politics* 55:178–90.

Jennings, Mary. 1995. Gay magazine panned at forum. *Cincinnati Enquirer,* C03.

Jones, J. 1997. Southern Baptists vote to boycott Disney. *Forth Worth Star-Telegram,* June 19.

Jones, Patrice M. 1996. Child's photo in Indian exhibit protested. Cleveland *Plain Dealer,* B5.

Kasten, Karl. 1998. Museum proposal. *San Francisco Chronicle,* A18.

Kauffman L. A. 1990. The anti-politics of identity. *Sociological Review* 90 (1): 67–80.

Kaufman, Ben L., and Cameron McWhirter. 1995. "Playboy" taking Deters to court. *Cincinnati Enquirer,* A01.

Kaufman, Jason. 1999. Three views of associationalism in 19th century America: An empirical examination. *American Journal of Sociology* 104:1296–345.

Keating, Larry. 2001. *Atlanta: Race, class, and urban expansion*. Philadelphia: Temple University Press.

Kelley, Pam. 1997. Hundreds enter arts debate: Citizens call county leaders with views on resolution. *Charlotte Observer*, B1.

Kennedy, Bud. 1997. Doesn't matter whether it's art if it isn't legal. *Fort Worth Star-Telegram*, 1.

Kennedy, Randy. 2005. With irreverence and an iPod, recreating the museum tour. *New York Times*, May 28.

Kisling, Jack. 1995. Deliver me from almost everyone. *Denver Post*, D03.

Kornhauser, William. 1959. *The politics of mass society*. New York: Free Press.

Lackmeyer, Steve. 1997. City council asked to block concert by Marilyn Manson. *Daily Oklahoman*, 10.

Laraña, Enrique, Hank Johnston, and Joseph Gusfield. 2004. *New social movements: From ideology to identity*. Philadelphia: Temple University Press.

Larson, Jeff, and Sarah Soule. 2003. Organizational resources and repertoires of collective action. Paper presented at the annual meeting of the American Sociological Association, Atlanta, Georgia, August 16.

Lazarsfeld, Paul Felix, Bernard Berelson, and Hazel Gaudet. 1968. *The people's choice: How the voter makes up his mind in a presidential campaign*. New York: Columbia University Press.

Leblanc, Lauraine. 1999. *Pretty in punk: Girls' gender resistance in a boy's subculture*. New Brunswick, NJ: Rutgers University Press.

Lee, Renee C. 1996. Passage on slavery in history textbook draws objections: The Arlington school district says supplemental materials are necessary for seventh-grade teachers to balance a "one-sided" quote. *Fort Worth Star-Telegram*, 1.

Lenhart, Amanda, and Mary Madden. 2005. Teen content creators and consumers. Report. Philadelphia: Pew Internet and American Life Project.

Levine, Judith. 2000. Shooting the messenger: Why censorship won't stop violence. Report. New York: Media Coalition.

Levine, Peter. 2000. Lessons from the Brooklyn Museum of Art controversy. *Philosophy and Public Policy Quarterly* 20 (2–3): 19–27.

Lewis, Helen B. 1971. *Shame and guilt in neurosis*. New York: International Universities Press.

Lewis, Sinclair. 1961. *Babbitt*. New York: New American Library.

———. 1961. *Main Street*. New York: New American Library.

Lieber, Dave. 1995. Southlake ban a textbook case of repression. *Fort Worth Star-Telegram*, 27.

Lienesch, Michael. 1993. *Redeeming America: Piety and politics in the new Christian Right*. Chapel Hill: University of North Carolina Press.

Lieske, J. 2004. The changing political subcultures of the United States. Paper presented at the annual meeting of the Midwest Political Science Association, Chicago, April 15.

Linneman, Thomas. 2003. *Weathering change: Gays, lesbians, Christian conservatives, and everyday hostilities*. New York: New York University Press.

Lippman, Walter. 1989. *The public philosophy*. New York: Transaction Publishers.

Lipset, Seymour Martin, and Earl Raab. 1978. *The politics of unreason: Right-wing extremism in America, 1790–1977*. 2nd ed. Chicago: University of Chicago Press.

Lo, Clarence. 1982. Countermovements and conservative movements in the contemporary U.S. *Annual Review of Sociology* 8:107–34.

Loupe, Diane. 1995. School board denies bid to restrict book: "Dinosaurs Divorce" ruled appropriate. *Atlanta Journal and Constitution*, June 16, J1.

Lovatt, Andy. 1996. The ecstasy of urban regeneration: Regulation of the night-time economy in the transition to a post-Fordist city. In *From the margins to the centre: Cultural production and consumption in the post-industrial city*, ed. J. O'Connor and D. Wynne. Hants, England: Ashgate.

Lynd, Helen M. 1961. *On shame and the search for identity.* New York: Science Editions.

Lynd, Robert, and Helen Lynd. 1937. *Middletown in transition: A study of cultural conflicts.* New York: Harcourt, Brace.

MacDonald, Sue. 1995. Teen readings: Parents, experts tackle ethics of monitoring cutting-edge magazines. *Cincinnati Enquirer*, B01.

Maggio, Tony. 1997. Library restrictions are reasonable. *Daily Oklahoman*, 4.

Makkai, Ellen. 1996. Jeffco inherits the controversy. *Denver Post*, B11.

Mannheim, Karl, and Edward Shils. 1940. *Man and society in an age of reconstruction: Studies in modern social structure.* New York: Harcourt Brace and World.

Marx, Gary, and James Wood. 1975. Strands of theory and research in collective behavior. *Annual Review of Sociology* 1:363–428.

Mason, Dick. 2009. Play fray. *La Grande Observer*, March 13.

McAdam, Doug. 1982. *Political process and the development of black insurgency, 1930–1970.* Chicago: University of Chicago Press.

McBride, Cilian. 2005. Deliberative democracy and the politics of recognition. *Political Studies* 53:497–515.

McCammon, Holly J., Soma Chaudhuri, Lyndi Hewitt, Courtney Sanders Muse, Harmony D. Newman, Carrie Lee Smith, and Teresa M. Terrell. 2008. Becoming full citizens: The U.S. women's jury rights campaigns, the pace of reform, and strategic adaptation. *American Journal of Sociology* 113:1104–48.

McCarthy, John D., Clark McPhail, and Jackie Smith. 1996. Images of protest: Dimensions of selection bias in media coverage of Washington demonstrations, 1982 and 1991. *American Sociological Review* 61:478–99.

McConnell, Gene. 1995. Don't blame retirees for Social Security woes. *Cincinnati Enquirer*, A07.

McMullen, David. 1996. In praise of *Angels*: Something for everyone. *Charlotte Observer*, March 22, A12.

McVeigh, Rory. 1995. Social structure, political institutions, and mobilization potential. *Social Forces* 74:461–85.

———. 1999. Structural incentives for conservative mobilization: Power devaluation and the rise of the Ku Klux Klan, 1915–1925. *Social Forces* 77:1461–96.

McVeigh, Rory, and Christian Smith. 1999. Who protests in America: An analysis of three political alternatives—inaction, institutionalized politics, or protest. *Sociological Forum* 14:685–702.

McWhirter, Cameron, Mark Curnutte, and Kristen Delguzzi. 1995. Old allies clash over pornography. *Cincinnati Enquirer*, A01.

Mendenhall, Robert. 2002. Responses to television from the new Christian right: The Donald Wildmon organizations' fight against sexual content. In *Sex, religion, and media*, ed. Dane S. Clausen. Oxford: Rowman and Littlefield.

Merton, Robert K. 1972. Insiders and outsiders: A chapter in the sociology of knowledge. *American Journal of Sociology* 78:9–47.

Metblog. 2005. "Slogan for Atlanta." February 1. Story accessed on February 8, 2010 at http://atlanta.metblogs.com/2005/02/01/slogan-for-atlanta/.

Meyer, David. 2004. Protest and political opportunities. *Annual Review of Sociology* 30: 125–45.

Meyer, Eugene. 1989. Flag desecration not a burning issue, disappointed artist finds. *Washington Post*, December 9.

Miceli, Melinda. 2005. Morality politics vs. identity politics: Framing processes and competition among Christian right and gay social movement organizations. *Sociological Forum* 20 (4): 589–612.

Miller, William F. 1995. Little Italy Columbus statue defaced for a second time. Cleveland *Plain Dealer*, B1.

———. 1996. Local Jewish, German groups call monthly publication anti-Semitic. Cleveland *Plain Dealer*, B1.

Milligan, Jessie. 1998. Hispanic leaders call public debate healthy, necessary. *Albuquerque Tribune*, A1.

Moen, Matthew. 1988. Status politics and the political agenda of the Christian right. *Sociological Quarterly* 29 (3): 429–37.

Money, Jack. 1997. Anti-porn group urges ousting of library director. *Daily Oklahoman*, 12.

Monkkonen, Eric H. 1988. *America becomes urban: The development of U.S. cities and towns, 1780–1980*. Berkeley: University of California Press.

Moriarty, Pia. 2004. *Immigrant participatory arts*. San Jose, CA: Cultural Initiatives of Silicon Valley.

Morrill, Jim, Tony Brown, Ken Garfield, and Tim Funk. 1998. Tumult and transition: The year since arts vote politics. *Charlotte Observer*, A12.

Morris, Holly, and Patti Puckett. 1994. Gay festivities keep focus on Cobb: Goal is to rescind resolution or stop Olympic volleyball. *Atlanta Journal and Constitution*, June 12, D2.

Mullen, Holly. 1995. Issues go to voters tomorrow: Northeast Tarrant residents—faced with growth, image and educational decisions—will be choosing city and school board officials. *Fort Worth Star-Telegram*, 1.

Nash, Kate. 1999. Barelas artwork choice fails to wow forum crowd. *Albuquerque Tribune*.

National Endowment for the Arts, Research Division. 1997. 1997 Survey of Public Participation in the Arts. Washington, DC: National Endowment for the Arts.

Newton, K. 1997. Social capital and democracy. *American Behavioral Scientist* 40:575–87.

Niebuhr, Gustav. 1999. Anger over work evokes anti-Catholic shadow, and Mary's power as icon. *New York Times*, October 3.

Nightshade, Terry. 1997. Minds met at Ozzfest. *Minneapolis Star Tribune*, June 29, A24.

Noelle-Neumann, Elisabeth. 1984. *The spiral of silence: Public opinion, our social skin*. Chicago: University of Chicago Press.

Nolan, James L., ed. 1996. *The American culture wars: Current contests and future prospects*. Charlottesville: University Press of Virginia.

Nowak, Peter J., R. E. Rickson, C. E. Ramsey, and W. J. Goudy. 1982. Community conflict and models of political participation. *Rural Sociology* 47:333–48.

Nuzzo, Arlene. 1996. Letter to the editor: Play's view of gay life anything but glamorous. *Charlotte Observer*, A14.

Oberschall, Anthony. 1978. Theories of social conflict. *Annual Review of Sociology* 4: 291–315.

Olasky, M. N. 1986. When world views collide: Journalists and the great monkey trial. Paper presented at the annual meeting of the Association for Education in Journalism and Mass Communication, Norman, Oklahoma, August 3–6.

Oliver, P. E., and D. J. Myers. 1999. How events enter the public sphere: Conflict, location, and sponsorship in local newspaper coverage of public events. *American Journal of Sociology* 105:38–87.

Olzak, Susan. 1989. Analysis of events in the study of collective action. *Annual Review of Sociology* 15:119–41.

———. 1990. The political context of competition: Lynching and urban racial violence, 1882–1914. *Social Forces* 69:395–421.

Olzak, Susan, Suzanne Shanahan, and Elizabeth H. McEneaney. 1996. Poverty, segregation, and race riots: 1960 to 1993. *American Sociological Review* 61:590–613.

Olzak, Susan, and Elizabeth West. 1991. Ethnic conflict and the rise and fall of ethnic newspapers. *American Sociological Review* 56:458–74.

O'Malley, Michael. 1996. Court says billboard is free speech. Cleveland *Plain Dealer*, 1B.

Owen, Penny. 1995a. Callers ask where to buy comic book seized by police. *Daily Oklahoman*, 10.

———. 1995b. Police raid store for explicit comic. *Daily Oklahoman*, 1.

Page, Ann, and Donald Clelland. 1978. The Kanawha County textbook controversy: A study of the politics of life style concern. *Social Forces* 57 (1): 265–81.

Page, B. I., P. W. Gronke, R. M. Rosenberg, and R. Y. Shapiro. 1983. Effects of public opinion on policy. *American Political Science Review* 77:175–90.

Pally, Marcia. 1994. *Sex and sensibility: Reflections on forbidden mirrors and the will to censor.* Hopewell, NJ: Ecco Press.

Parents Television Council. 2008. Children assaulted by sex, violence, drugs and explicit language on BET and MTV. Press release accessed on February 10, 2010 at www .parentstv.org/ptc/news/release/2008/0410.asp.

Parker, John. 1997. Macy in "Tin Drum" loop, motion says seized film lawsuit amended. *Daily Oklahoman*, 6.

Patton, Natalie. 1996. Controversial AIDS exhibit for teens leaves Las Vegas. *Las Vegas Review Journal*, July 8, B1.

People for the American Way and Artsave. 1992, 1994, 1995, 1996. *Artistic freedom under attack.* Washington, DC: People for the American Way.

Peter, Jennifer, and Louis Crosier, eds. 1995. *The cultural battlefield: Art censorship and public funding.* Gilsum, NH: Avocus Publishing.

Phillips, Anne. 1998. *The politics of presence.* New York: Oxford University Press.

Pincus, Robert L. 1996. Corporate collection anticipates trends, challenges employees. Cleveland *Plain Dealer*, H11.

Plain Dealer. 1996. Mr. Sysack, just sign off. Cleveland *Plain Dealer*, B8.

Polletta, Francesca, and James Jasper. 2001. Collective identity in social movements. *Annual Review of Sociology* 27:283–305.

Portes, A. 1998. Social capital: Its origins and applications in modern sociology. *Annual Review of Sociology* 24:1–24.

Posavec, Steven J. 1996. Letters, faxes & email: Keep religion out of the science classroom. *Denver Post*, B06.

Potts, Leanne. 2000. Oñate gets his day. *Albuquerque Tribune*, March 7, A1.

Powe, L. A., Jr. 1974. Evolution to absolutism: Justice Douglas and the First Amendment. *Columbia Law Review* 74 (3): 371–411.

Purdy, Mark. 1995. Step right up! A battle legal: Leis vs. Deters. *Cincinnati Enquirer*, C01.

Putnam, Robert D. 1995. Bowling alone: America's declining social capital. *Journal of Democracy* 6:65–78.

———. 2000. *Bowling alone: The collapse and revival of American community*. New York: Simon and Schuster.

———. 2007. E Pluribus Unum: Diversity and community in the 21st century. *Scandinavian Political Studies* 30 (2): 137–74.

Putnam, Robert D., Robert Leonardi, and Raffaella Nanetti. 1993. *Making democracy work: Civic traditions in modern Italy*. Princeton, NJ: Princeton University Press.

Raben, Bruce. 1995. Too often words can hurt us. *Fort Worth Star-Telegram*, 2.

Ransford, Edward. 1968. Isolation, powerlessness, and violence: A study of attitudes and participation in the Watts riot. *American Journal of Sociology* 73:581–91.

Reed, Ollie, Jr. 1998a. Artists blend cultures, concepts, feelings for Oñate monument. *Albuquerque Tribune*, A1.

Reed, Ollie, Jr. 1998b. Arts board grapples with legacy of Oñate. *Albuquerque Tribune*.

Reed, Ollie, Jr. 1998c. Oñate artists now sure they can't please everyone. *Albuquerque Tribune*, A7.

Reed, Ollie Jr. 1998d. Panel wants cuarto centenario to focus on more than Oñate. *Albuquerque Tribune*, A1.

Reeder, Harry L., III. 1997. Culture war has come here: It is an aggressive cultural agenda that is absolutely committed to the total reconstruction of our culture. *Charlotte Observer*, 19A.

Rich, Frank. 2004. The great indecency hoax. *New York Times*, November 28, AR1.

Riesman, David. 2001. *The lonely crowd: A study of the changing American character*. Rev. ed. New Haven, CT: Yale University Press.

Roane, Kit. 1999. Buchanan visits art exhibit in Brooklyn and doesn't like it. *New York Times*, November 6.

Roberts, Steven, and Dorian Friedman. 1990. The culture wars of 1990: Conservatives are using flag burning, obscenity, and other hot-button issues to win votes. *U.S. News and World Report* 108 (25): 22–24.

Rodgers, Harrell, Jr. 1974. Censorship campaigns in eighteen cities: An impact analysis. *American Politics Quarterly* 2:371–92.

Rodriguez, Joseph A. 1999. *City against suburb: The culture wars in an American metropolis*. Westport, CT: Praeger.

Rodriguez, Roberto. 1996. Barbed wired for controversy: Symbolic sculpture by Native American rejected by the University of New Mexico. *Black Issues in Higher Education*, November 14.

Roper Center. 1999. Controversial arts funding survey. Nashville: Freedom Forum First Amendment Center.

Rosdil, D. 1991. The context of radical populism in U.S. cities: A comparative analysis. *Journal of Urban Affairs* 13:77–96.

Rothfield, Lawrence, ed. 2001. *Unsettling Sensation: Arts-policy lessons from the Brooklyn Museum of Art controversy*. New Brunswick, NJ: Rutgers University Press.

Rothrock, Donna. 1997. Letters to the editor: Good grief—maybe we really ARE yahoos. *Charlotte Observer*, A18.

Ruiz, Rosanna. 1997. Graffiti art earns split verdict at town hall: The painting of a mural on a Berry Street store by a group of youths drew some praise, but was criticized by others at a District 9 meeting. *Fort Worth Star-Telegram*, 3.

Rule, James. 1988. *Theories of civil violence*. Berkeley: University of California Press.

Russell, Diana. 1997. Tonya vs. Larry Flynt. *San Francisco Chronicle*, A18.

Sabulis, Jill. 1996. Portraying old South during the Olympics: To showcase or shelve? *Atlanta Journal and Constitution*, June 23, J2.

Salant, Jonathan. 2004. FCC to investigate Jackson's display at Super Bowl. *Washington Post.* February 2, 2004. Accessed online on February 13, 2010, at www.washington post.com/wp-dyn/articles/A5734-20004Feb2.html.

Sampson, Robert, Doug McAdam, Heather MacIndoe, and Simón Weffer-Elizondo. 2005. Civil society reconsidered: The durable nature and community structure of collective civic action. *American Journal of Sociology* 111 (3): 673–714.

San Jose Mercury News. 1995a. Learning from Huck: Banning a great work of literature would be a mistake. *San Jose Mercury News,* 6B.

———. 1995b. Skating star's racism quote won't be on art, A1.

Sano, Emily. 1997. Paintings a problem for museum. *San Francisco Chronicle,* B3.

Sartin, V. David. 1997. Game tells wrong story, NAACP says; schools drop software after it gets complaint. Cleveland *Plain Dealer,* 1B.

Saunders, Frances Stonor. 2000. *The cultural cold war: The CIA and the world of arts and letters.* New York: New Press.

Saylor, Nicole. 1995. Relief that unsettling hurtful, debate is over. *Kansas City Star,* 1.

Saylor, Nicole, and Laurie Scott. 1993. Olathe district bans two gay books. *Kansas City Star.*

Scharf, L. 1986. The women's movement in Cleveland from 1850. In *Cleveland: A tradition of reform,* ed. David Van Tassel and John Grabowski. Kent, OH: Kent State University Press.

Schauer, F., and J. Garvey. 1995. *The First Amendment: A reader.* 2nd ed. Eagan, MN: West Publishing.

Scheff, T. 1988. Shame and conformity: The deference/emotion system. *American Sociological Review* 53:395–406

———. 2010. Shame and the social bond: A sociological theory. Essay accessed on February 13, 2010, at http://www.soc.ucsb.edu/faculty/scheff/main.php?id=2.html.

Scheper, Richard J. 1995. Values and morals. *Cincinnati Enquirer,* A15.

Schlesinger, Arthur. 1998. *The disuniting of America: Reflections on a multicultural society.* New York: W. W. Norton.

Schouten, John W. 1991. Selves in transition: Symbolic Consumption in personal rites of passage and identity reconstruction. *Journal of Consumer Research* 17:412–25.

Schudson, Michael. 1996. What if civic life didn't die? *American Prospect* 24:17–20.

Schulman, Bruce. 1993. The Sunbelt South: Old times forgotten. *Reviews in American History* 21:340–45.

Schultze, Quentin J. 2003. *Christianity and the mass media in America: Toward a democratic accommodation.* East Lansing: Michigan State University Press.

Schumaker, Paul. 1999. Moral principles of local officials and the resolution of culture war issues. In *Culture wars and local politics,* ed. Elaine B. Sharp. Lawrence: University Press of Kansas.

Schwartz, M. 1976. *Radical protest and social structure: The Southern Farmers' Alliance and cotton tenancy, 1880–1890.* Chicago: University of Chicago Press.

Selznick, Philip. 1951. Institutional vulnerability in mass society. *American Journal of Sociology* 56:320–31.

Senie, Harriet, 1998. *Critical issues in public art.* Washington, DC: Smithsonian Institution Press.

Sharp, Elaine B. 2005a. Cities and subcultures: Exploring validity and predicting connections. *Urban Affairs Review* 41 (2): 132–56

———. 2005b. *Morality politics in American cities.* Lawrence: University Press of Kansas.

Sharp, Elaine B., ed. 1999. *Culture wars and local politics.* Lawrence: University Press of Kansas.

Shinn, Jerry. 1997. Lights out in Charlotte? No, just a wake-up call small-minded interests have made a big splash, but the people who really care about Charlotte have seen enough. *Charlotte Observer*, 23A.

Shorter, E., and Charles Tilly. 1974. *Strikes in France, 1830–1968*. London; New York: Cambridge University Press.

Silver, Daniel, Terry Clark, Lawrence Rothfield, and Tim Hotze. 2007. Scenescapes: What we can learn from where our scenes are. Paper presented at the annual meeting of the American Sociological Association, New York City, August 11.

Simmel, Georg. 1955. *Conflict*. Trans. Kurt Wolff. *The web of group-affiliation*. Trans. Reinhard Bendix. Glencoe, IL: Free Press.

———. 1971. *On individuality and social forms: Selected writings*. Chicago: University of Chicago Press.

Simpson, Kevin. 1998. Fired teacher decries "banality" of education. *Denver Post*, B1.

Sjoquist, David L. 2000. *The Atlanta paradox*. New York: Russell Sage Foundation.

Skocpol, Theda. 1985. Bringing the state back in: Strategies of analysis in current research. In *Bringing the State Back In*, ed. Peter B. Evans, Dietrich Rueschemeyer, and Theda Skocpol. Cambridge: Cambridge University Press.

Slonaker, Larry. 1995a. Parents still aflame over "racist" book. *San Jose Mercury News*, 1B.

———. 1995b. School board to keep book on list: Oak Grove board backs use of "Cay." *San Jose Mercury News*, B1.

Smith, Whitney. 1997. Is Memphis more accepting of controversy? More apathetic? *Commercial Appeal*.

Smith-Rosenberg, Carroll. 1978. Sex as symbol in Victorian purity: An ethnohistorical analysis of Jacksonian America. *American Journal of Sociology*. Suppl. Turning Points: Historical and Sociological Essays on the Family, no. 84:212–74.

Solis, Suzanne Espinosa. 1996. Feminists protest film's portrayal of Flynt. *San Francisco Chronicle*, A21.

Soule, S. A., and N. Van Dyke. 1999. Black church arson in the United States, 1989–1996. *Ethnic and Racial Studies* 22:724–42.

Spilerman, S. 1970 The causes of racial disturbances: A comparison of alternative explanations. *American Sociological Review* 35 (4): 627–49.

Springfield News Sun. 1995. Clark theater pulls "Showgirls." *Springfield News Sun*, B1.

Stafford, Leon. 1999. Georgia schools becoming re-segregated: Immigration, living patterns, parental desire for neighborhood schools are bringing change. *Atlanta Journal and Constitution*, June 17.

Steiner, Wendy. 1995. *The scandal of pleasure: Art in an age of fundamentalism*. Chicago: University of Chicago Press.

Stepp, Diane R. 1995. Mom objects to movie seen by class: Film contained obscenities, teen said. *Atlanta Journal and Constitution*, December 14, J1.

———. 1997. War on words. *Atlanta Journal and Constitution*, May 16, B2.

Stewart, Barbara. 1999. Some arts groups silent on museum dispute. *New York Times*, October 11.

Summa, Mary Potter. 1998. Tumult and transition: The year since arts vote politics. *Charlotte Observer*, A12.

Suryaraman, Maya. 1995. Panel backs "Huckleberry Finn" recommendation: Keep controversial book in east side schools. *San Jose Mercury News*, B1.

⌐tkey, Benjamin. 1995. Disney catches hell. *Entertainment Weekly*, December 15, 42.

⌐, C., and others. 1994. *Multiculturalism: Examining the politics of recognition*. Ed. and ⌐. Amy Gutmann. Princeton, NJ: Princeton University Press.

Taylor, Verta, Leila J. Rupp, and Joshua Gamson. 2004. Performing protest: Drag shows as tactical repertoires of the gay and lesbian movement. *Research in Social Movements, Conflict and Change* 25:105–37.

Tepper, Steven. 2000. Unfamiliar objects in familiar places: The public response to art-in-architecture. *International Journal of Cultural Policy* 6:283–316.

Tepper, Steven, and Bill Ivey. 2007. *Engaging art: The next great transformation of America's cultural life*. New York: Routledge.

Tilly, Charles. 1978. *From mobilization to revolution*. Reading, MA: Addison-Wesley.

———. 1986. *The contentious French*. Cambridge, MA: Belknap Press of Harvard University Press.

———. 1995. *Popular contention in Great Britain, 1758–1834*. Cambridge, MA: Harvard University Press.

———. 2006. *Regimes and repertoires*. Chicago: University of Chicago Press.

Tilly, Charles, and Sidney Tarrow. 2006. *Contentious politics*. Boulder, CO: Paradigm Publishers.

Tilly, Charles, Louise Tilly, and Richard H. Tilly. 1975. *The rebellious century, 1830–1930*. Cambridge, MA: Harvard University Press.

Tocqueville, Alexis de. 1994 [1835]. *Democracy in America*. Ed. J. P. Mayer. London: Fontana.

Tönnies, Ferdinand. 1957. *Community and society*: East Lansing: Michigan State University Press.

Tran, De. 1995. Vietnamese play evokes hope, conflicting perspectives. *San Jose Mercury News*, B1.

———. 1998. Protests tear at Viet community; ongoing anti-communist pickets at S. J. paper raise free-speech questions. *San Jose Mercury News*, A1.

Van Der Werf, Martin. 1996. Freedom rings loudly in new protest of flag show. *Arizona Republic*, April 29, A1.

Van Tassel, David, and John Grabowski. 1986. *Cleveland: A tradition of reform*. Kent OH: Kent State University Press.

Vargas, Gustavo. 1995. Letters to the editor. *San Jose Mercury News*, F6.

Vejnoska, Jill. 1993. County thrives on "go it alone" attitude: Move to condemn homosexuality continues a maverick tradition of being politically unpredictable. *Atlanta Journal and Constitution*, August 15, A1.

Wald, K. D., J. W. Button, and B. A. Rienzo. 1996. The politics of gay rights in American communities: Explaining antidiscrimination ordinances and policies. *American Journal of Political Science* 40:1152–78.

Wald, Kenneth, and Barbara Rienzo. 1999. The politics of gay rights legislation. In *Culture Wars and Local Politics*, ed. Elaine B. Sharp. Lawrence: University Press of Kansas.

Waldrip, Cheryl. 1995a. Anti-nudity not anti-art. *Tampa Tribune*.

———. 1995b. Clearwater asks hall to be sensitive. *Tampa Tribune*.

Walker, Samuel. 1999. *In defense of American liberties: A history of the ACLU*. Carbondale: Southern Illinois University Press.

Wallach, Todd. 1994. Satan's tools sent to blaze. *Dayton Daily News*.

Watson, Christy. 1997. Mayor to ask council to restrict readers. *Daily Oklahoman*, 32.

Watson, Christy, and Jack Money. 1997. Area mayor wants book restricted. *Daily Oklahoman*, 1.

Watson, Tom. 1993. Gay fight unfolds in Georgia: Legislation condemns lifestyle. *USA Today*, August 23.

Weatherford, M. S. 1980. The politics of school busing: Contextual effects and community polarization. *Gainesville Journal of Politics* 42:747–65.

Weber, Max. 1946. Class, status, party. In *From Max Weber: Essays in sociology*. Oxford: Oxford University Press.

———. 1973. *Economy and society*. Berkeley: University of California Press.

Webster, Gerald, and Jonathan Leib. 2001. Whose South is it anyway? Race and the Confederate battle flag in South Carolina. *Political Geography* 20 (3): 271–99.

Weissenstein, Michael. 1997. Burleson divided over rescinding book ban: Sides rally forces for tonight's meeting. *Fort Worth Star-Telegram*, 1.

Wiesel, Eli. 1986. Nobel lecture: Hope, despair and memory. Lecture delivered on December 11, 1986. Accessed online February 13, 2010, at www.nobelprize.org/nobel_prizes/lareatues/1986/wiesel-lecture.html.

Wildmon, D. E. 1986. *The case against pornography*. Wheaton, IL: Victor Books.

Williams, Mara Rose. 1994. Library chief recommends relocating sex-ed book. *Atlanta Journal and Constitution*, July 28, A1.

Williams, Paige, Tony Brown, and Gary Wright. 1996. Judge: Let "Angels" play: Controversial work opens to street protests. *Charlotte Observer*, March 21, A1.

Williams, Rhys H., ed. 1997. *Cultural wars in American politics: Critical reviews of a popular myth*. New York: Aldine de Gruyter.

Willis, Lowell. 1996. Letter to the editor: Righteous folks don't need this kind of realism. *Charlotte Observer*, 14A.

Wilson, Charles R., and Mark Silk, eds. 2005. *Religion and public life in the South: In the evangelical mode*. Walnut Creek, CA: Altamira Press.

Wolfinger, Raymond E., and Steven J. Rosenstone. 1980. *Who votes?* New Haven, CT: Yale University Press.

Wood, M., and M. Hughes. 1984. The moral basis of moral reform: Status discontent vs. culture and socialization as explanations of anti-pornography social movement adherence. *American Sociological Review* 49:86–99.

Woods, L. B. 1979. *A decade of censorship in America: The threat to classrooms and libraries, 1966–1975*. Metuchen, NJ: Scarecrow Press.

Wright, G. C., R. S. Erikson, and J. P. McIver. 1987. Public-opinion and policy liberalism in the American states. *American Journal of Political Science* 31 (4): 980–1001.

Wuthnow, Robert. 1987. *Meaning and moral order: Explorations in cultural analysis*. Berkeley: University of California Press.

———. 2001. Arts leaders and religious leaders: Mutual perceptions. In *Crossroads: Art and religion in American life*, ed. Alberta Arthurs and Glenn Wallach. New York: New Press.

———. 2006. Clash of values: Government funding for the arts and religion. In *Nonprofits and government: Collaboration and conflict*, ed. Elizabeth Boris and C. Eugene Steuele. Washington, DC: Urban Institute Press.

Wye, Christopher. 1986. At the leading edge: The movement for black civil rights in Cleveland, 1830–1920. In *Cleveland: A tradition of reform*, ed. David Van Tassell and John Grabowski. Kent OH: Kent State University Press.

Yanowitz, Herbert. 1998. Frightening prospect. *San Francisco Chronicle*, A24.

Young, Michael. 2006. *Bearing witness against sin: The evangelical birth of the American social movement*. Chicago: University of Chicago Press.

Zald, Mayer, and John D. McCarthy. 1979. *The dynamics of social movements: Resource mobilization, social control, and tactics*. Cambridge, MA: Winthrop Publishers.

Zolberg, Vera. 1998. Contested remembrance: The Hiroshima exhibit controversy. *Theory and Society* 27:565–90.

ᵉr, Louis A., and R. George Kirkpatrick. 1976. *Citizens for decency: Antipornography ᵈes as status defense*. Austin: University of Texas Press.

INDEX

accountability, 268–69, 279. *See also* democracy, substantive
Acoma Indians, 42
Advocate (magazine), 158, 161, 331
African American Parent Coalition, 204, 210, 211, 212
African Folktales: Traditional Stories of the Black World (Abrahams), 176
AIDS, 3, 29, 68, 114–15, 124, 131, 251, 266
Albuquerque, NM, 10, 22, 42, 132, 172, 189–220, 248
Allen, Steve, 225
Allentown, PA, 30, 132
American Civil Liberties Union (ACLU), 9, 31, 53, 111, 129, 141, 154, 166–69, 201, 272, 301
American Conservative Union, 329
American Family Association, 6, 10, 28, 30–33, 46, 51, 56–57, 157, 161–62, 266, 279
American Jewish Committee of Cleveland, 202
American Library Association (ALA), 7, 40, 111, 154, 163, 272
American Life League, 30
American Temperance Movement, 64, 67, 70, 88. *See also* temperance
Anderson, Bob, 161–64
Angelou, Maya, 80, 58, 176, 184, 188, 257
Angels in America (Kushner), 9, 29, 124, 171, 176, 178, 180–83, 186–87, 257–58, 281, 284
animal rights, 176
Annie on My Mind (Garden), 80, 158, 164–68, 249, 257

anti-busing, 141
anti-Hispanic defamation league, 42, 199
anti-obscenity campaign, 75
anti-pornography campaign, 65, 154. *See also* pornography
anti-vice campaigns, 65, 67, 71, 156
Artistic Freedom Under Attack (People for the American Way), 11, 56, 124
arts funding, 9, 124, 188, 257, 260, 281
Arts Inc. (Ivey), 34
artworks, definition of, 293–95
Asian Arts Committee, 207
Asian-Pacific Democratic Club, 210
associative relations, 86
Atlanta, GA, 19, 21, 38, 96–99, 104, 105–20, 149, 171, 219, 248, 254, 278; Chamber of Commerce, 105, 109; Convention and Visitors' Bureau, 115; History Center, 117; Stone Mountain Park, 117
Austin, TX, 9, 80, 100, 132
authentic identity, 191
authentic responsiveness, 276, 280–81

Bailey, Robert, 191
Baker, James, 174
Baker, Wayne, 109
Baldwin, Alec, 159
Balk, Julia, 26
Bangor, ME, 38, 96
Barber, Benjamin, 227
Barlow, Philip, 156
Barnes and Noble, 158, 161–65, 167–68, 175
Barrie, Dennis, 157
Basketball Diaries (Carroll), 111

Baton Rouge, LA, 9
bearing witness, 22–23, 90, 130, 210, 238–43, 251, 259. *See also* protest
Beisel, Nicola, 5, 12, 65
Bell, Daniel, 8
Bender, Thomas, 94
Berkeley Free Speech Movement, 272
Berninghausen, David, 125
Bertolucci, Bernardo, 175, 179, 183, 185
billboard, protest over, 201, 226–27
Binder, Amy, 228
Birch, Thomas, 88, 125
Black Power, 237
Blume, Judy, 40
body piercing and tattoos, 61–62
Bond, Jill, 11
books, protest over, 39–42, 66–70, 73–77, 80–81, 87–88, 101, 110–12, 123–26, 156–69, 175–76, 179–81, 183–85, 188, 198, 202–4, 249, 251, 257, 284. *See also* protest, books
book burning, 168, 249
Boston, MA, 2, 12
Brooks, David, 261
Brown, Willie, 196
Bryan, William Jennings, 25
Buchanan, Pat, 29, 183
Buffalo, NY, 135
bulimia and anorexia, 62
Burress, Phil, 160–61

Caelum Moor (Hines), 176, 179, 185, 248
Café Europa, 213
Camus, Albert, 192
Catcher in the Rye (Salinger), 40–41
Cathedral of Hope, 174
Catholic League for Religious and Civil Rights, 29, 51, 56
Cay, The (Taylor), 204, 210, 211
censorship, 17, 37, 46–47, 111, 124–25, 131, 141, 224, 244; censorious disposition, 72–84; emotions of, 124–25; in the nineteenth century, 12; in the 1970s, 37; in the 1980s, 5, 11, 14, 93
censuring, 224, 244
Centennial Olympic Park, 107
Chambers, Joseph, 183
Charleston, SC, 66, 147
arlotte, NC, 9, 22, 69, 80, 124, 22, 171–219, 257–58, 281
Repertory Theatre, 9, 178, 180

Chicago, IL, 9, 35, 100, 102, 135, 150
children: authority over, 164; class reproduction, 5, 12, 65–67; harm to, 41–42, 75, 168, 184, 204–5, 225, 227–29, 238–39; of immigrants, 234, 236–37; lack of respect by, 232–33; parental responsibility, 33, 40–41, 69–70, 164, 225, 231, 239; violence of, 232–33
Christian Action Network, 56
Christian Broadcasting Network, 28
Christian Coalition, 6–7, 29, 31, 51, 56–57, 157, 160–61, 179
Christian Family Network, 157, 162
Christian Life Coalition, 162
Cincinnati, OH, 9, 22, 149, 153–69, 257
Cincinnati Contemporary Arts Center, 9, 28, 157. *See also* Mapplethorpe, Robert
cities of contention, 148–50, 171–88, 193, 249
cities of cultural regulation, 22, 148–49, 153–70, 193, 249
cities of recognition, 148, 150, 189–216
Citizens Alliance for Responsible Education, 184
Citizens for Community Values, 159, 160
Citizens for Decency Through Law, 156, 160
Citizens for Decent Literature, 33
Citizens for Family Friendly Libraries, 110, 254
Citizens Opposing Pornography, 29
Citizens Supporting Open Libraries, 167
city characteristics, 147, 158
city profiles. *See* cities of contention; cities of cultural regulation; cities of regulation
Civil War reenactments, 117
Clark County Citizens Against Pornography, 162, 164
Clearwater, FL, 29, 56
Cleveland, OH, 22, 150, 189–216
Cleveland Gay and Lesbian Community Center, 201
Clinton, Hillary, 35
Clinton, William Jefferson, 3
Coalition of 100 Black Women, 118
Cobb, Jim, 174
Cobb County, GA, 124, 132–34. *See also* Atlanta, GA
Coleman, James, 13, 91, 138–40, 172, 255, 263, 279
collective action, 45, 55, 59, 126–28, 144, 237, 256, 262

collective trauma, 62

Combs, Mary, 118, 248

comic books, protest over, 159, 160, 162, 166

communism, 182, 184, 203

community: belonging and alienation, 70, 138, 252–53, 261–62, 284; change, 3, 18, 62–63, 66–67, 74, 80–81, 113–14, 233–37; conflict, 13, 91, 138, 255, 263, 279; decline of community, 21, 70, 86–90, 92, 101, 103, 109, 138, 227, 229–31; definition of, 93–95; identity, 16, 64, 68–69, 85–86, 101, 104, 113, 185–86; sense of, 60, 74–75, 101–4, 111, 205, 253, 305; solidarity, 75, 86–87, 144; standards and values, 2, 5, 60, 73–74, 91, 111–12, 114, 119, 134, 141, 148–51, 153, 158–60, 162–64, 168–69, 178, 189, 215, 229–30, 236, 263, 268; structural transformation, 87; symbols of, 118, 247–49, 263; tensions, 11, 26–27, 59–60, 87, 101, 173, 178, 248–49, 266

Comstock, Anthony, 33, 65, 272

Concord, CA, 11

Concord, MA, 35

Confederate flag, 248

confessional politics, 90

conflict, 126–27; over community identity, 149, 175, 185–87, 209, 215–16, 263; definition of, 95; economic, 4; symbolic 4–5, 64–65, 69, 71, 104, 112, 115, 120, 198, 278; theory of, 4–6. See also cultural conflict; morality politics; protest

conservative values, 43, 75, 101–4, 109–10, 143, 150, 153–58, 172, 194, 222, 292

context effects, 141

control, 70–71, 85, 240; over children, 67–69, 111, 233; disposition to restrict media, 73–79, 83, 85; over identity, 191; local vs. national, 25, 66–67, 162–65; loss of control, 251; regulation, 87–88, 153–54; symbolic, 61–64, 85, 106, 112, 24. See also cultural regulation

Cook, Joe, 141

Cooley, Charles, 86, 251

Corporation for Olympic Development, 117

Coser, Lewis, 5

cosmopolitanism, 132, 172, 194

creative class, 132, 150

cultural change: globalization and modernization, 15, 62–63, 274–75; media,

23, 227, 229–30, 240, 274, 282; New South, 106, 108, 174, 248; values, 64–65, 70–71, 77–78, 260–61

cultural conflict: community context, 60, 89–93; explanations for, 4–5, 8–3, 27, 31–32, 67, 73–77, 120; fields of, 32, 93; law enforcement, role of, 158–80; local vs. national, 13–14, 25–26, 50–54, 56–60, 84, 89–90, 149–50, 162–64, 259–62, 279; national cases, 31, 110–12, 192–93, 218–22; objects of, 39–41, 92; structure of, 13–14, 122, 126; twentieth century vs. twenty-first century, 23, 268–75

cultural graffiti, 281

cultural policy, 23, 265–85

cultural sociology, 123, 262–64

culture of complaint, 283

culture of protest, 215

culture wars, 6–7, 19, 30, 37, 47–48, 51–52, 56–60, 119, 125, 140–41, 149–50, 171–72, 174–75, 177–78, 180–81, 183–84, 217–18, 223–24, 231, 255–56, 259–62, 267, 282–83. See also Hunter, James Davison

Daddy's Roommate (Wonderland), 80, 168

Dallas, TX, 22, 38, 135, 149, 171–89, 219, 248

D'Amato, Alphonse, 28

Dark of the Moon (play), 158, 257

Darrow, Clarence, 25

David and Jonathan (Voigt), 175–76

Dayton, OH, 22, 123–24, 134, 149, 153–69

Dayton, TN, 25

DDB Needham Worldwide Inc. Life Style Survey, 77–78

DeLeon, Richard, 194

democracy: authentic responsiveness, 276, 280–81; breakdown of, 138; civic culture, 137; civic engagement, 55, 58, 62, 66–67, 72–77, 120–22, 134–36, 137–40, 145, 160–62, 241–43, 254–59, 275; civility and incivility, 134, 256–59, 279; elections, 7, 11, 34–36, 139; political culture, 121–22, 126, 131–34, 145; political voice, 42–43, 108, 241–43, 254–55; substantive democracy, 276–81; voting and its relationship to conflict levels, 139. See also voice

Democracy in America (Tocqueville), 137

demographic change, 23, 86, 99; Atlanta, 106–8, 12. *See also* immigration; social change

Denver, CO, 3, 22, 38, 135, 149, 171–88

DiMaggio, Paul, 11, 20, 35, 37, 260, 289–90, 293–94, 296–98

Dionne, E. J., Jr., 10

discomfort, 232–37. *See also* protest, emotional dimensions of

disengaged citizenry, 138

Disney, controversy and boycott, 7, 30–31, 51, 57, 124, 179

diversity, 100–104, 149–50, 172, 184, 194, 198, 213–16. *See also* ethnicity

Dixie Chicks, 1, 270

Dobrzynski, Judith 14, 36, 93

Dole, Bob, 7, 10, 40

Don Juan de Ornate (sculpture), 42, 198, 208, 211, 213, 248

Donohue, William, 29

Doss, Erika, 11–12, 35, 138, 145, 142

Douglas, Mary, 8

drug use, 124, 230, 266

Dubin, Steven, 2, 8, 11, 14, 35, 43, 67–68, 150, 160, 166, 191–92, 217

Duke Power, 192, 217

Dunkin' Donuts, 226

Durkheim, Émile, 12–13, 67, 86, 94, 149, 154, 250, 261, 284

Eagle Forum, 28, 33, 224

Egypt Game (Snyder), 175

Elazar, Daniel, 131, 148

Elias, Norbert, 251

Ellen, 7, 31

English Only, protest over, 92

ethnicity, 42–43, 198; African Americans, 70, 105, 118, 176, 192, 196–98, 202, 204, 210, 251; Arab Americans, 192, 200; Asian Americans, 192, 207, 210, 214–15; Hispanics and Latinos, 42, 69, 92, 101, 102, 107, 177, 181–82, 185, 192, 195–203, 205–6, 210–11, 214, 234–37, 248; Japanese Americans, 12, 193, 210; Native Americans, 42, 177, 195, 198–200, 206, 210, 212, 214, 291, 294; Vietnamese Americans, 214–15, 203. *See also* cities of recognition; iden-'v politics; politics of recognition
Amitai, 276

evangelical churches, evangelism, 18, 34, 73, 222, 258, 315. *See also* fundamentalism

Evansville, IN, 8, 96

evolution, protest over, 25, 165, 175, 179, 181, 188

Faber's Book of Short Gay Fiction (White), 80, 176

factionalism, 330

Falwell, Jerry, 33

Family Guy (TV show), 227, 331

Family Research Center, 224

Family Research Council, 6

family values, 29, 30–31, 57

Federal Communication Commission, 219, 222, 273, 319

Feinberg, Joel, 1, 238, 251

feminism, 34, 133, 201, 237

film, protest over, 2–3, 30, 40, 42, 51–53, 68, 85, 92, 157–69, 175–76, 179, 183, 185, 192, 201, 209, 251, 278, 284, 331. *See also* protest, film

fine art (drawing, painting, sculpture), protest over, 7–8, 11, 13, 27–29, 31–34, 39, 42, 56, 67, 118, 176, 179, 185, 198, 203, 207–8, 210–15, 239, 248, 268. *See also* protest, fine art

Fish Called Wanda A, (film), 192

flag burning, 9, 116

flags, protest over, 9, 65, 67, 123, 248. *See also* protest, flags

flairs of competition, 150, 173

Florida, Richard, 147

Flynt, Larry, 156, 206

focusing events, 113

Focus on the Family, 51, 174, 224

Fort Apache (film), 192

Fort Worth, TX, 22, 38, 149, 171–88, 219, 248

Frank, Thomas, 156

Fraser, Nancy, 190

Freedom (computer game), 202

Freedom Forum, 272, 332

free expression, and the First Amendment, 7, 28, 145, 241, 253, 256–59, 265, 270–72, 277

Fulton County (Atlanta), GA, 107, 117, 119

fundamentalism, 12, 25, 33–34, 69, 82, 102, 142, 150, 172, 175, 319

Galindo, Rudy, 205
Garden, Nancy, 80, 158, 164–68, 249, 257
Gay and Lesbian Employee Association, 178
gays and lesbians, 27–28, 30–31, 41, 69,
 80–81, 91, 103–4, 108, 114–15, 122–
 24, 136, 141, 167, 159, 164, 165, 167,
 173–74, 176, 178, 196, 200–201, 229,
 232, 237, 248–49, 266
Gemeinschaft, 86
General Social Survey, 79–83, 109–10, 310
Georgiou, Myria, 197
Gibson, Mel, 85, 284
Gingrich, Newt, 194
Girls Gone Wild (DVDs), 234
Gitlin, Todd, 19, 68
Giuliani, Rudolph, 10, 28, 34, 56
Goffman, Erving, 251, 284
Gone with the Wind (Mitchell), 116
Gonzales, Ron, 196
Gore, Tipper, 7
Grand Rapids, MI, 96
Grand Theft Auto (video game), 231
Greensboro, NC, 132
Grendel (Gardner), 175
grievance box, 279–80. *See also* democracy;
 voice
Griswold, Wendy, 238
group competition, source of cultural con-
 flict, 15
group identity, 189–93. *See also* identity
 politics; politics of recognition
Gusfield, Joseph, 5, 15, 64–65, 67–71, 88,
 91, 114, 142
Gwinett County (Atlanta), GA, 107, 110–12,
 119

Hair, 157
Haitians, 68, 251
Hansen, Art, 107
Haozous, Bob, 212
Harer, John, and Steven Harris, 11, 14, 37,
 93, 124
Harrisburg, PA, 80
Hartford, CT, 9, 135
Heather Has Two Mommies (Newman), 80,
 168
Helms, Jesse, 9, 10, 28
Hillsboro Village (Nashville), TN, 94
Hines, Norm, 16, 179, 185, 248. See also
 Caelum Moor

Hirschman, Albert, 23, 122, 243, 254, 276,
 284
history, as target of protest, 114–18, 195,
 198–200, 202, 211, 213, 248
history, of protest in a city, 134–37. *See also*
 protest culture
history, social construction of, 118
Hollywood, as target of protest, 29–30,
 207, 223, 239, 244, 254
Holocaust Memorial, 200, 213
Houston, TX, 96, 100
Howard, Bill, 115
How Stella Got Her Groove Back (film), 3,
 68, 251
Huckleberry Finn (Twain), 40, 42, 70, 124,
 126, 202, 204, 208–9, 211–12, 251, 284
Hunt, Alan, 87
Hunter, James Davison, 6–8, 10, 31–31,
 35, 56, 59–60, 88–89, 171–83, 218,
 255–56, 259, 276–77. *See also* culture
 wars
Hustler magazine, 156, 158, 206–7
hyperpluralism, 193

identity: affirmation of, 3, 237, 260;
 Atlanta, 108–10; collective, 67–8, 284;
 community, 16, 50, 64, 68, 75, 86, 92,
 101, 104–6, 108–13, 133, 149, 164,
 168, 248–50, 265, 270; confusion, 62;
 identity politics, 22, 42–43, 68–71, 148–
 51, 172, 190–209, 215–16; insults to,
 189, language of, 194; national, 59, 89;
 politics of recognition, 190
I Know Why the Caged Bird Sings (Angelou),
 80, 158, 176, 184, 188, 257
imagined communities, 94–95, 120, 249
Immaculate Misconceptions (exhibit), 158,
 165, 167
immigration, 15–17, 21, 65, 69, 73–77,
 80–83, 91–92, 96–104, 107–9, 149–51,
 172, 194–95, 233–37
Institute for Contemporary Art, 35
It's Perfectly Normal (Harris), 157, 161, 163
Ivey, William, 34, 36, 40, 273

Jackson, Janet: nipple controversy, 13, 142,
 218–22, 232
James, Bill, 187
Jefferson, Thomas, 118
Jelen, Ted, 141–42

Jewish Federation of Greater Albuquerque, 213
Johnson County (Kansas City), KS, 156
Jordan, Michael, 26
Joy of Sex (Comfort), 40
Justice, Bill, 29

Kanawha County, WV: textbook controversy, 66, 87
Kansas City, MO/KS, 2, 22, 41, 149, 153–69, 248, 257
Kauffman, L. A., 191
Keating, Charles, 33, 107, 156, 160
Keep Quality in Plano Schools, 179
Kenneth Copeland Ministries, 174
Knoxville, TN, 131, 132, 222
Krueger, Barbara, 12, 192, 210
Ku Klux Klan, 13, 117
Kushner, Tony, 9, 29, 176. See *Angels in America*

LaGrande, OR, 273
Larkin, Donovan A., 168
Larson, Jeff, 127
Last Mission (Mazer), 179–81, 183–85, 188
Last Tango in Paris (film), 157
Las Vegas, NV, 68, 96, 131
law enforcement, 158–80. *See also* cultural conflict
Lear, Norman, 56
Legion of Decency, 160
Lehman, Arnold, 268
Leis, Simon, 156, 158–59, 164. *See also* Cincinnati, OH
Lesbian Avengers, 114, 178
Levine, Peter, 270
Lewis, Helen, 252
Lewis, John, 117
Lewis, Sinclair, 149, 156
Libido: The Journal of Sex and Sensibility, 158
libraries, 55, 58–60, 66, 70, 73–77, 101, 110–12, 164–66, 175, 271
lifestyle concerns, 36, 65–67, 71, 87–89
lifestyle politics, 15, 21, 91, 126, 132–34
Lippman, Walter, 277
Lips Together, Teeth Apart (McNally), 115
Little Tokyo (Los Angeles), CA, 12, 192, 210
localism, 111, 273–74
local morality groups, 160–62
Lomas, Michael, 119

Los Angeles, CA, 12, 113
Los Angeles Coliseum, 113
Louganis, Greg, 114
Louisville, KY, 80, 132
Lynd, Helen, 252

"Macarena, The," 124
MacFarlane, Seth, 331
magazine subscriptions, as a measure of city culture, 132–33, 154
Mann, Sally, 175
Manson, Marilyn, 52, 57, 124, 126, 131, 157, 162, 165, 167, 249, 253, 256
Mapplethorpe, Robert, 7, 9, 13, 27–29, 67, 157, 293
marginalization, 22, 34, 191, 202, 211
MARTA (Atlanta), 107
Martin, Steve, 273, 282
Marx, Karl, 4, 284
masturbation, concerns about, 87, 157, 161, 176
McCrory, Pat, 187
McNally, Terrence, 115
McVeigh, Rory, 13, 91, 125, 126
media, 13, 217–45; environment, 23, 240, 274, 282; market, 95. *See also* cultural change
mega-churches, 173
Memory House (sculpture), 118
Memphis, TN, 9
Mencken, H. L., 25
Merchant of Venice (Shakespeare), 192
Merton, Robert, 63, 68, 197, 249–50
methodology, 37, 71–72, 90–91, 287–326
Metropolitan Museum of Art, 28
metropolitan statistical area (MSA), as unit of analysis, 93–95, 327
Mexican-American National Women's Association, 214
Miami, FL, 3
Middletown, 149, 156
midwestern cities, 156–58, 172
Milk, Harvey, 196
Minneapolis, MN, 131, 256
minority groups, 68–69, 145, 150, 172, 189–216, 249–50, 263. *See also* ethnicity
misrepresentation, 190, 209–10
Miss Saigon (Schonberg and Boublil), 192
Mitchell, Margaret, historic home, 116–17
modernism, 8, 86, 268, 271; vs. traditionalism, 75, 87–88

moral authority and control, 185, 233, 242
moral conservatism, 142, 149, 156, 172–75
moral crusades, 160
moral deference, 211
morality policy and politics, 5, 7, 13, 31–32, 35, 125, 162–65
Moral Majority, 33, 57
moral reformers and entrepreneurs, 8, 10–11, 17, 88, 90, 160–62
moral shock, 224
Motion Picture Association of America, 260
MTV, 162, 164
multiculturalism, 193, 194, 198. *See also* ethnicity
Murphy, Eddie, 226
music, protest over, 6–7, 37, 39, 52, 124, 126, 131, 156–69, 201, 228, 249, 253, 256, 270. *See also* protest, music
Musica (LeQuire), 18
My Brother Sam Is Dead (Collier and Collier), 175

NAACP, 176–77, 202
name-calling, incivility, 50, 52–54, 181, 258
Nashville, TN, 18, 94, 132, 147, 219
National Coalition Against Censorship, 111, 272
National Coalition Against Pornography, 156
National Endowment for the Arts, 7, 19, 25, 27–29, 260
National Science Foundation, 79
National Stuttering Project, 192
Native Americans, 42, 177, 195, 198–200, 206, 210, 212, 214, 291, 294. *See also* ethnicity
N.C. Pride Action Committee, 178
New Joy of Gay Sex (Silverstein and Picano), 80, 168
new localism, 274
new media, 273, 281
New Orleans, LA, 96
new social movements, 191
newspapers, as data source for protest events, 19–20, 95, 253
New York, NY, 7, 11, 28, 56, 192, 268, 277
Nigger Drawings (Newman), 192
1900 (film, Bertolucci), 175, 179, 183, 185
Nip/Tuck (TV show), 224
Noelle-Neumann, Elisabeth, 141, 268

noisy culture, 23, 240, 274, 282. *See also* cultural change; media environment
Nolan, James, 7
nonprofit arts organizations, growth of, 271
Norfolk, VA, 38, 96
Northern Kentucky University, 167
not in my backyard (NIMBY) concerns, 223
nudity, 18, 113, 124, 157, 159, 166, 175, 178, 219–22
NYPD Blue (TV show), 157

Obama, Barack, 197
obscenity, 2, 53, 65, 80, 148, 156, 162
O! Calcutta! (Tynan), 157
Ocean Apart (Pilcher), 203
O'Connor, Cardinal John, 28
offense, 1, 62, 85, 92, 166, 189–90, 210, 238, 256, 278–79
Office of Intellectual Freedom of the American Library Association, 272
Ofili, Christopher, 28
Of Pandas and People (Davis and Kenyon), 180, 184
Oklahoma City, OK, 2, 22, 53, 149, 153–69
Oklahomans for Children and Families, 160
O'Neill, Thomas Phillip ("Tip"), 260
old South, 115–17, 248
Olympics (1996), 21, 105, 107, 112–20
Olzak, Susan, 13, 91, 98, 135–36, 287, 289, 298
One Day in the Life of Ivan Denisovich (Solzhenitsyn), 179
opinion climate, 140–46. *See also* public opinion
oppositional movements, 177
organic solidarity, 86
Out (magazine), 175
Outbreak (film), 278
Out of Control (Mazer), 162, 165

Palin, Sarah, 239
Parents Advocating Greater Education, 181, 183–84
Parents Involved for a Better Community, 110
Parents Television Council, 10, 22, 40, 217–45, 250, 253; activities of local chapters, 226–27; broad concerns, 227–31; conversion and recruitment stories, 223–26; future of, 245
Park, Robert, 86

Passion of the Christ (film), 85, 92, 284
patriotism, 193
Pelosi, Nancy, 194
People for the American Way, 7, 11, 30, 56, 124, 291
People versus Larry Flynt (film), 206
Pew Survey for Teen Media Use, 281
Philadelphia, PA, 9, 11–12, 35, 37, 134
Phoenix, AZ, 9, 30, 65, 149, 171, 219
photography, protest over, 7–8, 13, 27, 51, 65, 67, 123, 128, 157, 166, 175, 203, 210
Piazzoni Mural, Asian Art Museum, San Francisco, 207, 210, 214–15
Picasso at the Lapin Agile (Martin), 273
Pittsburgh, PA, 132, 219–22
Playboy magazine, 156, 158, 166
Pledge of Allegiance, 12
pluralism, 150; hyper-, 193; religious, 88
political culture/context, 131–37
political subcultures 131, 148. *See also* Elazar, Daniel
politics: elected officials, 28–29, 43–46, 53–54, 57–58, 96, 141–42, 158–60, 165–69, 207–8, 280–81; elections, 7, 34–36, 197; expressive, 60, 126, 218, 237, 259; extreme, 10, 60, 125, 130; lifestyle, 91, 126, 132–33, 319; local, 113–18, 158–60, 132, 136–37, 158–60, 165–69, 196; material vs. symbolic 4–6, 15, 61–71, 198; new political culture, 35–36, 126, 131, 144, 147–48, 191; political cycles, 35; symbolic, 4–5, 15, 65, 71, 198
politics of presence, 210
politics of representation, 195, 197, 205, 207, 209
popular culture, 51–54, 183, 253, 273, 300
population growth, 19, 38, 100–104, 106–8, 132, 153–56, 185, 236–37. *See also* immigration
pornography, 5, 41, 141, 156, 163, 164. *See also* anti-pornography campaign
poverty, 109
poverty culture, 234–37
Powell, Michael, 219
presidential election (1992, 2000), 6, 140
Priest (film), 51, 57, 95, 129, 157, 162
Princeton, NJ, 85
principals of engagement, debating conflict, 276–83

private culture vs. public culture, 59–60
professionalism and expertise in the arts community, 269–71
progressive politics, 194
progressives vs. traditionalists, 10, 31–32, 261. *See also* culture wars
protest: bearing witness, 22–23, 90, 130, 210–11, 237–38, 251, 259; books, 39–42, 66–70, 73–77, 80–81, 87–88, 101, 110–12, 123–26, 156–69, 175–76, 179–81, 183–85, 188, 198, 202–4, 249, 251, 257, 284; culture of, 59, 89–90; definition of, 95–96; emotional dimensions, 232, 237; film, 2–3, 30, 40, 42, 51–53, 68, 85, 92, 157–69, 175–76, 179, 183, 185, 192, 201, 209, 251, 278, 284, 331; fine art (drawing, painting, sculpture), 7–8, 11, 13, 27–29, 31–34, 39, 42, 56, 67, 118, 176, 179, 185, 198, 203, 207–8, 210–15, 239, 248, 268; flags, 9, 65, 67, 123, 248; history of, 134–37, 263; intensity of protest, 47–56, 57–58, 137–40; law enforcement, 157–62, 167; levels of intensity, 143; local vs. national 13–14, 25–26, 50–54, 56–60, 160–62, 259–62, 279; music, 6–7, 37, 39, 52, 124, 126, 131, 156–69, 201, 228, 249, 253, 256, 270; outcomes, 46–50; photography, 7–8, 13, 27, 51, 65, 67, 123, 128, 157, 166, 175, 203, 210; protest culture, 134–37; repertoires of contention, 21, 59, 127, 148–50; role of elected officials, 28–29, 43–45, 53–54, 57–58, 130, 141–42, 280–81; role of religion, 27–31, 32–34, 50–58, 223–24, 238; television, 7, 29, 31, 33–34, 39–40, 77–78, 131, 157, 217–46; theater, 9, 29, 124, 158, 171, 176, 178, 180–83, 186–87, 257–58, 265–66, 273, 281, 284; types of actors, 34, 43–45, 50–54, 56; types of grievances, 26–27, 28, 41–43, 47–48, 55, 177; types of protest, 45–50; valence, conservative or liberal, 43, 103, 299
public art, 8, 11, 35, 138, 145, 185–86, 199–200, 205
public education, 25, 41, 59, 66–67, 107, 179–80, 184, 198, 212, 257, 265–67
public libraries, 3, 41, 42, 55, 58–59, 70, 73, 76, 80–82, 123, 157–58, 161, 163–68, 175, 182, 184, 188, 199

public opinion: Atlanta, 109; climate of opinion, 121, 122, 140–45; spiral of silence, 141, 240
Pueblo tradition, 195, 198
Putnam, Robert, 73, 134, 144, 274, 304, 307

race and ethnic relations, 27, 91, 109–10, 176, 248. *See also* ethnicity
racial segregation, 109–10
racism, 109, 116–18, 188, 193
Radiant Identity (Sturges), 168. *See also* Sturges, Jock
radio, protest over, 30, 40
Raleigh, NC, 11, 38, 124, 132, 219–22
Reagan, Ronald, 10, 33
real politics, definition of, 5, 126
Reeder, Harry, 183
religion: Christian Right, 3, 30–31, 33, 142, 173–74; fundamentalism, 25, 101–4, 142; Islam, 42, 195, 200, 209; Judaism, 3, 98, 179, 192, 196, 200, 201–2, 209, 213; pluralism, 88; religious minorities, 201; role of religion in protest, 27–31, 32–34, 43–45, 50–53, 55–56, 57–58
Religious Roundtable, 173
Rent (Larson), 266
repertoires of contention, 21, 121, 127, 144–45
resistance identity, 210–11
respect and self-determination, 207, 210–11
Richardson, Jim, 9
Richmond, VA, 149
Riesman, David, 70
rituals of protest, 64, 148–51, 154, 168, 175, 249, 255
Riverside, CA, 30
Robertson, Pat, 28
Rock & Roll Hall of Fame, 202
Rodgers, Harrell, 141
Rodriguez, Joseph, 13, 195, 212
Romeo and Juliet (Shakespeare), 257
Roseanne (TV show), 157
Rosenberg-Smith, Carroll, 87
Rosenstone, Steven, 139
Roswell Historic Preservation Committee (Atlanta), 117
Rothfield, Larry, 10
routine politics, 130–31

Run Shelley Run (Samuels), 80
Ruth Eckerd Hall (Clearwater, FL), 29

Saavedra, Ron, 196
Saguaro Seminar, 73–77, 80
Salinger, J. D., 40–41
Salo: 120 Days of Sodom (film), 158–59
Salt Lake City, UT, 3, 30, 147
San Diego, CA, 135
San Francisco, CA, 22, 96, 100–101, 150, 189–216
San Francisco Library, 207, 210, 214–15. *See also* Piazzoni mural
San Francisco values, 194
San Jose, CA, 22, 68, 100, 150, 189–216
San Jose African American Parent Coalition, 204
San Jose Museum of Art, 203
Sano, Emily, 215
Santa Rosa, CA, 135
Saving Private Ryan (film), 331
Saturday Night Live (TV show), 273, 282
Scheff, Thomas, 252, 253
Schindler's List (film), 175
Schlafly, Phyllis, 33
schools, 55, 59–60, 66, 73–76, 175–76, 257, 278–79. *See also* public education
Schultze, Quentin, 34, 253
Schumaker, Paul, 142
Scopes trial, 25
Scorsese, Martin, 159
Scott, Dread, 65, 123
Seattle, WA, 11, 132
secular humanism, 149, 183, 194
Senie, Harriet, 8
Sensation exhibit, Brooklyn Museum of Art, 7, 11, 13, 28, 31, 34, 56, 268
Serrano, Andre, 7, 27, 29, 67, 203, 210
sex education, 40, 87–88, 91, 110, 141, 184
sexism, 201
Shakespeare, William, 192
Shakespeare's Dogs (play), 2
shame, emotions of, 23, 251–53
Sharp, Elaine, 7, 13, 35, 125, 131
Shields, Carole, 124
Showgirls (film), 30, 51–52, 157, 162, 164–65, 201
Siege (film), 42, 209
silent majority, 239

Silent Sam (statue), 27
Simmel, Georg, 86, 255, 284
sin of commission and sin of omission,
 205
Sjoquist, David, 108–9
Skocpol, Theda, 89
slap in the face, 193. *See also* respect
Smith, Christian, 126
social anxiety, 62
Social Capital and Community Benchmark
 Survey, 73, 77, 304–6
social change: definition of, 14, 63; fear of
 and discomfort surrounding, 16, 23, 62–
 63, 72, 77–83, 85–86, 89–91, 232–37;
 group competition, 35, 91; immigration,
 15–17, 21, 65, 69, 73–77, 79–83, 91,
 96–104, 107–8, 109–10, 148–50, 172,
 194–95, 233–37, 250; measures of, 98;
 theory of, 63, 68, 70–71, 79–83, 148–49
social class, 5, 8, 12, 64–65, 69, 71, 88–89
social justice, 193
social movements, 4, 21, 32, 59, 72, 89, 90,
 113, 125–27, 191, 224, 232
social prestige, status, and recognition,
 5–6, 64–69, 91, 250. *See also* Gusfield,
 Joseph; status politics
sociology of shame, 251–52
solidarity, 62, 75, 86–87, 101, 144, 232,
 263
Soule, Sarah, 127
South Carolina State Capitol, 248
Southern Baptist Convention, 7, 31
southern cities, 101–3, 105, 172, 221–22
speaking out, 23, 122, 239–43, 254, 276,
 284. *See also* voice
spiral of silence, 141, 240, 332
Spirit Poles (sculpture), 11
Springfield, IL, 19, 38, 96, 288
Sprinkle, Annie, 13
Starr, Kenneth, 3
status anxiety, 66, 250
status politics, 69, 91. *See also* Gusfield,
 Joseph
stereotypes, 26, 176–77, 189, 191, 204–5,
 251
Steven, Chester, 210
Stokes, Carl Burton, 196
Stone, Oliver, 206
Stuart, Alfred, 187
Student Body (Balk), 26–27

student protest, 26–27, 32, 206
Sturges, Jock, 51, 165, 168, 175
sumptuary laws, 4, 87
Sunbelt cities, 38, 100, 149, 172, 173, 186
Super Bowl (2004), 13
symbols: art and media as, 36, 60, 115,
 191, 198, 247–53, 284; role in com-
 munity, 22–23, 37–38, 43, 60, 92, 118,
 123–24, 248–50, 262–63, 28; symbolic
 conflict, 64–65, 68, 89, 104, 115–16;
 symbolic control, 5, 61–63, 71 112,
 120, 150, 249; symbolic politics, 4–5,
 15, 65, 71, 198

Tampa, FL, 3
Tarrow, Sidney, 127
Tasini vs. New York Times, 327
Taylor, Charles, 190–91, 197
Taylor, Theodore, 204, 210–11
technology, role in conflict, 273, 281. *See
 also* noisy culture
teenage girls, 62
teenage pregnancy, 228, 235
teenage sex, 124, 225, 332, 243–44
television, protest over, 7, 29–31, 33–34,
 39–40, 77–78, 131, 157, 217–46; harm
 to children, 30–31, 34, 81, 217–46. *See
 also* protest, television
temperance, 64–65, 67, 70, 88, 332
Thanh Lan (singer), 203
theater, 9, 29, 124, 158, 171, 176, 178,
 180–83, 186–87, 257–58, 265–66, 273,
 281, 284. *See also* protest, theater
Tilly, Charles, 121, 127, 289
Tin Drum (film), 2, 53, 157, 160, 161, 163,
 166, 167
Tocqueville, Alexis de, 137, 274
tolerance, 100, 114, 137, 142, 185–87,
 190, 201
Tongues Untied (documentary), 178
Tonnies, Ferdinand, 86, 94
Topeka, KS, 30
traditionalism, 3, 10, 75–76, 261; effects on
 protest, 133–34, 322; measures of, 320.
 See also progressives vs. traditionalists
Tucker, Dolores, 7, 40
Tupelo, MS, 30, 60
Twain, Mark, 40, 42, 70, 124, 126, 202,
 204, 208–9, 211–12, 251, 284
2 Live Crew, 157, 161

unconventional culture, 31, 133; measure of, 319
United States Supreme Court, 2, 219, 327
Unity Movement, 156
Universal Studios, 68
University of New Mexico, 212–13
University of North Carolina at Chapel Hill, 26–27, 32
Untouchable (Brian), 80
urbanism, 86

Vanderbilt University students, 1, 140 189, 243, 245
Verotika (comic book), 159, 162
video games, 231, 244
Vietnamese immigrants, 129, 203–4, 214
violence, 165, 228, 231, 232–33, 243–44
voice and democracy, 23, 60, 69–70, 112, 122, 126, 145, 150, 191, 214, 237–41, 243, 253–56, 259, 264, 267, 269, 275–78, 282–85. *See also* bearing witness; expressive politics
voter turnout, as measure of civic activism, 18, 21, 139–40, 144

Washington, Harold, 35
Weber, Max, 86, 269

What Is a Girl? What Is a Boy? (Waxman), 110
Whistler, James, 121
White, Michael R., 202
Widmon, Donald (reverend), 28–40
Wiesel, Eli, 238
Williams, Hosea L., 116
Williams, Rhys, 7
Wills, Garry, 174
Wirth, Louis, 86
witch hunts, 64, 87, 175
Wolfinger, Raymond, 139
Women on Top (Friday), 110
women's movement, 196
Woods, L. B., 37
World Values Survey, 109
Wuthnow, Robert, 33, 64, 67, 255
Wye, Christopher, 196
Wysong, Gordon, 113–14

Young, Andrew, 115
Young, Michael, 90, 238
youth and crime, 182
YouTube, 273

Zapata, Emiliano, 177
zeitgeist, 89, 263
Zenith, 149